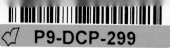
UNDERSTANDING PHOTOGRAPHY

Carl Shipman

Richard Scherz

Contents

Editor:	Bill Fisher
Cover Photos:	Josh Young
Design:	Josh Young
Book Assembly:	Nancy Fisher
Typesetting:	Grace Williams
	Ellen L. Duerr

ISBN Number 0-912656-24-7
Library of Congress Catalog
 Card Number 74-82518
H. P. Books Number 24
© 1974 Printed in U.S.A 9-74
H. P. BOOKS, P. O. Box 5367
Tucson, AZ 85703

This is one of a series of H. P. Books on photography. When planning the series, we decided to begin with a good readable book on fundamentals written for the average person with an interest in photography.

Every serious photographer must be part artist and part technician—some lean more in one way than the other. If your interest is in photography as a means of self-expression through creative images, then these technical ideas are your tools as are canvas and pigments to the painter. Lenses, light, film characteristics, exposure and color principles are important and essential as ways to reach your goal. You will look for a clear sensible presentation of these matters and you will find that in this book.

If you appreciate both a striking photograph and the equipment and processes which made it happen, you'll share the joy of discovery with author Carl Shipman in this ramble called *Understanding Photography*.

This book is a break with tradition in several way. Even though it covers material found in many college-level text books, it doesn't read like a text. It's informal, unhurried, friendly and person-to-person. Pictures are explained with pictures. It doesn't require much from the reader except a lively interest to match the lively presentation. It covers things you must know, and things that are interesting to know about.

You'll have fun in this book and when you are through, I think you'll take better pictures.

Bill Fisher
Publisher

ABOUT THE AUTHOR

The writing assignment for this book was given to Carl Shipman, Managing Editor of H. P. Books. In addition, he is editor of the other photo books in this series.

The technical base for this book stems from Shipman's work in photographic sound recording in the motion-picture industry. During this time he also lectured at the University of Southern California and contributed to the Journal of the Society of Motion Picture and Television Engineers.

The practical emphasis results from his experience as a writer and photographer. He has been a columnist, contributing editor and regular contributor to several popular magazines. He has written and photo-illustrated five books on engine tuning, motorcycling and photography.

Maybe you've gotten into this book by mistake

When you click the shutter on your camera, you are participating in a process which is probably more complicated than any other thing you ever become involved in. However, the canny wizards in the photographic industry have simplified the art of taking pictures so the only *requirement* imposed on the customer is clicking the shutter.

Curiously, you can take pictures this way with the cheapest box camera and also with a very expensive fully automatic camera. Either way, the result is usually average pictures of average scenes. The kind you take and toss into a drawer. A couple of years later you wonder why you took that photo in the first place. If you are content with this kind of picture-taking, you are welcome to leave quietly and I won't scold you.

The implication is that some level of understanding beyond what is in your finger is needed to take pictures that are more satisfying. Meaning that your picture fulfills the purpose you had in mind when you took it. If you don't have a purpose don't take the picture. Lie down a while and maybe you'll think of something.

Nearly every branch of modern knowledge has contributed to the hobo-stew of photography. It draws from several kinds of physics, optics, atmospheric phenomenology, chemistry, math, geometry, mechanical engineering—all of which you knew were lurking in there somewhere—and also psychophysics, which you may never have heard of even.

Fear not that I will try to explain all those scientific disciplines. I plan to explain those parts important to the person with a camera in his hand. From two points of view: things which contribute to making a satisfactory picture, and some basic ideas which allow us to understand the practical stuff. Also there will be some things which I think are interesting even though only vaguely related. And, I plan to ramble some.

Without the rambling, parts of this book might be nearly indistinguishable from a textbook and neither of us would have any fun.

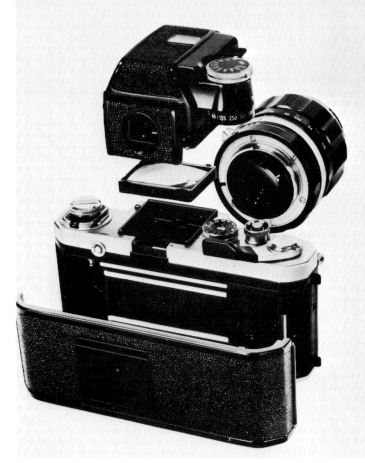

This exploded view of a Nikon F2 shows some of the camera features discussed in this book: lenses and apertures, focusing and finders, shutters and exposure controls. It helps to understand how they work, along with films and human factors, also discussed here.

Herr Weber and friends

Around 1890, in Germany, a gentleman named Weber became curious about the response of human beings to physical stimulus. As an example, if we stand by a fire we feel warmth. Weber wanted to know things like: How much more heat would it take so the observer *feels* twice as warm?

Accordingly, he alienated his friends by subjecting them to heat, loud noises, pain, bright lights, pressure and all that. It's likely he extracted a lot of confessions that way which he never recorded in his notebook. What he did conclude and record is that human response to a changing stimulus depends greatly on how much stimulus is already present.

Such as the fellow who didn't notice his sore toe anymore after he got run over by a truck.

3

Weber concluded that for each kind of stimulus there is some minimum change in amount which will produce a "just noticeable difference" in the sensation of his victims under test. They would say, "That's just barely more painful, Sir."

This can be expressed by a simple formula:

$$N/O = K$$

In this formula, **N** is the new value of some stimulus which produces a just noticeable difference from the amount that existed before. **O** is the amount of the old stimulus, before it was changed. **K** is some fixed number which is constant for *each type* of stimulus.

To keep it simple, let's decide that **K** is the number 2 for some stimulus that humans can feel or sense. Then if **O** is 4, **N** has to be 8 for the fraction **N/O** to equal 2. In other words, when stimulus starts at a value of 4, it has to increase to a value of 8 to create a noticeable change.

If the old value is 20, then the new value has to be 40—an increase of 20 units to create a noticeable change. The larger the value of the old stimulus, the larger the amount of change required for you to notice it. This rule applies to all of the physical things we can sense, such as light and sound.

Without much more hammering on the point, it should be obvious that when the Weber constant, **K**, is equal to 2 the stimulus must always be doubled or halved to create a sensible change. The constant is not always 2; it depends on what the stimulus is.

IMPORTANT NEWS FROM ENGLAND

In England, about the same time, a bunch of photographers were having a meeting. They had gone past the point of observing that more exposure to light caused negatives to get blacker and the resulting prints to get whiter. Now they were trying to agree on some logical series of steps in exposure so each step would make a visible difference on the film and they could get some standardization by all using steps of the same size.

They agreed on a rule that each higher step in exposure would be exactly double the preceding value. When going in the other direction, decreasing exposure, the lower value is obviously half of the higher value.

It's interesting that these practical photographers hit on the same basic idea as Weber did.

Between white and black are all the shades of gray which we sometimes think of as steps along a gray scale. A rule of photography is, the amount of light representing one step is double the amount of the next lower step. These steps are arbitrarily chosen, but represent a change in brightness which is perceptible to most any viewer. Model's name is Goodo.

Weber did it by exposing his victims to mild pain at times; the photographers did it by a similar process—showing each other their pictures.

In looking at photo prints, the victim perceives basically changes in the amount of light reflected from different parts of the print. The English photographers were not looking for the minimum change in light which could be detected by a human observer—they were looking for a change any dummy can see. However the basic idea is the same: To get a series of exposure differences which *appear* to be *equal* changes, you double the exposure for each step.

This factor-of-two idea pervades photography. It pops up all the time and you will be using it constantly whether you are aware of it or not. Hang in there and you will be aware of it.

Incidentally, what Herr Weber got started became a branch of science called psychophysics and you can read more about it in an encyclopedia. A very large amount of practical photography rests on that psychophysical base.

Color or black-and-white

I have read that 70 or 80 percent of all photographic exposures are made on color film. It may seem that a photography book should jump right into color because that's where the action is.

As far as the idea of it is concerned, color is merely an adornment of black-and-white (b&w) even though technically it is complicated. If you imagine that you obtain a very good b&w picture and then substitute the correct colors and brightnesses for the shades of gray in the b&w version, you are pretty close to what most color processes really do. When you expose normal color film you are in fact capturing b&w images on the film which get changed to color images in subsequent processing.

Most of the facts about photography apply equally to color and b&w processes but it is a lot simpler to explain and understand them when considering b&w. On that base, it is just another few steps of logic to add in the ideas of color. That's the path followed by this and most other books on photography.

To say it more bluntly, you can't just start out learning about color even if that's your main

interest. You have to begin by learning about b&w, comforted perhaps by the assurance that you are learning about color simultaneously even though it doesn't seem that way.

Learning to see

I betcha that paragraph title, "Learning to See" appears in at least a dozen books on photography. The writers tell us in a quite straightforward way that taking pictures somehow improves our ability to see and enjoy nature's wonders. By training the eye, one becomes better at looking at sunsets and skin.

In my sometimes contrary way of thinking, that's all wrong. Even after you become the

Even in a relatively simple scene such as this, your eyes don't take it all in with one glance. You scan around the picture looking at individual parts of it in sequence, spending more time looking at parts that interest you. Model's name is Irene.

world's greatest photographer you still see in exactly the same way. What you learn to do is *think differently* about what you see. You also learn to think about how other people see because this helps you make good pictures.

You are now looking at a page of a book. After you have completed reading this paragraph, please do what it asks and see if you agree with the conclusions. Look fixedly at one word in the middle of some paragraph. Don't let your attention stray from that one word. Then notice how small the area is where you can also read other words clearly, while continuing to look at that same one word. It's a pretty tiny area, isn't it?

The human eye does not take in great vistas, all at a glance.

Now look at a wall or a grouping of furniture. Try to take in all the visual detail that is there. Notice what your eyes are doing. They are scanning all around over the scene, sometimes returning to look at something a second time.

We scan a scene and to see all of it we have to look at every part. It is your brain that assembles the entire image of the scene in view. Now look at any photo in this book. Your eyes do exactly the same thing.

When we fail to observe some detail in a scene or photo, it is either because our eyes did not stop and take data at that point or the brain refused to accept data from that point. Either of these happenings can cause a photo to fail, if the thing that was missed is important to the purpose of the picture.

The eye is not just roaming around of its own volition, it is commanded by the brain to look here, look there, oops!, go back to that good part again.

Therefore, if you wish to compel attention to some particular area of your picture, it's a good idea to try to arrange things so that will happen. One simple way is a photo caption or title located near the picture. It can say, for example, "Notice the beautiful model is missing some front teeth."

Another way is to paste an arrow on the photo, pointing to the area of interest. Crude but effective.

There are some more subtle ways. Lighting, composition, geometric forms in the image, framing effects, and other tricks you will think of. Some examples are among the illustrations.

When all parts of the image are in pretty good focus, you can look anywhere you choose.

When part of the image is out of focus, it practically forces you to look at the part which is in focus, doesn't it?

More parlor tricks now. Hold up one finger, far enough away so you can focus comfortably on it. Now keep looking at it but select some distant small object such as a vase or telephone and see *how many* of that distant object you see, out of focus, while looking directly at your finger. You will see two provided you have the standard number of eyes.

Close your eyes, one at a time, and you will see which of the distant objects is being viewed by which eye while your eyes converge to focus on your finger. Beyond the finger, your right eye is looking out into left field, and vice versa.

If you look at the distant object, you will then see two fingers where there is really only one. Fiddle around some more and you will be able to figure out which of your two eyes is dominant—some people are right-eyed, some left-eyed, just as some are right-handed or left-handed.

BASIC IDEA: RECIPROCALS

A reciprocal of a fraction is simply that fraction turned upside down. The reciprocal doesn't convey any more information or any different information than the original fraction did. The difference is point-of-view.

For example, if we make a fraction A/B and ask what is its reciprocal, the answer is B/A, which is exactly the same information turned upside down. If we take the reciprocal of a reciprocal, we get right back where we started. The reciprocal of X is 1/X. The reciprocal of 1/X is X.

Reciprocals are used largely as a matter of convenience or to highlight a point of view. You can talk about a ranch in terms of cows per acre, or acres per cow, which are reciprocal relationships. If you know a number, you also know its reciprocal.

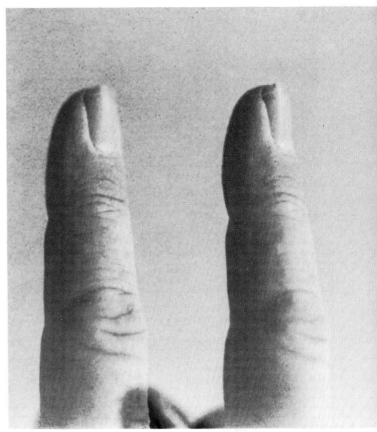

If the camera had two eyes as you do, it would see this view when looking into the distance past only one finger. When you look past your finger, you see two of it but your mind selects only one view. Try it and see which. This was a double exposure, moving finger between shots.

This business of eye-convergence on the object of interest is one of the clues which the brain interprets to tell how far away an object is. Considering a scene at large, each eye gets a different view.

On a photograph, everything is the same distance from your eyes and each eye gets the same view. Therefore we are denied eye-convergence as a way of discerning depth in a picture.

Do the finger bit again with one eye closed. This time focus first on your finger and then on the distant object. The eye has a flexible front lens and muscles to change it so it can focus near or far. Notice that you can feel your eye doing this. This is another way people can judge depth.

On a photo, everything is still the same distance from your eye, so you are also denied this "sense" of focusing as an aid to depth perception in a picture.

Go back to the one-eye one-finger trick again and this time, while admiring your finger, notice that distant objects are not in sharp focus. The more distant, the more blurred. Or if you focus on something across the street, near objects are blurred.

This aspect can be preserved in a photo. By proper use of your camera, you can throw near or distant objects out of focus to convey a sense of depth if you want to.

You can also have the whole picture in focus and still convey depth. Part of photographic depth is in perspective and part of it is in the relative sizes of known objects in the picture.

One way to think about perspective is to recall how a long straight highway looks to you from a rise in the road. It goes straight away toward the horizon, but it seems to get narrower and narrower in the distance. Roads don't really do that unless

The road occupies a smaller part of your total angle of view as it recedes into the distance. Because you expect the road to have constant width, when it looks narrower you know it is farther away.

If you know what it is, the apparent size will tell you how far away it is. If you know how far it is, you can judge the size. With no information, you are baffled. How big is this object? How far away is it? It's a photo of the back end of a lens with the image out of focus. Diameter of the circle is about one inch.

the highway contractor was taking more than normal profits out of the job. Your brain expects the road to have constant width and therefore *interprets* the reduced apparent width to mean greater distance.

Perception of distance also relates to the angle of view occupied by something you are looking at. If you hold your arms out to each side, and waggle your fingers, you will notice that with both eyes open you can see everything in a horizontal angle of about 110°, more or less. Within that overall angle of view, each object in your sight occupies some part of the total angle.

For objects you have seen before, your brain remembers the viewing angle intercepted, or subtended, by that object at some *known distance.* Then, if the object subtends a smaller angle your brain says it is farther away.

You can test that with this book. Hold it up close to your face and then move it away. Your brain is getting an array of signals telling it that the book has moved farther away. One of them is, the book subtends a smaller angle in your view.

If you see your dog so far away that he looks only about six inches high, you don't say your dog has shrunk, you say he is at a distance.

For an object of known size, subtended angle tells us how far away it is. For an object at known distance, the angle tells us how big it is.

What about an unknown object at unknown distance? Imagine you are lying on your back, looking at nothing but clear blue sky. Then, at some great distance, you see an unknown object, possibly a flying saucer. If it is far away, then eye-convergence does not help much because our eyes don't converge much when looking far away. Similarly, the feeling of your eyes focusing outward is all used up within a few hundred feet so you can't get any clues from that.

There you are, flat on the ground, with nothing but subtended angle to tell you *both* how big it is and how far away it is. You can't do that. You have to know one or the other. If you do make a decision it may even be wrong. An airplane sometimes looks bigger than the moon, but it never is.

BASIC IDEA: LOGARITHMS

If you don't already know about logs, you can learn the fundamentals in three minutes.

$$10 \times 10 = 100$$
$$10 \times 10 \times 10 = 1{,}000$$

To multiply a number by itself several times, you can write the numbers in a row, as above, and then multiply them. A shorter way to show the same thing is:

$$10^2 = 100$$
$$10^3 = 1{,}000$$

The small number written above the 10 is called the exponent and its purpose is to show how many tens are being multiplied together. 10^3 means $10 \times 10 \times 10 = 1{,}000$.

If you used this notation all day long because your job was multiplying tens together, you would soon adopt an even shorter way of writing down the problem. You would start using 2 to mean 10^2, 7 to mean 10^7, and so forth. Obviously those numbers 2 and 7, used that way, do not mean two apples and seven bananas. They have a special meaning and a special name: *Logarithms.* Because the basic number being multiplied in this example is ten, these are called logarithms to the base ten, indicated: Log_{10}.

Log_{10} of 10,000. = 4	$10 \times 10 \times 10 \times 10 = 10{,}000$	
Log_{10} of 1,000. = 3	$10 \times 10 \times 10 = 1{,}000$	
Log_{10} of 100. = 2	$10 \times 10 = 100$	
Log_{10} of 10. = 1		
Log_{10} of 1. = 0		
Log_{10} of 0.1 = $\overline{1}$		
Log_{10} of 0.01 = $\overline{2}$		

Here is an incomplete table of logarithms. On the top line, notice that the logarithm, 4, is the same as the number of zeros after the one and ahead of the decimal point.

Continue on down the table and that rule still applies. The logarithm 2 is the number of zeros in the number 100, still 10×10.

Follow on down the table, applying the rule as you go and you should convince yourself that the log of the number 1 is zero. You have to *believe* in the rule, because it works for all the other numbers. Or else you're a mathematical anarchist.

An interesting thing to notice is that all logarithms between zero and one are fractions or decimal fractions such as 0.3. Therefore all *numbers* between 1 and 10 have a logarithm between zero and one.

Specifically, the log of the number two is 0.301 which most people round off to 0.3 and some people even remember that.

Logarithms are the standard way to measure stimulus applied to people, on account of what Weber found out. Let's suppose that for some stimulus such as sex appeal it takes ten times as much before your victim notices the improvement. The Weber constant is ten.

On the log table, the *numbers* go up in *multiples* of ten: 1, 10, 100, 1,000 and so forth. Each of these numbers therefore should represent *one step more* sex appeal. One hundred is one noticeable step better than ten—not ten times as much.

The logarithms show exactly that. The log of 10 is 1 and the log of 100 is 2. Two is one step bigger than one. The whole table carries on the same way. Each time you multiply the number by ten, the log goes up by one unit. Therefore the logarithm more nearly reflects how people respond to stimulus.

The Weber constant doesn't always have to be ten, and the logarithms will work anyway. If the constant is the number two, logarithmic increases will be 0.3. In photography the step ratios are usually two. Representing this by logarithms, 0.6 is one step more sensation than 0.3, and 0.9 is a step above 0.6, and so forth.

Another way the mind interprets distance is by *relative* subtended angles of known objects. If I take a picture of you standing close to the camera, with a mountain in the background, it won't fool the viewer into thinking you are bigger than a mountain, even though that's exactly what's on the film.

All of these facts bear on how you take a picture and what you include in it to get the desired result in *the mind of the viewer.*

Probably all of the interpretive ability of our minds is based on prior learning—or things we are used to seeing. We are all used to noticing distance as a change in the horizontal angle occupied by something. We have less built-in education about how things look which fade away vertically.

Standing at the bottom of a tall building, we rubberneck upward and see it tapering away into the sky. "My gracious, that thing sure is tall!"

If you put your camera where your eye is, you will get about the same view on film. The building will taper away majestically, right there on your picture. But a viewer's mind may not interpret it that way. He may think the building is falling over backwards.

MENTAL ADAPTATIONS

It's a sad fact that most of the marvelous adaptations our minds and eyes perform, to help us view things in the real world, change character completely when we are viewing a picture and serve to make it look worse than it really is. Also, many of these adaptations make our own senses completely unreliable when it comes to judging the amount of light or its color at the time we are taking a photo.

Our eyes constantly adjust for brightness of scenes and even parts of scenes. This is done both by changing the size of the iris to allow more or less light to enter, and also by changing the sensitivity of vision. With this automatic adjustment feature, we can look at the bright exterior of a building and also into open doors or windows to see what's inside. Take that same picture and it won't look the same. If you expose for the bright exterior, the windows and doors will be black rectangles. Even if the film manages to capture some detail in the dark areas, the eye of the viewer of the picture will be regulated more by the surrounding ambient light in the room than it is by

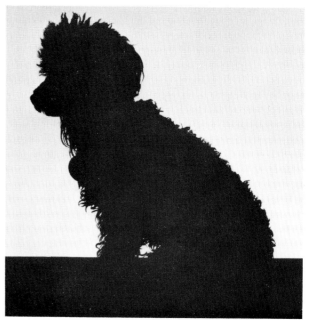

You can look at poodle in the window and also outside. Film can't. If you expose for the sky background, poodle becomes a silhouette.

If you expose for Jolie, the sky washes out completely.

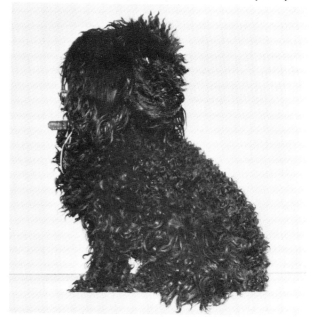

the light and dark areas of the photo. It won't adapt nearly as well to the picture as it did in real life.

Brightness adaptation tends to make us *feel* like we are always in nearly constant brightness. You can be comfortable in normal room illumination and then step outdoors into bright sunshine. After a short time, you adapt to the brighter light and you feel just as comfortable. Because of brightness adaptation, your senses are generally unreliable in judging the amount of light to help you set camera exposure.

We make adaptations in favor of image integrity—that is a complete image—when we are out in the real world. If we see somebody with half his face in shadow, we tend to ignore the shadow and conclude that the person has a complete face. Take the picture and your viewer will not be so charitable.

Part of this lies in the feeling of participation we have in the real world. We are there, the objects are there, and our brain accepts the objects as factual and complete entities. When viewing a picture, we are not experiencing the event recorded on film. We tend to view the photo itself as an object, independent of our direct experience, and therefore look at it differently.

We also make color adaptations. If I sit with you for a while under blue light, I will not conclude that you have turned blue. But if I take a color slide of you under those conditions, people will say, "My, that guy sure has blue skin." Or else they will say I took a bad picture. Neither is true. If I wanted a picture of you looking blue, and took one that made you look that way, it is a very good picture, at least in my opinion.

Sunlight is white. Skylight is blue. Candles and incandescent lights are yellowish. Fluorescent light is funny-looking. We live in all these different kinds of light and don't notice, except briefly, the difference in color. The viewer of our color pictures will notice it unless we take steps to prevent it. These corrections involve light filters and film selection, discussed later in the book.

Who are you?

These are the qualifications I expect of you as a reader. It may seem that I am unnaturally vigorous in trying to drive away unqualified readers and you may think this is testimony to my high principles of honesty. Not so. I am merely trying to get a sympathetic audience.

I expect you to be a relatively inexperienced person with a camera who has taken some pictures. Some bad, some good. You may think the good ones were the result of your innate artistic ability. I'll display my prejudice about photography as an art form later, and it will offend you. If you think your occasional good picture was partly good luck, welcome. Our object is to reduce the necessity of luck.

Depending on your background, some of the ideas discussed may be tough to understand. A book for some homogenous group, such as practicing engineers or high-school students, can assume that some things are already known. In a book such as this, intended for anybody who wants to read it, some basic ideas must be elaborated which you may already know. If you find these parts boring, skip ahead. Most of the topics are important in my opinion so when you come to a strange idea, please work at it a little. Some of the more difficult ideas are separated from the main text so as not to create an insurmountable barrier for anybody.

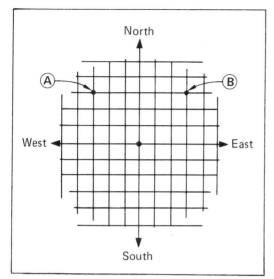

Curves to show things like film data are drawn on a grid system similar to the map of your town. In this illustration, location A is in the Northwest part, 3 blocks West and 3 blocks North of the center of town. Location B is identified by another pair of numbers on the grid.

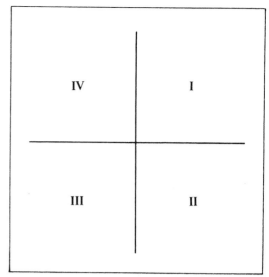

The center or *origin* of a mathematical curve is designated by the intersection of the two lines, called *axes*. This divides the plane into four quadrants which have Roman numerals for names.

BASIC IDEA: READING CURVES

If you are a great lawyer or gourmet cook, life may not have prepared you to read data from mathematical curves, although it's really very simple. Because film characteristics are important and nearly always presented as curves on a chart, it's worth your time to learn to read them.

The basis is a grid system just like most towns use for street addresses. A line drawn vertically on the city map is the reference axis for East-West locations. The 1000 block East is ten blocks East of the reference. Similarly a horizontal line is used for a North-South reference.

When the value of one thing depends on the value of another, a curve drawn on a two-axis map is a handy way to show a range of values for each of the two variables, and show the effect of one on the other. Such as density versus exposure, or the weight of an elephant versus the amount of food it eats.

A pair of reference axes, crossing at right angles to each other define the center, or origin, of the map. The origin is where the two axes cross. The axes divide the map into four quarters, called quadrants such as Northwest. All four may be used and usually are used in the plotting of a town, however if there are no houses (or data) in one or more of the quadrants, it is not necessary to show the unused quadrants on the plot.

When dealing with numbers, North and South don't have any significance, but plus and minus do. The horizontal axis is usually called the X-axis, just to give it a name, and the vertical axis is called "Y."

The rules are, "North" on the Y axis

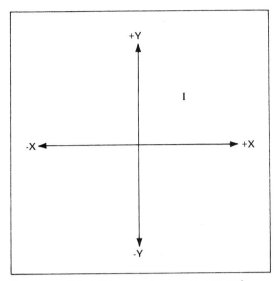

Any two related things, such as exposure and density, can be plotted on a two-axis curve. Here I have just labeled one axis X and the other Y. Notice that a location with a plus value for *both* X and Y is in quadrant I.

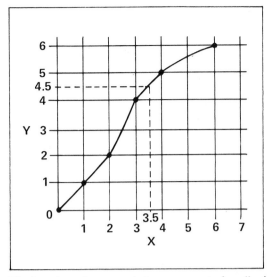

The location of every point on a curve is described by two numbers, one for each axis. The point indicated by the dotted lines is 3.5 units out on the X axis and 4.5 units up on the Y axis. Its location is 3.5, 4.5.

is the location of positive Y values, so everything above the X axis has some positive value for Y. Everything to the right of the Y axis has some positive value of X.

When both X and Y have positive values, only Quadrant I is needed.

Suppose we have made some scientific measurements to determine the amount of Y produced by several different values of X. The data is usually tabulated:

X	Y
1	1
2	2
3	4
4	5
6	6

Each *pair* of numbers shows a measured relationship between the two variables and is also an address on the map, or plot.

It is conventional to write the pairs of numbers with the X-value shown first, such as 1,1—the first pair in the table.

The number pair 1,1 describes a location in the first quadrant because they are both positive numbers. The location is 1 block out on the X axis and 1 block up on the Y axis.

All of these two-number data points are plotted on the curve shown. For most physical variables, we can assume that there are values in between the ones we actually measured and that those values will lie on a smooth line which is drawn to connect all the data points that were determined by experiment. I connected the known points with a smooth curve and can now read the value of Y when X is 3.5, as shown by the dotted lines.

Negative black-and-white film

Negative film is a dispersion of small particles of a silver compound, called *silver halide* as a general name, in gelatin. The resulting *emulsion* is formed as a layer on a base which is normally transparent. On the base there is usually a light-absorbing layer, called an anti-halation coating. It is intended to absorb the light which gets all the way through the emulsion and prevent it from reflecting back into the emulsion again and causing halo effects. For small cameras and movie cameras, the film is perforated with sprocket holes, used to pull the film through the camera in a uniform way and allow frame counting.

A property of silver halides is they turn dark on exposure to light. This happens two ways. If left in the light long enough, they will turn dark with no further treatment. This length of time is too long for ordinary photography. If an image is formed by this method, with some light areas and some dark areas, it will still be necessary to process the film in some chemical way to remove the silver halide which was shielded from light during the formation of the image. Otherwise the picture will become black all over while you are showing it around to your friends.

An exposure about a million times less than one which will itself darken the silver halide produces an invisible image in the emulsion, called a *latent* image or a *developable* image. The mechanism of this is complex but can be thought of as a sensitizing process. Those particles of silver halide "touched" by light become chemically sensitive to the action of a developing solution. The developer darkens the sensitized grains in the emulsion but does not appreciably darken those not altered by exposure to light.

When the latent image is brought out by chemical development, the undeveloped grains of silver halide remain in the emulsion in their original unexposed form. These unexposed grains must then be removed chemically for the same reason described above—so they won't turn dark later. The process of removing the unexposed grains is called "fixing" because it fixes the image in place permanently.

Negative film records light values in reverse. The brightest parts of the scene are darkest on the negative.

Because a print is "a negative of a negative" tone values are reversed again and match the original scene.

So far this sounds like a negative must be either black or clear. Where the light struck, it should be *black*. Where it didn't strike it should be *clear.* Of course this is not so. The emulsion reproduces shades of gray representing different amounts of illumination on the film.

The mechanism for providing shades of gray is also complex, but explained mainly by two observations. Each crystal of silver halide has some *threshold* of sensitivity. At a certain amount of light exposure it will become sensitized and developable. This threshold varies both with size of the crystal and variations of composition. Larger crystals have *lower* thresholds and sensitize first, which

is why films that are more sensitive to light are sometimes grainy. It is not possible to manufacture an emulsion in which all the grains are the same size nor is it desirable. With grains of different sizes and sensitivity thresholds, a small amount of light will sensitize only a small percentage of the silver halide crystals, making some particular shade of gray.

Another contributor to the varying blackness of film after exposure and processing is the fact that the emulsion layer has some thickness. A small amount of light will sensitize the surface. Stronger light will penetrate deeper and sensitize more of the crystals.

Curves may have a slope, or steepness, which changes along the way. You can think of slope as the gain in altitude divided by the horizontal distance traveled.

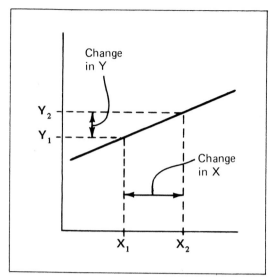

The measurement of slope is the amount of change in Y divided by the corresponding change in X.

BASIC IDEA: THE SLOPE OF A CURVE

You already know how to read curves and find the X and Y set of values for any point on a curve.

A useful way to look at a plot of two variables is to consider them to be changing while you watch the result. Put your eye at the end of a curve closest to the origin and then follow the curve away from the origin, imagining that you are increasing the value of X, *causing* a change in the value of Y. Notice how Y changes in respect to X.

You can also look at a curve as though it is a hillside and you are driving a car up the hill. Unless the curve happens to be a straight line, the steepness of the slope will vary as you drive up the curve. If the curve is a straight line, inclined upward, then the slope is constant all the way to the top.

It is useful to find a way to measure the *slope* of a curve or hill and express it by number. This requires defining what "slope" means. Slope is the change in vertical height—Y value—between two points on the curve, divided by the change in X value *between those same two points*. This is shown on the accompanying drawing.

If a curve is not a straight line, the slope will vary along the curve. By choosing two points somewhere along the curve, the slope between them can be measured. Two different measuring points, at a different location on the curve, will have some other

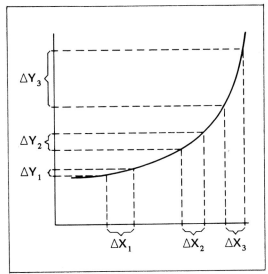

When the slope changes along a curve, the measurement of it changes also. Using the symbol \triangle to mean "change", $\triangle Y_1$ divided by $\triangle X_1$ is a low value of slope because the curve is nearly horizontal. At $\triangle Y_3$ and $\triangle X_3$ the slope is high because the curve is steeply inclined.

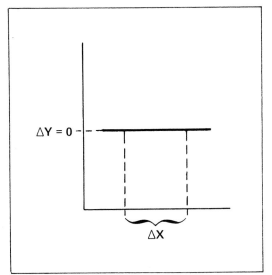

When a curve is exactly horizontal the slope is zero.

value of slope, higher or lower depending on what the curve is doing.

This definition of slope, and way of measuring it, fits the real world very well. A rule of arithmetic says that zero divided by X equals zero, where X is a number such as 4 or 7. If some part of a curve is a horizontal line, then the Y-value change is zero while the X-values change by some amount. $0/X = 0$. A horizontal line has zero slope, which you can see just by looking.

An interesting special case is a slope of 1.0. This means that one unit of change on the X-axis produces one unit of change on the Y-axis. $1/1 = 1$. If the scales are the same on the two axes, this is a straight line at a 45° angle.

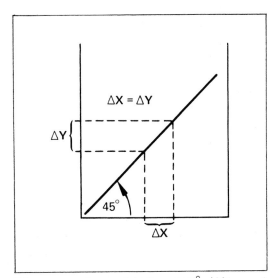

When a curve is a straight line at 45°, $\triangle Y$ is equal to $\triangle X$ and the slope is 1.0.

MR. H AND MR. D

In the late 1800's, before the British photographers had their meeting to decide on standard increments of exposure, two English chaps named Hurter and Driffield undertook a serious investigation of the exposure process. They were trying to discover the relationship between a given amount of exposure to light and the resulting darkening of the film.

Their work was a great success. They found the relationship and established some terms, definitions, and methods which became the basis of our present knowledge.

Their discoveries are not out of date and they still apply *in full force* to modern photography no matter who says they don't. You can't begin to understand photography until you understand what these gentlemen found out a hundred years ago.

First, they had to define what the word *exposure* means. The darkening effect of light on silver halides is the result of both the amount of light and the length of time it is allowed to fall on the film. Using I to represent illumination, or light, T to represent time, and E to represent the amount of exposure, the relationship is apparently simple:

$$E = I \times T$$

which is also written:

$$E = IT$$

Exposure = Illumination x Time

If either I or T is doubled, exposure will double.

This became known as the *reciprocity law* and was thought to apply to all values of light and time.

Then it was observed that the "law" did not seem to fit the facts when the light was either excessively bright or excessively dim. So an additional idea was added to the basic notion and the new idea became known, cleverly, as the *failure* of the reciprocity law. We'll have more on that later.

Having succeeded in finding a way to assign some exact number to exposure, by multiplying the amount of light by the time duration, it then becomes necessary to figure a way to assign some numerical value to the darkening of the silver halides. If you can only say that more exposure makes it more blacker, you are not well equipped to investigate photography. If instead you can say that an exposure of 57 units caused a darkening of 2 units, then you have a handle on the problem.

The natural thing to do when you have a piece of developed negative in your hand and want to see how dark it got, is to hold it up to the light. Then you can see how much light comes through, or is *transmitted* through the film.

Transmission, T, is a measure of the light passing through the film and is just a fraction which compares the light transmitted to the amount of *incident* light which falls on the other side of the film.

$$T = I_0/I$$

where I_0 is the light *output* through the film, and I is the incident light.

For example, if 80 units of light fall on the film and only 20 units pass through, the transmission is 20/80, which reduces to 1/4 or 25%.

This seems OK, but it is contrary to the basic idea of the whole exposure process. The intent of the darkened film is to stop light transmission and the main interest is in how much got *stopped*, rather than how much got through.

The amount stopped is the reciprocal of transmission and all it needs now is a name. It is called *opacity*, O_p.

$$O_p = I/I_0 = 1/T$$

In the same example, opacity would be 80/20 = 4, and it is easy to see that 4 is the reciprocal of 1/4. Because the incident light is always more than the transmitted light, the fraction representing opacity is always a number larger than one.

For the reason discussed in the Basic Idea panel on logarithms, opacity is not really suitable as a measurement of how black the film looks to a human observer. The logarithm of opacity will change, when opacity changes, and the log will more nearly represent the human response to that variation. Therefore H & D invented one more term, *density*, D, and defined it as the log of opacity.

$$D = Log_{10}\ O_p$$

The information contained in a density measurement is not any different than that contained

TRANSMISSION IN PERCENT	OPACITY	DENSITY
100	1.0	0
89	1.1	0.05
79	1.3	0.1
63	1.6	0.2
50	2	0.3
25	4	0.6
12.5	8	0.9
10	10	1.0
5	20	1.3
2.5	40	1.6
1.25	80	1.9
1.00	100	2.0
0.1	1,000	3.0
0.01	10,000	4.0

The relationship among Transmission, Opacity and Density.

in an opacity measurement, but the density numbers will be smaller and more nearly related to human response. When opacity changes from 1 to 1,000 the logarithm, density, will change only from 0 to 3. All usual densities fall in that range. Zero density is clear and a density of 3 is very black indeed.

Densities are measured by a special laboratory instrument called a *densitometer.* What it does is direct a calibrated light source through a spot on the film and measure the light output.

If you are an average person, you are pretty good at mixing a root-beer float but not worth a hoot at figuring logarithms. You will never need to figure any logs, but if you ever look at a film-data sheet, you will need to understand the basic idea of density and the fact that zero to 3 is its usual range of values.

Rushing back to rejoin Messrs. H and D, we left them back in the last century trying to figure out the relationship between exposure and the darkening of the film, which we have learned to think of as density.

It turned out that this relationship is not any simple matter and the best way to display it is to draw a curve showing how density changes with variations in exposure. If you need a refresher course on curves, consult the Basic Idea panel on that subject. It's worth doing because film data sheets present the info by using curves.

One of the standard curves has a lot of names. It's called a *film characteristic curve,* or an *H & D curve* in honor of our friends, and also a *D-Log E curve.* The more common name these days is D-Log E where **D** means density and **Log E** tells us that more trickery lies ahead.

Yep. Instead of using the numerical value of exposure on these curves, the log is used instead. Mainly because logarithms are already used to express density. No worry here either; the same rules apply. When **Log E** changes from 0 to 3, **E** will have changed from 1 to 1,000.

When you start looking carefully at film characteristic curves, you will notice that the Log E scale often goes below zero and the numbers $\overline{1}$, $\overline{2}$, and $\overline{3}$ appear. Same idea: When **Log E** is $\overline{1}$, its numerical value is 1/10. At $\overline{3}$, it is 1/1,000. All you really have to remember is that the Log E scale is a range of exposures.

It turns out that negative films usually require exposures to the left of the origin on the Log E scale, therefore they have negative signs. Printing papers usually work with positive Log E values.

Figure 1 (page 20) shows the shape of a typical characteristic curve for general-purpose films that you use for portraits and landscapes. Locations on this curve are given names and the names are often used in articles and books.

The center part, where the curve is fairly steep and fairly straight, is called the *straight line* portion. At the lower left, where it flattens out and becomes horizontal, is the *toe.* At the top, where it flattens out, is the *shoulder* of the curve.

Notice that if you start near the middle of the curve and decrease the amount of exposure, the result will be less density. However, once you get below the toe of the curve, a continuing decrease in exposure does not reduce density any more. This minimum density is around 0.1 and is the smallest value you can get with that piece of film even if you don't expose it at all but run it through the developing process anyway. That minimum density means that a processed negative can never be completely clear or have a density of zero.

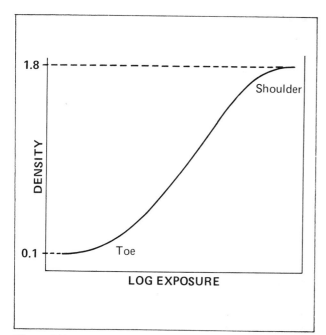

Figure 1/A typical general-purpose negative film will have a toe and shoulder with a more-or-less straight portion in between. This film characteristic curve shows the density value resulting from each exposure value. Minimum density is about 0.1 and the maximum value is about 1.8 for this particular film and processing.

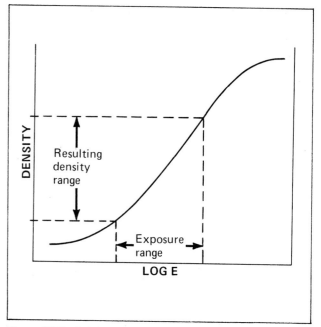

Figure 2/The brightness range of the scene establishes the exposure range on the film. The shape of the D-Log E curve and the *location* of the exposure on the curve will together determine the resulting density *range* on the film.

The minimum density results from two things. The film base itself is not perfectly transparent. The emulsion will be developed a small amount by the developing solution even though it was not exposed to light, creating an overall darkening called *fog*. The minimum density of any film is the base density *plus* the fog density.

Look at the other end of the curve at the shoulder. If you start at the middle, then increase exposure up to where the curve flattens and becomes horizontal, you reach a point at some high density where further increases in exposure cause no further increase in density. On the curve of Figure 1 this maximum density is about 1.8. In normal photography with this piece of film, that's as black as you can get. The film behaves as though all of the silver halides had been developed and there is nothing left to make it blacker.

There are a couple of important conclusions from this first look at a characteristic curve.

The density *range* has a definite limit. Reducing exposure will never yield a density less than the minimum and increasing exposure will never create a density greater than the maximum. The density range of a piece of film is the difference between maximum and minimum, in this case it is 1.8 - 0.1 = 1.7.

This is a very important bit of information whether you evaluate it analytically or practically. You can't put ten pounds of wienies in a five-pound bag and you can't put a density range of 2.0 on this piece of film.

Because film densities are intended to represent light variations of the scene photographed, the density range of the film you are using *seems* to put a definite limit on the brightness range of a scene you can shoot and still capture all of the brightness variations.

If you decide to shoot a scene with a brightness range greater than the density range of the film, you won't get faithful reproduction unless you do something about the light on the scene, or use some other trick. If you are indoors, you can change the lighting to make the brightest spots less bright or you can throw more light into the shadows. If you are outdoors, there isn't much you can do about the amount of light on the brightest parts of the scene. But you can use reflectors, even makeshift, to put more light onto the dark areas. If you reduce the range of brightness of the scene, you reduce the need for a high density range on the film.

Putting the light variations onto the curve

Figure 2 gives a better look at the problem. It's the same curve we used before except that two exposures have been selected on the Log E axis, representing maximum and minimum brightnesses of the scene. From the min value, trace vertically to the curve and then over to the D scale. Do the same for the max exposure value. This translates the exposure extremes into density extremes. It also shows what portion of the film curve is being used to make this negative. In this case, the exposure range does not exceed the density range of the film and only the straight-line portion of the curve is being used.

By using the camera controls, exposure can be changed to shift the segment of the characteristic curve being used—up or down on the curve as desired.

If only the center straight-line portion of the D-Log E curve is used the photographer is following the original recommendations of Hurter and Driffield. This old-time gospel is derived from some straight logic. Imagine that exposure is changed in a series of uniform steps along the Log E axis and each point is transferred up to the curve and then over to the D axis. If the steps in Log E are uniform, and if the curve is a straight line, then the steps of density will also be uniform, which H & D thought was a good idea. This is called a *linear transfer*.

If the film curve is not only straight but also has a slope of 1.0, the steps along the X axis and the resulting steps along the Y axis will be *equal in size*. If the slope of the curve is less than 1.0, but the curve is still a straight line, uniform steps on one axis will produce uniform steps along the other, but the steps will not be the same size. When the slope is less than 1.0, steps along the Y axis will be smaller.

If the curve is not a straight line, but is actually curved, then the slope is changing along the curve. In the region near the toe of the curve, a series of uniform steps of *decreasing* exposure will also cause a series of steps of decreasing density, but the density steps will gradually become smaller and smaller, even though the variations in exposure are all the same. As you can see, when

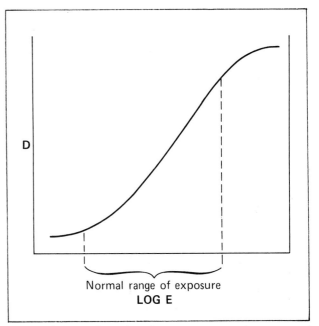

Figure 3/The modern idea of proper exposure is to use part of the toe and stop short of the shoulder of the film curve. Not everybody agrees with that.

the curve becomes horizontal, further changes in exposure will cause no more changes in density, below the minimum value.

At this point details of the scene will be lost because there will be no difference on the film between a spot of low brightness and another spot of even less brightness.

The same thing happens at the shoulder of the curve if the exposure variations reach up that far. When this happens at *either* end of the exposure range the picture detail is said to be "blocked." In one case the highlights are blocked, in the other the shadows are blocked and without shadow detail.

Modern doctrine for black-and-white films is to make use of the toe of the curve as shown in Figure 3 (page 22). If it isn't carried too far, use of the toe region will not block the shadow detail. Because succeeding reductions in exposure cause diminishing changes in density, the density values are compressed. But there is still one density value for each exposure value. This is usually considered satisfactory to a viewer of the resulting print un-

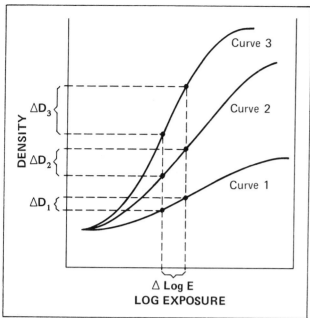

The same type of negative film can exhibit more than one characteristic curve, depending on the time of development and the developing solutions used. In the same solution, longer time of development will change the film characteristic from curve #1 toward #3 on this drawing. The *same* exposure yields a greater density range on curve #3 than either #2 or #1. Because of this, development is often coordinated with amount and location of exposure on the curve.

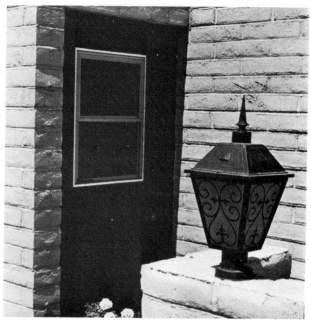

Figure 4/If picture detail on the door is important, this photo is underexposed and goes too far down into the toe region of the curve. Wood grain and construction details of the door are not visible. For comparison, see photo below.

less the compression of tones is too much or important detail in the shadows is lost.

Figure 4 shows what happens if you underexpose so much that your picture extends past the toe of the curve into the region of zero slope. The opposite can happen if the exposure range goes off the top of the D-Log E curve: All the highlight areas which should have some picture detail will come out plain white.

The main reason film manufacturers recommend using the toe of the curve on black-and-white negatives is that this gives less total exposure to the film than would occur if the exposure range was centered higher up on the curve. This produces a "thin" negative which will normally be less grainy and stand greater enlargement during the printing process. Also, thin negatives print faster because they transmit more light and the printing paper can be properly exposed in a shorter length of time. Also, using the toe of the curve extends the allowable exposure range which is sometimes useful.

Using the toe of the curve does not result in

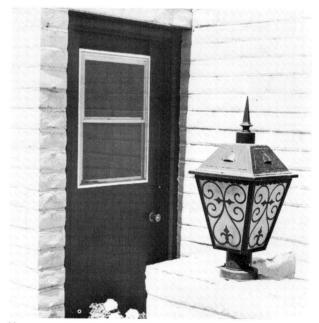

Here you can see details of the molding around the door. However some of the highlights are blocked. Considering the wall and flowers, this picture is overexposed. Sometimes you have to go one way or the other depending on the purpose of the shot. Photos were taken in bright sunlight but door is shaded, which is about as tough as you can get. Could have been done properly by using lighting or reflectors to put more light on door.

density variations on the negative, or the resulting print, which are faithful reproductions of the brightness variations of the scene. However the result is usually acceptable.

When the brightness range of the scene is greater than the exposure range of the film and you can't change the scene illumination, you've got a problem. If you allow your exposure meter to manage the problem for you it will most likely allow both ends of the scene to hang off the ends of the curve. The highlights and shadows will both be blocked, which may be OK under the circumstances. If your purpose in making the picture is to show detail in the shadows, then you cannot allow them to be compressed too much. So you give an exposure greater than your meter suggests. This preserves shadow detail but blocks up the highlights still more. If it's highlight detail you are after, then you have to sacrifice the shadows.

When the film exposure range is not exceeded by the scene, then there is some exposure *latitude* as shown in Figure 5. There are several exposures centered on different segments of the film characteristic curve such that none of the different exposures will cause unacceptable highlight or shadow compression.

When the exposure range can fit onto the straight-line portion of the curve with room left over, then that exposure range can be moved up and down the curve as desired. The result of several different exposures, all on the straight or linear part of the curve would theoretically be a series of negatives, each with an identical image in terms of density gradations. The only difference among them would be that the negatives receiving more exposure would have a higher *average* density and therefore take more exposure during printing.

Two important ideas were concealed in the discussions above. One is the idea of linear transfer. A film characteristic curve shows how light variations from the scene are transferred to become density variations on the negative. Where the curve is straight, or linear, the negative is a satisfactory rendition even though the density variations may be larger or smaller than the light variations of the scene they represent.

If a non-linear part of the curve is used, toe or shoulder, then the light-values, or "tones," are compressed and no longer proportional to the

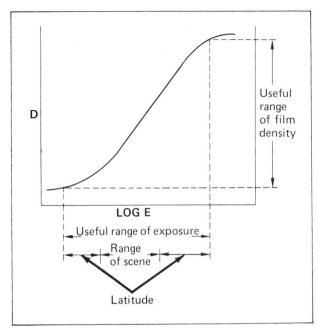

Figure 5/When the brightness range of the scene is less than the exposure range of the negative there is some *latitude*. Locating exposure on the film curve is less critical but still important.

light variations of the scene.

The other idea is that of "room on the curve." If the exposure range of the scene can be contained within the exposure range of the film—on the straight part or at least not too far into the curved parts—then all light-values of the scene will generate a distinguishable density or tone on the film.

If there are areas of scene brightness which drive the film past the toe or shoulder, these areas will not have distinguishable detail.

These two ideas, linearity and exposure range, are a major part of the exposure problem when taking pictures. In a later section on exposure you will meet them again, along with some other considerations.

Incidentally, when making a print from a negative the neg becomes the scene and the printing paper must make an acceptable image from the light-variations caused by the varying densities of the negative. The same problems exist: linearity and *tonal range*.

SOUL

A lot of photographers enter photo contests, judge photos, enter salon displays and that sort of thing. I have no quarrel with these people. I just

don't understand what they are doing.

When a photographer takes a portrait, writers about it often say his goal is to somehow discover the soul of the person being photographed and capture it on film. This is exactly the conviction of some of the native tribes in remote places of the world and therefore they don't want their souls stolen by your camera. I accord the same level of credibility to both concepts.

Or the photographer takes a picture of an old barn and thereby bares *his own* soul to the world at large. Writers say the picture is a statement made by the photographer reflecting his views on life and dark moments of his childhood.

Amazingly, critics sit in judgment on pictures pronouncing some good and some bad, evidently according to how much soul is hanging out. I read of one critic who required that no captions, titles, or other written words should accompany a photo to be judged so the critic could decide strictly on the basis of the "statement" made by the picture.

I continue to feel that the success of a photo is determined entirely on how well it accomplishes the intent of the photographer. Sometimes the intent is apparent in the picture, sometimes not. Without knowing what it is, nobody can judge the quality of another's work.

This leaves it squarely up to you to find out how good your pictures are and because the usual intent is to communicate something, you have to try to find out if yours are sending the right message.

You can display your photo to a bunch of people and say, "I intend this print to show about 30% soul and the rest morbid sex."

Some will reply, "Gosh I see it as an ineffable statement about viable self-effacement and the disciplined loneliness of the ardent artist."

You can't win 'em all.

GAMMA

Notice the new paragraph title above. Rejoice. Possibly you think that means we are finished with all those D-Log E curves and can now get on to some zippy stuff like pictures of good-looking gals or guys. Stop rejoicing.

Another very important idea is hiding out among that curvaceous H & D thing. The idea starts out worrying about the steepness of the curve and winds up explaining how you can get a

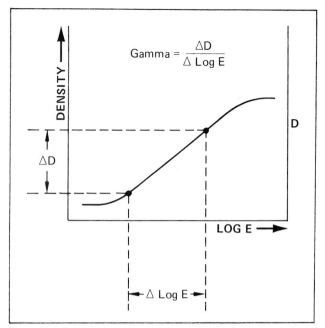

The mysterious property of film, known as Gamma, is revealed to be merely the slope of the characteristic curve.

good print from a bad neg, and the reverse.

To keep newcomers ill at ease and respectful, photographers don't call the slope of the film curve "slope." They call it *gamma*, which is the name of the Greek letter γ. Gamma means slope.

You already know that the slope of a film characteristic curve can be 1.0 but doesn't have to be that value. Film can exhibit a gamma of 0.6 or 1.5 or any of a wide range of values. In fact it is manufactured with different values of gamma for different purposes and to solve different problems.

One problem, mentioned back there before I became exasperated at the photo contests, is a scene-brightness range which exceeds the exposure range of the negative. Gamma helps solve this problem. Let's see how.

Figure 6 shows a film with a high gamma being used to photograph a scene with too much exposure range. The scene hangs off one end of the linear part of the curve and you know what is happening there.

Figure 6 also shows a different film with a lower gamma being used to record the same scene. It has the *same* density range as the other negative. Both films use the same density range, but the

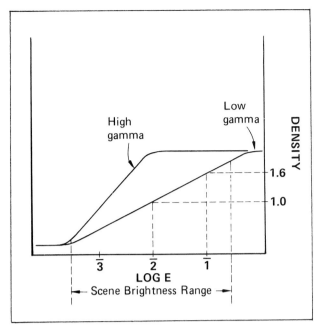

Figure 6/If a scene of some brightness range as shown is recorded on high-gamma film, starting at the toe of the curve, it will extend well past the shoulder and the highlights will be compressed or blocked. The same scene can be recorded on low-gamma film without extending past toe or shoulder.

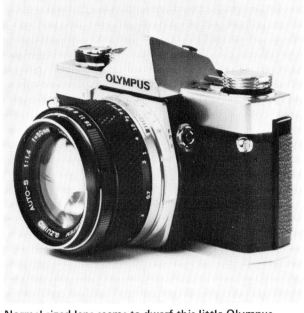

Normal-sized lens seems to dwarf this little Olympus single-lens reflex because the camera body was designed for small size and weight—very nice when you are carrying two or three cameras and accessories.

film with lower gamma has a longer exposure range to use up the density range. When a scene has a high brightness range, low gamma film will help capture it all on the curve.

There is a price to pay for that luxury. The price is measured exactly by the gamma of the film. For example, in Figure 6, two exposure points on the low-gamma neg at $\overline{1}.0$ and $\overline{2}.0$ create two resulting densities of 1.0 and 1.6. In other words an exposure change of 1.0 caused a density change of 0.6.

Gamma is defined as:

Density change

Exposure change

which in this case is:

$$\frac{0.6}{1.0} = 0.6$$

On the straight part of the curve, uniform exposure steps will create uniform density steps, but the density steps will each be only 0.6, or sixty percent as large as the exposure steps. This is a uniform compression of all the tone-values of the scene but each tone of the scene is represented by some density.

Gamma therefore can be thought about as a sort of magnification factor, or reduction factor. To get a wide-exposure range onto a negative with some limited density range, low gamma—less than 1.0—does the trick.

Films are manufactured with different gamma so by studying the curves and data supplied by the manufacturers, you can select film to suit your purpose. For any particular film, gamma is *also* affected by the developing procedure, both the chemicals used and the amount of time the film is soaked in the soup. Hopefully that last nugget caused you to say, "AHA!"

If you take a roll of film to a custom lab and tell the man you were photographing black cats in the snow again, he will process that roll so it has low gamma. You can only use that trick if you have exposed the entire roll under similar circumstances, though. If you shoot large-format single negs, then you can process each one individually according to your notes or recollections about how you exposed each negative. If you take your film to the drug store, it will receive standard processing in a big machine no matter what you confess to the clerk.

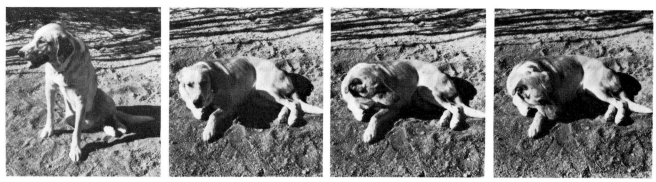

My dirt-colored dog on his favorite dirt patch is a scene with very narrow brightness range. Shot on Plus-X film it has a lot of latitude. Exposures, from left to right, were -1, 0, +1, and +2 where 0 means normal exposure as read by a meter. The picture is essentially the same in each case because each was printed for the same tone-value of the dirt but the exposures cover a range of four steps. The camera setting for the right-hand picture admitted eight times as much light as for the left-hand photo.

This is my best soul-photo. It epitomizes the conjunction of light and dark in the murky recesses of the human mind. Actually, it's upside down. You'll see later how to get strong contrast between clouds and sky.

Now assume you have your negative with the density steps modified by the gamma of the film. If gamma is 0.6, then the density steps are *each smaller* than the original scene.

Because the negative is used to expose the print, and printing paper also has a film characteristic and a gamma, the density steps on the negative are in turn affected by the gamma of the positive paper on which you are making the print.

There is no question that a more realistic print can be obtained if the reflected light from that print exactly duplicates the steps of reflected light from the original scene. If your subject's face reflects twice as much light as his jacket, in real life, then an ideal print would show the same thing—not 1.5 times as much or 0.3 times as much.

This goal can be achieved if the gamma of the printing paper magnifies the steps enough to exactly compensate for the reduction by 0.6 on the negative. To do this, the printing paper must have a gamma greater than one. The positive gamma must be some number which, when multiplied by 0.6, causes the overall result to equal 1.0.

The number is 1.6 in this example:

1.6 x 0.6 = 1.0 approximately

Typically, printing papers have gamma values larger than one and negative films have gamma less than one.

The idea of an overall gamma equal to one stands as a monolith of logic, secure and unassailable, *provided* it is applied to the tone values *of the scene* as compared to the tones of a print seen by reflected light or a transparency viewed by transmitted light. In other words when the visual impact of the print exactly matches the visual appearance of the original scene perfect fidelity of reproduction results.

Hardly anybody attacks the idea of an overall gamma equal to one, when defined as in the paragraph above—visual results. A valid question is whether or not this is achieved when the product of negative and positive *film* gammas is equal to one, and usually the answer is no. If the range of light variations captured by the negative was an exact duplicate of reality, then film gammas alone would be involved.

For reasons this book has not yet prepared you for, the exposure range on the film does not duplicate the light variations at the scene and is

Atmospheric haze is caused by light scattering which happens to blue light more than to red light.

NOTE: A thoughtful idea from Robert Routh who reviewed the manuscript:
Faithful reproduction of tone values is an option, as is the haze cutting shown in these photos. Sometimes the message of a photo has more impact when tone-values are deliberately changed, haze left in, focus not sharp, or movement blurred.
The technical aspects of photography are like a double-edged sword and can cut either way. If you know how to make an image sharp, then you also know how to make it unsharp. What you do is your option.

See the difference in the photo taken through a red filter.

always less. The causes are light scattering in the atmosphere between scene and camera, and light scattering inside the camera due to reflections from lens surfaces and lens mounts. All of this scattering of the light rays causes them to become intermingled some amount. Light rays originating from a very bright part of the scene stray from the desired path and land on the film at some point where there should be less light. The result is lower contrast between two adjacent elements of the picture which should have different brightnesses and a reduced overall density range on the neg.

The net result is some compression of the tone scale even before the light gets on the film. If you want to think of this as yet another gamma, associated with the camera and the light-gathering process, then this third gamma is also less than one. It is not possible in practice to measure this third "phantom" gamma because it will vary from scene to scene and even with distance to the camera. However if the *overall film gamma* is made larger than one, that will tend to compensate for the tone-scale compressions of the image en route to the film.

Sure enough, an overall *film* gamma—meaning negative gamma multiplied by positive gamma—which is higher than one is often considered a more realistic presentation of the original scene by an observer of the print. Sometimes this good gamma gets as high as 1.5.

You can verify the reduction in scene contrast due to atmospheric *scattering* just by looking at distant scenes. If you compare a distant landscape to one nearby, you will notice no black shadows are apparent in the distant scene. The shadow-areas are overlaid by spurious light rays during travel from scene to you which both obliterate shadow detail and make shadows *appear* less dark.

In viewing a print of a distant scene there appears to be a haze between viewer and scene. Filters to improve the situation are called haze filters. Improvement is possible because some colors of light are scattered more than others. Blue, violet, and invisible ultraviolet are scattered the most. A filter over your lens to keep these colors out of your camera will improve definition and contrast of a distant scene. This is covered in

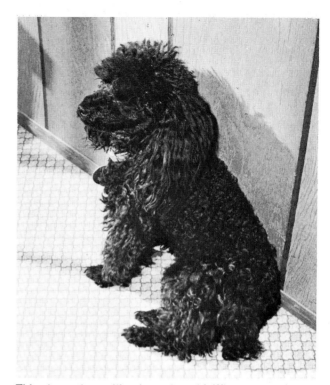

This picture is not like the real world. When you look at Jolie she is a black void with no visual detail. This shot was exposed to get her up above the toe of the curve. There is a shade of gray in the picture for every shade of gray the viewer *expects* to see, so it is an acceptable photo.

more detail later.

Emphasis at the beginning of this discussion was on the use of a low-gamma negative to compress the tone values of a scene to fit them all into the density range on the film without losing any at either end. The idea also works in reverse. If you are shooting a scene with a low range of brightnesses, such as a white cat in a snowbank or a piece of toast on a yellow plate, then you might consider expanding the scale of tones, rather than compressing them. Expanding the scale creates a greater visual difference between two adjacent brightnesses and helps the viewer distinguish details. To do this, you would choose a negative film with a high gamma and possibly process for higher gamma.

Either way, with expanded or compressed tones on the resulting print, a viewer is likely to accept the result as a good representation of a scene which could have existed, *as long as* there is one shade of gray in the print for each different brightness in the scene. Or at least each different

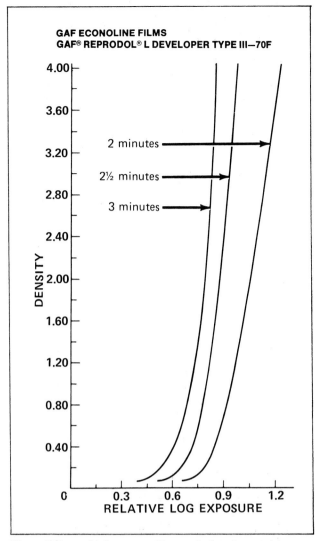

Figure 7/Steep high-gamma film made for the graphics industry by GAF Corporation is used to copy print or line drawings. Steepness of curve gives very white white and very black black without much intermediate gray scale.

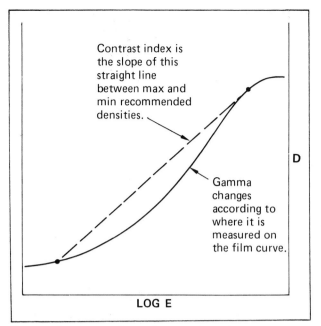

Figure 8/Contrast index and gamma have the same general meaning but are measured in a slightly different way.

it looked in the first place. Everybody agrees you made an excellent picture as long as what you got on film meets our expectations of reality.

A special type of film is used in the printing industry to photograph pages of type and drawings made with pen and ink. Black ink on white paper doesn't have any intermediate shades of gray and therefore the gray scale is not important. What is important is that the white paper should produce a very black image on the negative and the black ink should produce minimum density on the neg. For this application, film with a very high gamma is used as shown in Figure 7. This allows the two different levels of exposure to drive the film to its extremes of density. Such film tends to ignore intermediate shades which in the graphic arts industry are often just smudges and fingerprints anyway.

CONTRAST

Gamma affects the contrast of a photograph as seen by a viewer or measured with a densitometer. Contrast relates to the "size" of the density steps and implies comparison with the original scene. If you took a picture of a book lying in a chair and the light reflected from the two was about the same, it might be hard to distinguish the book from the chair when viewing a print. That would be a case of low contrast.

brightness the viewer *expects* to find in that scene. If you allow the brightness range to extend too far into the toe or the shoulder, the viewer will not see things he *knows* should be there and he may reject the photo.

Neither you nor the viewer is likely to criticize the shot because it is not an exact copy of the scene. The viewer probably never saw it anyway and you have probably forgotten exactly how

KODAK TRI-X Pan Professional Film

This fast panchromatic film yields negatives with excellent gradation and brilliant high-lights. It can be used with all types of lighting, both outdoors and indoors. The emulsion gives good exposure latitude and control of contrast in development. KODAK TRI-X Films in rolls and film packs have retouching surfaces on both sides of the film.

Forms Available: 120- and 220-size roll films and film packs.

Speed: ASA 320.

Safelight: Handle in total darkness. After development is half completed, a KODAK Safelight Filter No. 3 (dark green) in a suitable safelight lamp with a 15-watt bulb can be used at 4 feet from the film *for a few seconds only.*

Filter Factors: Multiply the normal exposure by the filter factor given below.

KODAK WRATTEN Filter	No. 6	No. 8	No. 15	No. 11	No. 29	No. 25	No. 58	No. 47	Polarizing Screen
Daylight	1.5	2*	2.5	4	16	8	8	6	2.5
Tungsten	1.5	1.5	2	4*	10	5	8	10	2.5

*For a gray-tone rendering of colors approximating their visual brightnesses.

Flash Exposure Guide Numbers

Blue Flashbulbs: Divide the guide number by the flash-to-subject distance in feet to find the *f*-number for average subjects. These guide numbers are for blue flashbulbs. If you use clear flashbulbs, reduce the lens opening ½ stop.

Synchronization	Shutter Speed	Flashcube	Shallow Cylindrical Reflector	Intermediate-Shaped Reflector		Polished Bowl-Shaped Reflector		Intermediate-Shaped Reflector		Polished Bowl-Shaped Reflector	
		Flashcube	AG-1B	M2B	AG-1B	M2B	AG-1B	6B* 26B*	M3B 5B 25B	M3B 5B 25B	6B* 26B*
F or X	1/25 —1/30	180	130	170	180	240	260	—	250	350	—
M	1/25 —1/30	130	90	—	130	—	180	230	240	350	340
	1/50 —1/60	120	90	—	130	—	180	180	220	310	260
	1/100—1/125	100	80	—	110	—	150	120	190	260	170
	1/200—1/250	80	60	—	90	—	130	85	150	210	120
	1/400—1/500	65	50	—	70	—	100	60	110	160	90

*Bulbs for focal-plane shutters; use with FP synchronization.

Caution: Bulbs may shatter when flashed; therefore we suggest that you use a flashguard over your reflector. **Do not flash bulbs in an explosive atmosphere.**

Electronic Flash: This table is intended as a starting point in determining the correct guide number. The table is for use with equipment rated in beam candlepower-seconds (BCPS) or effective candlepower-seconds (ECPS). Divide the appropriate guide number by the flash-to-subject distance in feet to determine the *f*-number for average subjects.

Output of Unit (BCPS or ECPS)	350	500	700	1000	1400	2000	2800	4000	5600	8000
Guide Number for Trial	75	90	110	130	150	180	210	250	300	360

Emulsion Characteristics

Grain: Fine. **Resolving Power:** High. **Degree of Enlargement:** Moderate.

Color Sensitivity: Panchromatic.

Reciprocity Effect Adjustments:

If Indicated Exposure Time Is (seconds)	Use Either		In Either Case, Use This Development Adjustment
	This Lens Aperture Adjustment	**Or** This Adjusted Exposure Time (seconds)	
1/1000	none	no adjustment	10% more
1/100	none	no adjustment	none
1/10	none	no adjustment	none
1	1 stop more	2	10% less
10	2 stops more	50	20% less
100	3 stops more	1200	30% less

Development:

Develop at approximate times and temperatures given below.*

KODAK Developer	Developing Times (in Minutes)									
	SMALL TANK—(Agitation at 30-Second Intervals)					LARGE TANK—(Agitation at 1-Minute Intervals)				
	65 F 18 C	68 F 20 C	70 F 21 C	72 F 22 C	75 F 24 C	65 F 18 C	68 F 20 C	70 F 21 C	72 F 22 C	75 F 24 C
POLYDOL	10	9	8	7½	6½	11	10	9	8	7
HC-110 (Dilution B)	10	9	8	7	6	11	10	9	8	7
DK-50 (1:1)	9	8	7½	7	6	10	9	8½	8	7
D-76	9	8	7½	7	6	10	9	8½	8	7
MICRODOL-X†	11	10	9	8½	7½	12	11	10	9	8

*For tray development of film packs, see instruction sheet that accompanies the film.
†Gives greater sharpness than other developers shown in table.

Note: Do not use developers containing silver halide solvents.

Characteristic Curves

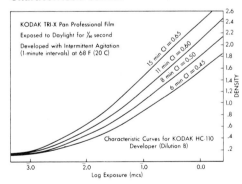

Contrast Index Curves

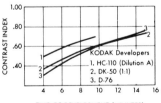

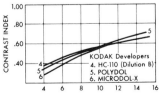

Figure 9/Data reproduced with permission from a copyrighted Eastman Kodak publication shows film characteristic curves and contrast index curves for Tri-X film with various developers and developing times. This comprehensive data sheet also illustrates other matters discussed later.

Shooting this scene on high-gamma film or printing it on high-gamma paper would cause a greater separation of the two densities—one would be higher and the other lower—so there would be more visual difference between the two objects on the print. This produces more contrast.

The terms "contrast" and "density range" are used almost interchangeably, but there is a difference in meaning. Density range refers to the overall span of densities on a negative or print, from the blackest to the lightest. Contrast means what the paragraph above says it means. A scene with a very wide range of brightnesses could use all of the density range of the film but still wind up with low contrast among the individual parts of the scene.

CONTRAST INDEX

Force yourself to look at Figure 8 (page 29) again. Where a curve is linear, you could measure gamma anywhere and get the same result. Where the curve is curved, gamma is changing because the slope is changing, and at the extremes of toe and shoulder gamma becomes zero. Some film-characteristic curves change gamma nearly everywhere along them because they have a very long curving toe connected to a long curving shoulder with only a very short reasonably straight segment between them.

Also, the modern idea of exposure is to use the toe of the curve as you know, to get a thin negative with tolerable compression of shadows. In a good light, you should be able to read the print on this page through the darkest part of a thin negative.

Therefore we face the unnerving proposition that gamma changes according to where the exposure is on the curve.

A slightly different measurement method gives results having the same general meaning as gamma but with the reassuring virtue of constancy for any one curve. This measurement is given the name *contrast index* and the way of getting it is shown in Figure 8.

A point is selected down on the toe of the curve which represents the lowest useful density of that film. Points above that location still have enough gamma to separate tones and give an acceptable image of a scene.

Another point is selected up near the shoulder which represents the highest recommended density for normal negatives.

These two points are joined by a straight line. The slope of that straight line is called the Contrast Index, labeled CI. The meaning of CI is obviously very close to the meaning of gamma and for a particular piece of film the numbers will be approximately the same. The CI number will be a little smaller than gamma taken near the center of the curve because CI includes some of the reduced slope of the toe region.

It may be that CI is a more significant measure because if you are doing what your exposure meter tells you to, you are probably using the toe of the curve. Anyway, if you buy a copy of Kodak's Data Book F-5, *Kodak Professional Black-and-White Films*, you will see CI, not gamma.

On Figure 9, you saw that gamma or CI changes according to how long the negative is left in the developer. Different developing *formulas* also produce different CI values and different rates of change of CI with varying development times. Presentation of this information requires another set of curves, shown in Figure 9. This shows how CI changes with development time but each of the individual curves represents the behavior of one particular developer formula. The curves are numbered and the key is on the chart.

THE SIGNIFICANCE OF ALL THAT

The foregoing was intended to show that a photographer who takes pictures one at a time each on a separate piece of film, or one who exposes a whole roll under similar conditions can have a lot of control over the results. He can select film for the range of gamma or CI that he thinks will be right. He can expose to put the image wherever he wants on the characteristic curve, favoring highlights or shadow detail if he chooses to. Then he can develop for the right length of time, in the right solution, so it all comes out exactly according to plan on the negative.

In making a positive, all those helpful factors can be used a second time—paper selection, exposure control and gamma control even though gamma control in practice is done through paper selection. Intelligent printing can make a good negative better or can make an acceptable print from a bad negative.

Even if you never do any processing yourself

BASIC IDEA: THE METRIC SYSTEM

The USA is finally facing conversion to the metric system of units. Specialists are appearing to help us do that. Any chore is aided by assignment of an impressive name to the work, particularly if the government is involved.

The name chosen is *metrication*! When the dam breaks, friends, flee in terror. If metrication is admitted to our vocabulary, related word-forms can not be far behind. We will soon be offered training in metricationism, taught by metricationismists fresh from metrical symposia. I will allow them to metricate you as necessary. Except for measuring how long things are.

Abandoning inches, feet, yards and miles to get metric units is a good bargain. The conversion factors in the English system are unhandy numbers like 12, 3 and 5,280 as you know. In metric, the conversion steps are all 10 just as in the decimal system of numbers and money.

The basic unit of length is the *meter* which is 39.37 inches long—a little longer than a yard. Yes, there are meter-sticks. I remember it as about 40 inches and rarely use 39.37 except when speaking metrically.

There is a large family of metric units of length, all obtained by multiplying ten times some other unit, but some are more popular than others. A *kilometer* is one-thousand meters and is about six-tenths of a mile.

A *centimeter* is useful to measure things that would otherwise be measured in inches. There are 2.54 centimeters in an inch. I once measured my fingernails to find one that is about one centimeter wide. I didn't tell anybody but it made me feel more friendly toward centimeters.

Here are some metric units used in this book:

1 centimeter = one-hundredth of a meter
1 millimeter = one-thousandth of a meter
1 nanometer = one-billionth of a meter
2.54 centimeters = one inch
25.4 millimeters = one inch

In learning a foreign language you go through two steps. First you think in English, translate to Spanish in your mind, and then say *Carramba*! The next step is to think in the new language. Think metric.

or don't have work done by a custom lab, you can't escape the effect of gamma, density range and exposure range. They apply to your pictures and your results, however you have to live with *standardized* processing and printing done on a routine basis.

Usually a high-volume professional photographer will standardize on a particular film for a certain type of photo and standardize the negative processing so he knows what to expect. Then control of what gets on the negative is done by careful exposure and sometimes lighting control.

The well-known photographer Ansel Adams has written a book about his approach to making pictures which he calls the *Zone System*. This system appears to be a way of thinking about gamma and exposure. The range of densities on film, and brightnesses of a scene, are arbitrarily divided into a number of zones. During exposure of the neg, the photographer mentally identifies the zones of the scene and decides where he wants a particular level of scene brightness to fall on the

film characteristic curve and the steepness of the curve which will separate the tones according to the pre-visualization by the photographer of the desired print.

Most of the literature on photography ignores the zone system except for a couple of books written to further explain it.

WHO AM I?

I become suspicious when a stranger springs out of a bush and offers me a serving of purest wisdom. You should do the same. The odds are that you never heard of me.

I've had two bouts with photography. As a young man I had a technical job in the motion-picture industry, involved with recording sound tracks photographically on film. We used ideas such as density and gamma as the routine tools which allowed us to control the results of our work. Nobody assumed that another qualified person could not understand the use of these tools and nobody assumed that the work could be done satisfactorily if the tools were left at home.

Later I started writing magazine articles about mechanical things such as engines and carburetors. I learned the hard way that golden words alone are not enough no matter how brightly they glitter. The magazines expect you also to send along some pictures to show what you are writing about. So I made some pictures which they returned with kind notes saying, "Your pictures are really bad!"

Thus inspired, I bought some of the popular photography books and set about improving my skill at pictorial photography as opposed to the recording of sound-wave images. I didn't find exactly what I was looking for. There was a lot of "how" but not enough "why" to suit me.

Then I waded through engineering-level and college-text type books and found a lot of "why." These books spoke to me in my native language derived from those earlier years in technical photography. But these books were short on "how" and when it was there it was often something like, "How to manufacture film," a thing I have zero intention of trying to do.

In the end I distilled out enough information to satisfy myself intellectually and help me make pictures that magazines would pay money for and actually use. After that I wrote some books illustrated with my photos and finally became an editor of books which use a lot of pictures—two or three per page.

Therefore I consider myself a professional only in the sense that I get paid money for doing it and sometimes my photos satisfactorily accomplish their intended purpose.

DOUBLE EXPOSURE

The paragraph title is a fraud. This is really a second exposure to H & D curves and related matters in the form of a few provocative questions.

If a negative proves to be too contrasty and you decide to do it over again, would you aim for a higher CI?

If you are developing a negative and your remarkable intuition tells you to give it a higher CI, would you leave it in the soup longer?

If exposing for good shadow detail, never mind the consequences to the rest of the picture, how would you expose? More than the exposure meter suggests?

If you are trying to take a picture of a marshmallow on a white tablecloth, how would you expose? What else would you do? Eating marshmallow is not allowed.

Reciprocity failure

Standard procedure among photographers is to open up a box of film, load the camera, and throw away the instruction sheet that came in the package. Good guys throw the stuff in a trash container.

Frequently, in the exposure instructions there will be advice to increase exposure by some stated amount above normal when the time of exposure is considerably longer than normal. This exposure increase is intended to compensate for reciprocity failure, RF, whose full name is Failure of the Reciprocity Law.

RF can happen at *both* very short and very long exposure times.

Failure of the reciprocity relationship means that the effective exposure is no longer the product of **I x T** and is less than that value. Exposure meters and calculators normally assume that **I x T** is the correct exposure, so when you are operating in the domain of reciprocity failure, you have to add more exposure to compensate for RF.

Because the instructions for RF compensation usually discuss exposure times, people tend to think that the phenomenon is the result of extra long or extra short exposure *times.* Not so. It results primarily from the *intensity* of light. The exposure times are merely clues. If the time is extremely short, that means the light is unusually bright. And the reverse.

Film emulsions are designed using grain size and composition to respond best over some limited range of light intensity. When the light on the film is more or less than the designed range, that light is *less effective* in exposing the film. Therefore you need more light which you get by allowing more exposure.

The RF exposure adjustment for one high-speed film is:

Exposure Time	RF Exposure Adjustment
1/1000 sec.	none
1/100	none
1/10	none
1	1/2 step more
10	1 step more
100 sec.	1.5 step more

You can see that over the intended range of light values for this film—where exposure times are shorter than 1/10 second, no adjustment is required for RF. At longer exposure times the amount of light is below the design range of the film, so more exposure is required than your exposure meter suggests.

Film instruction sheets for amateurs give exposure corrections only for RF because amateurs typically take their film to the drug store where the pharmacist is too busy to give any special attention to development.

Instructions for professionals usually specify RF corrections in both exposure and developing time.

The mechanisms for both high-light-intensity RF and low-light RF are complicated and because the photographer can't do anything about it except follow instructions, we don't need to fuss over the theory. The book *Exposure* by W. F. Berg has a very thorough discussion of RF and is generally an excellent book. If you want stronger wine than I am serving, try Berg.

Bracketing

Much of the literature about taking pictures advises us to "bracket" our exposures. This means we figure out what exposure we think is right for a particular scene and take a picture that way. Then we take another shot with one step more exposure, still another with one step less. For important pictures, we take two more shots, two steps up and two steps down. This is a total of five exposures to try to get one good picture.

The basis for this advice usually begins by saying, "Film is cheap," which isn't really true, and goes on to include other lures. Such as the idea that the best shot may be one of your extra exposures or you may even get two excellent photos, each with a different mood. Film is cheap only in relation to things which are dear. If you charter an airplane to take pictures of the Grand Canyon, film is cheap.

It's understandable that film manufacturers would urge everybody to bracket and bracket. It's a great marketing idea and the world should be grateful that P. K. Wrigley didn't think of it.

Most authors of popular books on photog-

raphy are also enthusiastic bracketers and I am not sure why.

I'm not big on bracketing for a bunch of reasons. It does increase your cost of taking pictures. In addition to paying for the film it has to be processed and printed so you can judge the results. I normally don't need two shots of a scene with different moods. I need one good one that satisfies the purpose of the shot. I'd rather spend my film and time shooting from different angles and points of view.

I think bracketing leads to sloppy picture-taking. If you work seriously at getting one good shot and then figure out why it is good or not good, you are on the way to becoming a photographer. If you fire all your bullets and then look to see if you hit anything, you are only dangerous.

Do I bracket? Yes, sometimes. My experience has been that when I bracket I am sorry I did and when I don't I am sorry I didn't. I leave the subject on that sorry note.

I didn't bracket exposures for this shot of a paper clip, just figured exposure and fired once. Take exposure reading on white background, give two steps more exposure than meter suggests. Good custom lab will print for white background no matter how exposed as long as the image is not on toe or shoulder of the film curve.

Light

Light comes first in photography—even in the word itself. Everything that happens is in one way or another influenced by the amount of light, its quality and quantity.

The primary light source is the sun and we consider direct sunlight to be white. Nobody knows what light is and the body of scientific data about it was accumulated by observing what light does and from those observations trying to figure out what it is. There are two dominant ideas. One supposes that a ray of light is a series of little bundles of energy called *quanta*, all in a row. When light strikes something it delivers those little energy messages. The quantum theory is the most advanced and explains things such as sensitizing photographic emulsion better than any other theory. But it is difficult to understand and requires both intricate reasoning and tough math.

For our purpose, the wave theory of light is entirely adequate and sufficiently complicated to be perplexing.

Waves in water are a good representation of light waves. They have amplitude—how high they are. They have wavelength—the distance from the crest of one wave to the crest of the next. And they have frequency which is a measurement of how many waves happen in a period of time. If you sit on the pier and count how many waves pass by in some interval of time, you can figure the frequency of that wave motion.

Waves in water have polarity, which relates to the direction of motion of the water particles which participate in the wave. A cork on the surface of the water bobs up and down as the wave passes, therefore the motion of the water itself is vertical, or vertically polarized.

Sometimes I get a picture which speaks more of the light than the subject and makes me think maybe I am artistic after all. Distant background is both overexposed and out of focus which I think is just fine for this shot.

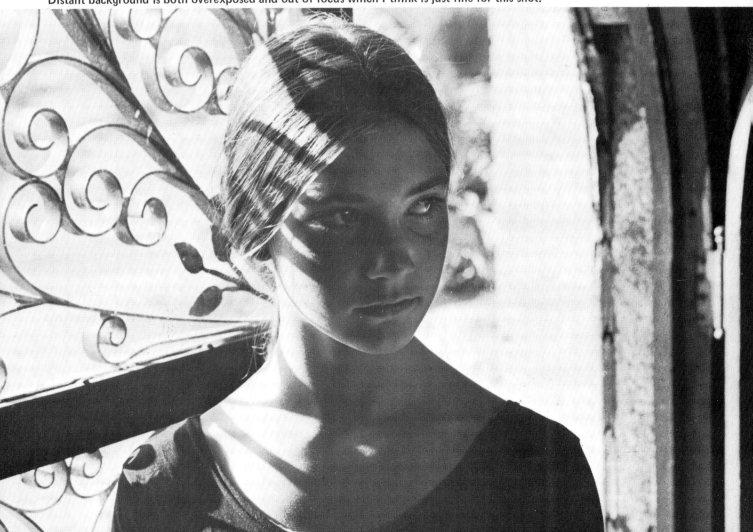

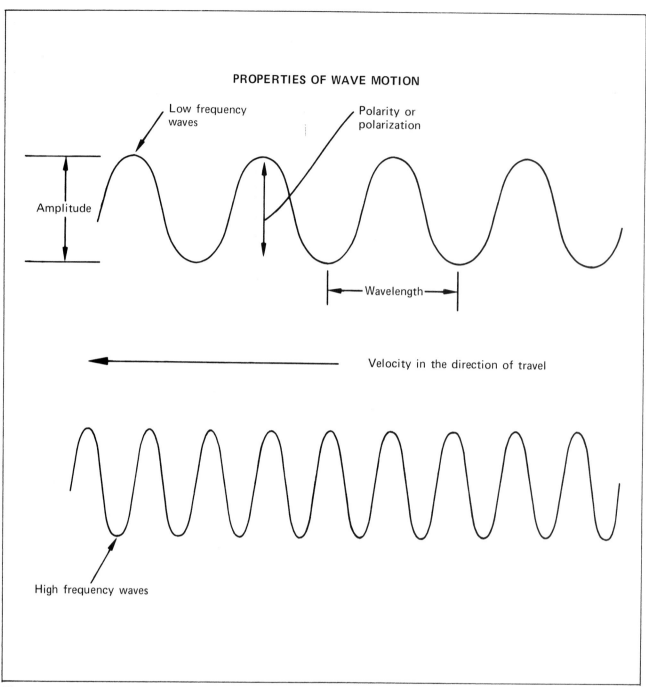

PROPERTIES OF WAVE MOTION

Low frequency waves

Polarity or polarization

Amplitude

Wavelength

Velocity in the direction of travel

High frequency waves

Waves are described by type, amplitude, frequency, velocity, polarization, direction and wavelength, unfortunately.

An important idea is that the wave is simply a shape which passes through the water. The wave moves along at some velocity in a horizontal direction. The water itself doesn't move horizontally at all due to the wave action. The cork is returned to the same spot after each wave passes.

Therefore the polarization of a wave motion is at right angles to the direction of travel of the wave itself. The wave has velocity in the direction of its travel. But the particles of water, or other medium, don't chase along in the direction of the wave at all, they move back and forth in the direction of wave polarization.

Water waves can only be polarized vertically. Light waves do not have this restriction. Light can be polarized vertically, horizontally, or at random—meaning that the polarization can be in many directions simultaneously, except of course that all directions of polarization must be perpendicular to the direction of wave motion. Think of a

bottle brush, with bristles sticking out radially in all directions, and you have a good model of randomly polarized light.

Light waves travel at a characteristic and constant speed in any homogenous medium. In air the speed of light is about 300,000,000 meters per second or 186,000 miles per second. If you decide to remember one of those numbers, choose the first one.

In a different medium which is optically more "dense," such as glass or water, light travels at a different and slower speed.

THE ELECTROMAGNETIC SPECTRUM

We humans swim around in a sea of radiations called *electromagnetic.* These radiations include light, radio waves, infra-red heat waves, ultraviolet invisible light, X-rays, and others. The main difference between these types of radiation is wavelength. They all travel at the same speed and therefore those with shorter wavelengths have higher frequencies, however you don't have to worry about that. Light waves are described by wavelength.

Because they are very short waves, the unit of measurement is also very short. There has been more than one unit of measurement but we will use only *nanometers*, nm, one-billionth of a meter. A meter is about a yard long (39.37 inches) and nanometers are manufactured by taking a full meter and slicing it into a billion pieces. A nanometer is 0.000000001 meter. The wavelength of light is very short indeed.

Visible light

Our eyes perceive electromagnetic radiations over a range of wavelengths from about 400 nanometers to about 700 nm, called the spectrum of visible light. Other light-sensitive devices respond to radiations at other wavelengths. Photographic film responds to wavelengths shorter than 400 nm—the ultraviolet region—and also to visible light. Our skin feels waves longer than 700 nm and senses them as heat. These longer waves are called infra-red and some special films can be exposed by infrared, IR.

Within the visible spectrum, different wavelengths create the sensation of color. A rainbow is a minor miracle which separates sunlight into an array of colors comprising the visible spectrum. Starting at the long waves, the colors are: red, orange, yellow, green, blue, violet.

I have remembered that sequence of colors for a long time and found it handy. I taught it to my ten-year-old daughter in about three minutes one afternoon while we were looking at a rainbow.

Figure 10 shows the spectrum of visible light plus a little more at each end, identified by color and wavelength. The spectrum is continuous, with energy at each wavelength. The colors gradually merge with one another at the point where our eyes decide that the wavelength is changing enough to produce the sensation of a different color.

An important thing to notice about this representation of the spectrum is that it keeps on

Figure 10/The visible spectrum is a very narrow slice of the total spectrum of electromagnetic radiation.

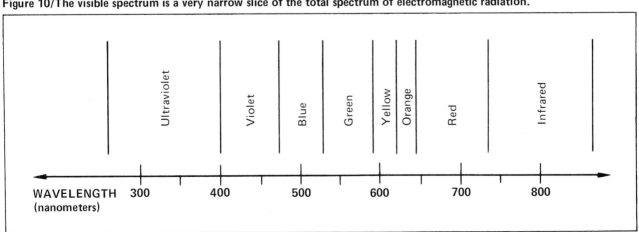

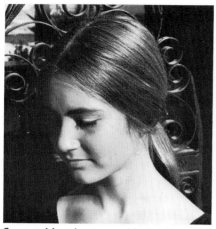

Same subject in strong side lighting, diffused light, and flat light.

going in both directions. From the short wavelengths at the violet end, the spectrum extends further to embrace ever smaller wavelengths, through ultraviolet and on out to X-rays and cosmic rays. From the long-wave red end, the wavelengths become still longer to make infrared and longer heat waves and then become long enough to become radio waves. The total radiation spectrum is very broad and we can see only a narrow slice of it.

The main point is, the spectrum of visible light does not form a circle or a triangle as often pictured in discussions of color photography. One end of the visible spectrum does not just naturally connect onto the other end to make any kind of a closed figure.

The circles and triangles used to depict arrangements of colors kept me from understanding the basic idea for a long time because I had prior knowledge that the spectrum does not make any circles or triangles naturally. I will use a triangle later as a form of color map but will be careful to point out that it does not represent nature.

Strong side lighting creates shadows and gives dimension to architecture or surface details.

Flat lighting doesn't.

Reflectance

We may occasionally take pictures of something which is itself a source of light such as a campfire or a table lamp which is turned on. Most objects do not make any light, they just reflect light from some other source.

If a scene is uniformly illuminated, perhaps from the sun, different amounts of light will be reflected from different objects due to variations in reflectance. This is usually expressed as a percentage. If, somehow, all of the incident light falling on the scene is reflected by an object, its reflectance is 100%. A hole, into which light can enter but not return, has zero reflectance. Both of these are uncommon in nature and the span of usual reflectances runs from about 3.5% to about 90%, more or less.

By measurement, the average reflectance of *typical* outdoor scenes is about 18%. If an outdoor scene contains mainly a white barn or the entrance to a cave, it is not typical.

It is sometimes useful to have something you can look at, or take a picture of, which has that average 18% reflectance. Kodak courteously prints cards which are 18% gray on one side and 90%-reflectance white on the other. You can get one at your friendly store. Later I will discuss how to use one and try to persuade you that an 18% gray card has no magic properties.

KINDS OF REFLECTION

Two words which you will see used to describe reflections are *specular* and *diffuse*. Specular reflection results from a smooth or shiny surface. If a flashlight beam impinges on this surface, the beam will be reflected as a bright ray of light and surface detail at the point of reflection is likely to be obscured by the very brightness of the reflection.

If the surface is rough and irregular, diffuse reflection will occur. Because the surface presents many different angles to the incoming light, it is not reflected in any regular way and the beam of light loses its form. It is broken up into diffused light which bounces off in many directions. To the viewer and to the camera, diffuse reflection is less bright than specular reflection even with the same source of light being reflected.

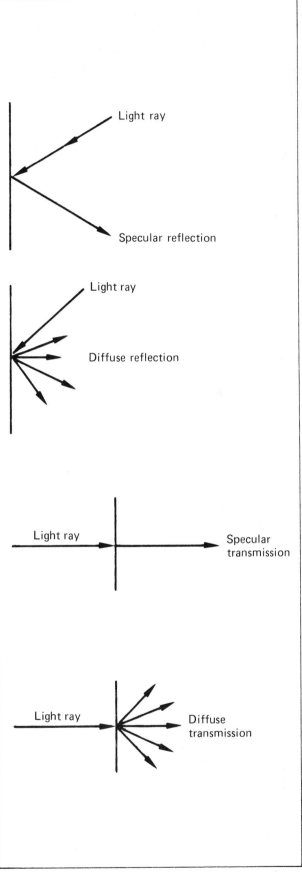

Light is specular or diffuse according to the amount of dispersion caused by a reflecting surface or by transmission through a medium such as glass.

Sunlight reflected from glass surface is a *specular* reflection. The rest of the picture is mainly diffuse reflection. Most scenes and surfaces have some of each.

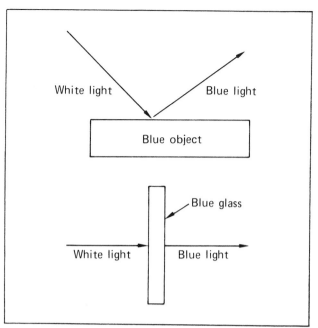

Objects illuminated by white light appear colored due to selective reflection or transmission. Only the wavelengths creating the apparent color reach our eyes, the rest are suppressed.

Unpolarized light, meaning randomly polarized, when reflecting from a smooth surface will become polarized unless the surface is unpainted metal. While light from the sun is unpolarized, light from the sky is polarized in varying degree and the effect is maximum when the sky is viewed at right angles to the sun. The angles of these polarizations are not vitally important to the photographer because when he wants to take advantage of some property of polarized light, he uses adjustable equipment which can "find" the angle of polarization.

SELECTIVE REFLECTION

Some objects reflect certain wavelengths and do not reflect others. This causes them to appear colored when illuminated with white light. Blue paint reflects only blue light. If you illuminate your blue car with light which does not contain any blue wavelengths, the car won't reflect anything and will appear black. An important idea of photography is that nothing can happen to a wavelength or color if that color isn't present in the first place.

SELECTIVE TRANSMISSION

If you hold a piece of green glass up to white light, it appears green because only the green wavelengths are transmitted through the glass. The other wavelengths do not get through. If you put a green glass between your eye and a source of light which has no green wavelengths, the glass will appear black.

WHERE DOES THE REST OF IT GO?

Light falling on an object can be accounted for by any bookkeeper. Some of it is reflected, some is transmitted, and the rest is absorbed by the object being illuminated. When it's all done, the sum of reflected light, transmitted light, and absorbed light will equal the amount of incident light on the object.

SOME DEFINITIONS

There are several kinds of electromagnetic radiation and special vocabularies have arisen for some of them. Visible light has its own set of words, some cousins of the basic unit, *lumen*. A lumen is a small amount of light which I will define precisely after a while. It is sometimes con-

venient to think of a lumen as one ray of light.

When people first began to try to measure amounts of light the need for some standard light source was quickly apparent. With an understood standard, one could then say that the light being measured was, say, five times as much as the standard.

Because this was before the days of electric lights, a candle of standard dimensions, made of oil from the sperm whale, was used. The lumen relates to the amount of light emitted by a standard candle. The whales vigorously opposed this concept and in later years a new standard candle, called a *candela*, was specified. It is the amount of light emitted by a specified hunk of platinum which is just solidifying from the molten state. So far, platinum has not objected to this treatment.

The word *luminous* to you and me means something glowing or emitting light. It is an im-precise adjective and it is difficult to use measured numbers in association with an adjective. It would result in statements such as, "That's a 4.5 pretty girl." Scientific folk like to coin words which are nouns, which have very specific meanings and can be grammatically used with numbers. The word *luminance* is a noun and it means the amount of *visible* light coming from a luminous source.

The word illuminate means to put light on an object. *Illuminance* is the scientific term referring to the exact amount of light *in the visible spectrum* which falls on an object. The common word *brightness* overlaps both of these technical terms.

The scientists who make up words like luminance and illuminance don't like to discuss them at the company picnic for fear ordinary people will learn them and pollute their meanings through loose use. Let's try not to.

We say light rays travel in all directions from a point source. If a surface, shown in dotted lines, is up close it will receive a lot of the light rays and have high illuminance. The same surface moved farther away captures less light.

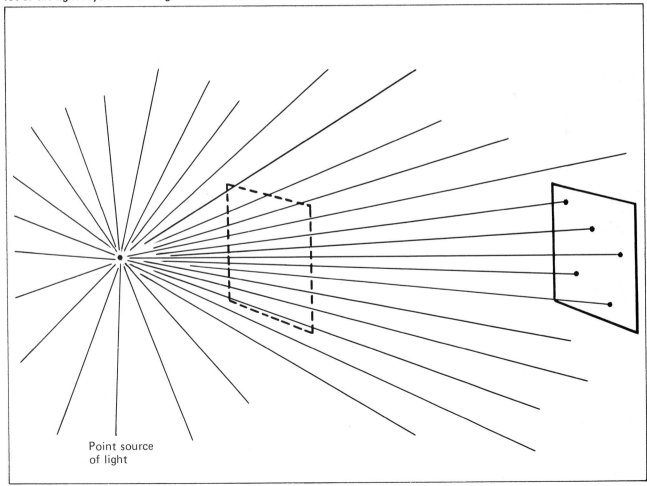

Point source
of light

Light rays

The behavior of light can nearly always be described by assuming that it consists of individual rays which tend to travel in straight lines. Most optical equipment is intended to cause light rays to change their direction of travel, and do something such as come to focus at a point.

It is often convenient to imagine a point-source of light even though no such thing exists. This is a tiny glowing object which emits light rays in all directions. If you made a small rectangle of cardboard and held it near a point source so light rays could fall on its surface, the surface would intercept some number of light rays and have some illuminance. If you move the cardboard closer to the light source. it will intercept more light rays and appear brighter. This is the basic idea of illuminance. The number of light rays, called lumens, which fall on a specified area such as a square foot or a square meter determine the illuminance.

If you were close to a point-source and could see the individual light rays, it would be obvious that none are parallel. They travel outwards in all directions from the point-source. If you back away from the source, fewer of those light rays will come in your direction but those which do will appear to be more nearly parallel. If you are a very great distance from the source, those light rays which come in your direction will appear to be parallel and can be considered so as a practical matter.

That is the case with the sun. It is so far away that practically all of the light it emits misses the earth completely. Those light rays which are intercepted by the earth are considered to be parallel to each other, or *collimated*.

Light rays can be caused to deviate from their normal straight line of travel in more than one way. If the ray makes grazing contact with a sharply-defined edge, such as a knife-edge or some mechanical part in your camera, the ray *behaves* as though there is some friction between the side of the ray and the knife-edge. This causes an apparent drag on one side of the ray and it will veer off course causing some spillover of light into the area where there should be shadow. This effect is called *diffraction*.

If the diffracting edge is straight, the diffraction pattern will be alternating bands of light and shadow. The explanation above is crude but practical and will serve to predict where a diffraction

Light rays from a point source obviously diverge when you are close to the source. At a great distance they still diverge, but *appear* **to be parallel. We consider the sun to be a point source at a great distance, so light rays from the sun are effectively parallel.**

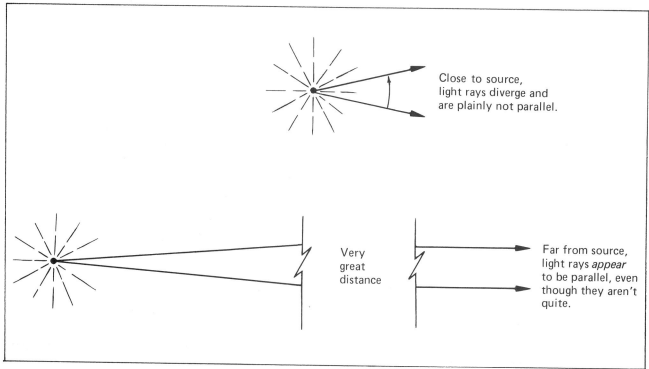

Close to source, light rays diverge and are plainly not parallel.

Very great distance

Far from source, light rays *appear* to be parallel, even though they aren't quite.

DIFFRACTION PATTERNS

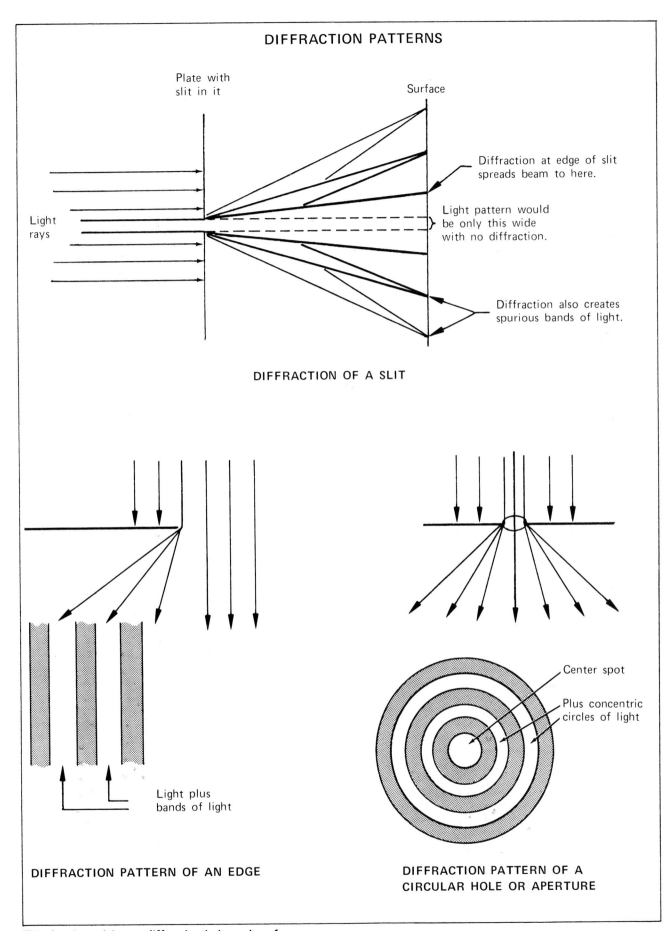

Plate with slit in it

Surface

Diffraction at edge of slit spreads beam to here.

Light pattern would be only this wide with no diffraction.

Light rays

Diffraction also creates spurious bands of light.

DIFFRACTION OF A SLIT

Light plus bands of light

DIFFRACTION PATTERN OF AN EDGE

Center spot

Plus concentric circles of light

DIFFRACTION PATTERN OF A CIRCULAR HOLE OR APERTURE

This drawing celebrates diffraction in its various forms.

pattern will occur and its general appearance.

If light passes through a small circular hole, the solid boundary of the hole will diffract the light, forming circular bands of alternating light and shadow. The resulting light pattern is a circular disc of light, larger than geometry alone would predict, surrounded by additional rings of light which become less bright at greater distances from the center of the disc. This light pattern is known as an *Airy disc.*

The aperture which lets light into a camera is a small opening and therefore creates a diffraction pattern. The effect of aperture diffraction on image quality will be covered later.

One of the stratagems of classical logic is called in Latin *reductio ad absurdum,* meaning reduce to an absurdity. It's a way of showing that a seemingly attractive proposition is basically false. Such as: If chubby babies are healthy, then a 2,000-pound infant would be nearly ideal. Obviously absurd, therefore the original premise is also suspect.

Sometimes it helps my thinking to begin with an absurdity. Such as:

The idea of photography is to capture on film the light rays reflected from the scene being photographed. Each tiny point on the surface of that scene reflects light according to the reflectivity of that point—more light where it is visually bright, less light where it is visually dark. Also, each point on a scene may reflect a characteristic color of light which is vital to color-photography and important in black-and-white photography sometimes.

I have decided to capture the reflected light rays from a nearby mountain on a piece of negative film. I hold the film under my jacket to protect it from unwanted light while I find a good location for my picture. When I judge that the location is correct, I whip the film out and face it toward the mountain.

Each point on the mountain is reflecting a cone of rays, so they travel in many different directions. Therefore light rays from one point land all over the surface of the film. Rays from all the other points on the mountain do the same thing. The result is the film collected light rays from all the points on the scene but they are all mixed up together and no image resulted. Also, the film collected extraneous light from the sky,

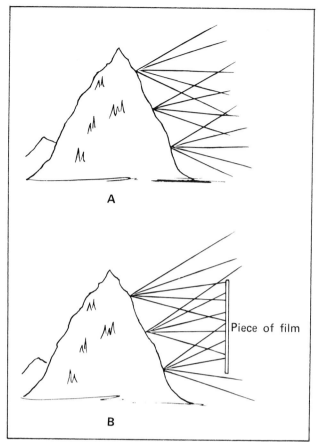

In part A, a mountain is busy reflecting light. Each point of the scene reflects light rays in all possible directions. In part B, I am committing an absurdity. The piece of film is capturing light rays from the scene, but the rays are all intermingled so no image of the mountain appears on the film. We have to do better than this.

the ground at my feet, objects to the left and right of the desired scene—in fact from an entire hemisphere. My absurd method of exposing the film resulted both in no definite image and no selectivity within the hemisphere the piece of film was facing.

This problem has two parts. The first is to get an actual image on the film. Obviously this requires some arrangement so the light rays from one point of the scene expose only one point on the film and not the entire surface.

The second is to find some way to control the area of the scene that we capture on film. It is not always desirable to photograph everything in sight.

Let's consider the first problem first. One ancient solution is to use a pinhole camera, originally called a *camera obscura.* In concept this is a light-tight box with a tiny hole in the front to

admit light to the film emulsion. If the hole is small enough, you can imagine that it will admit only one ray of light from one point of the scene. All the other rays from that point diverge a little and thereby miss the hole.

Because the ray travels in a straight line, that single ray from one point of the scene falls on one point of the film. A ray from every other point of the scene passes through the pinhole and falls on some other point on the film and therefore problem number one is solved. The exposure of the film is an image of the scene, upside down and reversed left to right.

Unfortunately, the total amount of light passing through a hole small enough to actually do that is so little that it takes a long time to make an exposure. Maybe longer. Also this solution ignores the problem of diffraction which fuzzes up the image.

Consider what would happen if we made the pinhole larger to admit more light. Instead of admitting only a single ray, a larger hole will allow passage of a bundle of rays which are *diverging*. The neat little point on the film, which represented a point on the scene, becomes a spot. The spot on the film is always larger than the hole due to diffraction and because the rays are diverging. If the pinhole is 1/16-inch in diameter, the spot will be more than 1/16-inch in diameter which is a poor

image of a tiny point. Image quality is degraded and the picture looks fuzzy.

How big does the hole have to be to get enough exposure in a short length of time? The normal lens on most modern 35mm Single-Lens-Reflex cameras is specified usually as something like 50mm focal length with a maximum aperture of about *f*-2. At this point, you don't have to know exactly what those lens identification numbers mean and I am using them here only so you will recognize that those are the specs of your camera lens, or close to it anyway.

For such a "normal" lens, when it is wide-open to admit the most light the diameter of the "hole" is very close to one inch. We call these fast lenses because they do let in a lot of light and allow exposing film in a short interval of time such as 1/1,000 second.

However a one-inch hole in a pinhole camera with no lens to help out will make a spot on the film bigger than one inch in diameter for each tiny point of the scene. Probably it will be a very poor photograph.

The *main purpose* of a camera lens is to provide a large opening to gather a lot of light rays from each point of the scene and then cause those rays to converge so as to make a point-image on the film.

The way it does that trick is interesting. It relies on a phenomenon called *refraction*.

The earliest way of forming an image probably resulted from a hole in the side of somebody's tent. A small hole will admit only one, or perhaps a narrow bundle of light rays from each point of the scene. The result is an image because light rays from different locations on the scene pass through the hole at different angles and do not intermingle. This is called a camera obscura, also pinhole camera. The latter name is less obscure.

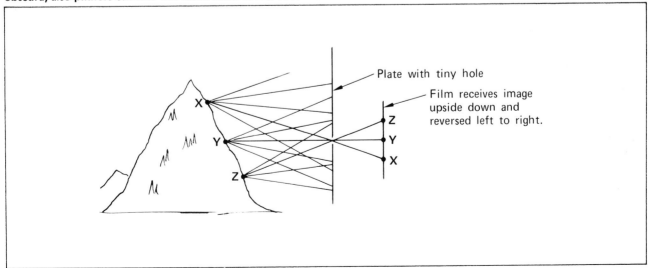

Plate with tiny hole

Film receives image upside down and reversed left to right.

Refraction

Refraction is a property of lenses which takes place because the velocity of light in glass is slower than in air. We can use another analogy.

If you ever marched in a school band, or in defense of our country, or even watched people marching, you can get a feel for the mechanism of refraction. When the front row of a marching band wants to turn left, the pivot man stops moving forward and marches in place. Each marcher to his right slows down some lesser amount, the guy on the far outside continuing to travel at his normal speed unless he has to hustle.

If the front row remains in a straight line, this maneuver causes a majestic left turn on the parade ground.

Now let's do it another way. A column of men is marching along approaching a dismal swamp, which all defenders of our nation will remember pleasantly. The swamp gets deeper and stickier from its edge toward the middle. As the defenders get there, the outside man walks on the bank and each man to his left travels in deeper and deeper muck. The inside guys slow down. If the row remains straight, the effect will be to turn the column of marchers.

The idea is that rays of light do appear to travel like marchers and appear to cling laterally to each other so as to keep the rows straight. The advancing face of a beam of light rays is considered to have a "wave front" similar to the front row of the marchers.

If a beam of light moves into a different medium which slows down part of the beam first, it will change direction. Remember that the new medium has to slow down part of the beam first. If a beam of light arrives perpendicular to a pane of glass, all of its rays will be slowed down the same amount and at the same instant. The entire beam will slow down while traveling through the windowpane, but will not be changed in direction.

Figure 11A shows refraction when a beam of light enters a glass surface at an angle.

If the light rays travel on through the glass and emerge at the other side, also at an angle to the surface, refraction will occur again. When the light rays leave the glass and go into air, they

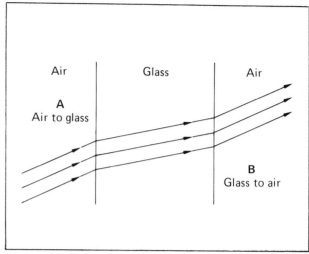

Figure 11/When light passes from one medium to another, refraction at the boundary surface changes the direction of travel of the rays. We must also celebrate refraction because camera lenses won't work without some.

speed up again. The edge that gets into the air first will speed up first and the result will be a change in the direction of travel. The beam will bend as shown in Figure 11B.

Notice that refraction only happens at the *surface* or boundary between two mediums of different chracteristics. As long as the light rays travel in the same medium, there is no refraction. Therefore the action of a lens is at its two surfaces, not inside the glass.

The rule is, any boundary surface between media with different light velocities will refract light rays. To make that rule valid—every surface refracts every ray—we have to make a special case of rays coming in at a right angle to a surface. They are also refracted, zero amount. Each surface also tends to *reflect* some of the light, but that's another problem. Here we are mainly concerned with the light rays that actually enter the lens.

Figure 12 is a sketch of a lens with both sides convex, cleverly called a double-convex lens. As you can see, rays entering the lens above the centerline are refracted toward the centerline at the first surface of the lens. When those rays leave the glass and get back into air, at the second surface of the lens, a happy coincidence occurs. They are

Carl Zeiss lens on this Rolleiflex SL66 does all the tricks discussed in this section. Camera is a single-lens reflex producing a square negative 5.7 by 5.7 cm which is 2¼″ by 2¼″. This frame size is usually called 6 by 6 cm, hence the camera model designation.

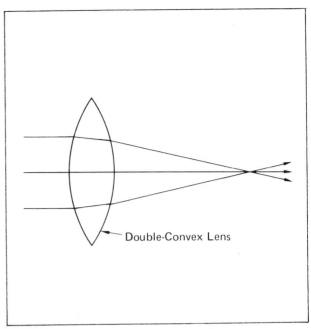

Double-Convex Lens

Figure 12/Refraction at both surfaces of double-convex lens bends rays toward centerline of lens.

refracted again, also toward the center line. At some distance past the second surface the light rays will cross the centerline of the lens because they are now headed in that direction.

Similarly, rays which enter the lens below the centerline are refracted upward, toward center. Rays to the left and right of center, not shown on the sketch, will also be refracted toward the central axis of the lens.

What about a light ray that is already on the centerline of the lens? With respect to the exact center of curvature of the lens, that ray is not entering at an angle—instead it is perpendicular to the surface. Therefore it is refracted zero amount and continues to travel along the axis of the lens, called the *axis of symmetry.*

You can now start suspecting that all those rays will meet at some location down the axis from the lens, making a bright spot of light, and if you look again at the figure, your suspicion will be confirmed. You should also notice that the figure was drawn so all the rays entering the lens are parallel to each other. Nothing in nature requires light rays to be so orderly but we can imagine such a case, so we can make a rule about lenses.

Because this double-convex lens causes rays to *converge,* it is called a converging lens and has the property of convergence. It is also called a *positive* lens for a reason I will get to shortly.

Figure 13 (page 50) shows a double-concave lens with light rays passing through and you can see that the rays *diverge.* They are refracted away from the central axis rather than toward it. Using the same analogy about one side of a beam of light being slowed down or speeded up, you can figure out for yourself how the diverging lens works. You can also assume that this is a *negative* lens.

If a positive lens and a negative lens are placed in a line so the same beam of light passes through one and then the other, a contest will ensue. The converging lens directs all the rays toward center and the diverging lens sends them all away from center. The end result depends on which lens is the more "powerful." If the converging lens wins, the light rays will finally converge and make that bright spot.

Most good camera lenses use several glass elements, one behind another, some positive and some negative. The reason is to correct lens defects, called aberrations, so the performance of the *compound* lens is better than any single piece of glass.

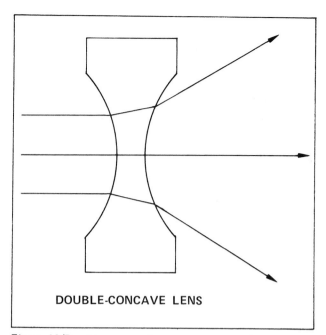

Figure 13/Double-concave lens causes rays to diverge due to refraction.

The benefit of calling convergent lenses positive and divergent lenses negative is that simple arithmetic can yield the net effect when such lenses are combined. A number representing the *power* of each type of lens is assigned to that lens. Because some are positive numbers and some are negative numbers, your adding machine can help find the end result. A positive lens with a power of 5, combined with a negative lens with a power of -3 has an overall power of +2 and is a converging compound lens.

The power of a lens is affected both by the curvatures of its surfaces and the material of which the lens is made. Glass of different chemical compositions exhibits different velocities of light and therefore different amounts of refraction of light rays. The change in velocity of light when rays enter a particular material, and therefore the ability of that material to refract, is given by a number called the *Index of Refraction*. High-index materials refract more than low-index stuff.

Because each lens surface refracts independently of the other surface, there is no reason both surfaces have to be positive or negative. A lens can be made with one surface of each type. A lens with one flat surface and one curved surface is called plano-convex or plano-concave depending on the curved surface. To parallel rays along the axis of the lens, the plane surface is not refractive,

it is neither positive nor negative, and its power is zero.

The rest of this part of the book is concerned with positive convergent lenses. I sometimes make up trivial stupidities to help me remember things. I tell myself that convergent lenses have a positive benefit to cameras because you couldn't make one without convergence. Then all I have to remember is that negative means the other kind.

Negative lenses will reappear later.

Focal length

Figure 14 is the classical simple way to illustrate the focal length of a lens. When the rays entering the lens are all parallel to each other and to the centerline of the lens, they are miraculously brought to focus at some point behind the lens, also on the centerline. The distance from the focal point, where the bright spot of light is, back to the lens is called the *focal length* of the lens, as shown in Figure 14. We will use the symbol **F** to represent focal length.

What I said was ambiguous. If you are measuring focal length, it's easy to figure out where to put one end of the ruler—it goes right on the spot of light. Where is the other end of the focal length measurement? Thank you for asking. For a simple single lens without appreciable thickness, **F** can be measured from the center of the lens. If the lens isn't simple, the answer isn't either.

If you have a simple convergent lens, such as a magnifying glass, you can measure **F**. Use it to collect some parallel rays such as from the sun and move the lens in relation to some surface until the rays are brought to focus. Quickly measure the distance from the surface to the lens and you know **F**. The reason to hurry is that focused light from the sun generates a lot of heat and can set things on fire. Magnifying glasses are also called *burning glasses*.

It takes some mental gymnastics now to understand how a lens can bring light from a distant point to focus. It is true that light from a remote point-source will come into focus at a distance behind the lens equal to the focal length. We have already seen that parallel rays entering the lens are brought to focus at the same spot. Therefore light rays from a distant point must also be parallel when they enter the lens.

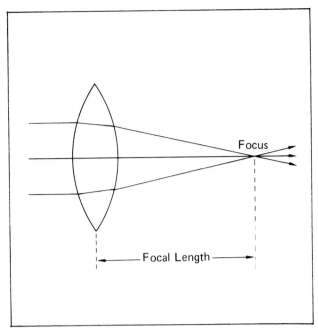

Figure 14/When parallel rays enter a converging lens and are brought to focus at a point, the distance from the point back to the lens is called the focal length, symbol F.

The focusing distance scale on this lens stops using numbers at 30 feet or about 10 meters. Next symbol is ∞, which means infinity. For this 50mm focal length Canon lens, scenes much farther than 30 feet appear to be at infinity and light rays from such scenes will seem parallel to the lens.

This is contrary to reason because we know that a point source sends rays out in all directions, therefore they are all diverging and none are parallel to each other.

If the lens is up close, it captures lots of rays with a lot of divergence between the outermost rays. If the lens is distant from the point source, it will capture fewer of the rays but the angle of divergence between the outside rays will be less. The greater the distance between source and lens, the smaller the angle between any two rays which can both enter the lens. Finally, at some distance the rays will *appear* parallel to the lens, which means that the lens can no longer distinguish them from actual parallel rays.

When light rays cannot be distinguished from parallel, then as a practical matter they are parallel. A surprising thing to me is the short distance between camera and scene at which the rays appear to be parallel.

Because sources at an infinitely large distance would naturally appear to produce parallel light rays, any source which does that is considered to be at infinity as far as the markings on your camera are concerned.

How a lens makes an image

There are some standard drawings, such as Figure 15 (page 52), used to show how a lens can image a subject. From here on, I am going to use the words *subject* and *scene* to mean whatever you are taking a picture of. I will also use the symbol **S** to mean *either* the subject or the distance to the subject. It will always be clear which.

In the standard presentations, the subject is nearly always either an arrow or a tree, depending on which has the greatest aesthetic value to the artist. I am using a rather large arrow which you can interpret as a stylized pine tree if you prefer.

Three points on the subject will be imaged by the lens, one on the axis, the tip of the arrow, and the base of the tree.

In part A of Figure 15, the axial point is imaged by tracing three rays from that point. One goes straight along the axis and nothing happens to it at the lens because it is axial. One ray goes to the top half of the lens and is refracted so it

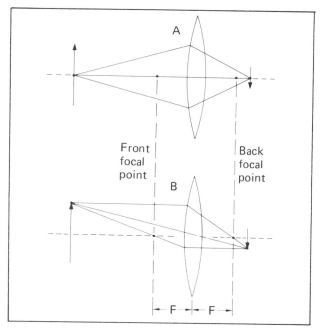

Figure 15/Images can be located by tracing light rays from points on the scene to points on the image plane as described in the text. This drawing and others of lenses in this section do not show refraction at both surfaces of the lens even though you know it is happening. Reason is simplicity of the drawings.

Assortment of Yashica lenses. A good rule in selecting lenses for your camera is to double the focal length approximately from lens to lens. Such as 28mm, 50mm, 100mm, and 200mm. You can fill the gaps, or vary this selection as you choose but the 2-to-1 ratio will allow versatility for a wide range of situations.

crosses the lens axis at a distance from the lens. The other ray goes to the bottom half of the lens and is also refracted to pass through the central axis. This is intended to demonstrate that any ray from that point on the subject will be brought to focus on the axis of the lens, no matter where it enters the lens.

Now let's image the top of the arrow, part B of Figure 15. One ray travels directly to the lens, parallel to the central axis, but not on the axis. It strikes the lens off-center and you know what's going to happen to it. It will pass through the focal point and keep on going in the same direction.

Another ray passes through the center of the lens and we assume it is not refracted significantly. At the point where these two rays from the tip of the arrow intersect, the tip is imaged. The location of the image is not on the axis of the lens.

Because I used three rays to establish the image of an axial point of the subject, I should use three rays to image the tip or you will suspect me of trickery. To find the third ray, the trick is to notice that simple lenses are symmetrical. That is, if you turned it around it wouldn't make any difference. Therefore a lens can be considered to

have two focal points, one in front and the other in back.

A point source at the focal point will emit diverging rays which enter the lens and then emerge on the other side as parallel rays.

Any light ray which passes through the front focal point and then enters the lens will emerge on the back side of the lens as a ray parallel to the axis of the lens. If you think about that a minute you will probably accept the idea.

The third ray from the tip goes through the front focal point, comes out parallel to the axis, and sure enough intersects the other two rays at a location on the focal plane. Notice that the image is apparently being turned upside down.

You can image the bottom of the arrow or tree by the same rules, and sketch the result for yourself on Figure 15.

The rules are: Parallel rays off-axis will pass through the focal point on the back of the lens. Rays from the subject which are on the lens axis go through without refraction. Rays from the subject which pass through the front focal point emerge as rays parallel to the axis.

You can also convince yourself that the

image is not only turned upside down, it is also reversed left and right.

In part A of Figure 15, imagine the subject at greater and greater distances from the lens. The outside rays will appear more nearly parallel to the central axis. At some great distance the lens cannot distinguish these rays from parallel, therefore on the back side of the lens they pass through the focal point.

Subjects at infinity are brought into focus at a distance from the lens equal to the focal length. Subjects nearer than infinity are also brought into focus but the distance behind the lens is greater than **F**.

There are no subjects farther away than infinity. Therefore the shortest distance ever required between lens and film is equal to **F** and that distance happens when the camera is focused on infinity. To focus on a nearer subject, usually the lens is moved mechanically so it is farther from the film. You can see your camera do that.

Focal length, **F**, is a *fixed distance* for any lens and is a *property* of that lens. It may or may not be the distance to the image, depending on where the subject is.

LENS ARITHMETIC

There is some arithmetic about lenses which helps camera designers figure out how far the lens should be from the film to focus on some distance such as 23 feet.

If we let **S** represent the distance from lens to subject, **I** stand for the distance from lens to image, and **F** the focal length of the lens, these three distances are related by:

$$1/S + 1/I = 1/F$$

Most books use the symbols **u** and **v** for subject and image distances but I can never remember which is which. So my mnemonic aids are the symbols **S** and **I**. *Mnemonic* is fancy for *memory*.

Unraveling this equation of reciprocals is tedious and we don't need to do it in any detail. It's easy to make some general conclusions just by observing that the arithmetic says one fraction is equal to the sum of two others.

For example, if **S** becomes a larger number then **I** has to become a smaller number because **F** is an unchanging property of the lens. Which is another way of saying that when the subject moves closer to the camera, the lens-film distance has to

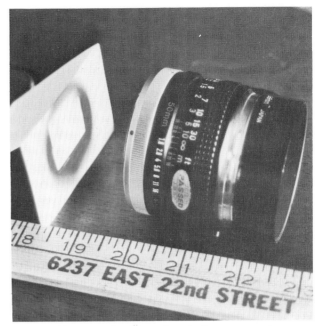

I let my 50mm lens look out the window, arranged a card to capture a focused image, adorned the arrangement with a precision yardstick, and photographed the whole affair. Rear focal distance of 50mm lens should be about 2 inches. Distance from card to lens mount is not 2 inches, so rear measuring point (node) for this lens is inside the lens but close to the mounting flange.

I did the same thing with a 200mm lens, focal length about 8 inches. Distance from back of lens to image plane is not 8 inches and is the same as with the 50mm lens because both lenses fit the same camera and image on the same film location. Rear nodal point for this telephoto lens is actually in the air out in front of the lens. The lens equation for subject and image distances works fine as long as you know where to measure from.

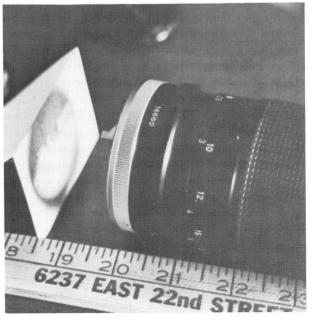

become larger.

Also, if **S** becomes an infinitely large number, the fraction 1/**S** has a value of zero. Then 1/**I** must equal 1/**F**. Which is another way of saying that a subject at infinity is brought to focus at a distance **F** from the lens.

The focal length of a lens is normally engraved on the lens holder. The lens which came with my camera has a 50mm focal length. I can remove that lens, take it to the window and let it look outside. By holding a piece of paper behind the lens I can capture the image that it ordinarily puts on film. The distance from the back of the lens to the film is not 50mm, which again raises the question, "From where do you measure focal length?" I also have a 200mm lens (about 8 inches focal length) and I can do the same trick with it. The distance from the back of the lens to the image is certainly not eight inches.

These lenses are compound, with several glass elements inside to correct some of the evil conditions we will discuss in the next section. There is no physical center of such a lens but there is nevertheless a point from which the focal length is measured. There are two such points, one for the front and one for the back. The points are called *nodes* and if you could find one you would measure focal length from there. The camera designer knows nodes and that's what counts.

Sometimes a photography writer will try to impress you and write about ultra-nodal distances and ultra-focal distances. The prefix *ultra* means greater than, or beyond. An ultra-nodal distance is measured from a node or effectively measured from the optical center of the lens. The focal length of every lens is an ultra-nodal distance. If an image is beyond the focal point of a lens then it has some ultra-focal distance as well as an ultra-nodal distance. The latter being greater than the former by an amount equal to **F**.

Isaac Newton didn't like the equation given earlier, with all those reciprocals, any more than you and I do. He simplified it by using ultra-focal distances instead of ultra-nodal distances. If we invent the symbol S_u to mean the ultra-focal distance to the subject, and so forth, then the relationship among those distances becomes:

$$S_u \times I_u = F^2$$

The range of lenses designed to fit a particular camera such as this Konica all mount on the camera body in the same way; therefore the distance between the rear mount of the lens and the film is the same no matter what focal-length lens is installed. When any lens is focused at infinity, the rear focal distance is equal to the focal length of the lens. So designers use optical tricks inside the lenses to make the optical path lengths agree with the physical distances.

That expression has no meaning for a subject at infinity because it then says, "Infinity multiplied by zero equals F^2." For other distances I think it works OK.

You don't have to read the preceding three paragraphs.

Aberrations

The word *aberration* means something ain't right. With respect to a lens it means about the same thing as "imperfections" or even "defects." However "aberration" has more class, so that's what expensive lenses give you.

There is a long shopping list of aberrations so you can get just about any kind you want. The lens designer tries to correct his lens as well as possible, considering cost and intended use of the lens. For *most* of the aberrations the user can't do anything to make them worse or better after the designer has finished his job. Therefore these are scientific curiosities—or words to use at cocktail parties—or a way to choose a lens if the amount of the various faults has been measured and published.

Some of the aberrations can be made worse or better by the way you use the camera, or they can influence the way you take a picture. These are handy to know about.

For openers, I will list most of the popular aberrations and give a brief description of the observable effect. Then I will discuss the important ones in more detail, either in this section or later in the book where the information fits in better. Or both.

SPHERICAL ABERRATION

For ease of manufacture, most lenses are segments of a sphere, meaning that the curved surface of the lens will exactly match part of the surface of some sphere, large or small. We *say* a spherical lens does all those good things I mentioned earlier, such as bring parallel rays all to a focus at the focal point. We should say the lens *nearly* does that because in practice rays which are farther from the axis of the lens are caused to converge more than rays which are close to the axis. In effect, the focal length is shorter for rays near the edge of the lens.

To figure out what effect this will have on a photograph, it helps me to remember an idea which is so simple it is easy to overlook entirely. Because an area of the scene is reproduced finally as an area in the photograph, it's easy to imagine that the light rays corresponding to those two

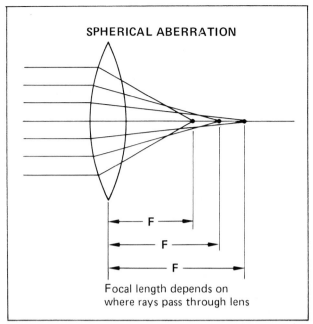

SPHERICAL ABERRATION

Focal length depends on where rays pass through lens

Spherical aberration brings rays to focus at different distances from the lens, depending on where the rays enter the lens.

small areas are confined to some similar small area all along the route between scene and film.

It isn't that way. From every point on the scene, light rays diverge so they fill the lens entirely with rays from that point. Every other point of the scene also fills the lens opening or aperture with rays. The lens then converges the rays for each point back into focus at the proper location on the negative. If the lens is ideal and perfect, a point source will produce a point image. There are no such lenses. However, there are lenses which make an *acceptable* image of a point.

Now, if rays from a point of the scene are falling all over the surface of the lens and due to spherical aberration the outermost rays converge more, then rays from that point of the scene come to more than one focus behind the lens. All these different points of focus, for different radial zones of the lens, fall on a line called a *locus* meaning something like "Where are they *located*?" The locus line where these different points of focus occur is perpendicular to the lens and to the film in your camera.

Nowhere along this locus are all the rays from that point in sharp focus. If you put the film at a place where one set of rays is in focus, other sets of rays will not be in focus. They will either be a

circle of rays not yet brought to focus, or a circle of rays which have already gone through focus and are diverging again. Either way, the light makes a disc on the film instead of a point.

If every point of a scene which should be sharply defined as a point on film is instead reproduced as a spot or disc the resulting photographic image will be blurred. Fine details will be lost entirely.

It happens that a negative lens produces the opposite effect, that is, rays near the edge are refracted less. The clever lens designer corrects for spherical aberrations by using positive and negative lenses of different materials in combination. A lens corrected for this aberration gives a much better picture because it reduces image degradation due to the problem of locus of focus.

You knew I was going to say that.

CHROMATIC ABERRATIONS

The word *chroma* refers to color therefore this lens fault arises from the fact that white light is composed of all colors of the spectrum.

The usual demonstration of that fact is to pass sunlight through a prism and capture the resulting colors on a screen where you see all the colors of the rainbow. This demonstration works because refractive materials such as glass do not refract all colors the same amount. Shorter wavelengths such as blue are refracted more.

That's fine as a laboratory analysis of the constituents of white light. It is an attractive effect you can see in a crystal chandelier or a diamond ring, but it's not too good in a lens for making a picture.

The general idea is similar to spherical aberration except that the change in angle of convergence relates to colors rather than to distance from the center of the lens. Every ray, no matter where it strikes the lens is separated into its colors and an image is made of each color. The blue image is closest to the camera lens and the red image is farthest away. There isn't any place you can locate the film and capture one single image in good focus.

The result is blurring of the image if the film is black-and-white, or color-fringes around the image if you are using color film.

The correction, again, is a compound lens with several glass elements with the purpose of bringing all colors to focus at the same point. Cor-

rection is never perfect so there is always some residual chromatic aberration in a lens.

You could get a good image as far as chromatic aberration is concerned with an uncorrected lens if you illuminated the scene with light of a single color, or if you put a filter over the camera lens to admit only monochromatic light.

Special films are available which respond to long-wave infrared and also to visible light. Ordinary lenses are corrected reasonably well for the color components of visible light, but not for infrared. Therefore when using special IR film, it is customary to put a filter over the camera lens which passes only long wavelengths.

However, because the lens is not corrected to put IR images on the same focal plane as visible light, the focusing marks on the lens will not be accurate. Some cameras have a special focusing mark to be used with IR film. If yours has one, notice that when you use it to set distance the lens is moved farther away from the film. That's because long waves are converged less by the lens material.

COMA

Coma is an off-axis problem in which pinpoints of light are imaged so they look like a comet with a tail. The farther away from the axis of the lens, the worse the problem. Correction is compound-lens trickery.

Because coma puts light where it doesn't belong, it tends to blur the image and reduce contrast between adjacent points in the original scene.

ASTIGMATISM

Astigmatism is another off-axis problem. Imagine an object which is two lines crossing at right angles and then bring the object to the lens so the center of the crossed lines is not on the center of the lens. One of the two lines, in your imagination, lies along a radius of the lens and the other is perpendicular to a radius line.

The idea of astigmatism is that the lens "looks" different when viewed along one of its radius lines than the other way and in fact will focus differently to those two lines of a subject.

Even a point subject has some size and therefore some part of it lies along a radial line in respect to the lens. Some other part of the subject lies along a line perpendicular to the lens radius.

If you imagine the film being moved through

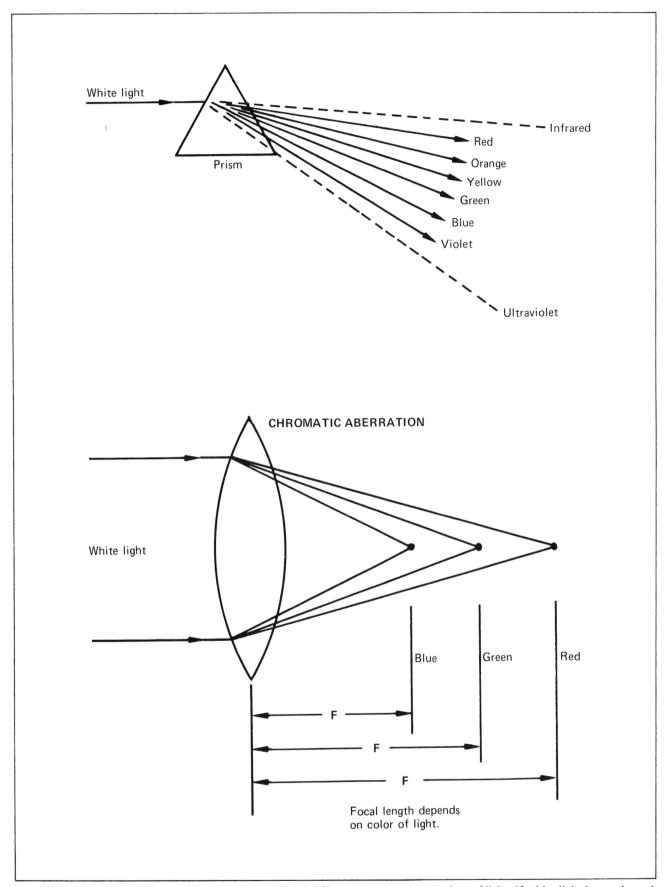

CHROMATIC ABERRATION

Chromatic aberration results from different refraction of different wavelengths or colors of light. If white light is put through a prism, a rainbow spectrum results which is a common demonstration of the fact that white light consists of all colors of the spectrum. In a lens, different colors are also refracted at different angles, so the point of focus depends on color.

the focal plane of a lens with astigmatism, the image of a point will first appear as an ellipse with the long axis in one direction, later as an ellipse with the long axis in the other direction. In between the two ellipses, the image will be approximately circular and that point is usually chosen as best focus.

In practice, astigmatism means that you can't get vertical lines of an image in focus at the same adjustment which causes horizontal lines to come into focus. And the reverse.

Correction is multiple lenses assembled into a compound lens. With adequate correction, neither photographer nor viewer is aware of the problem.

DISTORTION

Whenever the geometry of the image does not look like the geometry of the original subject, we say the picture is *distorted.* In this sense, distortion is on a larger scale so it relates to the overall shape of things in the picture such as a window or a building rather than non-exact rendering of some small detail.

Distortion can naturally be caused by a poorly manufactured lens but it can also result from improper use of a normal spherical lens. Two kinds of distortion are characteristic of improper use and have names: *Barrel distortion* causes the straight sides of a rectangle to bow outward. *Pincushion distortion* curves them inward. These shapes occur according to the physical relationship between a lens and the mechanical aperture controlling the amount of light passing through. If a compound lens is symmetrically arranged with the aperture in the middle of the lens, neither type of distortion occurs.

Very wideangle "fish eye" lenses have barrel distortion because it is an unavoidable price for the extra-wide angle of coverage.

CURVATURE OF FIELD

A way to make a circle on the ground, for a flower bed perhaps, is to tie one end of a string to a stake and then use the other to trace a circle of constant radius.

The focal length of a lens is, in effect, a radius line to the surface where that lens makes the image of a scene at infinity. Therefore in this simple example the surface that would get an image in best focus would be spherical. It is diffi-

This shot into a mirror illustrates several things. You should see a fall-off in illumination in the upper corners of the picture because light from the lens has to travel farther inside the camera to reach the corners of the frame—and other reasons. It shows a good way to hold a camera to keep it steady and operate the controls quickly. Front of lens is not in focus which is either good or bad, depending on intent of photographer.

cult to get a flat piece of film to conform to that shape, so lenses are corrected for curvature of field with the goal of having the focused image surface as flat as possible—in other words, an *image plane.*

Correction is done with compound lenses and is never perfect. A lens corrected for flatness of field will still have a focal "plane" slightly curved in both directions. The flat negative film cuts through this plane and normally the focus is acceptable at all locations on the negative.

DISTRIBUTION OF LIGHT

If you take a photo of an evenly illuminated wall your picture won't interest many people but it will interest you if you are checking the evenness of illumination across the image on the film. There are several reasons for the illumination on the film to vary even when the scene has uniform brightness. The simplest of these is: When the film plane is flat, light from the center of the lens has to travel a farther distance to reach the corners of the picture. The amount of light is thereby reduced. This, together with other causes produces an exposure near the edges of a picture which may

be only about 50% of that at the center. This is one step less and should be visible if you look for it. The process of printing tends to correct the problem because the printing lens has the same defect. You may have to think about that for a minute.

VIGNETTING

Vignetting is an extreme case of uneven light distribution which happens by accident or on purpose. If an accident it is usually considered bad.

Wide-angle lenses accept light over a wide angle and then relay the light on to the film at that same wide angle. Therefore light distribution to the edges of the film gets worse with wider angles.

A lens hood which is too long or too small in diameter can cause vignetting, as you will see on page 118.

LOSS OF LIGHT IN THE LENS

A lens does not transmit all the incident light that falls on its outer surface. Some is reflected and some is absorbed during travel through the glass.

Absorption through modern lenses which have not colored with age or otherwise deteriorated is very low. There is more light loss when the glass is thicker.

This loss is virtually uniform across the visible spectrum so there is very little color discrimination in a clear-glass lens. Such lenses normally attenuate ultraviolet rays. This is usually a good thing because most film is sensitive to UV and lenses are not corrected beyond the span of visible light.

Reflection

The loss of light due to reflection is much greater. For untreated glass surfaces the loss at each glass-air boundary is around 5%. As we have seen, lens corrections require multiple lenses in a common holder. Three lenses separated by air would have six glass-air surfaces and the light loss due to reflections would be about 26%. Reflections from the interior surfaces of a compound lens tend to "reverberate" around in the enclosure and among the various surfaces resulting in an overall reduction in contrast and image detail on the film.

Imagine a single simple lens and then imagine a flat surface inside the lens, with glass on both sides of the imaginary surface. It's plain that no reflection or refraction will occur at that surface no matter how hard you imagine it into the lens. Because the light rays will evidently disregard this boundary, such a surface is obviously ideal for a system of lenses and we can inquire what makes it so good.

The color of the glass and the velocity of light is the same on both sides of the imaginary surface, so the light rays don't even know it is there.

In the real world, compound lenses are sometimes cemented together to reduce internal reflections. Before cementing, there are two air-glass surfaces no matter how tightly the dry lenses are pressed together. After cementing, the two air-glass surfaces are replaced by two air-cement surfaces. A lens cement is clear and the velocity of light in the cement is very close to that in lens glass. Such a glass-cement boundary therefore is less noticeable to light and the reflections will be less.

LENS COATINGS

For years lens designers had to compromise between the desirability of better corrections for aberrations and the undesirable effects of reflection at the multiple lens surfaces. The number of lens elements which could be used in practice were limited by the amount of reflection considered tolerable.

Today all surfaces of most good-quality lenses are coated in a special way to reduce reflections. The coating is typically vacuum-deposited and its thickness is precisely controlled so it is a quarter-wavelength at some point in the visible spectrum. Multiples of a quarter-wavelength are also effective.

How this works is too complicated to explain in any way that is easy to understand. What it does is to reduce the amount of reflection at each surface from about 5% to about 1%.

With coated lens surfaces, designers can use more elements in a compound lens and image quality is greatly improved. Also we have lenses capable of fancy tricks such as zooming—which requires a lot of lens elements.

FLARE AND GHOSTS

If a bright object is near the edge of the field

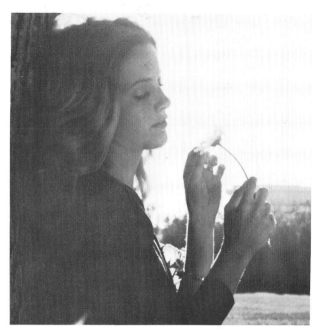

Honeywell Photographic Products Division furnished these two photos to show the benefit of lens coating to reduce reflections and flare. The good picture is taken with their Takumar Super-Multi-Coated lens.

of view of a lens, or even just outside the field but positioned so that light from the object strikes the surface of the lens, the effect of internal reflections of that bright light is often visible on the film.

Sometimes the light appears as an ellipse or patch of light on the print. Sometimes the light forms a detectable image of the aperture, which typically appears as a many-sided geometric figure on the film.

When the sun is just out of view, it may still illuminate the surface of the lens and some light will enter. Multiple reflections occur and the result is a chain of bright spots and halos. These usually get on the film by accident, I think, but it's a rare photographer who will admit that.

The worst problem due to lens reflections happens when you take a photo of a backlighted subject, such as a person in front of a window. The bright light behind the subject gets into the lens, bounces around, and usually obliterates most facial detail of your model.

All of these problems are greatly reduced by using good coated lenses, and keeping the front surface free of dust and finger prints.

Diffraction

As you remember, diffraction is an edge-effect which happens to light rays which graze past an opaque edge, such as the lens aperture of your camera. The effect is to make a spot of light on the film larger than it would be without any diffraction and then to surround that large spot with rings of light, diminishing in brightness as the rings get farther away from the center.

You should also remember that light from every point of a scene fills the lens and is then converged to a point or spot on the negative. Therefore every point of a scene is diffracted by the edge of the aperture in your lens.

The rays from the scene which do not graze the aperture are of course not diffracted by the edge. So the light which reaches the film and which should record a small point of the scene is composed partly of diffracted light and partly of non-diffracted light rays which never got near the edge of the aperture.

Image quality of every point on the negative will be determined in part by the proportion of

light which was diffracted. This proportion is governed by the size of the hole, aperture, through which the light passed.

Actually it is governed by how much hole there is, compared to how much edge there is around the hole. We can express that idea as a fraction comparing the circumference of a circle—the edge—to the size of the circle—the area.

$$\frac{\text{Total edge}}{\text{Total area}} = \frac{\pi D}{\pi D^2/4} = \frac{4}{D}$$

Which says that the ratio of edge to area becomes larger as the diameter, D, gets smaller. Therefore smaller apertures cause more diffraction.

If you imagine a hole that becomes smaller and smaller, at the point where the hole just disappears it is virtually all edge and no area. All of the light rays would be diffracted.

This is the back side of a lens for an SLR camera. My finger is on the lever which closes down the aperture inside the lens. Here the aperture, or iris, or diaphragm, is wide open.

Moving the lever reduces the size of the aperture. This is about halfway between the largest and smallest opening.

Moving the aperture-control lever all the way closes the lens as far as it will go. Reflections from the glass surface are more visible against the dark background of the diaphragm. The reflection is me taking the picture. Notice I put best focus where I want you to look.

Camera types

Let's hurry through the elementary stuff. A camera is a light-tight box which holds a piece of film so an image can fall on it. The image results from light entering the box through a lens. The amount of light is governed by an *aperture* near the lens. The duration of exposure is regulated by a *shutter* which prevents light from reaching the film except when we want it to.

Focus is achieved by moving the lens in relation to the plane of the film. Some cameras don't focus but you and I don't buy that kind. Some cameras have interchangeable lenses to allow use of different focal lengths. That's the kind.

It's handy to have something on the camera so we can tell where it is pointed. It's even better to have a peep hole which shows us about the same view that the film gets. It's still better to have a peep-hole which allows us to look through the picture-taking lens—then we see exactly the same view as the film gets. This is a single-lens-reflex camera, SLR.

Your faithless eyeballs won't tell you reliably how much light there is on the scene, so you have to measure it or consult a recipe book which tells you what to do on bright sunny days or some other kind. It's better to measure the light.

If you measure the light outside the camera, you have to figure out how much gets in through the lens and the filter if you are using one. If you measure the light inside the camera, you know how much light is reaching the film without any fiddling around.

Following is a brief description of each of the three main types of cameras used by serious amateurs and many professionals. All of these types are available to shoot 35mm and larger negative sizes such as 2¼" by 2¼", 6 cm by 7 cm, and so on.

Most photo books I have read seem to be written by fellows who were actually present in the early 1900's when Oscar Barnack invented the 35mm camera which eventually became the famous Leica. His original purpose was to test motion pic-

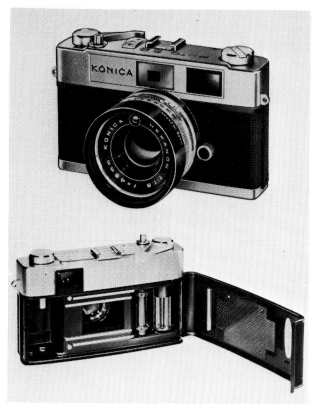

The Konica Auto S2 is representative of modern rangefinder cameras with automatic features. Both aperture and shutter are in the lens. Photocell at top of lens measures light so camera can automatically adjust itself for exposure—or you can do it manually.

Open the back, drop 35mm film cartridge into pocket at left. Film travels across bright-metal guide bars, across teeth of sprocket and onto take-up spool. Rewind lever on top of camera rotates take-up while sprocket "counts" the sprocket holes as they pass by so you can advance exactly one frame at a time.

ture film without the bother of cranking a big movie camera to do it. Anyway, such books often recite the names of all camera models and lenses ever made and recall fondly the good old Bangaflex camera they used to use with its good old Fondalux lens.

You won't find any of that here because I was out fishing. And not even taking pictures of the fish.

RANGEFINDER CAMERAS

These use two optical systems, one for view-

Bright line frame

Parallax compensation mark

Rangefinder's double image section

Meter visible in viewfinder

16
11
8
5.6
4
2.8
1.8

Viewfinder display of the Konica S3 rangefinder camera includes a simple method of parallax compensation. When subject is closer than four feet, image should not extend above or to the left of the compensation mark in the upper left corner of the viewfinder. Metering and double-image focusing area is also shown.

ing and one for taking the picture. Focusing is done while looking through the viewing aperture and moving the control until two images become one, or some other indication of focus. The focusing control is simultaneously moving the lens so the image is in focus at the film when the subject looks in focus through the viewfinder.

Adherents say focusing and viewing is easier in dim light with a well-designed rangefinder camera. Because the viewing and taking lenses are not on the same centerline, *parallax* can result. Which means that the picture you see is not the picture you get. Some cameras of this type have automatic parallax correction, done by tilting the viewing system toward the lens when focusing on nearby subjects.

Some rangefinder cameras have interchangeable lenses and meter through the lens, inside the camera.

TWIN-LENS REFLEX

Basically a TLR is two cameras in one box, with two lenses of the same focal length. One is

Basic arrangement of a twin-lens reflex is one lens for viewing and another for taking the picture.

- Folding light shield
- Viewing screen
- Viewing lens
- Mirror
- Taking lens
- Film

Yashica Mat in 2¼″ by 2¼″ format is a popular and relatively inexpensive twin-lens reflex camera.

used for taking and the other for viewing. The same parallax problem exists and the same automatic solution is used in some models.

The lenses are moved in unison for focusing and the operator judges focus and picture composition by viewing a ground-glass screen illuminated by the viewing lens. The viewing lens can be less fully corrected than the taking lens and therefore less expensive. Also, the viewing lens can have larger aperture for dim light.

The standard design is for waist-level use of the camera, viewing an image through the top of the box. There are adaptors for eye-level viewing on some models. The classic design does not use interchangeable lenses, but some more recent models offer interchangeable panels mounting two lenses.

A mirror is fixed in place behind the viewing lens to reflect the image up to the viewing screen. This arrangement is mechanically more simple than the single-lens-reflex to be described in the next section, but the price for that simplicity is the second viewing lens. Modern TLR cameras also offer built-in exposure meters.

The Canon EF is a single-lens reflex using a movable mirror to allow viewing through the lens and then taking through the same lens.

How a single-lens reflex camera works

The word *reflex* is a form of the word "reflection" and as applied to cameras means viewing the image after reflection by a mirror. In an SLR, one lens is used both to put light on the film and also to let you peek. The lens is arranged to favor exposing the film, which means it's right out in front of the film. To peek, a mirror placed between lens and film captures the image and bounces it up to the viewfinder so you can look at it. When you want to take the picture, you have to move the mirror out of the way.

The general scheme of an SLR is shown in Figure 16. When the movable mirror is "down" so it intercepts the image, the image is routed up and through a special prism where it is relayed over to your anxious eye.

The *pentaprism* bends the light as shown and also presents the photographer with a correct image in the sense of left-right and up-down. That is, neither is reversed. When the scene is composed

and appears in focus, the operator punches the shutter release button and a lot of things happen very rapidly:

1. Aperture closes down to the value selected in advance by the photographer. This is sometimes called "preselected" aperture.
2. Mirror swings up out of the way.
3. Shutter opens and closes, admitting light to the film.
4. Aperture returns to fully open.
5. Mirror returns to viewing position.

Steps 1 and 2, also 4 and 5, can occur in reverse order in some cameras—that is, mirror motion before aperture-size change.

When the operator advances the film to the next frame, the mechanical motion of doing this is also used to wind up the camera again so it can do all those things once more. No other type of camera has all that monkey-motion associated with just opening the shutter, so let's see why it is necessary.

Viewing and focusing the image is difficult anyway in dim light and would be more difficult if it had to be done at less than full aperture of the lens. Therefore while focusing, the lens is left wide open. In making the camera adjustments prior to exposure, the desired aperture is selected

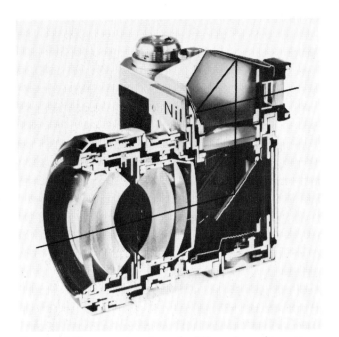

Figure 16/Cross-section view of a Nikon shows how you see through the same lens that will take the picture.

Figure 17/This is a Vivitar lens with a mounting arrangement to fit a Canon camera. Pins and levers on the lens allow camera body and lens mechanism to communicate with each other during the picture-taking sequence of events.

but the camera does not close down to that size aperture until the moment of taking the picture.

If the mirror is completely opaque as most are, then it has to be moved out of the way so light can fall on the film. When this is done automatically by the camera, the film exposure happens so soon after the mirror stops moving that the camera may still be vibrating from mirror movement. It's possible for mirror movement to jar the camera and blur the image.

The most likely cause of camera vibration is at the instant the mirror reaches the end of its travel and bangs against the stop. Therefore most cameras have some way to reduce the amount of banging. A resilient cushion, air-damping cylinders, or whatever the designer thinks will do the job.

Some cameras allow the operator to compose and focus using the mirror and then manually move it up out of the way with a lever, before tripping the shutter. If you are worried about vibration, you can move the mirror up and lock it in position. If you are that worried, you should also use a cable release to trip the shutter or a time-delay release. In most cases the vibration is sufficiently well controlled so as not to be a problem.

When the mirror is out of the way the shut-ter opens and closes.

Some early SLR cameras left the mirror up after taking the picture. Resetting was done manually or was part of the procedure for taking the next exposure. The result is a peculiar sensation of "going blind" the instant the picture is taken. Losing view of the subject is also a disadvantage when trying to take pictures rapidly in sequence. Therefore most modern SLR cameras return the mirror to the viewing position quickly and automatically. This feature is called something like "instant-return mirror" in advertising.

When the mirror is down again, the aperture is fully open once more so there is maximum light for viewing.

Because this arrangement causes you to view at full aperture, you do not see the scene as it will appear when the aperture closes down for taking the shot. The main difference, with a smaller aperture, is depth of field, which will be discussed shortly. Most SLR cameras have a lever or button which allows you to close down the lens while viewing, so you can see the depth of field you are going to get in the picture. This control is often called a *preview button* or *lever* and it is one of the most important features on your camera.

The rest of an SLR camera is about the same

as any other. It has a place to put the film. A film-advance lever and frame counter. The lens is adjustable for aperture and focus. There is a shutter-speed control to set the time duration of exposure.

Incidentally, I may have alarmed you unduly earlier about mirror vibration. Most vibration occurs when the mirror is returned to the viewing position. When it is doing that, the picture has already been exposed so there is less need to return it gently. You can feel the difference if you set your camera for an exposure of one second and trip the shutter. You will feel two separate motions. The first is the one that happens before taking the shot. The second one is the big thud.

FULLY AUTOMATIC SLR CAMERAS

The exposure controls are aperture and shutter speed which must both be set by the user of a normal SLR camera. Because light is measured behind the lens it is possible to compute the desired amount of exposure automatically by an electronic circuit in the camera. This information can be used to set one or the other of the two exposure controls, leaving just one for the photographer to worry about. SLR cameras which do that are called "automatic."

With a "shutter-preferred" system, you set shutter speed and the automatic feature will set aperture size based on measuring the reflected light from the scene just before you take the picture. With an "aperture-preferred" system, it's done the opposite way.

A great advertising contest results. The reasons are explained in more detail elsewhere in the book, but here are the basic arguments.

Aperture size governs depth of field meaning which parts of a scene are in sharp focus. Sometimes this is very important to the success of a picture. For example if you are taking a picture of a building you probably want the entire building to be in good focus rather than part sharp and part blurred. If the camera is setting aperture for you it may not do it the way you want.

Shutter speed controls blurring of moving subjects. If you are shooting a baseball player hitting the ball, you may want to "freeze" motion of the bat which requires a short exposure time. If the camera is setting exposure time for you, it may decide to use a longer exposure because the day is cloudy and your picture may be blurred.

Viewfinder display of Minolta automatic camera shows aperture at top and shutter speed along the side. Camera is aperture-preferred, meaning you choose aperture and camera then sets shutter speed.

Internals of a Minolta SLR show the clockwork complexity of a modern camera and why you shouldn't take yours apart.

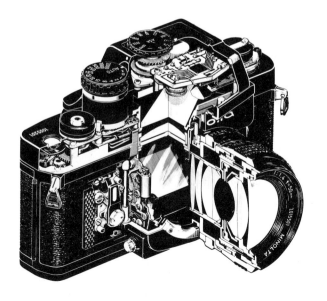

When you get good equipment, it's important to take care of it. Keep covers on the back of lenses when they are not on the camera.

Keep a lens cap in place to protect the coated front surface of your lenses.

Camera makers like to cover all the bases so they tell you a lot of things. First, they tell you their way of automating the instrument is best—shutter-preferred or aperture-preferred. Then they tell you that you are not really at the mercy of the camera anyway.

For example, if you have set aperture then the camera choice of shutter speed depends on the aperture you selected. If you don't like it, you can pick a different aperture and the camera will use a different shutter speed to get proper exposure.

If that seems confusing or unwieldy, they fish the aces out of their sleeves and show you the handy switch on the camera that turns the automation off. Now you can do it manually and set both controls yourself.

The success of camera automation in producing good pictures is based on shooting average scenes. If you shoot a non-average scene no automatic exposure control can solve the problem without some help from you. For example, a portrait against a sky background is likely to be underexposed if given the standard exposure which an exposure meter will suggest and an automatic camera will do. The face of your subject will be too dark.

Remedy is to give more exposure so the face looks OK. Method is to turn off the automation and dial in more exposure. An alternate method is built into some automatic cameras. There is a switch labeled something like ½X, 2X and 4X. In the ½X position, the camera can be left on auto but it will give only half the normal amount of exposure. The 2X setting doubles the normal exposure. By learning to recognize scenes which require more or less exposure than normal, and using the handy switch, you can have the convenience of automation and still be in control of special exposure problems.

If you are shopping for an automatic SLR, your basic decision has to be shutter-preferred or aperture-preferred. There are some other factors such as using lenses you may already own, but disregarding that, your choice should be made according to the type of pictures you plan to shoot and whether you personally worry more about depth of field or stopping subjects in motion.

A DIM VIEW OF THE SITUATION

The first requirement for a satisfactory viewfinder is that it show the scene at which the lens is pointed. This suggests that the mirror in an SLR should be large enough to capture everything that will expose the frame of film. Conflicting requirements suggest using a smaller mirror. One is, there has to be enough room for the mirror to swing out of the way, even with the lens focused at infinity. Another is to make the mirror as small and light as possible so it can be moved quickly, so taking the picture is not delayed unduly after you push the button.

When photographing action such as basketball or a golf swing, most experts advise tripping the shutter before you think you should, to allow for your own reflexes. Some additional amount of time is required for the goings-on inside the camera, but this extra time interval should be as short as possible.

To start the mirror from rest and then to stop it again requires mechanical forces. The heavier the mirror or the more acceleration it receives, the more force must be used. Whenever the mechanism of the camera is pushing on the mirror, the mirror is pushing back. This causes the turmoil inside the box which you feel during the events of exposure.

All of this leads to some compromises which you should accept. One is to make the mirror as lightweight as practical. Therefore it is fragile. Another is to make it as small as practical. Therefore it should show you only what is necessary—maybe not the entire frame.

One reason to view the entire frame is to compose the picture for color slides because with slides there is no separate process of making a print from a negative during which the scene can be cropped to put the right view on the print. In the color-slide process, the negative you expose in your camera becomes the positive slide you project for admiring audiences.

Some slide holders cover up about 10% of the picture area of 35mm film, so you don't really need to see that part through your viewfinder. Most photographers don't gamble by trying to fill the projected slide completely with the image of interest, so you can probably do with a view of a little less than 90%. My camera manual says I am

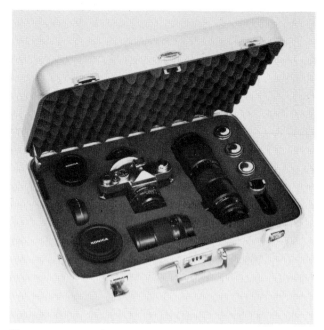

You can carry and protect an SLR camera with lenses and accessories in a neat case such as this aluminum one by Zero Halliburton.

seeing 94% of the picture area, which I think of as a form of insurance to keep me from taking more photo than there is film.

Another consideration which may or may not be important to you is the size of the camera body. A larger mirror requires more room to maneuver and therefore a bigger box. There have been some tricky mirror arrangements to reduce size, such as folding mirrors, barn-door arrangements, and tricky slide-while-turning movements. An SLR is an intricate mechanism anyway and no extra complexity is needed, in my opinion.

If you take off the lens of an SLR camera, you can see the mirror. Don't touch.

A special mirror used in some SLR cameras, called a *pellicle mirror*, is not moved out of the way because it is semi-reflecting, or semi-transparent whichever way you prefer to look at it. The pellicle remains in the light path during exposure. It may reflect 30% of the light into the viewfinder and transmit 70% of the light toward the film, all the time. Obviously there is no vibration or monkey-motion. The price for it is less light when viewing which can be helped by better viewing optics, and less light when taking the picture which can sometimes be helped by using a faster lens.

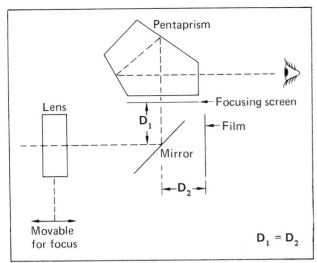

Figure 18/Through multiple reflections in the penta-prism which are too complicated to show on this diagram, it presents a correct viewing image, both vertically and horizontally. Focusing screen intercepts light rays bounced off mirror and camera operator views the focusing screen to determine best focus. When the mirror is "down" distance from lens to viewing screen should be same as distance to film plane when mirror is out of the way.

IMAGE INVERSAL

There is a vocabulary about optical images pertaining to the vertical and horizontal orientation of the image as seen by a viewer. It uses unfamiliar words like *inversal*. A word like that is hard to use in communicating with other people because the other guy has to know what it means.

I will stick to reverse and reversal, both of which mean rotate the thing 180°. If you are normally bright you may have wondered, while viewing your handsome physiognomy in a mirror, why the image is reversed laterally but not vertically. If you are unusually bright, you have already figured it out.

I qualify as normal but not unusual because I had to find the answer in a book. L. P. Clerc's six-volume set *Photographic Theory and Practice*, which costs a lot and is worth it. If you feel a draft from the holes I have left in this book, Clerc will make you warm and cozy.

A lens image is reversed in both directions, laterally and vertically, as was concealed back in the earlier discussion of lenses. A mirror reverses the image only in one direction, but it will *always* do that. To avoid mental confusion, you can judge reversals by mentally comparing the view as seen through optics to the view you would get if looking directly at the subject.

To reflect an image from one plane to a different plane, the mirror must be at an angle in respect to *both* planes. The axis about which the mirror is rotated, to assume that angle, is the key. If the mirror is rotated about a vertical axis when positioning it to reflect the image, it will reverse the image laterally but not vertically. A second reflection from another mirror which was rotated on a vertical axis will restore lateral orientation. The same idea also applies to vertical orientation of an image. If we use the word "rotation" to imply bouncing off a mirror which has been rotated on an axis, we can derive a rule: To preserve image orientation, the horizontal axis must be "rotated" an even number of times, and the vertical axis must be "rotated" an even number of times.

The reason that vertical and horizontal axes must be considered separately is that the very first reflection in an SLR—off the movable mirror—causes a vertical image reversal but not a horizontal reversal. The viewing system between that mirror and your eye has to have one more rotation in one of the directions than in the other.

This is accomplished in most SLR cameras by use of a *pentaprism* as shown in Figure 18. It is five-sided only in cross section as shown on the drawing. Actually the top of it is shaped like the roof of a house and there are a total of nine faces on a pentaprism, if I counted them all. The optical path indicated on the drawing is greatly oversimplified.

It probably will not help you make better pictures to understand it further, however if you feel that you cannot face life without doing some ray-tracing through a pentaprism, Clerc will tell you all about it. The main reason I called your attention to it is to assist in explaining another thing.

FOCUS INDICATORS

The viewing system of an SLR also helps you find focus. It's important to remember that what you are actually moving when focusing on a subject is the position of the camera lens. When it is right, the image on the film should be in focus.

Most SLR cameras create an image in the viewing system by putting a piece of ground glass, or equivalent, into the optical path at a place

where the image should be in focus. This means that the distance from lens to the ground glass used for viewing should be the same as the distance to the film, which requires mechanical precision in building the camera and locating the mirror in the viewing position.

Ground glass causes light to become visible by intercepting it and becoming luminous. The surface irregularities individually receive light and scatter it into many rays in many directions. Thus each little point on the ground glass screen becomes an apparent point-source of light.

The viewing optics, through the pentaprism, allow you to examine the image on the ground-glass screen for both focus and image composition. This method of judging focus is not precise because your judgment is based on blurring of the image, mainly at the edges of objects in the scene.

Because natural objects usually do not have precise edges and boundaries, you may be working under a handicap.

FOCUSING AIDS

Most SLR cameras have one or more focusing aids to help you find best focus. Typically these are right in the middle of the scene as seen on the screen. One type is based on the idea that you can determine very accurately when a line in the image is not continuous even if the line itself is a gradation rather than a sharp knife-edge. This is called split-image focusing.

The principle is shown in Figure 19. It is based on use of two small prisms facing in opposite directions so the front surfaces angle in opposite directions. The biprism assembly is set into the focusing screen. The line where the sides of the two prisms touch each other is visible and normally horizontal in the viewfinder.

The upper prism will change the direction of light rays which pass through it and alter the apparent position of the image, shifting that part of the image either to the left or to the right. The lower prism affects a different, but adjacent, part of the scene and shifts the image in the opposite direction.

If focusing is imperfect and light rays from the scene are brought to focus somewhere before they reach the viewing screen, each of the two prisms takes its own view of the focused image out in front. One will displace its part of the image to the left and the other to the right. If there is a

A biprism is two wedges of glass "pointing" in opposite directions usually made to fit a circular area of the viewing screen, as shown.

Figure 19/If the image is brought to focus in front of a biprism it breaks the image into two parts and moves them laterally with respect to each other. If focus is behind the biprism, it moves the two halves of the image in the opposite direction. When focus is correct, the two halves are in alignment.

VIEWFINDER DISPLAY WITH BIPRISM

A microprism is an array of pyramidal shapes whose intersections work like little biprisms.

Several camera makers offer interchangeable viewing screens so a focusing aid can be chosen for the job at hand. This is how Nikon interchangeable screens are installed.

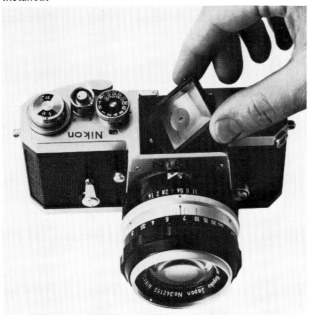

vertical line in the scene which passes through both prisms, the top part of the line will be displaced in respect to the bottom part and the line will not be continuous in your view. If you are looking at a telephone pole, it will be broken in the middle. After passing through focus ahead of the viewing screen, the light rays will then strike the ground glass and become visible to you, out of focus.

If the point of focus is behind the viewing screen, the biprism will deflect the images in the opposite direction.

When the image is in focus on the screen, and therefore also in focus on the film, there is no horizontal displacement of the images. Vertical lines will not be broken and that is the indication of best focus.

A biprism works best on scenes where there are strong vertical lines. If the scene is more random geometrically, such as a mottled surface or foliage, then a biprism is hard to use.

An alternate focusing aid is called a *microprism.* This is an array of small pyramids set into the viewing screen. They are either three-sided or four-sided, usually, and they make V-shaped intersections at their bases where adjacent pyramids touch each other. Those V-shaped intersections do the same thing as biprisms, except that there are many more of them.

For scenes without strong vertical lines a microprism usually works better than a biprism. It will break up all the lines when the image is out of focus. Also, if the camera shakes a little while you are focusing the broken lines jump around and the image appears to scintillate.

Because the little pyramids are not actually prisms, geometrically speaking, the word "microprism" is a misnomer, but that doesn't stop it from working.

For any viewing system, light from the outside world has to pass through the optical system and finally reach the viewer's eye. If we take the opposite point of view, we can say that there must be a line-of-sight between the eye and the scene, through the optical system. In that sense, you are looking out at the world through prisms, each face of which causes your line of sight to veer away from the centerline. If the face of a prism caused your line of sight to veer so much that you ended

up looking at the lens housing or the opaque part of the aperture then you would not see any of the outside world.

The angle of the faces of a biprism or microprism is therefore limited. If the angles are steep, the focusing effect is large and dramatic but the lens system has to have a large aperture so you can look out through it. If the angles are less steep the focusing aid will work with smaller apertures.

Usually the designer makes a compromise such that the prism-type focusing aid will work with the lens on your camera set at large apertures, but will not work when you close down the lens.

If your SLR has a preview lever which you can use to view through reduced aperture, you will notice that a prism-type focusing aid becomes useless at small apertures. With a biprism, one face or the other will go black determined by where your eye is. If you move your eye, the other side will go black. With a microprism, some of the faces will be black. While you are looking, you can see if your microprism uses pyramids with three or four sides.

Some cameras accept an accessory magnifier lens which flips over the normal viewing port for focusing and allows you to examine a smaller part of the image with magnification. You can't compose your shot through a magnifier because you see only part of the image that will be on the film.

If you wear glasses it is difficult to use them while peering through the focusing window. Auxiliary lenses to match your eye-glass prescription are available which fit over or replace the viewing lens of your camera.

Choice among these focusing aids is largely a matter of personal preference and the intended use of the camera. Some camera makers offer plug-in focusing screens so the type of indicator can be changed to suit conditions at hand. Some focusing screens use more than one focusing aid so you can use the one that works best for a particular type of scene.

WHAT ARE ALL THOSE RINGS?

In many viewfinders you can see an array of concentric rings in the image. I wouldn't bother to mention them if you couldn't see them, because they are not really important.

They improve the overall brightness of the image in a viewfinder. A ground-glass or matte sur-

Figure 20/A ground glass or matte screen scatters the light passing through. Near the edges, most of the scattered light goes in the wrong direction for viewing so the image is dim except at the center. A converging lens as shown at B captures rays at the edges and directs them toward the eye. A Fresnel lens, shown at C, does the same job with less bulk and weight and makes those concentric circles you see in the viewfinder.

face produces an image by intercepting light and then scattering the light from each point of the ground-glass surface. Rays which leave the screen perpendicular to it are the brightest. Rays which leave the screen at an angle are less bright to an observer.

When viewing the screen from a fixed position such as the window in your camera, your eye is effectively centered on the screen and therefore the center part appears more bright. Without correction, the light from the edges of the screen is going mainly in the wrong direction and that which your eye receives is not very bright.

Therefore a *plano-convex* lens is often used in conjunction with a viewing screen. The lens captures the perpendicular rays from the edges of the screen which would otherwise miss your eye, and changes their angles so they do come into vision.

If made of glass and with a normal shape, this lens would occupy needed space in a compact camera and add weight. Because the glass *inside* a lens does not refract light—the surface does—it is only the surface that is needed.

A *Fresnel lens* eliminates bulk by taking circular segments of the face of the lens and "sliding" them back toward the plano face, as shown in Figure 20, thereby eliminating material from the interior of the lens.

Each circular segment viewed head-on is a ring and the boundaries of each ring are visible in the viewfinder as circles. Viewed from the side each segment has the same curvature it would have in a normal lens of that power and therefore it refracts light just the same way. With precision molds, these illumination-improvers can be made of plastic so they occupy small space and have little weight.

Nikon offers a variety of focusing screens, some shown in this series of illustrations. Type A is a matte Fresnel field with split-image rangefinder spot and a 12mm diameter circle to show the area favored by the Nikon "center-weighted" exposure metering system. Recommended for general photography with lenses out to about 200mm focal length. A Type L finder screen is similar to this one except the split-image spot is set at a 45° angle to make focusing easier on horizontal lines.
Type B screen has matte Fresnel field surrounding a 12mm diameter fine-ground matte spot. Recommended for general pho-photography.
Type C has clear spot with cross-hair reticle for high-magnification photography. Requires Magnifying Finder accessory to view image in clear area.
Type D is an all matte fine-ground surface for specialized copy photography and high-magnification applications.
There are a series of Type G finder screens with a clear Fresnel field surrounding a 12mm microprism focusing spot.
Type J is a matte Fresnel field with a small microprism focusing spot surrounded by a 12mm circle. Nikon finder drawings courtesy of EPOI.

Camera adjustments

Among all the buttons and gadgets on your camera, three are most important in taking a picture: focus, aperture, and duration of exposure, usually called shutter speed.

Focus is basically independent of the other two and is simply positioning the lens so the desired part of the scene is in sharp focus at the film plane. Focusing is achieved in an SLR by using the mirror to borrow the light that would otherwise expose the film, causing this light to fall on a screen at the same distance from the lens as the film plane, and examining the image visually. We've covered most of that already. The rule governing focusing is:

$$1/S + 1/I = 1/F$$

You also remember that exposure is defined as the product of illuminance on the film and the time duration of shutter opening.

$$E = I \times T$$

On this Mamiya/Sekor, shutter speed is set by numbered dial to left of pentaprism. Aperture is set by the aperture ring on the lens near camera body. Focus is adjusted by knurled ring near front of lens. ASA speed rating is set into the camera by lifting and turning shutter speed knob and can also be used as a form of exposure control. Most SLR cameras are about the same in respect to these primary controls, although there are special features and variations found on some brands.

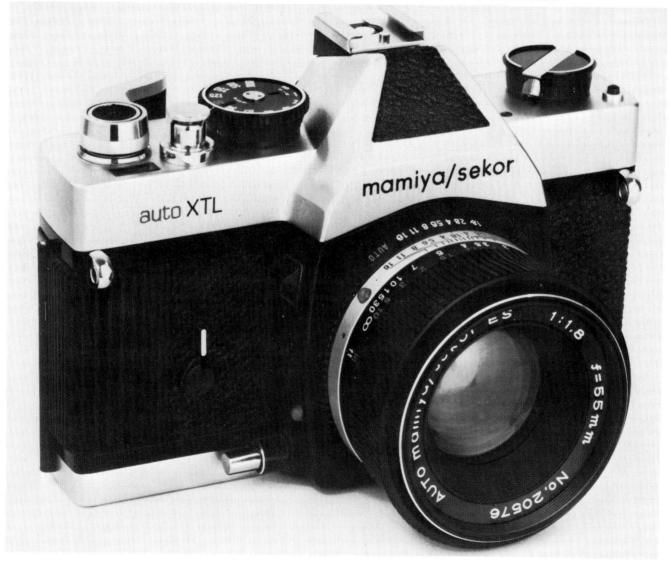

For a particular scene with some brightness, the exposure on the film can be regulated by varying the size of the aperture at the lens or varying the shutter speed. Therefore these two adjustments are interrelated in the sense that, for a given amount of exposure, their product must be a constant number equal to the desired exposure. If you open up the aperture to admit more light you must decrease the time the shutter is open if you intend to keep the same total exposure of the film.

Because both aperture and shutter speed are variable, there are several combinations of the two which will produce the same exposure. For a certain aperture, a certain shutter speed will give correct exposure. For a different aperture, some other speed will give the *same* desired exposure of the film.

The photographer or the camera if it is automatic has to select some pair of settings on these two controls. You could select one setting at random, then choose the other setting for correct exposure. This would not be a *reasoned* choice. It's much better to make your settings of the two exposure controls for reasons related to the type of subject you are photographing and your intended purpose.

That's because the two controls have other effects besides total light-exposure of the film. Aperture size affects image quality. If you make the aperture smaller, most aberrations have less effect and the lens can do a better job. Except for diffraction. When you make the aperture smaller diffraction gets worse!

No lens manufacturer will allow you to open or close the aperture so much that the picture is seriously degraded. The aperture control won't move that far in either direction. The range of available aperture sizes is such that aberrations are worse but diffraction is better when the lens is wide open. Also, diffraction will be worse and aberrations better when the lens is closed as much as the control will allow.

Somewhere near the center of the range of apertures the image on the film will be best. You should always have a reason for selecting aperture. If you have no other reason, set it near the middle of its range for the reason above.

Usually it isn't that simple. Aperture also affects depth of field. Shutter speed affects how

This is a visual test of the effect of aperture on picture quality. It's a wood fence so depth of field can't be seen, the surface is in focus in each picture. The fence isn't moving and the camera is on a tripod, so shutter speed doesn't matter in terms of stopping motion. All that's left to evaluate is lens aberrations and diffraction at three apertures.
Top photo was taken with the lens aperture wide open. Middle picture with aperture half open. Bottom with aperture closed as much as it will go. Shutter speed was adjusted in each case to give same total exposure.
Theory says middle picture should be best. Using ordinary film, I can't see any difference. Lens is a Canon 50mm.

well the film can capture a moving subject. To stop motion use a fast shutter speed. If you want to blur the subject to give the visual impact of motion use a slow shutter speed.

Very often one of these considerations will cause you to use an aperture not near the middle of the range. But you should *always* think about the subject and your purpose and you should *always* have a reason for the camera settings you choose.

In discussing the camera controls we have to get our minds set up to use some nomenclature which seems backwards. The size of the lens aperture, actually the light-gathering ability of a lens, is stated by an *f*-number. When this number is bigger the hole in the lens is smaller. Eventually I'll tell you why. A high shutter speed means that the shutter opens and then closes very quickly, resulting in a very *short* time of exposure. Even though we talk about shutter speed, the camera control is actually marked in units of time. Such as 125, 250, and 500. These numbers really mean 1/125, 1/250, and 1/500 and they are the shutter opening time in fractions of a second. Therefore 500 is less exposure time than 125.

THE GREEK STAIRCASE

The early Greeks didn't have any TV so they invented other recreations. One was studying geometry. These guys would sit around at the beach peeling grapes, drawing triangles in the sand, and figuring the angles.

One of their good ideas was a simple series of numbers. Because it is written two times on your camera, you may be interested to know what it is.

An ordinary staircase has steps of uniform size. If I pointed to one with seven steps and asked you to sit on the middle one, you would choose step number four. Leaving three unoccupied sitting places above you and three below.

The middle step of a series of *uniform* steps is called the *arithmetic* average, and you already know how to average two *ordinary* numbers. Add them together and divide by 2. The average of 7 and 1 is 4.

$$\frac{7 + 1}{2} = 4$$

The clever Greeks thought of a different kind of number series which is a little more complicated

than counting on your fingers. If you think of it as a different kind of staircase with steps, each step is a multiple of the value of the preceding step. The multiplying factor can be any number, but let's suppose it is 2.

Then if the first step is 1, the next is 2, the next is 4, then 8, 16, 32, 64, and the mind boggles. Each of these numbers is *twice* the value of the preceding, or half the value of the one above. This is called a *geometric* series.

Where is it written twice on your camera? Once on the aperture ring, the *f*-number scale, although it is not obviously so.

The other place is on the shutter speed control where you set the exposure time. It will be helpful now if you go get your camera. You can use it as an illustration of several things we are going to discuss along here.

Exposure-time numbers are intended to double as they go along in a geometric series. The numbers get rounded off a little, to keep it simple I suppose, but it is basically a geometric series with a multiplier of 2.

Here are the shutter speed numbers on my camera, along with what they would be if not rounded off:

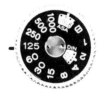

Camera Markings	True Geometric Series
1 second	1 second
1/2	1/2
1/4	1/4
1/8	1/8
1/15	1/16
1/30	1/32
1/60	1/64
1/125	1/128
1/250	1/256
1/500	1/512
1/1,000	1/1,024

On my camera, the top part of the fractions is omitted so it says 15 instead of 1/15 and yours is probably the same way. In any event, the camera markings never get very far from a true geometric series and are actually intended to be that

series. Somebody in the past evidently thought 1/60 was a neater number than 1/64.

Now suppose the camera time scale is a flight of steps. Starting at the bottom, the first step up is only 1/500 second, the next step gains 1/250 second, and so on until the last step gains a full 1/2 second above the one immediately below.

There are 11 steps. Go sit on the middle one. You picked 1/30, didn't you? You are right. This is the middle or average of that geometric series even though it is 29/30 from the top and less than 1/30 from the bottom. You remember about Herr Weber and those British chaps. Each of these steps doubles the exposure by allowing twice as much time. The effect of each step is about the same as seen by the viewer of the picture so, as photographers, we consider these steps to have *equal* value.

The Greeks went beyond this and even figured out how to find the geometric average of any two numbers without the labor of building an actual staircase and sending you over to sit on it.

If the numbers are **A** and **B**,

Geometric average $= \sqrt{A \times B}$

If you are wondering about the geometric average of the two numbers 3.5 and 90,

Geometric average $= \sqrt{3.5 \times 90}$

$$= \sqrt{315}$$

$$= 18, \text{ approximately}$$

If you are wondering why you are wondering about that, 3.5 and 90 are approximately the highest and lowest reflectances found in natural scenes, and an 18% gray card represents the *average* reflectance of natural scenes.

What kind of an average is that?

f-numbers

In the good ole days, the light-gathering ability or "speed" of a lens was probably more important to photographers than it is today. Emulsions then were very slow and flash lighting was either nonexistent or comical.

When a lens maker developed a faster lens to expose film in a shorter time by putting more light on it, he naturally offered it to the trade. They all

wanted to know, "How fast is it, Buddy?"

When lenses have variable aperture, the specified speed rating is always the fastest, that is, maximum aperture.

Today lenses are very fast indeed and, like horsepower, manufacturers seem to want to sell everybody more than they need. People steal money from their kids and buy those super-fast lenses. Because we are speed-crazed we also buy the fastest film available.

When all done, we put fast film in the camera, go out into the sunshine and shoot all our pictures at the smallest opening the lens has and the shortest shutter time the camera can accomplish. Somehow we are missing the point.

It turns out that a numerical value representing the light-gathering ability of a lens can be obtained from a fraction, F/D, where **F** is still focal length and **D** is still the diameter of the hole or aperture.

The complete expression is:

$$f = F/D$$

where f is obviously the name of that simple fraction. Unfortunately nobody knows how to pronounce f so we all just call it f-number and try to

On this lens the aperture control (arrow) is marked in f-numbers ranging from f-2.5 to f-22. The next scale is a depth-of-field indicator which we'll get to in a minute. The scale farthest from the camera is the focused distance either in meters or feet. The dots near the center of the scales are index marks which show that this lens is set for f-11 and focused at a distance of about 5 feet.

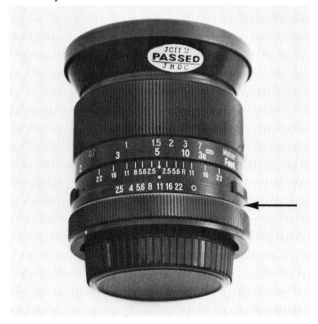

remember that it relates to the light-gathering ability. Unfortunately f confuses because it is similar to **F** which does not mean f. To separate the two symbols more graphically, printers always use an f that is $funny$-looking.

Some authorities have given up on f because folks continue to think it means **F**, focal length. They use **N** to represent f. I don't think using **N** for f is any great stroke of genius so I am not going to do it.

Lens diameter in the f-number fraction means the *effective* diameter of the aperture and as you can see in Figure 21, the effective aperture is not usually the diameter of the hole. The lenses alter the ray paths so the hole is *effectively* larger or smaller than its actual physical diameter.

If you hold a lens at arm's length and look at one end, you will see a spot of light smaller than the glass. This spot of light looks very much like the pupil of your eye. It is called the pupil of the lens. Turn the lens around and you will see another pupil from the other direction. On simple lenses they are close to the same size.

The pupil is the *effective* size of the aperture and if you want to know that number, you can measure it with a ruler. Or you can calculate it by rearranging f = **F**/**D** so it says:

$$D = F/f$$

A 50mm (focal length) lens with an f-2 rating should have an entrance pupil diameter of 25mm— very close to one inch.

You know that a larger aperture will admit more light; however, in the fraction **F**/**D**, when **D** gets larger the overall value of the fraction becomes smaller, and the resulting f-number is smaller. Therefore smaller f-numbers imply more light on the film and vice versa.

In the early days of photography, lens apertures were sometimes just holes of various sizes cut into metal plates. If the photographer wanted to reduce the amount of light reaching the film, he would substitute an aperture plate with a smaller hole, thus *stopping* more of the light. Because the function of the hole was considered to be stopping light, changing apertures came to be known as changing *stops*.

Today people still speak of "stopping down" or even "stopping up" when they mean changing the size of the aperture. This is legitimate language

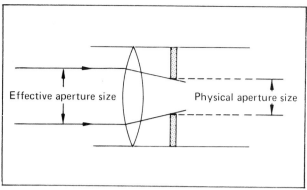

Figure 21/Because the lens causes light rays to converge as they travel toward the aperture, the *effective* size is larger than the actual physical size of the aperture opening. With some lens arrangements, the effective aperture can be smaller than the physical aperture.

Konica explains it this way in the T3 Autoreflex instruction booklet. Considering f-2 as the starting point, it shows the amount of light doubling toward smaller f-numbers and decreasing by 2 toward larger f-numbers.

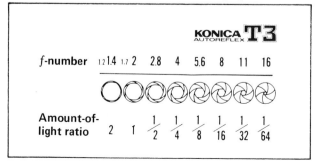

based on history.

However, photographers and books also speak of changing *exposure* by one stop up or down, meaning as you know doubling or halving the exposure on the film. Use of the word "stop" in relation to exposure is not valid and is unduly restrictive because exposure can be changed either by different aperture or different time. $E = I \times T$.

Therefore this book uses the word "step" to mean changing *exposure* up or down by a factor of two. The United States Standard and the International Standards Organization nomenclature for photography both use the word "step" in relation to exposure.

However you slice it, exposure is the light on the film regulated by the exposure time and the lens *f*-number. For any particular normal lens, focal length is a *fixed property* and does not change during use of that lens. The *f*-number changes when the aperture is changed.

The scale of *f*-numbers engraved on the aperture ring is another geometric series where the multiplier is the number 2. But it doesn't look that way and the reason is based on the geometry of a circle.

The light admitted by an aperture is controlled by the size of the hole—size means area. If the aperture is circular, with some diameter, **D**, the area of that circle is $\pi D^2/4$. π and 4 are constant numbers and don't change. So the area of a circle is proportional to the diameter squared. If **D** is doubled, area goes up four times.

The main object of this monologue is to explain the series of *f*-numbers engraved on your lens. Doing that requires one more reminder from your high-school days before we can get on with

it. A reminder about square root. The square root of 9 is 3, because 3 times 3 equals 9. The square root of any number, call it **y**, is indicated by the symbol \sqrt{y}. Therefore $\sqrt{y} \times \sqrt{y} = y$. And, $\sqrt{2} \times \sqrt{2} = 2$.

Each successive *f*-number on the scale will *double* exposure, the same as successive shutter speed numbers double exposure.

To double the exposure by changing aperture, the *area* of the hole should become twice as large. But you don't get that result if you double the diameter, you get four times as much area.

Therefore the diameter should be increased only by $\sqrt{2}$ to get twice as much area. Example: If we start with some value of **D** and multiply it by $\sqrt{2}$, the result is $\sqrt{2} D$. The new area will then be proportional to the square of the new value of **D**. Which is $\sqrt{2} D \times \sqrt{2} D = 2D^2$. And that is obviously twice as big as plain old **D²**.

To accomplish area increases that are doubled, the aperture diameter should be multiplied by $\sqrt{2}$, which is 1.4 approximately. Each time you multiply **D** by 1.4, one step-increase in exposure results.

But the aperture control is labeled in *f*-numbers and they are figured as **F/D**. Therefore *f*-numbers are a geometric series using 1.4 as the multiplier rather than 2. Even so, they represent exposure increments of double or one-half at each step.

As you can see, some of these *f*-numbers are rounded off for convenience, the same as the shutter speed numbers. The *f*-number scale is another Greek staircase and we consider the effect of any step to be the same as any other step. The geometric average of *f*-2 and *f*-16 is *f*-5.6, the mid-

It's easy to write or remember the *f*-number series by starting with two numbers: 1 and 1.4. Begin the series with those two numbers and then double them alternately as shown.

dle step between them. $\sqrt{2 \times 16} = \sqrt{32} = 5.6$ approximately.

EXPOSURE VALUE

An idea called *exposure value, EV,* is interesting. It is based on the fact that several aperture and shutter speed combinations can result in the same exposure on the film. An increase of one step in aperture is exactly counterbalanced by a decrease of one step in shutter speed. For example, if your camera is set at *f*-8 and 1/250 second and you want to change the *f*-number to get a different depth of field, you can figure another pair of camera settings that will give the same total exposure on the film. You can use *f*-11 with 1/125 second, or you can use *f*-5.6 with 1/500 second.

The bright idea of exposure values is incorporated mechanically into some cameras by connecting aperture and shutter speed controls together so a change in one automatically produces a compensating change in the other.

The user can dial in the desired **EV** number and then select an *f*-number without bothering with shutter speed, or the reverse. The idea gained popularity—then lost favor—but now has returned again in a different guise. Modern *automatic* SLR cameras are advertised as shutter-preferred or aperture-preferred. Which means you only set one of them and the automatic camera does the rest.

The **EV** idea used to be incorporated in the United States Standard which deals with exposure but is no longer. Some exposure meters still yield **EV** numbers as well as a pair of values for *f*-number and shutter speed. You can use either according to preference or the type of camera you have.

The series of **EV** numbers runs from about 2 to 18 and with dogged persistency they also decrease to represent increasing exposure. It is naturally a geometric series and each change of one **EV** unit doubles or halves the exposure.

The **EV** scale is sometimes referred to as the *light value* scale.

LENS IDENTIFICATION

A lens will be described in sales literature by the largest aperture at which it can be set—the smallest *f*-number. The series of *f*-numbers given earlier is an international standard and nearly every lens maker uses it these days.

However, larger apertures are sought after by the general public and there is some sales competi-

tion based on who can quote the biggest aperture. So as not to stifle progress or competition, the international standard allows a manufacturer to label his lens with its smallest *f*-number even though that number does not appear on the standard series. The next larger *f*-number engraved on the control should pick up the standard series and all other numbers should be standard.

For example, *f*-1.8 is not a standard *f*-number but there are such lenses. The aperture series for the lens should read: 1.8, 2, 2.8, 4, etc.

Even though the standard steps in exposure are obtained using a factor of 2, these steps are not necessarily the smallest that can be detected by the viewer of a photo. Exposure tables often recommend changing aperture in fractions of a full stop such as 1/3 or 1/2. Cameras usually only mark full stops on the *f* scale but provide detents between the full steps which click as you rotate the control. Watch the scale and count the clicks to determine how many there are between full stops on your camera. Check your camera manual on this, but you can probably set the aperture control anywhere you want it whether on a detent or not.

You can check the maximum aperture of most lenses just by looking at the aperture ring and noting the smallest *f*-number the lens can be set for. Or you can look on the front of the lens where there will be a set of numbers engraved in the metal surrounding the glass. One of these is likely to be a serial number.

Another identification on the front of the lens will be the focal length, usually stated in millimeters, such as 100mm.

The other identifying number will either be the *f*-number using the funny *f* symbol, or that same number turned upside down without the *f* symbol.

I don't think there is any major virtue in consistency and don't require it of myself; however undue inconsistency is either confusing or frivolous.

An *f*-4.5 lens is likely to be marked 1:4.5 on the front of the lens, which is plainly 4.5 turned upside down. There is a name for this inverted *f*-number, but I see no point in remembering what it is.

THE LONG AND SHORT OF IT

Lenses are made in a range of focal lengths,

called long, normal, and short. For 35mm cameras, long is above about 85mm, short is around 35mm or less, and normal is 50 or 55mm. The main difference among these lenses is angle of coverage, or lens viewing angle.

The longer the focal length the narrower the viewing angle, or field of view.

Normal lenses are supposed to have a focal length about the same as the diagonal of the exposure area on the negative. For 35mm film, this diagonal is about 50mm. By coincidence the angle of view for a 50mm lens is about 45° and some writers point out that this must be the "normal" lens because it has the same viewing angle, approximately, as the human eye.

The reasoning escapes me, however people who say that really do mean *the* human eye because for it to be true you have to go around with one eye closed. However, it doesn't matter. Everybody agrees that the normal lens for a 35mm camera is about 50mm focal length.

The angle of view for different lenses is shown in Figure 22 (page 82).

The basic reason for different focal-length lenses is to allow you to fill the frame with whatever you want to put there without having to take long walks toward or away from the scene you are photographing, or to defeat barriers such as fences and walls.

For portraits, a lens longer than 50mm, say 85mm or 100mm is recommended because you can get a full-frame head shot without crowding your customer. For sportscar racing and things like that, a 200mm lens is pretty good if you learn to hold it without shaking too much. For birds and distant small subjects, a 500mm is useful. For interiors, such as furniture arrangements in a room, a 35mm lens is good. If you buy all these lenses, it will make your dealer cheerful.

Depth-of-field

Field means field-of-view and is used to describe whatever the camera lens is "seeing." In numbers, a lens field of view is the angle between the outermost limits of the field, shown in Figure 22.

Within that field there are usually subjects at varying distances from the lens. It is possible to have everything the camera sees in sharp focus but often subjects in the near foreground are out of focus and subjects in the distance are also out of focus. The zone of good focus has some measurable depth, called *depth of field.*

If the region of good focus extends from five feet out to 20 feet, the depth of field is 15 feet.

The obvious problem is, "What does good focus mean and who decides when it's good?"

If we focus a camera at 12 feet and have our willing assistant run out there with a ping-pong ball, when he holds it at 12 feet the focus should be as good as it is going to get. Now let's ask him to stroll toward the camera, holding the ball so we can examine it through the viewfinder. At some point along the way I decide the focus is no longer good, therefore it is bad, therefore I have discovered the near end of the depth of field. It is exactly six feet.

Now you try it. You're kidding! What do you mean it's 4.5 feet?

The depth of good or acceptable focus is very much a personal observation. To standardize the measurement of it we will have to specify some limit of acceptable focus which can be measured scientifically.

It's natural to say that the image of a point should be a point if the focus is perfect and the lens is perfect.

Let's assume we own a point-source of light and can put it at different distances from the lens. If we put the point-source on either side of the location of best focus, the image on the film will be larger because the light rays will be coming to focus ahead of the film plane, or behind it. Even with a perfect lens this will happen.

If we keep on moving the point-source toward the camera the pattern of light gets larger and larger on the film. The name of that light-spot is *circle of confusion* and I didn't choose that name.

There are two ways to define how big the spot gets before we say it is no longer in acceptable focus. One is to state its diameter. But the diameter of a spot on a negative doesn't mean much. It's the diameter of the spot on the print that counts—or on the screen if we project a slide.

If you get up close to a TV tube you can see all the little lines that make the picture, and the picture doesn't look very sharp. Back away and those raster lines disappear and the picture looks more sharp. If the picture tube in your TV magic-

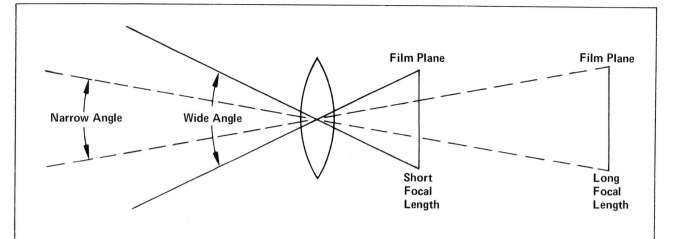

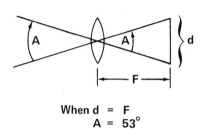

When d = F
A = 53°

Diagonal of film frame
is minimum allowable
diameter of image circle.

ANGLE OF VIEW OF TYPICAL 35mm LENSES

Focal Length	Angle of View
21 mm	92°
28 mm	76°
35 mm	64°
50 mm	45°
90 mm	27°
135 mm	18°
200 mm	12°
300 mm	8°
500 mm	5°

NORMAL LENSES FOR DIFFERENT FILM FORMATS

Film Size cm.	Film Size in.	Image Diagonal	Normal Lens
1.0 x 1.4		17mm	20mm
*2.4 x 3.6		43mm	50mm
6 x 6	2 1/4 x 2 1/4	80mm	80mm
6 x 7	2 1/4 x 2 7/8	92mm	100mm
6 x 9	2 1/4 x 3 1/4	99mm	100mm
	3 1/4 x 4 1/4	137mm	150mm
	4 x 5	162mm	180mm
	5 x 7	219mm	240mm
	8 x 10	325mm	360mm

*Size of 35mm frame

Figure 22/Study this a while.

200mm

100mm

50mm

28mm

Focal length of lenses can be exploited in two ways: keeping the camera at the same location while changing focal length, or moving the camera to a different location for each different focal length lens.

These four pictures were made with four different lenses, moving the camera location each time so the model in the foreground was the same height in the viewfinder. Result is to change the apparent distance between model and distant rock cliffs. Top left 200mm; top right, 100mm; bottom left, 50mm; bottom right, 28mm.

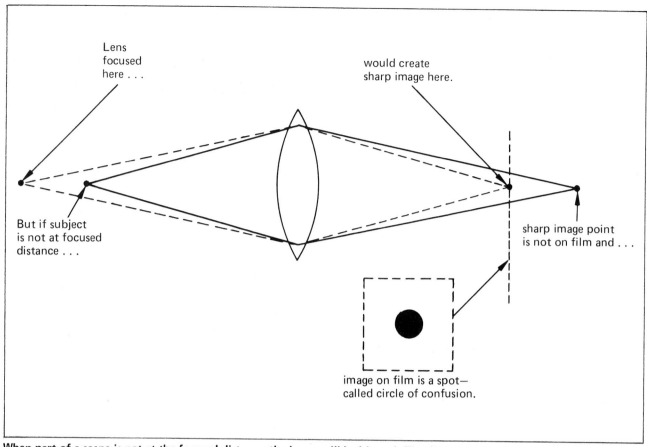

Lens focused here . . .

would create sharp image here.

But if subject is not at focused distance . . .

sharp image point is not on film and . . .

image on film is a spot—called circle of confusion.

When part of a scene is not at the focused distance, the image will be blurred. The distance from good focus to the point where focus is judged unsatisfactory is a measure of depth of field.

ally got bigger, you would have to back still farther away for the picture to have equivalent sharpness.

So good focus is not determined just by how big the circle of confusion is on a print. It is also determined by how far away the viewer stands. The only way to define the diameter of the circle of confusion as the limit of good focus is also to pass some laws about how much enlargement the negative can have and how far away the viewer must stand.

There is another way to specify acceptable focus which automatically passes all those laws. It is to state the angle occupied by the circle of confusion on the negative as viewed from the back node of the lens. By stating the angle, we state the size of the spot in relation to the size of the negative and all other subjects on the negative. Then it doesn't matter how much the neg is enlarged or how far away the viewer stands because everything is relative. If you don't understand that right

The *relative* size of a blurred spot is stated by the angle of the light rays which make the spot. As the rays travel farther, the spot has larger diameter but it still appears to be the same size to a viewer.

A

away, don't fuss over it because it isn't really important. It's still only an arbitrary specification of sharpness and in the real world sharpness is determined by the eye and mind of the viewer no matter what the book says.

There isn't universal agreement even on what the angle should be that defines the limits of acceptable focus. Some authorities define the spot diameter by saying it cannot exceed 1/1,000 of the viewing distance, which of course stipulates the viewing angle. On the negative, the maximum size of the circle of confusion cannot exceed one-thousandth of the distance from lens to film which is approximately the focal length of the lens. On a print or projection, the size of the spot cannot exceed one-thousandth of the distance to the viewer. In all these cases, the angle intercepted by the spot is the same, which is why it is all relative. Fundamentally, this specification is based on the idea that a spot whose diameter is only one-thousandth of the viewing distance is indistinguishable from a point.

DEPTH OF FIELD INDICATOR

Based on an assumption of tolerable limits of focus, the manufacturer of your camera has engraved a depth-of-field indicator on the lens, associated with the focusing ring. When you have the lens focused on a subject, you can read the approximate distance to that subject using a distance scale on the focusing ring by noting the distance opposite a fixed reference or index mark on the body of the lens. Or, you can measure the distance to the subject and set that distance opposite the index by rotating the focus control.

A typical depth-of-field indicator is pairs of lines engraved on each side of the distance index mark. The nearest pair, that is the first mark to the left of the index and the first mark to the right, will be labeled with an f-number, such as f-4. Each succeeding pair at a greater distance from the index will carry a higher f-number. You use the pair with the same f-number as the aperture you have selected with the aperture control. If you are shooting at f-4, it is that pair of lines that are operative. The pair of lines will span some distance on the distance scale, indicating the near and far limits of good focus. Notice that higher f-numbers give greater depth of field. Sometimes the lines are color-coded or connected to make using the depth-of-field indicator easier.

This lens is set at f-16 and focused at a distance of about 5 meters. The depth of field indicator (arrow) is the scale of numbers on each side of the index mark, ranging from 16 to 16. Depth of field is the span between any pair of numbers on that scale which have the same value, such as 4 to 4, or 11 to 11. The number pair to use is determined by the f-stop of the lens. In this photo the lens is set at f-16 so the span is from 16 to 16.

The distance limits for good focus are found by reading the focused distance scale opposite 16 and 16 on the depth of field indicator. Good focus is from about 2.5 meters to infinity or about 8 feet to infinity depending on which distance scale you look at.

If this lens were set at f-8, depth of field would extend from about 11 feet to 30 feet. Smaller lens openings give greater depth of field.

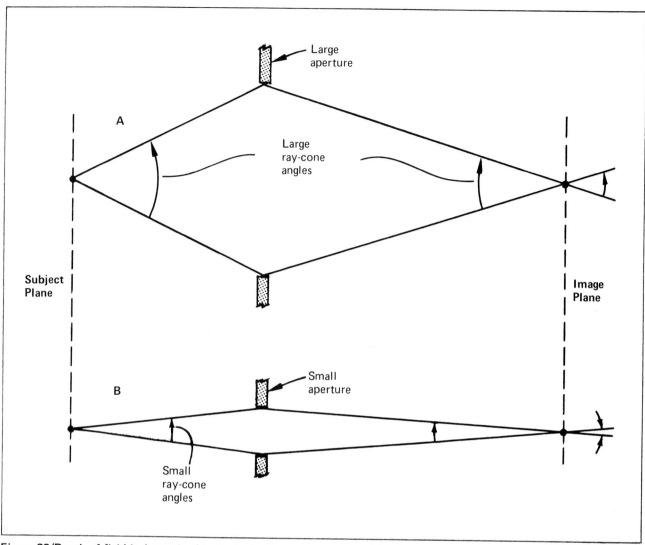

Figure 23/Depth of field is determined basically by the ray-cone angle which for a particular lens depends on aperture.

Practical depth-of-field considerations

More important than arbitrary definitions, scales and charts, is the actual depth of field in your actual photograph. If your SLR has a depth-of-field preview button, it makes sense to punch the button after you have focused but before you take the picture. With practice and attention to the problem you can judge depth of field very well. If it isn't what you want, don't shoot. Make appropriate camera adjustments to alter depth of field and take another look.

What are the adjustments? In the simplest

analysis, assuming a perfect lens and geometric ray-behavior, depth of field merely relates to cones of light. Rays from a point are converged to focus at a point and then diverge behind the point of focus. The light beam has the shape of two cones, tip to tip. The proposition is: How far is the distance from the focal point before the circle of light becomes too large?

If the cones of light make a narrow angle with the centerline, the film can be quite a distance away from focus before the spot becomes unacceptably large. If the cones are fat and make a large angle, then the distance to poor focus is shorter. Depth of field then is controlled by those things which make the light cones on each side of focus have larger or smaller angles.

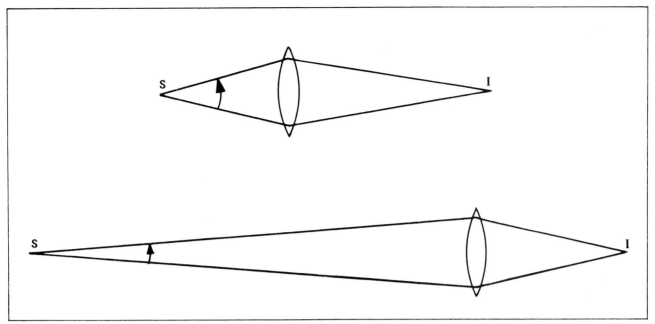

Figure 24/If the same lens is focused on a nearby subject and then on a distant subject, depth of field will be improved at the distant subject because the ray-cone angle is automatically smaller.

That's the basic idea. Of course, the film doesn't move with respect to the focal point. Subjects at different distances from the camera are brought to focus at different locations inside the camera. If that location is not at the film plane, then the film is illuminated by a slice through a cone of light.

Figure 23 shows the effect of aperture size. In part A, the larger aperture admits more of the outside rays from the subject and the cone-angle of light between lens and focal point is larger.

If a point-source is not at the subject plane, its image will not be exactly at the film plane and instead of a point of light on the film, there will be a circle of confusion. The diameter of the circle will be smaller if the cone angle is smaller and the cone angle will be smaller if the aperture opening is smaller. Therefore small apertures tend to make images sharp everywhere in the scene.

Notice that the reduction in cone angle due to a smaller aperture takes place both at the image plane and the subject plane. If you will accept the idea, even intuitively, that reduction of cone angles at the subject plane improves depth of field, then a simple explanation of the remaining two factors is easy.

Figure 24 shows a lens focused on a near and a distant subject. The cone angle at the distant subject is automatically smaller and depth of field is improved.

It is commonly said that short focal-length lenses improve depth of field. This implies taking one lens off your camera and installing another with a shorter focal length. Now we have to have some rules about the new lens and the way we take the picture. The rules are: The picture will be taken from the same location and the new lens must be set at the same f-number.

You will conclude that the benefit resides mainly in those rules; however no other set of rules governing the exchange of one lens for another seems to make sense.

Because f is equal to F/D, when focal length is reduced by some percentage, the lens diameter or aperture must be reduced by that same percentage, if f is not to change. If a lens with a focal length of 50mm is substituted for one of 100mm and both are set to the same f-number, the aperture of the 50mm lens will be smaller—the diameter will be half as large.

This amounts to revisiting part B of Figure 23. However, under the rules of the game, shorter focal lengths do improve depth of field.

The shorter lens will reduce the image distance but we have forced the subject distance to remain the same; therefore magnification will

Low camera position and wide-angle lens emphasize length of engine compartment in this old-time racer. Depth-of-field is stopped cold by that brick wall, but you can see it creeping toward you along the pavement. Photo by Andy Cummings.

change. Magnification, defined as image size/subject size, will be only one-half the value it was with the longer lens. Every part of the scene will be imaged at half-size by the short lens. Which is another way of saying that short lenses have a wider angle of view.

For the image taken by the short lens to have the same magnification on a print it will have to be enlarged twice as much in the printing process. It seems only fair to also take that as a rule: The image size resulting from use of the short lens has to be the same as that obtained with the long lens. The arithmetic is complicated but even when the images are the same size there is a depth-of-field payoff in use of a shorter lens. The disadvantage is greater enlargement and possibly intolerable graininess on the enlarged print.

Whenever you are looking for great depth of field use the shortest lens you can get by with, other factors being considered.

In summary, depth of field is increased by smaller apertures, more distance between camera and subject, and use of shorter focal-length lenses.

Another possibility, not admitted by the rules above but nevertheless a practical thing to consider, is changing the camera-to-subject distance when changing between two lenses of different focal length. It is possible to stand closer with the shorter lens and get the same image on the negative as with a longer lens used from greater distance. This amounts to getting the larger image with the shorter lens by changing magnification while taking the picture rather than in the enlarger. The result is the same, you are still better off using the short lens when you can, as far as depth of field alone is concerned.

Depth of field is not symmetrically arranged around the subject plane. If the depth is 20 feet, there will not be ten feet in front and ten feet behind the location of best focus. To visualize the

reason, imagine a point source at the subject plane and therefore being imaged as a point on the film. If you then move the point source toward the camera, the spot on the film becomes larger and *also* the ray angles are changing so the cone angle is also getting larger. Focus will deteriorate both because of subject movement toward the camera and because of cone-angle enlargement.

If the point is moved from the subject plane away from the camera, the image is degraded by going out of focus but the cone angles are becoming smaller which represents some improvement.

Therefore there is more depth of field behind the point of best focus than there is in front of it. If you are taking a photo where depth is a problem, for example a chair in dim room light, and you want the front edge and the rear edge of the subject to have about the same quality of focus, then you should put the point of best visual focus about one-third of the way back from the front of the subject.

For maximum depth of field you should never focus on the front edge of your subject because you will waste whatever depth there is in front of the subject plane.

In close-up or high-magnification photography two things happen to make depth of field a difficult and sometimes impossible problem. Aperture size becomes less effective in improving depth but it always has some effect even though small. Cranking the lens down to f-22 and pouring a lot of light on the subject doesn't do as much as you hope it will, but you do it anyway because every little bit of improvement helps.

Also, magnification becomes the dominant factor in depth of field. The more you magnify, the less depth you have and there isn't much you can do about it. When magnification, **M**, is greater than one, that is the image on the negative is larger than the subject, depth of field is controlled almost totally by the amount of magnification. Double **M** and depth will be only half as much.

When fighting a depth problem and closing your lens down to the smallest aperture to get some, you will probably have a nagging worry about image degradation by diffraction through the tiny lens opening. You have to make up your own mind about what to do. Making some test shots with your camera will help you decide what is best for your way of working.

Everything said so far on this subject has been based on use of a perfect lens. Depth of field problems *are not* lens defects. However, lens defects do exist, generally they cause images that appear blurred or out of focus, so whatever the lens aberrations are doing to the image will have the effect of reducing the depth of field as judged by a viewer. Most aberrations but not diffraction are off-axis effects. They all are reduced by use of smaller aperture.

DEPTH OF FOCUS

Depth-of-field discussions suppose that the film remains in one place while the subject wanders around going in and out of focus. Depth of field measures how far in each direction the subject can wander and still be in acceptable focus as judged by a viewer.

Depth of focus is exactly the same thing, viewed from the other direction. It supposes that the subject does not move but the film is wobbled around so point-images get out of focus and larger in size.

They are not two separate things going on in the image system of your camera. Both cannot help you at the same time. If you are using all the depth of field, then you don't have any depth of focus. If you are using depth of focus, then you don't have any depth of field.

Sorry about that!

Stand-by camera settings

Magazine writers become desperate at times, just like everybody else. They need an article written by noon and have no inspirations or new ideas. Resort is made to some black magic called *hyperfocal distance* as the subject of a quick article. These are usually lucid and well done but I read a few of them before it dawned on me that these were *practical* suggestions about a way to set up my camera.

Benefit results only after you have learned to dial the magic numbers into your camera, so if you still have it handy it will be handy.

If you have just taken a picture and laid your camera aside chances are you left the camera settings the way they were for the last shot. Sometimes you get an opportunity to take a "grab

The first step in setting a lens to the hyperfocal distance is to focus it at infinity. At ƒ-22 notice that the near limit of focus is about 4 feet. The far limit is 'way out past infinity somewhere.

After seeing all that depth of field with a 28mm lens, look what happens with a 200mm.

Now refocus to the previous near limit, about 4 feet. The new near limit of good focus is about 2.5 feet and the far limit is infinity. That astonishing depth of field happens with a 28mm lens set at ƒ-22.
If you experiment a bit with a lens, you may find an even simpler way to set it at the hyperfocal distance. What if you just put the far-focus limit of the depth of field scale—ƒ-22 or ƒ-11 or whatever you have the lens set for—just opposite the infinity mark on the focused distance scale?

shot" of some unusual thing that is happening quickly. The less you have to fiddle with the controls, the more likely you are to catch the shot.

The best guess about what the exposure settings should be is to assume they are probably the same as they were a few minutes ago, so don't change those. However, if you were focused on something 50 feet away and the new action is at 15 feet, you are going to lose time trying to focus.

The best standby setting for focus is the hyperfocal distance. It is sometimes worth setting your camera this way after you have taken a picture for the reason mentioned above.

Turn the focusing ring all the way to infinity. Notice that the depth-of-field indication says things are in focus for some distance this side of infinity and some distance beyond. There aren't any subjects beyond infinity so all the depth of field hanging over in that direction is wasted.

Notice the number in feet or meters representing the near limit of depth of field with the camera focused at infinity. That distance—whatever it is on your lens—is called *hyperfocal*.

Now, change the control to focus at the hyperfocal distance. On my 50mm lens the distance is 10 meters when set at ƒ-8.

When refocused to the hyperfocal number, take another look at the depth-of-field indication.

It will extend all the way out to infinity. In the other direction, toward the camera, it extends to one-half of the hyperfocal distance.

On my lens, after refocusing, the depth of field at *f*-8 ranges from 5 meters to infinity. That means I should get satisfactory focus on anything in that range without bothering to worry about it or check it.

If I am using *f*-16, I can get good focus all the way from 2.5 meters to infinity.

AN ULTRA-MICRO-MACRO-CLOSE-UP

In the race-car business there used to be an expression: "Give an Englishman a piece of metal and he will do something silly with it." That certainly is not true as a general rule. However, I have seen a few isolated instances which tend to support the observation.

In the photography business it doesn't take long for you or me to figure out that the technical people involved with making film, lenses, and cameras are very smart folk. But it does appear at times that they get pretty disorganized in the way they use words and numbers. I have hinted at some of these photo foibles before. What we must do about it is decide that the little bit of helter-skelter is fun and the people who do it are lovable.

For example: The prefixes *macro* and *micro* mean large and small. Macro is the one that means large. If you have a macropaycheck you can buy a new camera. With a micropaycheck you can buy a roll of film for it.

My basic training is in the field of electronics where we have managed to use prefixes like these for many years without becoming hopelessly confused or even lovable about it.

Not so in photography and the only reason I am devoting space to the matter is so you won't begin to think there is something wrong with you. You are OK, friend.

Imagine one of the lovables taking a picture of a giant rhinoceros on a tiny frame of film. The subject is very large—the image is small. Which is macro and which is micro?

Kodak's interesting booklet entitled "Photomacrography" bravely sets out to define terms so as to avoid any confusion. Four of the terms are really a lot of fun: microphotography, photomicrography, macrophotography, photomacrography.

Microphotography means making little bitty pictures, such as on microfilm. *Macrophotography* means making very large pictures such as a wall-sized mural or poster. Makes you feel pretty good, doesn't it?

Photomicrography means taking pictures through a microscope to get something on film which is too small to see with the naked eye.

Photomacrography means taking pictures through a high-magnification lens to get details on film—details too small to see with the naked eye. About half the people half the time call this macrophotography.

Photomacrography and photomicrography mean about the same thing. The basic difference is that one is done through a microscope and the other through photographic lenses.

Therefore if you are taking high-magnification pictures and you are not doing it through a microscope, you are engaging in photomacrography. What kind of lens do you use for this? A macro lens. Unless you buy it from Nikon. They call it a micro lens. Others do too. I'm not saying bad things about Kodak or Nikon or anybody. Just pointing out that even very smart people can occasionally get their underwear on backwards and learn to like it that way. It's lovable.

Image magnification

The size of the image on the negative is usually different than the size of the subject in the real world, although it is possible for them to have the same dimensions (in one plane!).

Magnification is the size of the image divided by the size of the subject, $M = I/S$, where M stands for magnification.

When the image is larger than the subject, which happens when you are doing photomacrography, the magnification is larger than one.

For normal negative images, magnification is less than one. Some books use other expressions, such as "reproduction ratio," for the case where magnification is less than unity. I think there are too many things to remember already without using two different names for the same things, so I stick to "magnification" no matter which is larger.

A simple geometric idea about magnification

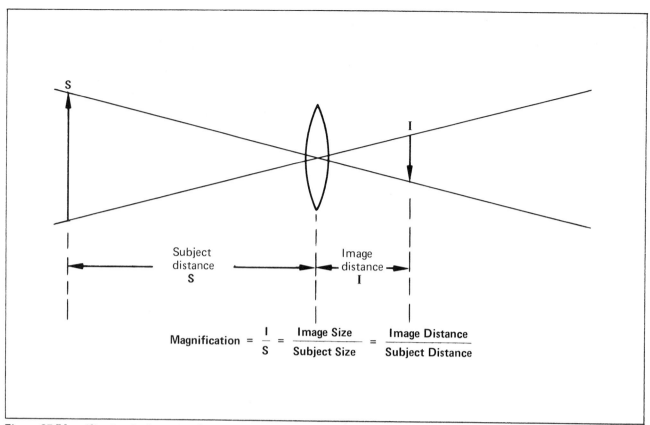

$$\text{Magnification} = \frac{I}{S} = \frac{\text{Image Size}}{\text{Subject Size}} = \frac{\text{Image Distance}}{\text{Subject Distance}}$$

Figure 25/Magnification is the ratio of image distance to subject distance. If image and subject are the same distance from the lens they will be the same size.

is illustrated in Figure 25. The outside rays from subject to image are shown, crossing each other in the center of the lens. Notice that these rays make two "V" shapes joined at their apexes and the interior angle of the two V's is the same.

Now imagine that either the subject or the image can be moved closer to or farther away from the lens but must always fit exactly between the two lines of the V. For example, if you start with a tiny image near the lens and slide the image away from the lens it will grow larger in proportion to the distance it is away from the lens. Same is true for the subject. Therefore the ratio of their sizes is the same as the ratio of their distances.

Magnification = I/S

where this time **I** and **S** are the respective distances from lens to image and lens to subject.

Let's work out a simple example. 35mm film is about one inch wide in its narrow dimension. Holding the camera with the viewer on top, this dimension will be vertical on the film. If the

camera is using a 50mm lens and is focused at infinity, the image distance will be 50mm or about 2 inches. If a subject is 100 feet away, the camera will be focused at infinity. In making any ratio, the units of measurement have to be the same, so convert 100 feet into 1,200 inches.

Magnification, M = I/S = 2/1,200 = 1/600

At a distance of 100 feet, a subject which is 600 inches tall (50 feet) will fill up the narrow dimension of 35mm film if the lens is 50mm and focused at infinity.

Nearer subjects will naturally not be reduced in size that much. More distant subjects will be reduced more, otherwise you could not get a mountain on film.

This is not really important in ordinary photography because the camera viewfinder shows what you are getting much better than arithmetic on paper does. The idea of magnification is important to close-up photography and we will use it again later.

Special lenses

Lenses discussed so far have had a single unchangeable focal length. To use a different focal length you have to attach a different lens.

VARIABLE FOCUS LENSES

There are compound lenses built so the spacing between the elements of the lens can be varied mechanically to change the focal length. In the simplest form, focal length only is adjustable and after you change it you have to focus the image. If you change focal length again, you have to focus the image again. These are called *variable-focus lenses.*

For still photography a lens which must be refocused at each focal-length setting may not be a disadvantage and such lenses usually cost less than zooms which maintain focus during changes in focal length or magnification.

Zoom lenses are handy for still-camera work and motion-picture photography where they allow zooming in for closeups.

For either type of lens, to prevent changes in exposure the *f*-number should be preserved when the focal length is changed. The mechanism must change aperture to preserve the relationship $f = F/D$.

Many authorities say these variable lenses can never quite equal a fixed lens in picture sharpness and contrast. Most lens makers who offer variable lenses challenge you to see any difference with your unaided eye.

AUXILIARY LENSES

Auxiliary *close-up* lenses are widely used to allow the camera to focus nearer than its shortest normal distance. The purpose is to fill the frame with the subject being photographed when the subject is small. Because magnification is the ratio I/S, any lens change which reduces subject distance will cause a larger image on the film.

Close-up lenses are positive converging lenses of relatively low power, sometimes sold in sets of three lenses to clip over the front of the camera lens.

In a system of lenses, convergences add together producing more convergence of the light rays and therefore a shorter focal length. A close-up lens has this effect.

Auxiliary close-up lenses fit on the end of the camera lens and do the trick shown in Figure 26.

You remember the basic lens equation $1/S + 1/I = 1/F$. If F is made smaller by addition of a close-up attachment, the subject distance can also be made smaller with no change required in image distance and the result is higher magnification.

If you buy a set of close-up lenses there will usually be three of them, marked 1, 2, and 3. This is not a thoughtful aid to help you keep them in proper order in the case, it is a way of concealing the focal length of the auxiliary lenses.

The *power* of a lens is defined as the reciprocal of its focal length, expressed in units called *diopters.* If you wear eyeglasses, the numbers on the prescription will be diopter units. My own correction for distant vision, for example, is 1.25 diopters. The corrective lenses you can buy to fit over the viewfinder of your camera so you don't have to wear glasses when taking pictures are called dioptric lenses.

$$\text{Power (in diopters)} = \frac{1}{\text{Focal Length (in meters)}}$$

The identification number of close-up lenses is normally the power in diopters. A 1 lens has a power of 1 diopter, and so forth. Some benefit from this sytem will soon appear.

93

Because focal length and lens power are reciprocals, it's easy to calculate the focal length of a set of close-up lenses:

DIOPTER	FOCAL LENGTH	
	mm	inches
1	1,000	40 (approx.)
2	500	20
3	330	13
10	100	4

Now we can do some little tricks. As shown in Figure 26, a camera lens set at infinity brings parallel rays to focus at the focal length of the lens. As you remember from the earlier discussion of lens properties, lenses have two focal points, one in front and one in back. And, rays from a point source at the focal point of a lens go through the lens and emerge as parallel rays.

The figure shows a source at the front focal point of an auxiliary close-up lens. On the back side of the close-up lens the rays emerge parallel to each other and immediately enter the camera lens. The camera lens brings them to focus at the focal plane because the lens is set for infinity and the lens is "expecting" parallel rays.

The subject brought into focus is not at infinity but the camera is persuaded so by the fact that the rays from that subject are parallel on entry into the camera lens. The auxiliary lens did that.

The actual distance between camera and subject is the focal length of the auxiliary lens and that will be so with all close-up lenses. The table of focal lengths tells us how far away to put the subject for lenses of different powers.

When you do this, you will find that focusing the camera lens closer than infinity will also move the subject plane closer and increase magnification. Because both are changing, distance and magnification, it is sometimes simpler to leave the camera lens set for infinity and move the entire camera toward or away from the subject until you find focus.

An advantage of stating lens power in diopters is the power of two lenses used in combina-

Figure 26/When a close-up lens is put on the camera lens, the front focal distance of the combination becomes the same as the focal length of the close-up lens. Magnification is easy to calculate.

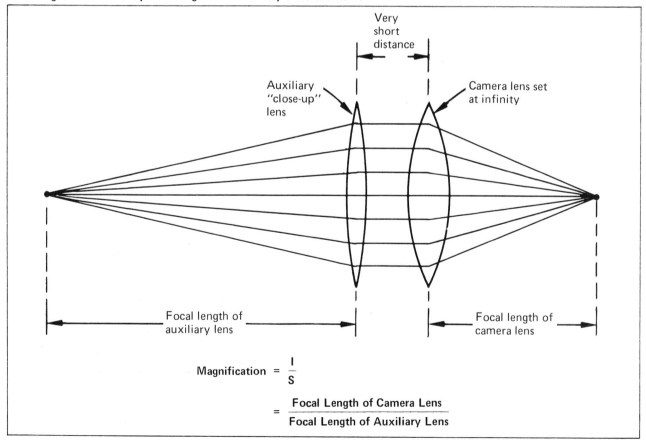

Very short distance

Auxiliary "close-up" lens

Camera lens set at infinity

Focal length of auxiliary lens

Focal length of camera lens

$$\text{Magnification} = \frac{I}{S}$$

$$= \frac{\text{Focal Length of Camera Lens}}{\text{Focal Length of Auxiliary Lens}}$$

tion can be figured just by adding the diopter ratings. Positive lenses have positive diopter ratings, negative have negative.

You can gang your close-up lenses to get more magnification. If you use a 1 and a 3, the result is a 4 lens. When you do that, put the lens with higher power nearest the camera lens to minimize the effect of its aberrations.

You can also figure the image magnification easily when the camera lens is set at infinity. The image distance is the focal length of the camera lens. The subject distance is the focal length of the auxiliary lens. Magnification is still the ratio I/S, or:

$$\frac{\text{Image Distance}}{\text{Subject Distance}}$$

If the camera lens is 50mm and the auxiliary lens is 1,000 mm (1 diopter) the magnification is 50/1,000 = 1/20. The image on film will be 1/20 the size of the subject.

These auxiliary lenses are inexpensive and very useful. They are not corrected for aberrations because no single piece of glass can be—it takes a compound lens. So, as you use higher powers of close-up lens, image quality deteriorates. The limit is up to you but you will probably agree that 10 diopters of uncorrected lens is enough. If so, you have set a limit to the amount of magnification you can get using auxiliary lenses of this type. It is 1/2, with a 50mm camera lens.

It's always better to use one close-up lens to get the desired magnification, rather than several in combination which I think is the reason the 10 lens is available.

Anyway, if you need more magnification than 1/2 or whatever your limit is, you can't get it by using more diopters out in front of your camera, because the image gets too bad.

Higher magnifications are obtained by lens spacing rings which fit between the camera lens and the camera body. There is no glass in them, they are just spacers. Modern SLR cameras have some pins and levers in the lens which move when lens adjustments are made. This mechanical motion is transmitted to the camera body, through the lens mount, so the camera knows what is happening out there. The spacer rings should transmit these mechanical signals back to the camera body so the SLR can continue to offer its automatic

1/This is the beginning of a series of pictures with increasing magnification. This one was taken with a 50mm lens and a +1 close-up attachment. With the camera lens set at infinity, focus should have been about 40 inches out there. Defective yardstick didn't have that many inches so I put the subject at about 20 inches. You can see depth of field.

2/Elated by the results, I substituted a +2 diopter auxiliary lens and positioned the yardstick so it does show distance between lens and subject.

3/Then I decided it would make a very timely shot if I combined a +1 and a +3 close-up lens to give a total of +4 which should focus at about 10 inches and give a magnification of 0.2 on the negative. Depth of field is getting worse.

4/I doubled the magnification by changing to a 100mm lens with +4 diopters added on the end.

5/Doubled again by switching to a 200mm lens still with +4 diopters of close-up attachment. Now the image on the negative is eight-tenths as large as the real-life subject. The yardstick is still there but you can barely see a hint of it. This was shot at *f*-5.6.

6/Same setup as before except lens set at *f*-22. Now you can see the yardstick a little better.

7/Using +5 diopters with the 200mm lens so the magnification would be 1.0, I made another experiment to show the benefit of small aperture. This photo is at f-5.6.

8/Same setup except shot at f-22. Sharpness and depth of field improved.

9/Still elated because none of the stuff had fallen off the front of my camera, I rewarded my faithful thumb by taking its picture at a magnification of 1.0. The negative was further enlarged to make this print.

10/I switched to 400mm with +5 diopters and photographed the yardstick at a magnification of 2. Image on the negative is twice life-size. Subject distance is 8 inches, image distance is 16 inches effectively.

features such as match-needle metering even when spacer rings are installed. Not all spacers, even those made by some SLR manufacturers, provide this nicely.

You can get a lot of argument about image quality when using auxiliary lenses versus spacer rings. Some say the rings must give a better picture because they have no glass in the light path and therefore no aberrations. That much is true, but the main lens is no longer operating within the designed distance range from the film when a spacer is installed so the camera lens corrections don't work as well. Image quality is deteriorated either way. The intent of spacer rings is to allow magnifications higher than you can get with close-up lenses and therefore each has its domain. Used properly, there is no big advantage in image quality either way.

The way the spacers work is pretty simple and you have probably figured it out already. If you focus your camera at infinity and then change the control to focus on nearer subjects, the lens is mechanically moved farther from the film plane. At some point you run out of control. That's as close as you can focus and as much magnification as you can get with the camera as the factory built it.

Incidentally, this forward movement of the lens is called "extension" in a lot of literature about cameras. Sometimes "camera extension" or "lens extension." To get more magnification you need more lens extension.

If the camera had been manufactured so you could crank the lens out farther, you could get more magnification. There doesn't seem to be any mechanical reason to prevent that. On my 50mm lens the focus control rotates only about 180° from minimum to maximum extension. So it seems that more could have been built in.

I think the reason the camera maker limits extension is based on image quality. If I made cameras, I would limit the smallest aperture and the largest aperture to values which produced some acceptable degradation according to my own standards of image quality. In other words each end of the control range would be bad, but not too bad. I would limit lens extension for the same reason, and I think that's what camera makers do. Anyway, there is a limit and if you want more magnification you have to modify the camera by putting in spacers, which the manufacturer will be glad to sell you.

By some tedious algebra, the formula for the amount of lens extension, X, is:

$$X = MF$$

where M is the desired magnification, F is still focal length of the lens being used, and X is the required extension of the lens *beyond* the position of focus at infinity.

By measuring the height of the subject and comparing that to the height of the 35mm film frame, about one inch, you can figure the amount of magnification you need to fill the frame vertically with the image. If the subject is 2 inches tall, magnification is $I/S = 1/2$ or 0.5.

Then lens extension, $X = 0.5 F$. If the focal length of the lens you are using is 50mm, the extension ring needed is 25mm. Extension rings come in sets with convenient lengths such as 12.5mm, 25mm, and 50mm. They can be ganged by screwing or latching them together. As with close-up lenses, it is usually better to set the camera lens at infinity and find focus by changing the subject distance.

Either method of increasing magnification results in a change in the amount of light reaching the film. If your camera measures light internally, the light meter "sees" what gets on the film and exposure corrections are made automatically.

Close-up lenses have the effect of changing focal length which in turn changes f and the light-gathering ability of the lens. With close-up lenses of low power the change in light is so small that it is usually ignored in practice even with cameras which do not measure light through the lens.

At larger magnifications such as produced by lens extensions or sometimes a bellows in the lens system, the light loss is enough to worry about and correct for. If the camera is measuring the light internally, correction is still not a major problem to the photographer.

When magnifications are one, or more than one, and you are using a normal camera lens the image distance is so much longer than the lens designer intended that many of the aberrations are not effectively corrected. Very poor picture quality results.

One way to improve that situation is to reverse the lens and install it on the camera backwards. The reasoning is that the lens was corrected for the case where the subject distance is longer than the image distance. If magnifications exceed one, then the image distance has to be longer than the subject distance and the lens will perform better if it is reversed.

To do that, you can buy hardware called *reversing rings* to adapt the front of the lens to fit on the camera body. The lens looks funny that way because the pins and levers which communicate lens settings to the camera are out in front. Worse, they can no longer do their job so the camera automation doesn't work anymore. Now you have to figure exposure corrections all by yourself.

A simple way to think about it is based on the amount of magnification. At one-to-one, light from the subject is put on an image which has the same area as the subject. If you change magnification so the image becomes larger, that does not change subject brightness. Light rays from the subject will have to paint a larger image, therefore the image will be less bright.

The procedure is to figure what the exposure would be normally, that is with low magnification. Then multiply that exposure by a correction factor which is usually $(M + 1)^2$. When M is very small, such as 0.001, then the correction is 1.001 x 1.001, which is still very close to 1, meaning no exposure correction is needed. Starting at magnifications of 1/10 and higher, the exposure correction is significant. At 1/10 for example, the factor is about 1.21 and from there it goes up rapidly.

All this is for an ordinary type lens, which you can determine by looking at the entrance and exit pupils. If they are about the same size, the lens is ordinary. If you use a special lens, such as a telephoto type, the pupils will not be the same size and the ratio of their sizes also enters into the calculation. That ratio,

$$\frac{\text{Exit Pupil Diameter}}{\text{Entrance Pupil Diameter}}$$

is called the *pupilary magnification*, p. When p is not close to 1.0 the exposure correction becomes $(M/p + 1)^2$.

Technical cameras which use sheet film and have a bellows extension usually do not have

Exit pupil of 200mm telephoto lens.

Entrance pupil of same 200mm telephoto is about twice the diameter of the exit pupil. Pupilary magnification is about 0.5 for this lens.

internal light meters. To help the photographer manage the close-up exposure problem, a scale along the bellows track displays the exposure correction for magnifications greater than 1/10.

Some makers offer special lenses called macro, sometimes micro, which are corrected for close work and don't have to be reversed at high magnifications. Also some special tele-lenses have a lever or control to switch them over for macro use. This repositions lens elements inside for the problem of longer extensions and shorter subject distances.

Close-up photography uses different accessories and techniques according to the amount of magnification needed. With a normal 50mm lens that focuses down to a subject distance of 2 feet, magnification is about 1/12 with no auxiliary equipment.

Auxiliary lenses are a convenient choice for additional magnification up to about 1/4 or higher if you can tolerate the image degradation. Extension rings work up to about 1/1 but when the magnification is near one, the lens should be reversed. Or use a macro lens. Magnifications greater than about one are well into photomacrography and bellows extensions with macro lenses are normally used.

TELE-LENSES

If a lens has a focal length of 8 inches, you would expect it to make an image at that distance when focused at infinity. There's nothing wrong with that optically but the resulting lens is cumbersome to use on a camera that you carry around. Accordingly, telephoto and similar tele-lenses have been designed to behave like long focal-length lenses but sit closer to the film plane of the camera.

We have already seen that the effective power of lenses in combination is the sum of the individual powers, expressed in diopters, remembering that divergent lenses have negative values of power. Start with a 20 diopter lens and find the focal length by taking the reciprocal of the diopter rating.

$$F = 1/Power = 1/20 = 0.05\ meter = 50mm$$

It's a 50mm lens. Now put a diverging lens nearby with a diopter value of -10. Combining the powers, 20 - 10 = 10. The result is a 10 diopter compound lens. It's focal length is 1/10 meter or 100mm.

According to arithmetic, adding a divergent lens to a convergent lens reduces the diopter rating and increases the focal length.

I think it's a good idea just to believe that because ray-diagrams to show the innards of a tele-lens don't make much sense to people who are not in the optics business.

It's easy to believe because you can put a tele-lens on your camera and see the result.

Because the lens is closer to the film than its focal length would suggest, and because focal distance is measured from the back node of a compound lens, we say that the negative element moved the node forward. Sometimes the back node is effectively out in front of the lens.

The main advantage of a tele-lens on a still camera is reduction in overall length achieved by that optical trick. A measure of that benefit is the ratio of the focal length to the actual distance between the back of the lens and the film, called *telephoto ratio*.

TELECONVERTERS

Using a negative lens to extend the focal length does not require the two elements to be in the same lens tube. This gives rise to an accessory lens which fits between the normal lens and the camera body, called a *teleconverter*. It is a negative lens and in combination with the normal lens produces a tele-lens with longer focal length than the normal lens.

Teleconverters are identified by a number which states their effect on the focal length of the normal lens. A 2X multiplies the focal length by 2. A 3X by 3.

You can consider that a diverging lens in a converging lens system has the effect of reducing the convergence. Therefore rays travel farther before converging to a point and focal length is longer. A negative lens in front of the normal camera lens would have this effect on both the front focus and the back focus of the lens, but the back focal point would lie behind the film plane. An extension tube would be required behind the lens to accommodate the added focal length due to a negative element placed in front.

That arrangement is unnecessarily cumbersome. A negative lens placed behind the normal camera lens both extends the focal length and also provides the necessary spacer between lens and film. That's what a teleconverter lens does.

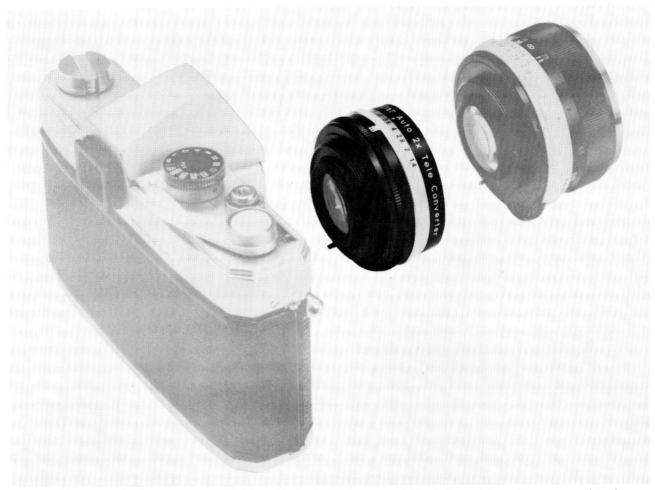

Vivitar teleconverter fits between camera and lens. Mechanical links connect signal-pins and levers to camera as though teleconverter was not there. Thus camera automation is not affected.

It is often stated that an advantage of a teleconverter used with a normal lens is that the near limit of subject distance remains the same as without the teleconverter, and the near focusing distance of normal lenses is usually much shorter than a tele-type long-focus lens manufactured as a single assembly. It seems odd that a "home-cooking" positive and negative lens assembly made of separate parts could "outperform" a factory equivalent made all in one piece with careful engineering and all that. The reason for the mechanical near-limit of a factory long lens is, again, allowable image degradation. The designer says, "That's as far as I want my lens to go." Correction of a compound lens becomes more difficult when the spacing between elements gets larger and there has to be some arbitrary limit. Nobody says the image quality with a teleconverter will be as good as the equivalent long lens.

Vivitar 2x and 3x teleconverters. 3x is the longer one.

Figure 27/A teleconverter attachment fits between the normal lens and the camera body. It causes the rays to diverge thereby increasing the back focal distance, increasing magnification, and making the combined lens exhibit a longer focal length.

There are some long-focus and telephoto lenses on the market with a "macro" control which makes an internal adjustment so the lens can then be focused nearer to get increased image size.

Figure 27 gives you the idea of a teleconverter. Assume the normal lens is focused as close as it will go. Dotted rays show where the focal plane would be without the teleconverter. Because the teleconverter reduces ray convergence, it brings the rays to focus at a farther distance behind the lens. Because the teleconverter is itself a lens extension, the new focal point coincides with the film plane. Therefore the normal lens still focuses as close as it ever did but the overall focal length of the lens combination has been multiplied by 2 or 3, depending on the teleconverter being used.

The price for the advantages of the attachment is some reduced picture quality plus the fact that a teleconverter reduces effective aperture in the same ratio as the change in focal length.

A 50mm *f*-2 lens used with a **3X** converter behaves like a 150mm *f*-6 lens, pretty slow compared to available single-unit long-focus lenses. Biprism and microprism focusing aids don't work below a certain aperture size and the use of a tele-converter could possibly get you into the "black-out" range. You can find out where your focusing aids black out just by looking through the view-finder at different *f*-stops and using the preview button to close down the lens while you are looking. On my camera, with a 50mm lens and micro-prism focusing, the focusing aid stops helping between *f*-4 and *f*-5.6 and is completely ineffective at *f*-5.6. I can still see focus changes in the viewer, but the microprism isn't doing much because half of its faces are dark.

REVERSED TELEPHOTO LENSES

When a telephoto is used in the customary way, the physical distance between the back of the lens and the film is smaller than the focal length due to the optical trick which moves the lens nodes forward. If such a lens were installed backwards on the camera, the physical distance, lens to film, would be longer than the focal length.

With very short focal-length lenses such as 28mm, the construction of the camera and lens mount may not allow the lens to get close enough to the film, if the lens is a normal type. Short lenses sometimes use the reversed telephoto idea to solve that problem.

OTHER SPECIAL LENSES

There are a lot of other types of special lenses. Some are aspheric—not spherical—such as a cylindrical lens which will distort the image deliberately by stretching dimension in one direction. There are diffusers to create a softer focus, lens attachments with two focal lengths in two different parts of the lens, mirror-gadgets to allow you to point the camera one way while taking a picture at right angles, and a variety of other special-purpose lenses or attachments.

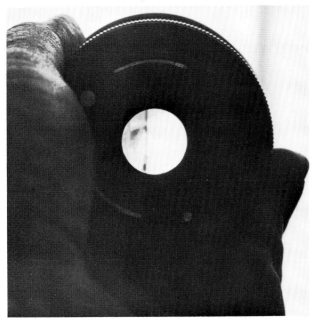

This 28mm lens is a reversed telephoto type. Exit pupil in the left photo is larger than the entrance pupil shown in right photo. Compare this to the normal 200mm telephoto lens.

Perspective

The word *perspective* is a good example of a fine upstanding and useful word gone wrong through loose use. It has come to mean point of view both mentally and actually and a lot of other things expressed so vaguely I never do know what people mean when they say things like "My perspective on life has changed."

The word *perspective* literally means *to see through*, and that is the clue to its proper use in art and photography.

Primitive artists struggled mightily with the problem of making a drawing on a flat surface to represent the three dimensions of the real world. Some of the schemes used required a lot of cooperation from the viewer—such as showing front and side views of the same subject simultaneously, which never happens in life.

In the late years of the 14th century, Italian artists got the idea of making drawings which looked "real" and which conveyed the idea of distance. They worked out a mathematical approach

Figure 28/Perspective means that an image captured on a flat surface between viewer and scene is indistinguishable from the real scene. If the image were removed, the viewer wouldn't notice any difference.

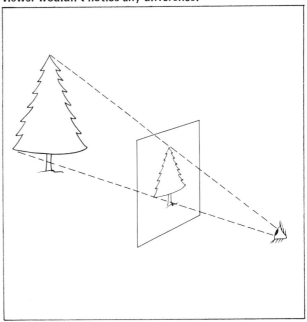

to the problem and practical ways of using the technique.

Leonardo Da Vinci, with his usual talent for getting to the root of things, provided a simple and lucid definition of perspective, illustrated in Figure 28 (page 103). Imagine you are looking at a scene and rays of light from each point on the scene are traveling directly to your eye, in straight lines. Now imagine that a screen of parchment or ground glass is placed between your eye and the scene, perpendicular to your line of vision. Assume the scene is then imaged on the screen with perfect quality. You would not be able to tell whether you were looking at that perfect image on the screen or looking at the scene itself. Suppose, while you are looking at the image on the screen, the scene behind it is magically removed. You wouldn't even know it. You would still consider that you were "seeing through" the screen and looking at the real subject.

When an image is captured on a flat surface by drawing, painting, or photography in such a way that the viewer perceives no difference between the image and the actual scene, then the perspective is correct. The viewer feels that he is *seeing through* the flat surface and looking at something in the real world.

Now please imagine it all over again. You are looking at a scene, a flat surface is put between your eye and the scene, rays from the scene are intercepted by the flat surface and strike it rather than reaching your eye directly. The flat surface becomes a piece of film and suddenly you are looking at a photograph of the scene. The photo is in proper perspective and it will look exactly the same to you as the scene would look if the photo were moved out of your view so you could see the real world again, directly.

There are only two ways in which this can go wrong to cause the photo not to have proper "see-through." Suppose the image of the subject is captured on the screen in some permanent way such as a photograph. Then suppose the screen is moved much closer to your eye. The parts of the subject will appear much larger to you on the photo than they do when viewing the scene directly. The perspective is wrong. Suppose the photo is moved farther away than it was when the

1/This series of pictures is another demonstration of the effect of focal length. This time the camera stays in the same place on a tripod and the distant rock formation is photographed with lenses of different focal length. This is taken with a 400mm lens—actually a 200mm telephoto with a 2X tele-extender.

2/Same scene, same camera location, 200mm lens. Angle of view is wider, magnification is less, perspective is the same. If the rock section were enlarged two times it would look the same as the previous picture.

3/A 100mm lens takes in a still wider view.

4/A 50mm lens, the "normal" lens for 35mm cameras.

5/A 28mm wide-angle lens takes in so much scenery you can hardly find the rock formation.

image was taken. Everything in the photo will appear smaller than it would if you were looking at the real scene. Let's call these *errors of apparent size* and get back to it in a minute.

The other thing which can go wrong requires some pretty fancy imagining on your part. You are sitting in a chair, looking at a scene. A transparent panel is put between your eye and the scene. You don't even notice it because the panel is transparent. Now the panel is turned a little so it is at an angle in respect to your line of vision. You still don't notice it—in the same way that you don't care whether you look straight out your window onto the street or look through your window at an angle.

While the clear pane is at some angle between your eye and the scene, it suddenly becomes film and becomes a picture of what you were looking at. As long as the picture remains in exactly the same position, you still don't notice it. Even though it is angled to your line of vision, it is angled the same way as it was when the picture was made, so the perspective is proper. The photo is indistinguishable from your view of the real scene—the *see-through* property still exists.

Now, turn the photo so it is perpendicular to your line of vision. What you see on the photo is nothing like what you saw in the real world. The perspective of the viewing *situation* is wrong. Question: Is the perspective wrong on the photograph? It's a hard question to answer, isn't it? Let's call this problem an *error due to line of sight*, and put it aside for a moment, along with the apparent size problem.

What does a camera do? In essence, it puts a piece of film "between" your eye and the scene and captures the image. This is not mechanically correct because you look through a viewfinder and the film is somewhere else in the camera. But, from a practical standpoint, the image on the film is the same as the image seen by your eye when taking the picture and therefore you can think of the exposure on the negative just the way Da Vinci thought of his screen between eye and subject.

In converting the negative to a print, it is usually enlarged which will obviously affect the apparent-size problem when a viewer looks at the print.

Most cameras are arranged so the film surface or film plane is parallel to the lens and the optical axis is perpendicular to both lens and film. This is equivalent to holding Da Vinci's screen perpendicular to your line of vision.

There is nothing to prevent a photographer from holding the camera any way he wants to when taking a picture. You can put your camera down at my ankles and take a picture of my face if you choose to. If you did that, would your picture have proper perspective? Another difficult question, isn't it?

The reason questions about perspective—and understanding of it—are difficult is that we have a problem deciding whether perspective is the responsibility of the camera, the photographer, or the viewer of the photograph—or all three.

I will assert that an ordinary camera *never* takes a picture with *wrong* perspective and, in fact, it is impossible for that to ever happen. Think about it and you may agree. The camera always gets an image on the negative which truly represents proper perspective from the viewpoint of the camera and photographer, no matter if the camera is angled in respect to the scene.

This excuses the photographer for these initial proceedings, but he will come to trial later for a related crime.

Perspective then is the *responsibility* of the viewer. Take the case of apparent size. For apparent size to be correct, the viewer must get the right distance from the photograph. If he doesn't he will not get proper perspective but there's not much the photographer can do about it unless he has his photo in one hand and the viewer by the ear.

Take the line-of-sight problem. You can stand at the bottom of a tall tree, point the camera up and take a picture. "Here's the way a tree looks if you stand at the bottom and rubberneck." Some viewers will say you took a picture with bad perspective. You did no such thing. What you did was fail to realize that a bunch of dummies would look at your artistic shots.

In photography, the law of perspective is basically a law placed upon the viewer of the photograph. If he gets at the right distance from the photo and accepts what he sees he will see true perspective. Otherwise he won't.

As viewers we have all become very tolerant of incorrect perspective—probably because we see a very large number of photographs. The apparent

size of the image is ignored by the modern viewer unless the error in size-perspective is something very dramatic. If we see a fly eye looking at us and the eye is as big as this page it causes us to hesitate a moment. Because we know all about enlargement of images we say "That sure is blown up a lot" rather than "That sure is a big fly!"

Similarly when we see a picture taken with a close-up lens so a person has a big nose and small ears we tend to think of it as a photographer's trick and say the picture has bad perspective. It doesn't really. If you put your eye up close, the picture will look just like faces always do when your eye is about two inches from somebody's nose.

Whenever a newspaper photographer wants to make traffic look bad or show how confusing the traffic signs are, the standard trick is to use a long focal-length lens which has a very narrow angle of view and stand way back to take the picture. Two cars in the distance which are fifty feet apart subtend about the same angle in your view.

On such a long shot, the viewer has a choice. He can assume that these two cars are fifty feet apart and at a great distance, or he can assume both cars are up close and the one in the back is about to gobble up the one in front. People used to make the second choice more often than they do today, however the long lens is still the press photographer's favorite trick to sneak some editorial bias into his pictures. If the editor is against suburban housing developments, he can send his ace photog out to get a picture showing how they blight the land. Out comes the long lens and the resulting picture appears to show a jammed-up sea of rooftops with hardly any room left for kids to play and people to breathe. You can decide for yourself whether this kind of photojournalism is honest. I think editorial opinion should be labeled as such whether expressed in words or pictures.

I own a book on photography which takes the classical view of perspective and which assumes viewers *require* an apparent size of the image agreeing with the geometry of true perspective. The book shows several pictures of the same house with different amounts of magnification. One of the pictures is supposed to "look right." They all look OK to me because my eyes and mind have been assaulted by too many pictures with incor-

I asked Josh Young, art director responsible for the layout of this book, to shoot a picture for me with his nifty 20mm lens. He did it to his own son. If you can get young Josh to hold still while you put your eye where the camera was, you will get the same view. The photo has proper perspective but hardly anybody will think so.

rect apparent size and I have long since quit worrying about that.

One thing most people have not yet adjusted to is a picture of a tall building taken from ground level. The thing tapers away toward the sky and the perspective is correct on the photo. We tend to think the tall building is falling over backwards. View-cameras and technical cameras have lenses and film-holders which can be tilted and moved laterally. The object is to take *false* perspectives of architecture so the prints will look OK to viewers.

As a photographer, you finally have to decide what to do about perspective and how you will think about it when making a photograph.

My own conclusion is to ignore Da Vinci's classical statement of perspective, which I find a lot easier to do after I understand it than when I didn't. I also ignore all other uses of the word *per-*

When I stand at the bottom of a building and tilt the camera upwards to get the shot, the building appears to be falling over backwards.

Building can be made vertical again by correction during printing as shown here, but it's better to get it right on the negative if you don't want it to look like it's leaning.

spective because they don't mean anything. When I see a magazine article about how lenses and camera angles alter perspective I look at all the pictures but ignore all the words. I have never seen a magazine article which actually defined perspective and if the author doesn't say what it means I figure he is only adding to the general confusion.

DEFINITION: A picture is in correct perspective if it is held at a certain distance and at a certain angle in respect to the viewer's eye so that what is seen on the photo is geometrically indistinguishable from the original scene.

What should you worry about then? You should think about how your picture will impress the viewer. When you are using different lenses and camera angles, what you are really trying to do is persuade or force the eye and mind of the viewer to some apparent location or position. The viewer may refuse to cooperate with you and de-

cide the tall building is falling over backwards. A sophisticated viewer will be less impressed with your trickery than the unsophisticated and both will reach some conclusion about your talent.

Long and short lenses do make the same scene look different—beyond the fact that the longer lens captures a smaller part of the scene. A lot of books on photography emphasize the idea that a camera at a fixed location will have the same perspective even with different lenses and these books show a bunch of pictures to illustrate that. The short lens captures a wide angle of view; longer lenses are shown to get smaller and smaller areas of the *same* photo.

Whether these shots have the *same* perspective or not depends on the viewer's willingness to view them from different viewing-distances and whether or not he falls victim to the idea that a long shot has brought him closer to the scene.

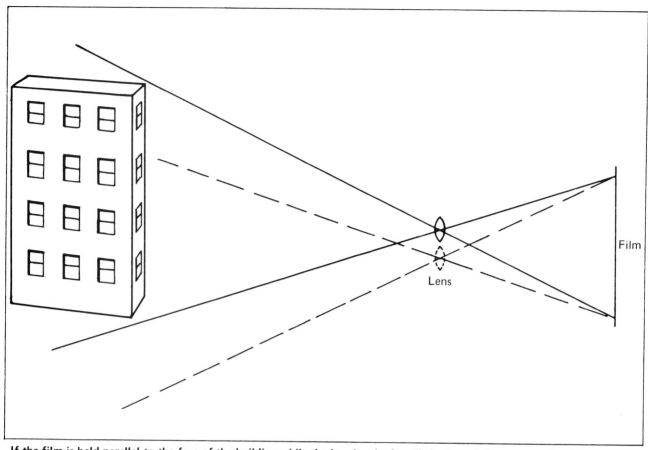

If the film is held parallel to the face of the building while the lens is raised until the top of the structure is within the frame then the apparent perspective of the shot is correct. It takes a special camera or lens to do that.

Linhof Technical or View Cameras have "movements" which allow the lens board to be raised or tilted for special problems and architectural photography.

This special Nikkor lens for 35mm cameras is called a PC lens—for Perspective Control. It can be moved in respect to the centerline of its mount. It's f-2.8 with a focal length of 35mm.

If that messes up your playhouse, I'm sorry. Anybody who offers you a neat and tidy lecture about perspective and tries to pin it all on you and your camera is maybe doing you a worse trick.

The real problem from all this is we've lost a word. If we use *perspective* only to mean what it means, then we have to flounder around trying to talk about how distances and sizes look in a photograph. We can no longer say the photo doesn't have proper perspective because, for its part, it does. Also we can't communicate with the world at large because they all think perspective means whatever they think it means.

I'll settle for the expression *apparent perspective* and use it to mean the way a picture looks in terms of size and distance.

By taking or examining pictures made with different lenses you can get an idea of the effect on apparent perspective resulting from use of lenses in various situations. Then, when one of these effects is helpful in accomplishing the purpose of the picture, you can brag about it.

If there is some particular area which you wish to photograph, such as somebody's nose, the side of a barn, or the side of a mountain, selection of a lens is governed either by where you wish to stand or the apparent perspective that you want to get on film.

Sometimes there are other constraints such as walls and geography. Wide-angle lenses are great for indoor furniture photographs because they will show more of the room while you remain inside the room. Otherwise you will want to remove a wall so you can get the picture. If you want a shot of something on one side of the Grand Canyon and you are on the other, your choice is between a very long lens or a two-day walk.

For sports events, a long lens is useful because you can't get very close to the players. In portraiture, a medium-long lens is useful for two reasons. It allows you to locate the camera a little farther from the subject which makes the procedure less discomfiting to the subject and gets more natural expressions. Also the camera-to-subject distance is a more normal viewing distance and results in better apparent perspective of the face and head.

Here are some handy hints about lenses for use with 35mm cameras.

Nature and Bird Photography	500mm
Sports	200mm
Portrait	85 or 100mm
Normal Situations	50mm
Wide-angle Views	35mm or shorter

The inverse square law

The illuminance of a subject decreases if the subject being illuminated is farther from the source of light. Usually.

Imagine a point source emitting rays of light in all directions. Imagine that the source is contained in a transparent sphere, with the source exactly in the center. The entire surface of the sphere is marked off in squares such that each is exactly one square meter in area, and the distance from the light source to the surface of the sphere is exactly one meter.

Now assume that you can actually see each ray of light emanating from the source. Every

If you lie down under it, this is what you see. Perspective of the photo is correct.

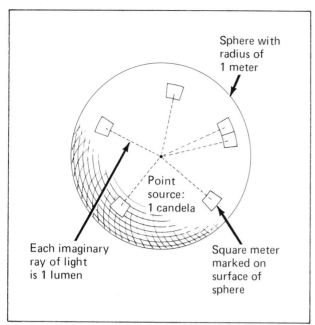

Figure 29/This sketch will help you understand the basic units of light measurement.

square meter of area on the sphere receives one and only one ray of light from the source. There isn't any law of nature that says only one ray can come through each square meter on the surface of the sphere. You just have to imagine that many as shown in Figure 29. If you are imagining two or three rays through each square meter, you are working too hard.

When all this happens, or is thoroughly imagined, the point source of light is called a standard candle, or *candela.* Each ray of light is called a *lumen*, and the illuminance on each square meter of the sphere is one *meter-candle* or *lux.* What you have just done is define some of the basic units of light measurement, *photometry.*

The single ray per unit area is imaginary, but the light source is not and a square meter of surface placed one meter distant is not. We can actually do those things and if the light source is the standard candela, the illuminance is one lumen per square meter, or one meter-candle, by definition. We don't really think a lumen is only one ray and we are not really sure that light consists of rays at all. But if it does, there must be more than one in a lumen because the entire square meter of surface is illuminated by a point source of light. The single-ray business is an aid to visualizing the distribution of light and the definition of a lumen.

If the radius of the sphere is doubled, so the

surface is now 2 meters from the light source, geometry tells us that the *area* of the surface goes up four times. $A = 4\pi r^2$, where A is area and r is radius of the sphere. When r is 2, r^2 is 4.

If the light source doesn't spray out any more lumens, then instead of one lumen for each square meter, one lumen will have to spread over four square meters. To say it another way, *each* square meter will receive only ¼ lumen.

Doubling the distance between source and surface caused the illuminance on the surface to decrease by a factor of 4.

That's the famous Inverse Square Law which says that illuminance varies inversely, meaning in the opposite direction, with the square of the distance from the light source. When the distance gets larger, illuminance is decreased by the square of distance.

Notice that the whole deal is based on the idea of a point source with rays going out in all directions, uniformly distributed. If a light beam is formed of parallel rays then moving a surface farther away will not change the illuminance on the surface. This can be done by placing the point source at the focal point of a positive lens. All the rays which go through the lens will emerge parallel.

If you have a handy point-source of light but you wish only to illuminate a scene in one direction from that source, all the light rays that head off in the wrong direction are wasted. Reflectors placed behind the source such as in a flashlight or flashbulb holder capture the rays going in the wrong direction and reflect them off in the right direction.

A reflector can be shaped to create a parallel beam of light from the rays it intercepts, or a beam that diverges, or one that converges. The reflector can't do anything about rays that don't strike it, so the forward beam from a source with a reflector is determined by the radiation pattern of the source and the reflection pattern of the reflector, each operating on part of the light rays. A reflector behind and a lens in front will control all of the rays emitted by the source, which is what an automobile headlight does.

It turns out that the famous Inverse Square Law isn't universal and is more a law about geometry than about light. It applies to point sources and light sources whose rays diverge. But not at all to parallel or converging beams.

The virtue of f-numbers

I have been saying that the *f*-number of a lens is a way of stating light-gathering power, with the reservation that smaller *f*-numbers mean more light through the lens. And, you know that $f = F/D$.

It may be interesting to compare two lenses of different diameter but the same *f*, to see how that works. Let's pick one lens with focal length of 50mm and an aperture of 25mm, *f*-2. Take another with a focal length of 100mm and an aperture of 50mm, also *f*-2. The proposition is that both these lenses will put the same amount of light on the film from the same scene.

Consider first the difference in lens diameter. The larger aperture is twice the diameter of the smaller, therefore area is four times as much and four times as much light gets through the 50mm aperture of the longer lens.

A simple way to think about the two different focal lengths is to consider some distant subject being imaged on the film. The magnification of the longer focal length lens will be double that of the short lens and therefore the vertical and horizontal dimensions of the image will be doubled—the area will be multiplied by 4.

The longer lens gathered in four times as much light from the subject because of the larger aperture, but used that light to make an image with four times as much area, so the illuminance in the image plane is the same with either lens. In other words, *f*-number does specify light-gathering power.

If you noticed that the argument depends on having a distant subject, you are correct. With shorter and shorter subject distances, *f* is no longer an accurate guide to light on the film because the lens-to-film distance is getting larger. This is the basic reason for the exposure corrections in close-up photography.

The argument also depends on having the subject near the center of the field and the inverse proportionality of f^2 to light on the film does not apply exactly to off-axis subjects. With such subjects, the exposure is less as will be discussed in the following section.

A more astonishing property of lenses is this:

If you stand near a subject, adjust your camera for proper focus and exposure and take the picture, then move back from that scene to take another shot, the only thing you will have to change is focus.

That statement requires some assumptions. It ignores light losses in the atmosphere between you and subject. It assumes that the average luminance of the scene is the same all over so the camera does not see a change in brightness simply because it sees more area when moved back. It assumes that the reflected light from the scene is diffuse, the rays are divergent, and the Inverse Square Law applies, so each point of the scene reflects light toward the camera as though it were a point source. These are reasonable assumptions for most outdoor scenes.

If we assume that the distance from camera to scene is doubled when you move back for the second shot, the amount of light arriving at the lens from each tiny point of the scene is reduced to ¼ the former value by the Inverse Square Law. However, the lens is now looking at a scene which is twice as wide and twice as tall, so the number of tiny points emitting light is multiplied by four. Again, the effects balance each other.

Even with all those assumptions, that is not *exactly* true. In the act of focusing for the longer distance you moved the lens in relation to the film, *decreasing* the distance between them. The Inverse Square Law applies inside the camera too, therefore the amount of light received by the film increases due to the smaller image distance. Let's figure how much more.

If the lens has a focal length of 50mm and is focused on a subject at a distance of 5 meters, the image distance is about 50.5mm. When refocused to a subject at a distance of 50 meters, the image distance becomes 50.05mm, a change in lens-to-film distance of only about 0.45mm. This is less than one percent and the change in light level on the film due to image distance variation will be negligible.

In close-up work, when the subject distance is comparable to image distance, the changes in each are about equal when focusing, and changes in image distance are relatively large. As you can see from the familiar $1/S + 1/I = 1/F$. Therefore the Inverse Square Law does have a major effect behind the lens and on film illuminance.

Illumination across the film plane

Even if the field of view of a lens is uniformly bright, the illuminance at the film plane will vary, being brightest at the center and fading out gradually toward the edges. The reason is in the optics. If the resulting negative with uneven exposure is enlarged, the printing optics are likely to also give uneven light distribution across the print. On account of the negative-positive relationship, an identical light-distribution pattern in printing would compensate for the problem on the negative. Total cancellation or compensation is unusual however and usually some variation is visible on prints if you look for it.

Most of the time the variation is tolerable to the viewer and usually it is not even noticed. I may have done you wrong by calling your attention to this persistent defect. Usually it only bothers me in photos with a lot of sky in view.

There are several causes for this variation of light on the film. Light from any point off the central axis of the lens has to travel *farther* to reach the lens. Inside the camera, light from an off-axis image also has to travel *farther* to reach the film.

If you look directly at a circular aperture, it appears circular and has some area. If you look at it from the side, it has the shape of an ellipse and the total area is *smaller*. Off-axis light "sees" an effectively smaller aperture than that presented to on-axis light.

Finally, the off-axis light arrives at the film at an angle to the plane of the film, rather than perpendicular. This distributes the light over a *larger area* on the film, reducing the illuminance.

For math fans, all these effects vary with the cosine of the angle between a light ray and the lens axis. The off-axis illuminance I_o equals $I_a \cos^4 A$, where I_a is the on-axis illuminance that would be produced by the same source and A is the angle.

All of the effects get worse as the light rays assume larger angles and none are reduced directly by use of a smaller aperture. The reason a smaller aperture doesn't help is that these undesirable effects result from angularity of light rays within the lens field. Closing down the aperture does not change the field of view and therefore is no help.

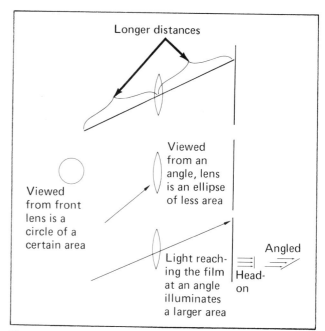

Three reasons why there is less light at the edges of the film frame than in the middle.

Because film-plane illumination falls off rapidly with increasing angles of light rays, lenses which admit wide angles of view are more likely to make pictures in which the effect is pronounced.

VIGNETTING

Compound lenses have significant length and are housed in a tube. Somewhere inside the tube is the mechanical aperture of the lens. As you have seen, the optics may cause the effective size of the aperture to be different than its physical size and of course it is the effective size that functions to regulate the light.

Figure 30 is a lens tube and an aperture. The size of the aperture, its position in the lens tube, and the size of the opening in the tube all work together to create an angle of acceptance for light rays. Within that angle, rays from a source can fully illuminate the aperture. If the source is moved away from the axis so it falls outside the acceptance angle of the lens housing, then the lens tube begins to cast a shadow over part of the aperture. If the source is still farther away from the lens axis, the aperture is completely shielded from the source by the projecting end of the lens tube.

In addition to the angle of acceptance created by the opaque parts of a lens housing, the

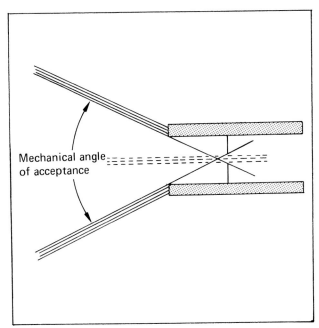

Figure 30/Geometry of lens tube mechanically establishes some angle of acceptance of light rays into the lens.

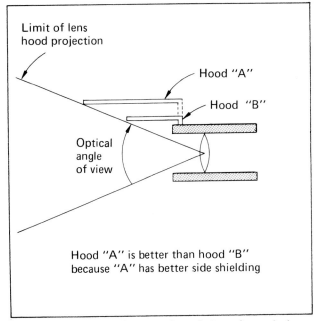

Hood "A" is better than hood "B" because "A" has better side shielding

Figure 31/A lens hood can not intrude into the optical angle of view or vignetting results. Among two hoods which both reach to the "edge" of the angle of view the one with larger diameter offers best protection from light sources outside the angle of view.

optics themselves have an angle of view. If the acceptance angle of the mechanical parts is larger than the field of view, then it doesn't matter what is happening to light from sources beyond the acceptance angle—the lens can't see them anyway.

A problem results when the angle of view of the glass is larger than the acceptance angle of the housing. Points on the edge of the field do not fully illuminate the aperture because some of the light is intercepted by the mechanical parts of the lens.

Obviously this can be caused by a wider-angle lens or a reduced mechanical acceptance angle. When the edges of the picture are noticeably dark the effect is called *vignetting.*

This reduction in edge illuminance is in addition to the other factors which reduce light in the edges of the photo (recited in the previous section).

Lens hoods are very important to reduce flare and ghosts and for maximum benefit to your picture, the lens hood should come as close as possible to vignetting. A rectangular hood does the best job because frames on the negative are rectangular and it can snug in to the edges. The mount must keep such hoods oriented properly.

Reducing aperture reduces vignetting because

it increases the mechanical angle of acceptance. Because a hood must work at max aperture it is therefore less effective at smaller apertures unless tailored or adjusted to the aperture being used.

Light which strikes the front surface of the lens, even though it originates from a point outside the field of view will enter the lens at some oblique angle, go through multiple reflections, reduce picture contrast and possibly cause ghost images. The edge of the angle of view of the lens is the forward limit for the edge of a lens hood, as shown in Figure 31. Among two lens hoods which both reach to the edge of the field, the one with larger diameter gives better protection from off-axis bright spots such as the sun.

Anti-reflection lens coatings on the interior surfaces of a compound lens are very beneficial in reducing flare due to internal reflections of light once it gets into the lens. An anti-reflection coating on the front surface can make the lens more "receptive" to light from sources outside the field of view, depending on the coating and the angle. If more spurious light gets in it is likely to degrade picture quality even though internal lens-surface reflections are reduced. Spurious light may bounce off the interior surface of the lens tube and end

This metal accessory lens hood screws into the threaded "accessory ring" on the front of most 35mm camera lenses.

up as a visible spot on the film. Interior baffling—ridges or surfaces to act as "traps" for the non-image light—is important in any lens and camera, but more so with better lenses.

CRITICAL ANGLE

One type of reflection is a "good guy." It allows you to see an upright image in your viewfinder. It is based on the idea of a critical angle of reflection.

If a light ray inside a high-index medium such as glass strikes a glass-air boundary surface, some of the light will be refracted during passage through the surface and some will be reflected by that boundary and remain in the glass.

As shown in Figure 32, if the angle of incidence of the incident ray is made progressively larger, the refracted ray on the other side of the surface becomes nearer and near parallel to the surface. With increasing angles, some point is reached where the refracted ray is parallel to the surface and does not actually escape from the denser medium.

That angle is called the *critical angle of reflection.* If the incident angle is greater than criti-

This rubber hood mounts the same way. I judge the rubber one is best because it has larger diameter and sticks out farther in front of the lens.

The rubber ones collapse neatly which sometimes allows you to store the lens in a case without removing the hood.

cal, the ray not only stays in the medium, it returns from the surface boundary and appears to bounce off in a new direction.

The lives of fish must be profoundly influenced by this phenomenon. If you lie on your back in the bottom of a pool of water and look up to the surface, it will appear as a mirror except for a circle directly above you, through which you can see the outside world. This circle is caused by the critical angle between water and air.

In an optical system, by keeping the angles above critical in a high-index medium such as glass, we can bounce light around as much as we choose without losing any except by absorption in the glass itself. None will get out. This is how prisms are used to change the direction of light and to turn an image upside down to make it right side up.

After a prism has done its tricks, it lets the light out finally by allowing it to find a surface at an angle smaller than the critical number. Incidentally, no law requires a prism to have only three faces.

At the points marked "A", the light inside the prism is totally reflected and none escapes because the angle of incidence is larger than critical. This is sometimes called total internal reflection.

Figure 32/At some angles of incidence, rays passing from a more dense medium are refracted at the boundary surface so they remain in the dense medium.

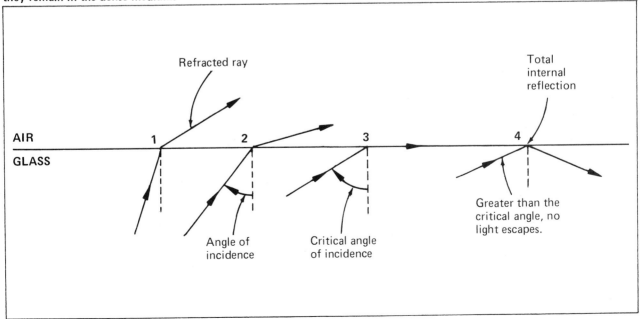

Light meters

Modern SLR cameras measure the amount of light en route to the film at a point somewhere inside the camera, between lens and film. This greatly simplifies light measurement and works fine as long as the light meter works fine.

Some manufacturers of separate hand-held light meters call attention to that last point in their ads and suggest you carry a hand-held as a spare. It is a point worth considering when it is vital that you get satisfactory photographs.

Light is measured by allowing it to fall on a little gadget like a transistor. One type, made of selenium, acts like a battery when light strikes it and generates more electrical current when there is more light. The amount of current is then measured with an electrical meter whose face is calibrated to read the amount of light. This type does not require any electrical power source, such as a battery, because the selenium sensor generates its own electricity. Selenium sensors are relatively insensitive.

Cadmium sensors are more sensitive to light but do not generate any electricity themselves. They require a battery connected in series with the sensor. Then when light strikes the sensor it reduces its electrical resistance and allows more current to flow from the battery. In a similar way this current can be measured by a meter and the light-value determined. When the battery goes dead the instrument stops measuring light.

However, cadmium sensors can be smaller due to their intrinsic higher sensitivity and when space is scarce—as on the inside of an SLR—small size has an advantage.

Most built-in light meters are cadmium and use a small battery housed in the camera. The battery is supposed to maintain a uniform voltage, last about a year with normal service, and then fail suddenly. I usually intend to change the battery before its birthday and I usually intend to carry a spare in case I forget.

I happened to have this frozen orange juice can so I decided to paint it black and make a handy inexpensive lens hood.

It turned out to be a handy inexpensive vignetting device. Goodo ordered a dozen wallet-size prints for his friends and an 8x10 enlargement.

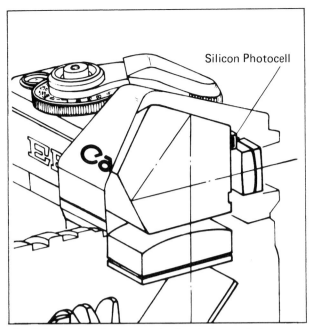

The light-sensing element can be located several places inside a camera. This sketch of a Canon EF shows the photocell "looking" into the pentaprism from a location just above the viewing eyepiece. The camera uses a silicon photocell for reasons shown in the next drawing.

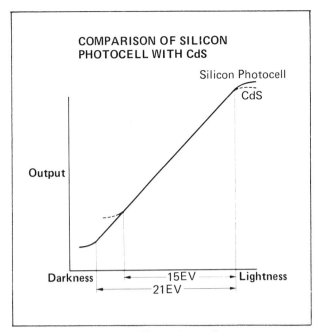

As shown by the curve, silicon photocells can operate over a greater range of light values or EV (exposure values) than a conventional cadmium-sulfide type, designated CdS on the dotted curve. Canon uses the extra sensitivity at the low-light end to allow the EF camera to operate automatically at very low illumination levels. Because silicon cells have low electrical output a sophisticated integrated-circuit amplifier is used inside the camera.

Life of the battery is not really regulated by the calendar. When it has delivered all of its charge, it's all done. Therefore battery life depends largely on how much the light meter is used and even how bright the light is you are measuring because more light means more current flow from the battery. Most battery-powered light meters have an on-off switch. If you leave it on and leave it in the sun, the battery will run down just like the one in your car when you leave the lights on in the parking lot.

Because a lens-cap prevents light from entering the lens, it also acts as an on-off control for the light meter built into an SLR. If you keep the lens covered, you don't have to worry about the meter switch and you will get longer life from the battery. Also the lens.

Exposure meters

There you stand, camera at the ready, the scene patiently holding still so you can take its picture.

"Hey there, old light meter," you say, "How much light is there?" Expectantly.

"Exactly 235,742 lumens, Friend." Reliably.

Mamiya/Sekor DTL cameras have an unusual feature— a switch to select either full-frame averaging or spot metering. When spot metering is selected, the built-in exposure meter reads only 6% of the frame area, indicated by marks in the viewfinder.

"I didn't mean that!" Testily.

"So what do you want to know?" Tiredly.

"How to set my camera." Firmly.

"Try *f*-8 at 1/250." Last-wordily.

Measuring the amount of light isn't enough. Proper exposure is what we are after. What is needed is a light meter to measure the amount of light *and* an exposure calculator to tell you how to set the camera. The exposure calculator needs more information.

In addition to illuminance, exposure calculators deal in film-speed numbers, *f*-numbers, and shutter speeds. That's four ingredients. Give the calculator any three and it can tell you the fourth. A light meter and an exposure calculator when combined make an exposure meter.

Built-in exposure meters either tell you what to do, or tell the camera what to do. If it is bossing you around, there will be a display in the viewfinder—a moving needle or flashing lights—which must be satisfied by you when you set the camera controls. If the camera is automatic, you set either shutter speed or *f*-number and the camera does the rest.

The Konica Vari-Angle metering system is designed to act as a spot meter with wide-angle lenses, a center-weighted meter with normal lenses, and an averaging meter with long lenses. The premise is, the subject of interest is usually a small part of the frame when you are using a wide-angle, and a larger part of the frame when you are using longer focal-length lenses. Diagrams show two sensors, one on each side of the eyepiece, each angled inward and toward center.

The sensor placement, together with the optics, automatically produces the meter sensitivity patterns shown—covering more of the scene with longer lenses.

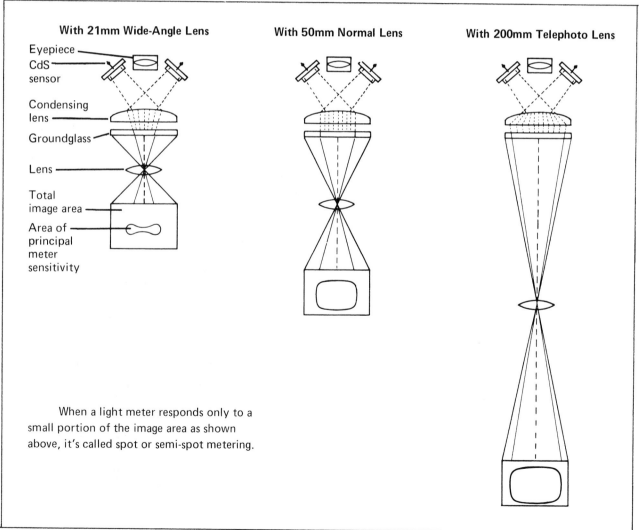

With 21mm Wide-Angle Lens

Eyepiece
CdS sensor
Condensing lens
Groundglass
Lens
Total image area
Area of principal meter sensitivity

With 50mm Normal Lens

With 200mm Telephoto Lens

When a light meter responds only to a small portion of the image area as shown above, it's called spot or semi-spot metering.

Either way, you will get good average pictures of average scenes. It's time you started thinking about that. Except for a couple of special cases I will mention later, every normal exposure meter, built-in or not, automatic or not, has to make some kind of *assumption* about the scene. The poor dumb thing doesn't know what it is looking at, so it has to assume some kind of a scene out there. What kind can it assume? An average scene and *only that.* It makes no sense at all to sell people cameras designed to work best on un-average scenes. Most people shoot landscapes, Aunt Minnie in the rose garden, and Sonny at graduation time. Those are average scenes.

Because $E = I \times T$, data on illuminance, *f*-number and shutter speed allow calculation of the amount of exposure there *is,* but that doesn't tell you how much there *should be.* Different exposure is required for different types of film. The basic information needed to calculate normal exposure for any particular film is concealed in the speed rating of that film as announced by the manufacturer and printed on the carton and instruction sheet.

In the USA, we call this information the ASA rating, or ASA speed, or sometimes just speed. Whatever we call it, it's a number which tells your exposure calculator what the exposure should be for that film. In a rather curious way.

FILM SPEED RATINGS

Actually speed numbers serve two purposes. One is to help you choose film for what you intend to do with it. You can buy film rated at ASA 25 which is slow film and takes a lot of exposure, or 125 which is intermediate, or 400 which is considered pretty fast.

If you intend to shoot outdoors in bright sunlight, you don't want the handicap of ASA 400 film unless you are willing to have depth of field

from here to infinity.

You learn about choosing film speed for the job to be done.

The second purpose of film-speed numbers is to tell your exposure calculator how much exposure the film needs to do a good job on an average scene. Film speed is an input to the calculator and you put it in by some control, such as a knob or dial. More info in the following section.

The two dominant speed-rating systems in use are ASA and the German DIN system. They agree at 12. From there ASA doubles (approximately) each time DIN goes up by adding 3 units.

FILM SPEED RATING	
ASA	DIN
12	12
25	15
50	18
100	21
125	22
160	23
200	24
400	27
800	30
3200	36

The Mamiya/Sekor 1000 DTL model does spot-average metering a different way. The two photocells near the pentaprism are switched in for average metering of the entire frame. For spot metering, a third cell just behind the mirror is selected by the switch. This cell reads only part of the picture area using light that gets through the semi-reflecting mirror.

The Mamiya/Sekor auto XTL model accomplishes spot-average metering with this sophisticated printed-circuit CdS sensor which is mounted behind the mirror and moves up when the mirror does. Reflex mirror is also special, it allows 30% of the light to pass through and fall on the CdS cell. Remaining 70% is used for viewing.

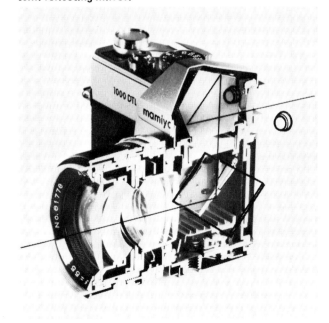

How a match-needle indicator works

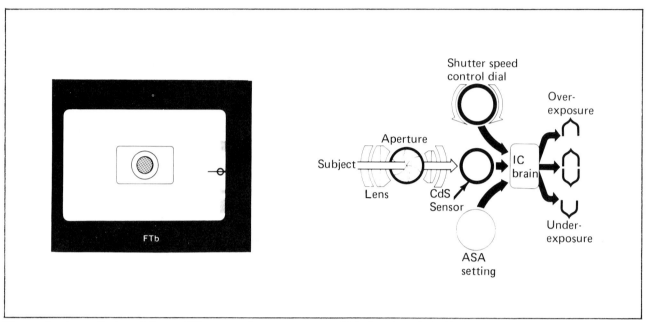

Ring and pointer display of Canon FTb camera is representative of match-needle displays on cameras which allow viewing at full aperture. Exposure controls plus light reading cause both ring and pointer to move in the display. When they are aligned as shown here, camera exposure computer is satisfied.

This drawing of the Yashica TL-ELECTRO shows use of an IC (Intergrated-Circuit) "brain" to solve the exposure equation and operate light-displays in the viewfinder to show over-, under-, or correct exposure. An exposure calculator has to know: Film speed, shutter speed, aperture, and the amount of light. Then it can figure exposure.

Let's assume for the moment that the scene is average, so the grand scheme will work, and look at the internals of a match-needle SLR. One arrangement is two moving indicators, a needle and a circle, both of which move up or down in the viewfinder, over at the side. Exposure is OK when they line up—the pointer passes through the circle.

Your camera may be similar, or use some other indicator system such as lights. However it is displayed, the idea is the same. It tells you when the exposure is right. Which means:

Required exposure = Actual exposure.

Actual exposure is what is coming in through the lens. Required exposure is the manufacturer's advice, fed into the calculator when you dial in the film speed.

The display in my viewfinder uses the ring and pointer scheme. The pointer is moved up by:

More light
Longer exposure time
Higher film speed.

The ring is moved up by larger *f*-numbers.

When the pointer and ring are in alignment, that means the required exposure is equal to the actual exposure. The calculator has solved an exposure equation, camera adjustments have been made, and you can trip the shutter.

Let's take a look at the "Required exposure" side of the equation. Some amount of illuminance, measured in lumens or meter-candles, multiplied by the exposure time in seconds, gives the required exposure in meter-candle-seconds. Several pairs of values for illuminance and time can give the desired exposure as long as the time doesn't become so long or so short as to cause reciprocity failure.

A typical value of required exposure for fast

film is 0.0025 meter-candle-seconds. Because the film-speed rating is intended to tell you and your camera how much exposure the film needs, you might expect the film maker to tell you very directly that it is 0.0025. He doesn't.

Evidently a tiny bit of a number such as 0.0025 is an embarrassment when it is supposed to impress you with how fast the film is. So the maker doesn't tell you that little number. He divides it into one—takes its reciprocal—and announces the reciprocal to the world as a film speed rating.

$$\text{Speed} = \frac{1}{\text{Required exposure}}$$

or,

$$\text{Required exposure} = \frac{1}{\text{Speed}}$$

In this example 1/0.0025 is 400 and the film we are talking about is good ole Tri-X, the photographer's friend.

You can live happily and accomplish great photographs without knowing that, but your camera can't. It has to know that required exposure is the reciprocal of film speed.

If you want to accept the idea that an exposure calculator first finds the reciprocal of film speed and then finds an actual camera exposure to match, fine. Skip on past the arithmetic below.

If you are comforted by the math, it isn't very complicated.

Some symbols we will use are:

I is the illuminance on the film as measured by the built-in light meter.

T is the length of time the shutter is open.

Exposure increases with an increase of either **I** or **T** and exposure also changes according to f-number. Because f is based on the diameter of the aperture instead of its area, exposure varies according to the f-number squared. Because larger f-numbers mean smaller exposure we have to put the f-number in the denominator of a fraction.

$$\text{Actual Exposure} = \frac{I \times T}{f^2}$$

$$\frac{1}{\text{Speed}} = \frac{I \times T}{f^2}$$

or,

$$f^2 = I \times T \times \text{Speed}$$

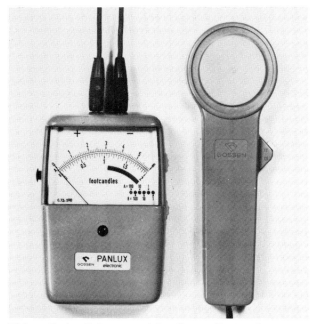

This really is a light meter. It's a Gossen Panlux Electronic Footcandle Meter and all it does is measure the amount of light in footcandles which are cousins of meter candles. Illumination engineers use these. Photographers need an exposure meter.

NOTE: The unit of light measurement called meter-candle is also called *lux*. There is a trend in technical literature to use *lux* and *lux-seconds* instead of meter-candle and meter-candle-seconds.

Gossen Super Pilot Exposure Meter measures light—either incident or reflected. With a little dial-setting by you, it recommends exposure either by pairs of f-numbers and shutter speeds, or an EV number.

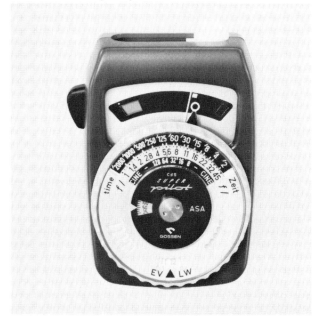

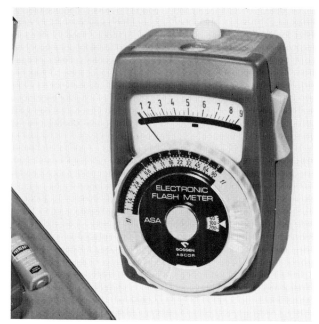

Electronic Flash Meter by Gossen Ascor is handy to check flash illumination of a scene without wasting film. Put the meter where you are going to shoot, pop the flash, then read the meter for *f*-number you should use to expose film.

which does exactly what the indicators in my camera do.

For example, a higher film speed can be balanced by a higher *f*, or smaller aperture, or shorter time. More light calls for a higher *f* or shorter time, and so forth. If you want to look back a few paragraphs to see again which way the indicators in the camera viewfinder are moving, you will see that they tell you when this exposure equation is in balance.

Some cameras use different indicators such as light-emitting diodes but they all must satisfy the exposure equation before they tell you to click the shutter. An automatic camera will even make an adjustment for you by changing either **T** or *f*, depending on how the camera is automated.

Incidentally, I fudged a little back there when I said the required exposure is equal to 1/Speed. I left out some constants. If you want to get really serious about it, the USA standard covering automatic exposure controls for cameras says exposure is equal to **qK/Speed**, where **q** and **K** are both constant numbers. The sense of it is not different than 1/Speed.

If you didn't chase the arithmetic all the way, it doesn't matter as long as you wind up with some ideas:

1. The film manufacturer states the normal exposure for an average scene. This information is concealed in a film-speed rating.
2. An exposure meter, whether built-in or not, measures the light and calculates a pair of values for *f* and shutter speed to give the exposure requested by the film speed.
3. Several combinations of *f* and shutter speed yield the same exposure. The photographer can select shutter speed and then use whatever *f* is indicated, or the reverse.
4. Because everybody who plays this game is assuming you are going to shoot an average scene, the system fails to expose properly if you shoot a non-average scene. More on this later.

THE STANDARD SERIES OF FILM-SPEED NUMBERS

There is a standard series of numbers to be used for film speeds, the same as there are standard series for *f* and shutter speeds. The film speed series is easy to construct. Start with ASA 25 and go up and down from there in a geometric series based on 2. The numbers are rounded off a little, for simplicity. The series is:

3, 6, 12, 25, 50, 100, 200, 400, 800, 1600, etc.

Intermediate speeds are allowed if that's what the film does. The film-speed number is sometimes called Exposure Index, abbreviated EI. This is often used to indicate a speed-number different than the standard ASA rating for a particular film.

Film speed as a camera control

Film speed is essentially only the manufacturer's recommendation. If you accept his recommendation, you feed that number into your exposure calculator and it will balance the exposure equation so the camera exposes that amount. If you want to expose some other amount, you can do it two ways.

You can set the standard speed number into the camera and then not balance the viewfinder display. Sometimes I choose to use more exposure than the manufacturer suggests, therefore I don't match the needle with the circle in the viewfinder. I can feel the clicks on the aperture ring and by counting them as I move the circle away from the needle I know how much extra exposure I am allowing. Two clicks is one step.

I prefer to do it that way because I always know when I am using more or less exposure than recommended.

If you decide you will always use more or less exposure than the maker suggests, or at least you are going to do it for a whole roll of film, then it is simpler to use a different speed rating. If you dial in a higher speed rating, the camera exposure computer will be satisfied when there is less exposure. If you then set the camera controls so the viewfinder display indicates correct exposure, you will be using less exposure than with the normal speed rating. If you dial in a lower speed number, you are asking the camera to use more exposure.

Because the speed-number dial on your camera controls exposure, you can certainly use it as an exposure control if you choose to. Film speed is not a magic number.

IS THE MANUFACTURER EVER WRONG?

I don't think film makers publish incorrect speed ratings on purpose and very rarely by accident. The way film speed ratings are obtained in the laboratory has changed a couple of times in the past, which really means that the definition of speed was changed. This caused some wholesale, across-the-board changes, but that is unusual. Sometimes a manufacturer will announce a new and different speed number for a type of film but my guess is they changed the film and published the new speed for that reason rather than to confess past errors. Some people interpret these occasional speed-rating changes as evidence of a big goof at the factory, but I suspect that is wishful thinking.

Also, some photographers go out and shoot non-average scenes with standard film-speed dialed into their cameras and make no exposure adjustments away from standard. The pictures don't come out right. The photographer falls into a bad mood and has dark suspicions about nearly everybody. He does a lot of thinking about it, maybe some experimenting, and finally discovers that he gets better results from a non-standard scene when he uses a non-standard speed rating. Then he hollers about the speed rating being wrong. It isn't.

Also, about every 30 minutes somebody discovers that a change in developing procedure makes the film act like it has a different speed. This is announced with fanfare and the multitudes contemplate about it. The published film speed is valid only for one method of development as you will see in about one more page more or less. The film makers know all about that. They just don't advertise it much.

Rather than suspect incorrectly rated film, you are better off with two ideas:

The published film speed is correct if you know what it means.

You don't have to use it unless you want to. Dialing it into your camera is just a way of controlling exposure. You change f and shutter speed 40 times a day, but you are afraid to touch the film speed dial, aren't you?

How negative film is speed-rated

Because speed rating is a way of stating a recommended exposure, it is a very important thing. The beginning photographer doesn't know exactly what it means and tends to accept it as gospel. Luckily, the average photographer also shoots mainly average scenes, so the doctrine of speed ratings is to base everything on the assumption of average scenes and thereby "save" the average cameraman.

You should review in your mind what the exposure problem is, in relation to a film-characteristic curve, with the toe and the shoulder and all that. The basic exposure problem is to center the exposure range on the curve so it doesn't hang off either end with resulting tone-value compression in both the light areas and dark areas. Obviously this is not possible if the brightness range of the image exceeds the exposure range of the film.

Therefore the first necessity is that the film

have enough exposure range to accept an average scene. We can trust the manufacturer to do that. Because he likes to sell the stuff.

Solving the exposure problem under those conditions and assumptions is straightforward. You merely have to locate the center point of the exposure range and put it on the H & D curve at the right place.

If the scene-brightness range is average, but we miss locating the center correctly on the film curve, then one end or the other will be compressed by toe or shoulder. A useful consideration is to inquire which is worse, tone-blocking in the toe region or the shoulder region of the negative. If we decide that one is much more critical than the other, we can take positive steps to prevent that one from happening.

Everybody agrees that blocking in the toe of the negative is bad. On the print, that region becomes the shadows and loss of shadow detail is very obvious to any viewer. Loss of highlight detail is generally less obvious except to experienced viewers. So the location of one end of the exposure range, the toe region, is more important and we will do that, allowing the other end to fall where it may.

As you remember, if the brightness range of the image is much less than the exposure range of the film, there is some exposure latitude. The center of exposure can be moved up and down along the straight part of the curve without compression at either end, as long as the latitude is not exceeded.

Because a thin negative is generally preferred, you want the low-brightness end of the exposure to be located on the toe.

For these reasons, speed rating of *negative* black-and-white films begins with the location of a point on the toe of the film characteristic curve, shown in Figure 33.

The point chosen on the toe is called H_m, meaning minimum exposure, and is considered to be the lowest useful density of the negative. It is on the toe but it still has enough slope or gamma to give separation of shadow tones.

From this minimum density a second point is found which has 1.3 units of additional exposure *and* has 0.8 additional density. The second point, called H_n, has to be a certain distance to the right of H_m and a certain distance above it. A

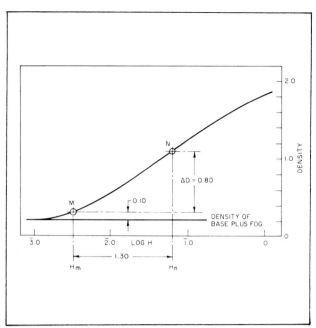

Figure 33/Speed of black & white negative film is determined by exposing and developing to get the film characteristic shown by this curve. The "speed point" M is found and the exposure for that point is identified as H_m. ASA speed is calculated by $0.8/H_m$. Which is the same as $1/H_m$ minus a 20% safety factor.
In most of this book the symbol used for exposure is E, rather than H. For the sake of authenticity, the drawing is reproduced exactly as it appears in the American standards document and therefore the symbol H is used in the drawing and discussion of the drawing.

further requirement is that the film curve has to pass through the H_n point and that requires the curve to have some definite slope or gamma. The required gamma is $0.8/1.3 = 0.6$ and this requires some particular development to get that value.

The assumption in regard to gamma is that's a good average slope of less than one so there will be a nice long exposure range to capture the brightness range of the scene.

Even though film can be developed to different values of gamma, or contrast index, speed is only measured when the gamma is 0.6 and the resulting value is only accurate at that gamma.

The density at H_m is standardized. It is a density 0.1 above the density of fog and base com-

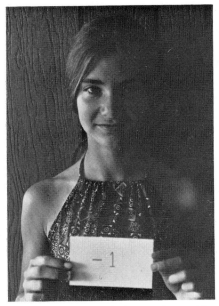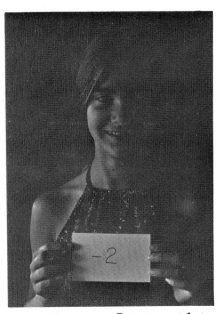

Photo at left was shot according to exposure meter recommendation, so is considered "normal" exposure. Exposures at 1 step less and 2 steps less show tone values of scene "sliding" down film characteristic curve and out along the toe of the curve so shadow detail is blocked.

bined. When you get that high up, you are starting into the useful range of densities of the negative.

The point on the curve, H_m, is called the speed point and that amount of *exposure* is used to calculate speed ratings.

In the earlier discussion of exposure calculators, I said that required exposure was figured by taking the reciprocal of speed, but near the end I confessed that I had simplified the idea by leaving out a constant qK. The exposure calculator in your camera actually figures required exposure as follows: Required exposure = qK multiplied by 1/**Speed**. Now we can understand what qK does. Its value is approximately 8.

Speed is calculated from an exposure down on the toe of the curve, but the center of the exposure range should be higher up, in fact about 8 times higher. What the qK factor does is simply multiply the minimum exposure to get the average exposure of an average scene.

What it all boils down to is this: The exposure calculator takes the reciprocal of speed to find the minimum exposure on the toe and then multiplies that value by 8 to find the exposure for the center of the brightness range.

SAFETY FACTOR

The speed rating and calculator procedures described above will locate an average scene on the film curve so the lowest light values fall near the minimum exposure point, which is exactly what the film manufacturer recommends. However, this creates a built-in booby trap for the guy who shoots a slightly non-average scene or who doesn't meter scenes accurately.

For example a subject against open sky is difficult to meter. If a lot of light from the sky gets into the meter, it will appear that there is more light coming from the overall scene and the exposure meter will suggest reduced exposure. The result will be an exposure which is fine for the sky but not for the subject. Subject will be underexposed.

To protect unwary photographers from problems like this, negative films have speed ratings which include a safety factor. For black-and-white, the advertised speed rating of the film is only 80% of that which would be calculated by taking the reciprocal of exposure at the speed point, H_m. Because the quoted speed is 20% low, when you dial that speed number into your calculator the resulting exposures are 20% *high*. That extra 20% is called a safety factor. In earlier days, the factor was a lot more, sometimes one or even two steps of exposure.

Where does the camera center the exposure?

The simplest type of exposure meter takes light from the entire scene being photographed and is unable to distinguish bright parts of the scene from dark parts. It just responds to all of the light that enters the meter. What it reads, then, is the *average luminance* of the scene.

When the exposure computer is given a target exposure by the speed rating and measures the average luminance of the scene, it then computes a camera control setting so enough total light is accepted from the scene to match the required exposure value.

When a scene is average, the *middle* light value comes from those parts of the scene which have 18% reflectivity. That's important. Also, the *entire* scene reflects 18% of the incident light as seen and averaged by the simple light meter. That's important too.

An average scene

Want to meet a genuine average scene? It is an 18-percent gray card which fills up the entire field-of-view of your camera. Therefore a card or the side of a house painted with 18-percent reflectance gray paint will look like Old School Colors to the exposure calculator in your camera.

The problem is that your exposure calculator has been taught to believe *every* scene is 18% reflectance. So if you shoot a snowbank in bright sunshine, the calculator will put that exposure at the mid-point on the curve. Your print will be a beautiful shade of 18-percent gray. Take a shot of a solid dark wall, back comes the print— 18-percent gray. Nothing is wrong with the system because that's how it's supposed to work. What's wrong is you.

Suppose you try the snowbank shot again. Your exposure meter takes a look at it and says, "The light on that 18-percent gray snowbank sure is bright because I am getting a terrific reflection from it." The camera stops down to make the snow look 18-percent gray.

1/I made a little demonstration out of paper. On a large piece I thought was close to 18% gray, I put two white cards and two black cards. Then I took the two photos at right.

If you want the snowbank to look white, you have to figure out some way to set the camera so it would make 18-percent gray look 18-percent gray and therefore snow would look like snow. There's a clue. If you put an 18-percent gray card on the snowbank, so it is illuminated by the same light that falls on the snowbank, and then take your exposure reading off the card, you will get a good realistic shot of a snowbank with an 18-percent gray card leaning on it.

If you remove the 18-percent-gray card after setting the camera and then take the shot, nobody will care. The snow will still look like snow should— on the negative. If you have your processing done at the drugstore, you have a problem with unusual scenes. The processing equipment is automatic and it too, believes all scenes have 18-percent reflectance.

However, at least in exposing a negative the 18-percent-gray card is a handy calibration. If you take the exposure reading off the card, everything in the scene should have the same exposure it would have if it were part of an average scene— even though it is really part of a non-average scene.

There are some other standard exposure references. The palm of your hand reflects about one exposure step more light than 18-percent gray. I

2/I placed the setup so half was in shadow, half in sunlight. In this photo I metered on the 18% gray section in direct sunlight. It came out gray, the white and black cards in sunlight came out reasonably close to real life. In the shadow, the white card is dark and the black card disappeared.

3/Then I took the exposure reading from the 18% gray section in shadow. In shadow, the black and white cards look fine. In sunlight, everything is overexposed. Moral: Metering on a gray card or any substitute metering surface whose reflectance is known does a fine job on scenes under uniform illumination. The technique can't cope with problems like this—half light and half shadow.

am told that this is true without regard to race, color, or prejudice. But maybe you should check your own palm anyway.

If so, you can take a reading from your palm recognizing that the meter saw one step more light than from an 18-percent-gray card. The meter will be fooled into recommending an exposure one step too low. Add one step to what it says and shoot.

If you take a reference exposure from a white surface, it will reflect about 90% of the light, five times as much as 18%. The exposure meter will give you a too-low camera setting.

Correct it by increasing exposure time by five and choosing the nearest setting. Or divide film speed by five and set to the nearest click. Or add about two stops of aperture, which means you take the second smaller f-number—about as close as you can get to a five times exposure increase.

Such tricks help to expose a scene which is unbalanced—either with a lot of light area or a lot of dark area. Caution: Don't be misled by the ads which say automatic cameras solve all exposure problems for you and you get only magnificent pictures. They will only expose properly for average scenes. They are not any smarter than simpler cameras, just fancier. Engage brain before clicking shutter.

Much of the time you can get acceptable pictures by just doing what the exposure calculator tells you, even if the scene is not exactly average, provided it does not have a wide range of brightness. Exposure latitude saves you.

INTEGRATED AND DISINTEGRATED

Time to think a little more particularly about what your exposure meter "sees." If it is simple-minded, it just averages, or integrates, the total light received and treats the scene just as though it has constant luminance everywhere. This kind of meter can get you in trouble as discussed already. You want to shoot a pretty face against the sky. If a lot of sky is showing, the excessive light from the sky will cause the computer to ask for less exposure. The face will be underexposed.

A solution is to walk right up to your subject and take an exposure reading so close that all the camera sees is the face. Add one step if you remember about Caucasian skin versus 18-percent gray. Back up and shoot. Face will be just right. Sky will be overexposed but there isn't anything you can do about that if you actually do want detail in the face image. If you get a lot of lens flare, face won't be just right after all, but that's a different problem.

If you have a bright subject and a dark subject in the same scene and you want to try to pre-

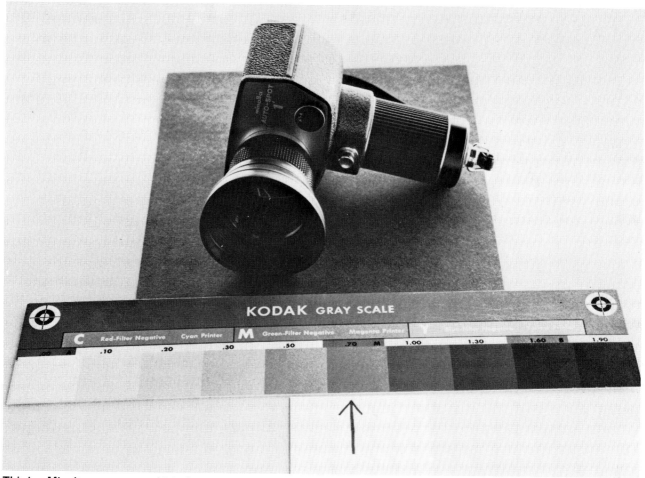

This is a Minolta spot meter which shows you 10 degrees viewing angle but meters on a 1-degree spot in the center. The Kodak gray scale is designed for the printing industry as an aid to color-balancing and that application will be touched on later.

The white patch at left on the gray scale is labeled .00, which is a relative indication of density. The other densities are referenced to that zero and range up to 1.90.

The arrow designates a shade which is approximately 18% gray. Look around in the print and you should find shades of gray to match all those on the gray scale. All shades of gray on the scale should be distinguishable to you but if not, don't worry too much. That's the perpetual problem in photo reproduction on a printing press.

NOTE: I am not showing you an 18% gray anywhere in this book that I represent to be accurate. To do so requires precision control of the printing process that is not practical in high-volume printing of books. Kodak supplies 18% gray cards that are made under precise control so they are accurate. If you want to see one, or use one, they are available from your camera dealer in several Kodak publications.

serve detail in each, then you want to expose so these two important areas are equidistant from center. You can put your hand-held exposure meter close to each subject, or put your camera lens there if you are metering through the lens. Each subject will yield an exposure setting. Use an exposure which is the geometric average of the two. Greek staircase again.

Makers of SLR cameras with internal metering offer a variety of solutions to that problem of metering the entire field. New models proliferate with many different schemes to allow you to photograph Aunt Minnie silhouetted against the sky or standing in front of her white-painted bungalow.

One scheme is called *center-weighted*. The metering system pays some attention to the entire

field but more attention to the center part of what you see in the viewfinder. If you meter your artistic photos with the subject of greatest interest in the middle of the frame, you'll love a center-weighted exposure meter.

Another way is to meter individual areas of the scene separately and then combine the readings some way to arrive at the compromise. Some cameras do this with more than one light-measuring cell inside the camera, each taking light from a different part of the scene. Some cameras meter the lower part of the scene to minimize the effect of sky in the background.

Any of these methods is probably better than metering the entire field unselectively if the photographer is taking non-standard scenes.

Some cameras approach the problem in a less technically sophisticated way which turns out to be more sophisticated in application. These cameras meter only a small area of the field and show you in the viewfinder which part of the scene is being metered. One brand measures with an angle of about 8°. With a 50mm lens, it is *taking* the picture over an angle of about 45°. This kind of limited-area metering is called *semi-spot metering*. You can meter a small area of the scene without

having to get so close, and you can do it faster. If you are shooting a portrait, you can meter on your subject's face without getting so close that your intentions are suspect.

The main disadvantage of semi-spot and center-weighted metering is that you have to know you own it. Because you are only metering part of the scene, you may not get good exposure of some portions which are very dark or very bright but are not included in your metering angle. The solution is to use the meter to look around in the scene, observe the brightness range if it is high, and then compromise the setting or do whatever you choose.

There are special hand-held spot meters which measure with an angle of only about one degree. To aim the meter you look through its viewfinder with a viewing angle of about 10°, the spot you are measuring is identified by a circle.

Drug stores don't really process film

I knew that all along. It was a little joke. Maybe.

I shot this handy motto two ways and sent the film to a commercial photofinisher for standard development and automatic print—the normal service you get through drugstores or film outlets. In one shot I surrounded the motto with white paper, put an 18% gray card beside it and metered on the gray card. In the other shot I did the same thing except the motto was surrounded by black paper.

Because I metered on the gray card, the tone values were correct on the negatives, but the automatic printer was "fooled" by my non-average scenes. It couldn't believe all that white background, so it darkened it some in printing and also darkened the gray card. Nor could it believe the black background, so it lightened it and also the gray card. This is not a criticism of automatic printers. That's the way they are programmed to work. It's to remind you that if you are making exposure tests or shooting a lot of non-average scenes, don't use automatic printing. Do it yourself or find a custom lab to do it for you.

Drug stores and most camera stores send customers' film to commercial photo-finishers for processing. These labs develop negatives in big machines and work hard at keeping the process uniform and standardized. In negative processing they assume you have exposed properly and develop accordingly.

Then they make prints. The process is basically the same as exposing a negative in the first place. A light reading must be taken through each negative, exposure adjusted to make a print, and the print exposed. Processing of the print is also standardized. If you are getting a feeling again about what this automatic printing equipment is going to do to your perfect exposure of a snowbank, you are right.

Even if you use a gray card for exposure calibration and get the snow just right on your negative, the automatic printer will try to make it 18% gray on the print, if it's black-and-white film. If it is color film, you get that plus another rule developed to help color printing machines make color corrections while printing. The rule for automatic color printing is that everything in the scene should integrate to gray.

If you shot a color negative under a green light, the automatic processor will do its best to get that strange green cast out of your print, because it has been taught to believe all scenes are average and average integrates to gray. Actually, machines that enforce this idea too strongly wind up spoiling too many prints, so some limit is placed on the amount of correction a commercial automatic color printer can dial in. But the idea is the same.

This part of the book is mainly about black-and-white films, so let's get back to that.

The trick in exposing your negatives is to learn to recognize non-average scenes and then expose accordingly. You learn to recognize non-average scenes very quickly after you have shot a few. In general, the background is the problem. If it is unusually bright, the exposure meter will take all that brightness into the average value of the scene, then put that average value near the midpoint of the exposure range. This will drive the *desired* part of the scene down toward the toe or into the toe of the curve. The reverse happens for a bright subject against a dark background.

Recently I needed a shot of a special small metal screw in a hurry. I put the screw on a white background, got some light on it, put a close-up lens on my camera, and shot the picture. The screw was so small that even with semi-spot metering most of the metered area was the white background.

I've been bit by this kind of snake before and think I know how much to open up to get both background and metal part to look right. I opened up two stops from the exposure meter recommendation.

Then I used commercial processing because I was in a hurry and could get prints the next day. The print came back with a gray background. So I sent the neg to a custom lab where they know the kind of pictures I take and what to do about them. Their print came back with a lovely white background and that little metal screw looked just fine.

Incident light versus reflected light

Because of competition from cameras with built-in meters, light-meter manufacturers have been doing a lot to make their products more attractive. You can buy them with attachments to measure either incident light falling on the scene or reflected light from the scene. You can get attachments to convert a wide-angle meter to a spot meter and to use the meter as an exposure measuring device when printing.

There has developed a big mystique about incident-light measurement and it is reputed to be somehow superior to measurement of reflected light from the scene. There isn't any basic difference.

Assume the scene is an 18-percent-gray card. There is one exact exposure for that scene which is correct for a particular film. If either type of meter gives you some other exposure, that meter is wrong. So, we should expect both to give the same reading. In the case of incident light, the meter is at the scene, reporting the light that falls there, therefore the meter is pointing toward the light or toward the camera or at some location in between. The meter isn't really interested in the light that falls on the scene except as a way to

Handy incident-light meter, this SPECTRA measures light falling on the scene. Some models tell you the ƒ-stop to use. Slides with tabs drop into slot behind white disc and alter the sensitivity of the instrument. Blank slide is used for zero-setting meter. By an accessory, this unit can be converted to read reflected light. Photo courtesy Berkey Marketing Companies, Inc.

less total reflected light from the different scenes due to variations in background, even if the illumination is the same. Camera exposure would be changed accordingly and the result is different skin tones from scene to scene.

Audiences refuse to believe that the lady acquired a sun tan while going to the bathroom.

Because skin reflectance does not really change, measurement of the incident light will be an indirect measurement of the luminance of the skin and if the camera is adjusted accordingly, the skin tone should always look the same.

A reflected-light meter computes exposure by the formula **qK/Speed** as discussed earlier where the value of **qK** is about 8. An incident-light meter merely uses a different constant number in the calculation, allowing for the difference between incident and reflected light due to the assumed standard reflectance of the scene.

If you are making a sequence of pictures and uniform skin tone, or uniform tone of any subject, is important, you can meter reflected light by moving the camera lens in close or by using a spot meter. Or you can meter incident light.

determine the light that will be reflected toward the camera. So where you point the incident-light meter depends on angles of light and camera and even the angles of the reflecting parts of the scene. Let's just assume the meter is pointed correctly. Now it has to tell the camera what exposure to use.

The meter doesn't know anything about the scene behind it, but to figure the amount of light reflected toward the camera it has to make an assumption. Yes. Eighteen percent.

You already know that the reflected-light meter does its calculations based on looking at a scene of 18-percent reflectance. If both are used on the same 18-percent scene, both should agree on exposure. If both are used on some other scene, then the photographer has to do the thinking and manage the job of finding proper exposure.

The incident-light meter was developed for motion pictures and serves a special purpose—uniform skin tones from one scene to the next. As the lovely female star moves from one set to another, a reflected-light meter would see more or

Shutter mechanisms

While I was preparing this book I was alert to book reviews in magazines. I noticed one review of a book on photography in which the reviewer criticized the author for not mentioning the pleasing soft quality of pictures made with a leaf shutter. Having never noticed any pleasing soft quality about pictures made that way, I'm not going to mention it either, even if it makes this book a shambles.

The two common shutter mechanisms are diaphragm or leaf type, which is in or near the lens, and the focal plane type which is near the film.

The diaphragm type is an array of metal "leaves" pivoted so they all swing toward the center or away from it. When the shutter is closed, all the leaves are overlapping in the center of the opening and no light gets through. Shutter action is to pivot the leaves away from center so light gets through—then close them again after the selected length of time has passed. A built-in

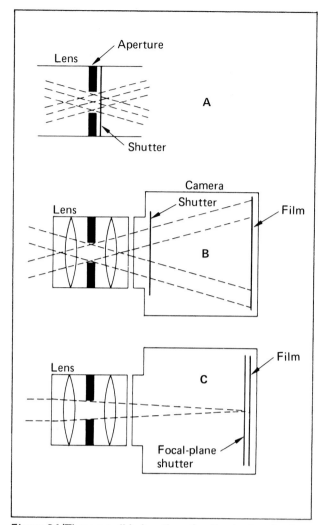

Figure 34/Three possible locations for the shutter: in the lens, behind the lens, at the film plane. Your camera is likely to have A or C.

timing mechanism, adjustable by a control on the camera, governs exposure time. On many cameras the built-in timer is a clockwork mechanism. On some models the timer is electronic.

In addition to the shutter which acts as a sort of off-on switch, lenses also have a separate aperture with the opening of adjustable size, often called an *iris*. The two of them together accomplish **E = I x T**.

In all conventional lenses the iris is part of the lens, located to minimize optical problems such as barrel and pincushion distortion. The shutter can be placed at more than one location, depending on the type of camera. The three common locations are shown in Figure 34.

Part A of the figure shows a diaphragm shutter located close to the lens aperture. This is called

a between-the-lens shutter, meaning it is inside a compound lens and will be removed from the camera if the lens is taken off. It is also called just a "lens shutter."

It is important to get the shutter open and closed quickly so the diameter of the beam of light which must be interrupted by the shutter is important. The diameter of this beam is usually minimum at the lens aperture, so that is a good place to put a leaf shutter.

Please notice that a shutter near the aperture will operate on the *entire* set of rays coming from all parts of the scene and falling on all parts of the film frame in the same way as the aperture affects rays from all parts of the scene.

Another good location is right at the film plane itself. Because the image is in focus at the film, this type of shutter is called a *focal-plane shutter*. It could also be called a film-plane shutter but isn't. Part C of Figure 34 shows how it works.

In the very simplest form, a focal-plane shutter can be thought of as a window blind which can be moved across the surface of the film to exclude outside light. If an opaque edge is traveling along, right at the surface, then it is shutting off the focused rays which make the picture, but it is shutting them off in some sequence, such as left to right along the film. This type of shutter cuts off the image a part at a time. When some of the image has been shut off, the remaining image is completely unaffected until the shutter gets to that part of the image. Over a period of time, the shutter covers the entire frame and all rays are obstructed.

Part B of Figure 34 shows another possible location for a shutter. It is part of the camera body but not at the focal plane. This is called a *behind-the-lens shutter* and has the main advantage of economy compared to shutters in the lens, because the camera needs only one rather than one for each lens. The location is otherwise not very good.

ADVANTAGES AND DISADVANTAGES

We will not consider the behind-the-lens type of shutter any more because you are not likely to find it in the camera you buy . . . unless you are buying antique view cameras.

You may find a leaf shutter built into each of the interchangeable lenses that fit your camera

body. When used on an SLR, the shutter has to be open for viewing and focusing, so some other means has to be provided to keep light off the film. The reflex mirror won't do that even when in the viewing position because it normally does not close off the path completely between lens and film. Therefore an auxiliary shutter or blind must be used to keep from exposing the film while viewing and focusing. This adds still more complexity to the camera mechanism.

A leaf shutter is handy because it doesn't have any special problems in synchronizing with flash. Also a leaf shutter does not cause the peculiar form of image distortion of moving subjects characteristic of focal-plane shutters. Both of these problems are discussed in more detail later.

A focal-plane shutter is closed while viewing and therefore protects the film automatically and without any extra mechanism. Interchangeable lenses can be used without a shutter in each lens because the shutter is in the camera. Focal-plane shutters do distort the shape of fast-moving subjects and do have problems in sync with flash. Most SLR makers decide in favor of the focal-plane shutter anyway.

How a focal-plane shutter works

Some descriptions of focal-plane shutters may be confusing because they describe an obsolete type—a single curtain with a rectangular opening in it. This is rolled up on two rollers with a wind-up spring. When the shutter is tripped, the curtain is wound from one roll to the other and as the opening passes by, the film is exposed. Different exposures result from different-sized windows in the curtain.

One type of modern FP shutter is made with two opaque curtains, usually wound on rollers. One of the curtains has a window *wider* than the frame to be exposed on the film.

To make an exposure, the first curtain which has the window is pulled across the frame so the leading edge of the window allows sequential exposure of picture elements across the frame. Once a "slice" of the frame is uncovered by the first curtain, it stays uncovered until the second curtain comes along to cover it up again.

At the end of the desired exposure period, the second curtain which does not have a window is tripped. It moves across the frame and ends the exposure interval.

If you imagine any point on the surface of the film, exposure for that point begins when the first edge passes by and ends when the second edge passes by. Therefore exposure time is the

Operation of a two-curtain Focal Plane (FP) shutter. Film frame to be exposed is shown in dotted lines.

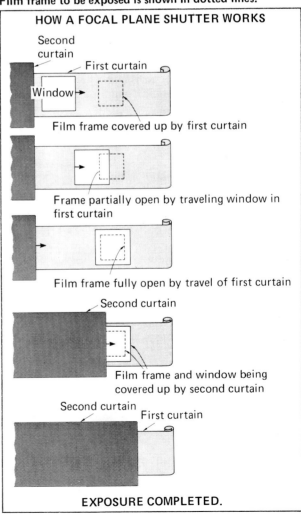

HOW A FOCAL PLANE SHUTTER WORKS

Second curtain

First curtain

Window

Film frame covered up by first curtain

Frame partially open by traveling window in first curtain

Film frame fully open by travel of first curtain

Second curtain

Film frame and window being covered up by second curtain

Second curtain

First curtain

EXPOSURE COMPLETED.

time difference between release of the first curtain and release of the second curtain. In effect, this creates a traveling slit which moves across the frame. All parts of the frame are not exposed at the same instant. That's important.

As exposure time is increased, there is more delay between release of the first curtain and the second, so the slit appears to be wider. For a time exposure of, say, ten seconds, the first curtain is tripped and it exposes the entire frame. Then nothing happens for ten seconds. Then the second curtain is tripped and closes off the frame. A small amount of time is used at the beginning to get the frame completely uncovered. A similar short length of time is used at the end to sweep the closing curtain across. For the rest of the exposure, the film is just sitting there looking out the window.

Now let's think about that small period of time when the opening curtain is moving across the frame. Suppose it takes 1/100 second for the curtain to travel that distance. The first part of the frame is exposed and it continues to receive light while the edge of the curtain moves along exposing each succeeding vertical segment along its path. When the edge of the curtain reaches the far edge of the film, that part of the frame is just beginning to receive exposure while the edge of the film which was first uncovered has been receiving light already for 1/100 second—the travel time of the curtain.

As long as the second curtain doesn't move, the film frame receives exposure but the first part has been exposed longer than the last part by the travel time of the curtain. At the center of the film frame, the emulsion has been receiving longer exposure by half the travel time of the curtain.

When the second curtain is released, it does it all backwards. It shuts off light to the first edge of the film 1/100 second before it will get over to the other side. The far side receives exposure longer than the first side, also by an amount equal to the travel time of the shutter curtain.

Therefore when it is all over, every part of the frame received the same length of exposure.

Now let's think about an exposure interval shorter than the curtains' travel time. Suppose it is 1/500 second. The first curtain is released and starts zipping across on a journey requiring 1/100 second to complete.

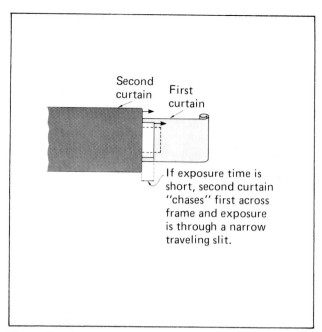

Second curtain First curtain

If exposure time is short, second curtain "chases" first across frame and exposure is through a narrow traveling slit.

Preceeding drawing showed film frame fully opened to light by window in first curtain before second curtain was released to cover it up. For shorter exposures, second curtain can't wait that long and takes off shortly after the first curtain moves. Result is a traveling *slit* of light across film.

After 1/500 second, the camera mechanism releases the second curtain to follow the first. The first curtain will be only about one-fifth of the way across the frame when the second curtain starts chasing it. What the film sees is a slit traveling across, whose width is about 1/5 the width of the frame. Each part of the emulsion is exposed for 1/500 second and everything is working according to plan.

Even though all parts of the frame did receive an exposure of 1/500 second, the various parts of the frame did not receive exposure in the *same* 1/500 second. Exposure at the first edge of the frame was all finished before it even started at the last segment of the frame.

It's interesting to figure out how long the time period is during which *any part* of the frame receives exposure. It began when the first curtain took off and some part of the frame was being exposed for all the travel time of that first curtain, call it 1/100 second. When the first curtain clears the far edge of the frame, that part continues to receive light until the second curtain gets there. The second curtain follows behind the first by a length of time equal to the desired exposure—in

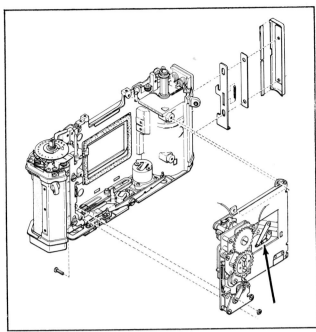

Although more illustration space has been given to horizontally-traveling FP shutters—to explain the basic principle—no derogation of vertical-running shutters is implied. This copy of a Konica assembly drawing shows how the famous Copal all-metal vertical shutter mechanism fits on the camera body. Shutter itself is operated by metal arms (arrow) controlled by mechanism at left.

As used on Nikkormat, the vertical all-metal shutter looks like this. View is from lens side, mirror up. Photo by Josh Young.

this example 1/500 second. So the very last slice of film at the far end of the frame continues to get light for another 1/500 second. There was a total time period of 1/100 plus 1/500 second during which *some part* of the frame was receiving exposure even though no single spot got light for more than 1/500 second.

The time to expose an entire frame is equal to the travel time of the first curtain plus the exposure interval.

This highlights another advantage/disadvantage which couldn't be explained earlier. Photographers believe that short exposure times stop motion of the subject and also reduce the necessity to hold the camera steady while taking the picture. You can hand-hold your camera when shooting at 1/1000 and jiggle around about as much as you want to without blurring the picture, *they say*. That's true for a lens shutter because it exposes the entire frame all at once. Not true for an FP shutter.

If you move the camera during the travel time of the shutter curtains, it will affect the picture no matter how short the exposure time you have selected. If the subject moves any detectable

amount during the travel time of the curtains, the image will be distorted.

We can write a television mystery which I will call "The Case of the High-Speed Bird." A photographer took a picture of three birds sitting on a telephone wire. He used his SLR set at 1/1000 second because it was a bright day. When the film was developed, only two birds were in the picture. What happened? Who done tole a dirty lie about how many birds there was?

The click of the shutter release startled the third bird and he took off. By the time the moving band of exposure got to the place where he was, he wasn't.

The detective part of this mystery is to figure out which way the shutter was moving. If the birds are numbered, with #1 on the left and #3 on the right, as the photographer saw them, which way did the curtains move? The slit traveled from the photographers right hand toward his left hand. Because the image is reversed on the film even though not in the viewfinder.

"Eat Crunchies! Now for the news . . ."

FP shutters can move the slit either horizontally or vertically and both arrangements are used.

They can go from left to right or right to left, top to bottom or bottom to top. Image distortion due to a subject in motion is influenced both by the direction of motion of the shutter and the direction of motion of the subject.

Suppose your shutter moves from top to bottom and you are shooting a high-speed race car. The car will move significantly during the shutter travel time. As the slice of light moves down across the film, the race car is moving horizontally in the scene. The result is image distortion to produce slanted elliptical wheels rather than round wheels. The camera is actually taking part of the picture with the wheel in one location and the next part of the picture with the wheel a little farther down the road.

If you don't shoot at fast-moving subjects, this kind of image distortion is not important to you. If you do, then you can do a couple of things. Remembering that the optical image is reversed on the film, you can first figure out which way your shutter moves by taking off the back of the camera and watching it go. Use a long exposure time so you can see what's happening.

Then you can figure out which way moving subjects will be distorted by the FP shutter in your camera.

Once you get all this info under your beanie, you can figure out which way to hold your camera while shooting race cars so the traveling slice of light *on the film* moves in the same direction as the race car. This will reduce the amount of image motion on the film.

If your shutter moves vertically, can you really do what I said?

SYNCHRONIZING SHUTTER WITH FLASH

The basic problem with *any type of shutter* is to have the flash occur while the shutter is open. The problem is compounded by the fact that flash *bulbs* take some time to reach full brightness. Cameras with leaf-type shutters fire the flash bulb and then delay opening the shutter until the bulb has had time to reach full brightness. Cameras with FP shutters can use a special type of flash bulb called an FP bulb and I will get to that later.

I use electronic flash and these units in their simplest forms are now so cheap they are plainly more economical in the long run than flash bulbs. I think they are more reliable and they make less trash.

If you shoot many flash pictures, you'll be money ahead in the long run to use an electronic flash unit. On many cameras the flash unit attaches to a "hot shoe" on the camera which makes the electrical connections automatically. On this Konica rangefinder camera with between-the-lens shutter the flash synchronizes at all shutter speeds. Camera automatically controls its own exposure even with flash.

Electronic flash has a very fast rise-time to full brilliance, so as a practical matter you can assume that the flash happens instantaneously when the unit is triggered by the camera.

Therefore instead of the shutter waiting for the flash, the flash waits until the shutter is fully open. When a leaf shutter is fully open, it triggers the electronic flash. There is no way it can get closed again before the flash is all over. This is called X sync. Some cameras have more than one connector on the body where you plug in the flash cord. If one is marked X that's it.

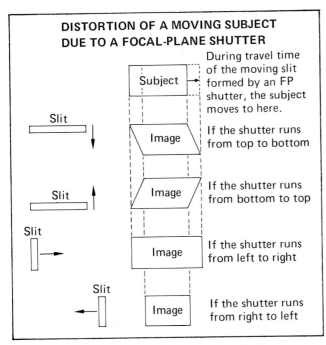

DISTORTION OF A MOVING SUBJECT DUE TO A FOCAL-PLANE SHUTTER

Subject → During travel time of the moving slit formed by an FP shutter, the subject moves to here.

Slit ↓

Image — If the shutter runs from top to bottom

Slit ↑

Image — If the shutter runs from bottom to top

Slit →

Image — If the shutter runs from left to right

Slit ←

Image — If the shutter runs from right to left

This puzzlement indicates what happens to the image on film when a rectangular subject is moving to the right, on the film, while the FP shutter is traveling to make an exposure. It shows vertical FP shutters moving both up and down, and horizontal-running shutters traveling both to left and right. As you can see, probably, the image gets stretched, shortened, or tilted depending on circumstances.

Rolleiflex SL35 has flash connectors for either X or FP sync on camera body.

Electronic flash with a focal-plane shutter

An X contact for use with an FP shutter will trip the flash unit when the first curtain has moved all the way across the frame. At this instant, the entire frame is open to light, *as far as the first curtain is concerned*, but the second curtain must not be moving yet and must not be covering part of the frame. To get uniform exposure of the frame, no part of the frame can be covered up by the second curtain while the short-duration flash is occurring.

The sequence of events has to be: First curtain uncovers the entire frame, flash happens, second curtain closes. That puts a definite limit on exposure time that you can select because you can't choose any shutter speed so fast that the second curtain is released before the first curtain gets all the way across.

The shortest exposure time you can use is equal to the travel time of the first curtain, plus the duration of the electronic flash.

If the curtain travel time is 1/100 second, typical of present horizontal shutters, you can't use an exposure time shorter than that. The next longer standard time on your exposure selector is 1/60 second, so your camera manual will say to set that time into the camera when using electronic flash.

Does that mean you are exposing for 1/60 second? No. You normally adjust camera controls so exposure depends on the light from the flash unit. When that light stops, exposure stops unless there is a very high level of ambient light. In general, no matter where you set the dial, exposure is only as long as the duration of the flash.

Some camera manuals allow you to set shutter speed at 1/60 or slower when using electronic flash but there is normally no reason to choose a longer exposure time because that makes it more likely that ambient light will produce noticeable exposure on the film, resulting sometimes in a ghost image of the scene. If you move the camera during the time the shutter is open but after the flash is over, the likelihood of a ghost image is higher be-

Using flash outdoors in daylight at 1/60 shutter speed puts some exposure on the film due to the flash and some due to the bright ambient light. In the good picture I held camera still for the entire duration of exposure. In the blurred photo, I moved the camera. Sharp exposure came from short-duration flash. Then with ambient light only, camera motion made blurred second image. Horizontal camera movement combined with horizontal FP shutter travel "stretched" ghost image.

cause any faint exposure caused by ambient light will not be in register with the image caused by the flash.

A lens shutter doesn't have these problems with electronic flash and will synchronize satisfactorily at any speed. The duration of electronic flash is shorter than the fastest speed you can select.

Some SLR cameras advertise that they can sync with electronic flash at 1/125 second rather than 1/60. In these cameras, the shutter travels vertically rather than horizontally across the frame. Typical vertical-travel shutters are the metal Copal-type as used in Nikkormat, Konica and other brands. The dimensions of a 35mm frame are 24mm x 36mm—the height is 2/3 the width.

The shutter velocity doesn't have to be any faster because it only has to travel 2/3 the distance. At the same velocity which produces a travel time of 1/100 second when moving horizontally, the travel time when moving vertically would be only 1/100 x 2/3 = 2/300 = 1/150 second. The exposure time requirement is to be a little longer than travel time; the next longer setting on the shutter speed dial is 1/125 second, so you can use it.

A shutter which moves vertically does shorten the whole exposure event by about 1/3, however the distortion of moving subjects due to a vertical shutter is sometimes more noticeable than with a horizontal shutter. You pays your money and takes your choice.

HOW FAST DO THE CURTAINS MOVE?

That means how fast is it traveling in miles per hour. It's easy to get the impression that the curtains must be going faster than a speeding bullet to give exposure times like 1/1,000 second. Not so. The long dimension of a 35mm frame is about 1.5 inches. If the travel time of a curtain across this distance is 1/100 second then it would travel 150 inches in one full second, and that is the required velocity of the curtain. Converting to feet, 150 inches is 150/12 feet, or 12.5 feet.

The curtain is zipping along at 12.5 feet per second. Pick out some distance that is about 12 feet long, count one second of time while scanning your eyes that distance and you get a feel for curtain speed. Pretty fast, isn't it.

In high school driver's education classes, students are told that a car traveling at 60 mph goes 88 feet in one second. By proportion, a car which

traveled 12.5 feet in one second will be going only about 8.5 miles per hour. Pretty slow, isn't it.

The technical achievement in a modern focal plane shutter is not getting the curtains up to the blazing speed of 8.5 mph. It is getting them started and stopped, designing the apparatus so the shutter keeps light off the film when the lens is open while you are focusing, building it so it is compact, reliable, and repeatable, and using a curtain material which can withstand being jerked around that way. The major achievement is precision timing between curtain releases.

The USA standard and the International Standard for exposure say that any combination of camera controls intended to produce some particular step of exposure must not be in error more than half a step. In other words, the exposure must be closer to the step you set it for than to the next step up or down.

Only flash can capture the unposed exuberance of a young lady's birthday party.

Exposure with flash bulbs

Flash bulbs have several different characteristics which are important to the user. Rise-time is the length of time after firing the flash before the bulb gets up to full brightness. "Full" really means half or more because once the bulb has reached half of its rated brightness it is within one step of full exposure. The rise-time affects the synchronization between shutter and flash bulb.

Duration is sometimes important. Total exposure due to the bulb's light output is naturally important. This is expressed by a Guide Number to be discussed in a minute.

Flash bulbs are grouped in classes with a letter designation related to flash duration according to this chart:

F	Fast	0.008 second	8 milliseconds
M	Medium	0.020 second	20 milliseconds
S	Slow	0.030 second	30 milliseconds
FP	Focal Plane	0.040 second	40 milliseconds

Cameras may have markings on the shutter control with these letter-symbols. If so, setting to a particular symbol adjusts the flash-trigger-signal timing so the shutter is fully open when the flash is at or near peak output. Cameras may have connectors into which the lead-wire from the flash

unit is plugged. And these may be identified by some of these letters for the same reason. If the connector on the camera is not labeled it will be described in the camera instruction book.

FP bulbs are specially designed to make a relatively uniform light output for a period of time longer than the travel time of the focal-plane-shutter curtains. If the travel time is 1/100 second: A 40-millisecond (0.040 second) flash duration is long enough for even the slowest focal-plane shutters. It will illuminate the scene throughout the time the focal-plane slit is passing across the frame, therefore as far as the camera is concerned an FP flash is indistinguishable from a steady source of light such as the sun. With an FP flash bulb a focal-plane shutter can be set for any speed that will give enough exposure and does not have to be limited to 1/60 second or some other relatively long exposure time.

That's the end of the paved road. One more step takes us into a jungle of different flash bulb type designations and different ways of using them with various cameras. The practical thing to do is consult the operating instructions for your camera and follow them if you actually do intend to use flash bulbs.

LEAF SHUTTER EFFICIENCY

Much is made of shutter efficiency, particularly in older books. The idea of it is illustrated in Figure 35 (page 142).

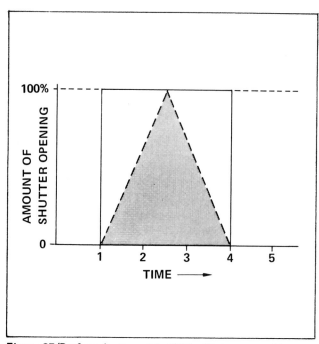

Figure 35/Perfect shutter with 100% efficiency would open instantly and close instantly as shown by the solid line. Real world imperfect shutters behave more like the sluggish pattern shown by the dotted line.

Figure 36/Leaf shutter efficiency is determined by amount of aperture opening because leaf shutter is effectively fully open as soon as it is open wider than the aperture. At large apertures, leaf shutter takes more time to get fully open—shutter efficiency is reduced.

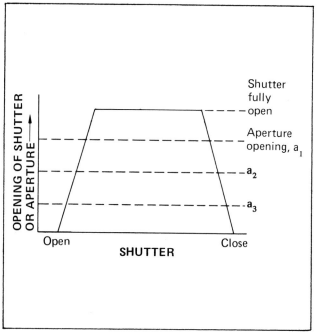

The shutter is supposed to open at time 1, stay open a while, and then close at time 4. The numbers 1 and 4 are just reference points. If you insist on reality consider it a three-second exposure.

If, at point 1, the pattern of shutter opening followed the solid line, it would go from closed to open in zero time. At point 4, it closes in zero time. This perfect shutter has 100% efficiency.

On the other hand, suppose the shutter can't pop open in zero time and instead follows the dotted-line path. Let's assume the shutter is so sluggish that by the time it gets open it has to immediately start closing again to get closed by point 4. The resulting tee-pee is the pattern of motion.

It should be obvious that the dotted-line pattern admits less total light because it was not fully open for the entire period it was supposed to be fully open.

Total light admitted by the shutter is proportional to the area under the shutter-motion curve. The shaded area under the dotted-line curve is less than the total area enclosed by the rectangle. The difference is in shutter efficiency. The dotted-line shutter pattern is only about 50% efficient as you can see by looking at it.

In the old days, shutters were calibrated by points 1 and 4. If the shutter was supposed to be open for 1/125 second, that would be the time between start-to-open and fully closed *no matter how quickly the shutter got open all the way and then got closed again.* Therefore shutters set for the same time of exposure gave different actual exposures according to the built-in efficiency of the shutter. Modern shutters are calibrated at maximum aperture so the shutter stays open long enough to admit the amount of light that it should *if it had 100% efficiency.* This means the photographer gets the amount of light he is expecting but inefficient, sluggish shutter mechanism may take longer to do that. Therefore exposure time may actually be longer than the shutter-speed dial says but the exposure you can calculate from the shutter speed number on the dial will be correct, *at maximum aperture only.*

Figure 36 shows another aspect of shutter efficiency. This time the shutter follows the solid-line path from Open to Close taking some time at each end due to inefficiency. It does stay at full

opening for some time though, before it has to start closing again.

If this is a *leaf* shutter, it has to work in harmony with the aperture and open up enough so it is not obstructing any of the rays which pass through the aperture at any setting. Aperture opening is indicated by the dotted lines across the shutter curve. At a_1, the aperture is fully open. When fully open, the shutter is not limiting the amount of light which enters the camera, the aperture is. At a_2, the aperture has closed down some amount. At a_3 it has closed down still more.

As soon as the shutter opens up enough to pass all of the light rays getting through the aperture then more shutter opening has no effect on exposure. The shutter is *effectively* open when the solid-line shutter curve crosses above the dotted-line aperture curves, which means the shutter has a larger opening than the aperture.

This also affects a *leaf* shutter's efficiency. Compare case a_1 with case a_3. At a_1 more time is spent getting the shutter open and closed and the shutter spends less time fully open (as far as a_1 aperture is concerned). At a_3, with smaller aperture, less time is spent getting opened up to the required size and more time is spent fully open in terms of a_3. Therefore a *leaf* shutter is more efficient at smaller apertures. For the same exposure time, total light on the film is proportionately greater at smaller apertures.

HOW ABOUT FOCAL PLANE SHUTTERS?

You only have to worry one time about the efficiency of FP shutters so let's just do it and get it over with.

If an FP shutter was very thin and in actual contact with the film, its efficiency would be 100%. However, it would scratch the film so photographers invariably prefer a less-efficient shutter.

When the FP shutter is moved away from the surface of the film it becomes less efficient for two reasons related, believe it or not, to exposure time and aperture.

As shown in Figure 37, rays from some point of the scene are reflected toward the camera lens. The lens accepts more or less of them according to the lens aperture. Those rays which do get through the aperture are brought to focus on the film and therefore look like a cone when viewed from the side. If the FP shutter were *at the sur-*

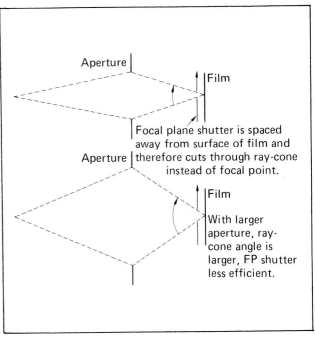

Figure 37/Because a focal plane shutter cuts through a cone of rays just ahead of the point of focus, the cone angle affects efficiency. As you can see, ray cone-angle is determined by aperture size.

Figure 38/To shut off all the rays passing through the traveling slit at any one point, an FP shutter has to travel far enough to cut off light to the illuminated strip of the film. Width of the light strip on the film is influenced by aperture size.

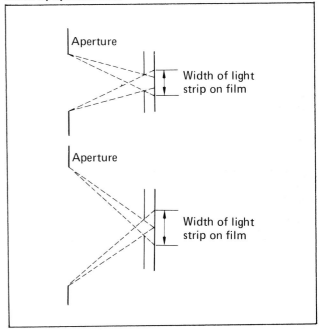

face of the film, it would interrupt all the individual rays forming the image point at the same instant of time, and you can't do better than that. Because the FP shutter is some distance from the surface it has to cut through the cone of rays *before* they are brought to point-focus. Therefore it takes some amount of time for the FP shutter to get either fully open or fully closed in respect to each point on the surface of the film.

If the aperture is made larger, the ray-cone has a larger diameter at every point between lens and film. Therefore it takes the FP shutter longer to cut through the fat beam than through a skinny one and efficiency is less. Larger apertures *reduce* the efficiency of an FP shutter.

Because the FP shutter's traveling slit is not in actual contact with the film, it is not slit width that determines time of exposure but the width of the light strip on the film, whatever it happens to be.

Aperture size influences light-strip width on the film, as shown in Figure 38 (page 143). Also, diffraction occurs at each edge of the FP slit, throwing light under the edges of the slit where there should be shadow. In both cases the slit edge has to travel farther across the film to get all the light cut off. Therefore, light to a point on the film is cut off over a period of time rather than in zero time. This also reduces efficiency. Similarly, when a slit edge is opening up a point on the film to light, the light appears gradually over an interval of time—instead of all at once.

The reduced-efficiency effects happening at the slit edges do not happen out in the middle where there aren't any edges. Therefore the wider the slit, the less significant the edge-effects are and the more efficient the FP slit is. To say it the opposite way, decreasing FP shutter exposure time also *decreases* the shutter efficiency.

If you are using a short exposure time to stop image blurring you may also be using large aperture to get enough light. Both reduce FP-shutter efficiency, but you will probably never notice it.

The big advantage of having gone through shutter efficiencies is this: Next time you have the opportunity to read about it, you can decline in good conscience.

Exposure from artificial light

We rambled right past flash bulbs and electronic flash gadgets without stopping to inquire how much light comes out of them and how do you know how to expose for them. You can't read it on your exposure meter before taking the shot because it didn't happen yet unless you use a special flash meter. Without the special meter, you have to *predict* the amount of light on the scene that will be there when the flash is popping and your camera is clicking.

You have already seen the candela derived in the classical way with a point-source light enclosed by an imaginary sphere. As you remember, if the sphere has a radius of one meter, the point-source is one candela, the sphere is marked off into surface areas of one square meter, then one lumen is intercepted by each square meter on the sphere. It happens that a sphere of one meter radius can not have an even number of square meters drawn on its surface. There is enough room there only for 12.56 of them. So we imagine that the portion of a square meter also got only a portion of a lumen. The sense of it is to define the number of lumens emitted by one candela—12.56, which is one candlepower.

Not satisfied with this amount of mischief, photometric fellows define the luminance of a *surface* by stating lumens per square meter. If the light is coming from a surface rather than a point, then the total light emitted depends both on the brightness and the total area of the luminous source.

If a surface *being* illuminated is very, very close to a light-emitting surface, then light output in lumens per square meter from the emitter must be exactly the same as the light falling on the adjacent surface being illuminated. Illuminance is *also* stated in lumens per square meter. When it is illuminance, it may be called *Lux*, the Latin word for light. One lumen per square meter is the same amount of light which would fall on an area of one square meter, one meter distant from a candela. Therefore *Lux* and *meter-candle* mean the

same thing and are used interchangeably.

With a flash we are interested not only in how many lumens it produces but also for how long because both determine exposure on the film. If a million lumens exist for one second, the total light is one million lumen-seconds. If the same light pulse has a duration of two seconds, the total light is two million lumen-seconds. Lumen-seconds is a measure of total light. Meter-candle-seconds means the same thing. Candle-power-seconds means a similar thing except that one candle-power is all the lumens emitted by a standard candle and is therefore 12.56 lumens. The conversion is: 12.56 meter-candle-seconds = 1 candle-power-second.

Flash bulbs vary in duration, peak lumen output, and total lumen-seconds output. Small bulbs may have a peak of about 1/2-million lumens and a total light output of about 7,500 lumen-seconds. Large bulbs run around 5 million lumens and about 100,000 lumen-seconds.

This information does not yet tell you how to set your camera even if you know the lumen-second rating of the flash bulb. Reflected light from your subject depends on a bunch of things: How much of the light output from the flash actually falls on the subject, the distance to the subject, and the reflectance of the subject. This

dilemma is solved by using *guide numbers.* We'll get to them in a minute.

REFLECTORS

A bare flash bulb is small and acts much like a point-source of light, sending light rays out in all directions. Bare means it has no reflector near it. Because flash bulbs cost money, it seems wasteful to send out some of the light in the wrong direction, so reflectors used behind the bulb capture the light heading off in the wrong direction and reflect it toward the subject. Light which comes out of the bulb but does not strike the reflector is not influenced at all by the presence of the reflector—it doesn't even notice it. Direct light rays from a flash bulb radiate outward in all directions and fit the Inverse Square Law.

A reflector behaves like a lens and forms the reflected rays into some sort of a beam—wide or narrow according to reflector size and shape. The reflector's main purpose is to capture rays heading in the "wrong" direction and turn them around. The result is that the forward beam from a bulb-reflector combination is brighter than without the reflector and has a beam angle, that is, the light may not cover a full hemisphere uniformly. It's important that the beam angle is as large as the angle of view of the lens you are using to get uniform illumination across the field.

Figure 39/When light rays diverge, the Inverse Square Law applies because a surface at double the distance has four times the area. Obviously it does not apply to a beam with parallel rays.

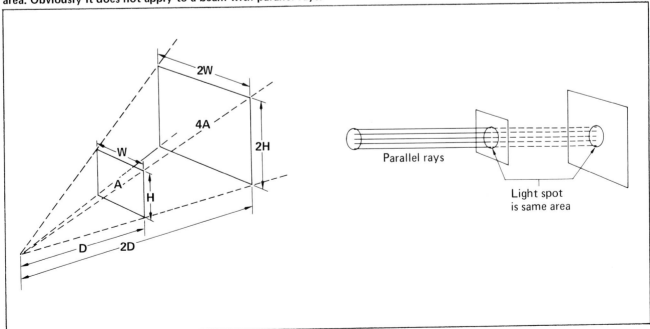

Inverse square law revisited

At this point we should take another look at the Inverse Square Law and notice that it is not really a law about light, it is a law about geometry. Figure 39 (page 145) shows its true nature. It only says if lines from a point define the four corners of a square, then the square is four times as large in area at double the distance.

This law applies to light only when light fits the situation. If light is uniformly illuminating a surface and the surface is then moved back to double the distance it becomes twice as large in each direction. If all of the rays which fell on the surface at the first location continue to fall on the surface at the second location (no light is lost), and no new light rays fall on the surface in the second location (no light is gained), then the Inverse Square Law applies and light follows the rule. Illuminance of the larger surface will be 1/4 the value at the second location. If the surface is not larger, illuminance is still only 1/4. The remaining rays miss the surface and go somewhere else.

A beam of light with parallel or converging rays will not fit the law. In general, beams with diverging rays fit the law and it is usually *assumed* that divergent beams fit the law exactly. Flash lamps, both bulb and electronic, are normally assumed to follow the Inverse Square Law.

Guide numbers

Guide numbers assume light from the flash obeys the laws, as you will see. A guide number is furnished by film and flash-lamp makers:

$$\frac{\text{Guide number}}{\text{Distance to subject}} = f$$

In use, you measure the distance to the subject and divide that distance into the guide number. The result is the recommended *f*-number. It makes a difference whether you measure distance in feet or meters, so note carefully what the instructions say. They will specify one or the other. A guide number is meaningless without the *unit* of distance.

For this to work, a lot of other things must be known or assumed: light output of the source, exposure time, film speed and reflectance of the scene.

Here is a table of guide numbers from the data sheet packed with a 125-speed film. The table specifies flash bulbs by type number, sync setting, reflector size, shutter speed, and a 125-film speed because that's what the data sheet is for. Welcome to the jungle.

Some light from the flash bulb reaches the subject and is reflected according to the type of subject—usually people are the victims of flash photography. Also some of the light bounces off ceiling, walls, and floor to reach the subject. Therefore guide numbers have to make some assumptions about subjects, room sizes and room reflectances.

No manufacturer makes you any promises about success with guide numbers. It is a *guide* and only that, and your best success will result from your own testing and determination of guide numbers for where and what you shoot with your favorite film and camera.

Assume you are using a guide number of 100 and a subject distance of 9 feet. Dividing 100 by 9 results in an *f*-number of 11. Now do it again with 18 feet. 100/18 = 5.6 approximately. Notice what happened. When the distance was doubled, the guide number formula changed exposure by *two steps* in the direction of increased exposure—for *four times* the exposure. Meaning that there is only 1/4 the amount of light from the flash bulb on the scene at double the distance. Meaning that light from flash is expected to follow the Inverse Square Law.

That's why your flash pictures look strange. Light from a flash falls off very rapidly with in-

FLASHBULB EXPOSURE GUIDE NUMBERS

Flashbulb*	Synchro-nization	Diameter of polished reflector**	1/30 sec. or slower	1/60 sec.	1/125 sec.	1/250 sec.
AG-1	X	2"	160	125	—	—
AG-1	M	2"	160	125	110	80
M-2	X	3 to 5"	190	—	—	—
M-3, M-5	M	3 to 5"	300	250	210	160
5, 25	M	4 to 5"	300	250	210	160
2, 22	M	6½ to 7½"	450	385	330	270
11, 40	M	6½ to 7½"	300	265	220	170
2A, 31***	M	6½ to 7½"	—	210	145	95
26, 6***	M	4 to 5"	310	235	170	105

*With blue flashbulbs, use ½ stop larger lens opening.
**For satin-finish or fan-type reflector multiply guide number by 0.7.
***Use with focal-plane shutters.

This chart showing Guide Numbers with different flash bulbs, synchronization, and reflectors is from the data sheet packed with GAF 125-speed film.

creasing distance. If you get the right amount of light on a subject, everything nearer is overexposed. If you expose properly for something in the foreground, everything beyond is underexposed. If you want a good shot of both Aunt Minnie and her needlework hanging on the wall, you'd better stand her right against the wall. Or use a better lighting technique than just one flash unit.

Ways to do this are discussed in the H. P. Book entitled *How To Take Great Pictures with Your SLR*.

NOBODY'S PERFECT

You won't look long at the variety of flash bulbs, reflectors, guide numbers and rules before you throw up your hands and exclaim something. You have to use flash bulbs by published recipes and the trick is to find ways that work for you and then stick pretty close to those methods. Or else skip the whole deal and use electronic flash, which is what I do.

This is not an indictment of the flash bulb industry. The business of making and selling bulbs started about 40 years ago and has resulted in a steady flow of different types and styles and continuous improvement of the different manufacturer's offerings. I spent a few years associated with the design and development of products and you can't always forecast the end of a development when you are only at the beginning. New improvements are suggested by the improvement you made yesterday. New type numbers and specifications proliferate until finally you have to try to get it all down on a big chart and say, "Do it that way."

ELECTRONIC FLASH

Electronic flash is a more recent development and industry at large, all over the world, was feeling the need for some agreed-upon standards and seeing benefit to everybody through using them.

The USA standard for specifying the light output of an electronic flash unit requires *both* the amount of light and the angle of coverage. The amount of light is specified in *Beam-Candlepower-Seconds*, the angle in degrees. If vertical and horizontal angles of coverage do not differ by more than 10%, one angle is given. If the difference is more, both vertical *and* horizontal angles should be stated.

Beam Candlepower Seconds (BCPS) is the product of candlepower in the beam (1 candlepower = 12.56 lumens) multiplied by flash duration. It's a plain statement of how much light comes out and a flash unit with a higher rating does put out more light.

However, for a world accustomed to using flash guide numbers to help in setting camera controls, BCPS doesn't do much. The USA standard recommends electronic-flash manufacturers also give a guide number to be used the same way as flash bulb guide numbers. There are conversion tables. The Kodak Master Photoguide has a clever little circular slide rule to help you convert BCPS to guide numbers. GAF publishes a chart I've reproduced here. Electronic-flash duration is so short that virtually any shutter speed allowed by the instructions on your camera will capture all of the light, so shutter speed is not important with electronic flash except for reasons you already know (for FP shutters) and does not affect guide numbers for electronic-flash units.

Light from an electronic flash follows the Inverse Square Law, at least approximately, so it does not solve any exposure problems due to the rapid decay of illuminance.

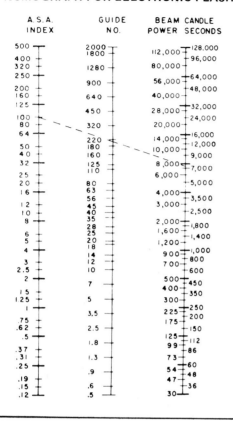

ASCOR GUIDE NUMBER NOMOGRAPH FOR ELECTRONIC FLASH

A.S.A. INDEX	GUIDE NO.	BEAM CANDLE POWER SECONDS

This handy nomograph furnished by Berkey Marketing Companies Inc., relates ASA film speed or index, Guide Number, and BCPS. A straight line drawn between any two will indicate the third, as shown by the dotted line on the chart.

But there are some neat tricks. Because shutter speed doesn't matter, light output is known, film speed is known, and the same assumptions about scene reflectance apply, the remaining variables are only subject distance and aperture.

This led to the development of different kinds of automatic-flash techniques.

One type made by Canon, called CAT for Canon Auto Tuning system, uses a ring-adaptor over the front of the lens connected to the focusing ring. When you focus on the subject, rotation of the control generates an electrical signal in the adaptor ring to tell the camera how far away the subject is. When you set aperture the camera computer also receives a signal from the lens. So, with flash in place on the camera and the adaptor on the lens you can shoot flash pictures by matching needles in the viewfinder in the same way as you shoot non-flash pictures. You don't measure any distances or fuss with guide numbers.

This system solves another problem associated with flash units using self-contained batteries. As the batteries discharge, they supply less energy to the flash and the light is less. The CAT system also monitors battery voltage and uses it to affect the match-needle indicator to compensate for lower voltage.

This chart from GAF gives guide number (feet) if you know the output of your electronic flash in Beam Candlepower Seconds or Watt-Seconds. Watt-Seconds is not a reliable indicator of light output because it states the electrical current into the flash tube rather than the resulting light output. Its use is gradually being discontinued. The BCPS numbers, because they do not also specify beam angle are based on an assumed average angle of 60 or 70 degrees. Guide Numbers are for 125-speed film.

ELECTRONIC FLASH EXPOSURE GUIDE NUMBERS

BCPS	350	500	650	1000	1600	2400	3200	4800	6400	12500	25000
GUIDE NUMBER	45	55	65	80	100	125	140	175	200	280	400
Watt-seconds	10	15	20	30	50	75	100	150	200	400	800

Proper specification of electronic flash is light output *plus* beam angle.

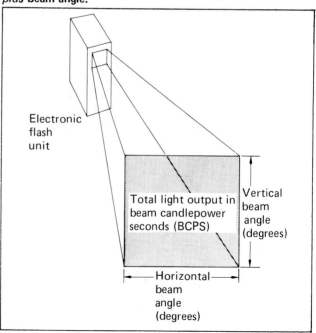

Electronic flash unit

Total light output in beam candlepower seconds (BCPS)

Vertical beam angle (degrees)

Horizontal beam angle (degrees)

Another way is to change the amount of light output according to subject distance. Polaroid sometimes puts movable louvers in front of the flash unit, mechanically coupled to the focusing adjustment. For near subjects the louvers close up to reduce light output.

Nikon makes a 45mm f-2.8 lens for flash photography called a GN type, for guide number. You set the guide number of the flash you are using into the lens by a control. When set, there is an internal mechanism which mechanically connects the focusing ring with the aperture control. Then the act of focusing on your subject automatically adjusts aperture so you will get the exposure requested by the guide number you are using.

How automatic flash units work

We'll work our way up to the fancy automatic units by starting with a simple non-auto flash as shown in part A of Figure 40 (page 150).

The heart of all flash units is the flash tube itself which is filled with xenon gas or a mixture of gases. When a high voltage is applied to the tube, the gas inside becomes ionized, which means electrically conductive. A rush of current flows through the gas and it simultaneously emits a very bright light. When the voltage applied to the flash tube drops below a certain value, the tube will extinguish and the light turns off.

Because the voltage required to ionize a flash tube is high, 400 volts or more, you can't get it directly out of a wall outlet or from a small number of flashlight batteries. The power source, AC or battery, is taken into a special circuit called a voltage converter on the diagram. The output of the converter is high-voltage DC.

An electrical capacitor has properties similar to the battery in your car. It can be charged up and it can be discharged. The high voltage from the converter is used to charge up the storage capacitor and when charged it is ready to operate the flash tube. Normally a signal light goes on when the capacitor is charged and ready.

To make flash happen, an electrical pulse is applied to the flash tube. Although high voltage is generated inside the flash unit, the pulse is triggered by the sync contacts in the camera so we can consider that the camera turns the flash tube on through a contact on the hot shoe, or though the cord connector.

When the capacitor is discharging through the flash tube, the voltage is decreasing and at some point the extinguishing voltage is reached. The flash turns off.

As you can see, in the simple system shown in part A of the drawing, the duration of the flash is governed by how much charge there is in the storage capacitor. Use a larger capacitor, or charge it to a higher voltage, and the flash will last longer.

A flash of this type will make a certain amount of light each time it is used, provided the capacitor is fully charged. Therefore such flash units are given guide numbers and used accordingly.

The next bright idea is to turn the flash tube off when the desired exposure is completed, whether the capacitor has finished discharging completely or not. This requires two tricks—some way to measure the amount of exposure created by the flash, and some way to turn it off.

Measuring exposure is straightforward. The flash unit is equipped with a light sensor similar to the one inside most SLR cameras. It measures the total amount of reflected light that it "sees" and when the total reaches some standard value, the sensor generates a trigger signal to turn off the flash tube. Let's identify the amount of exposure needed to trigger the "stop" signal as the *threshold* value and consider it to be some constant value.

The big problem in designing these "second-generation" flash units was in finding a way to switch off the flash tube. The electronic switches available at a tolerable price in those days could close the circuit between capacitor and flash tube but could not open it up again while the great rush of current was flowing. If you try to make one open up the circuit will destroy itself.

The solution was to enclose a second flash tube inside the unit, buried so no light from it could escape, and divert the current from the first flash tube to the one buried inside. The effect is to shut off the flash tube that illuminates the scene, on command from the light sensor.

The main disadvantage of this scheme is that

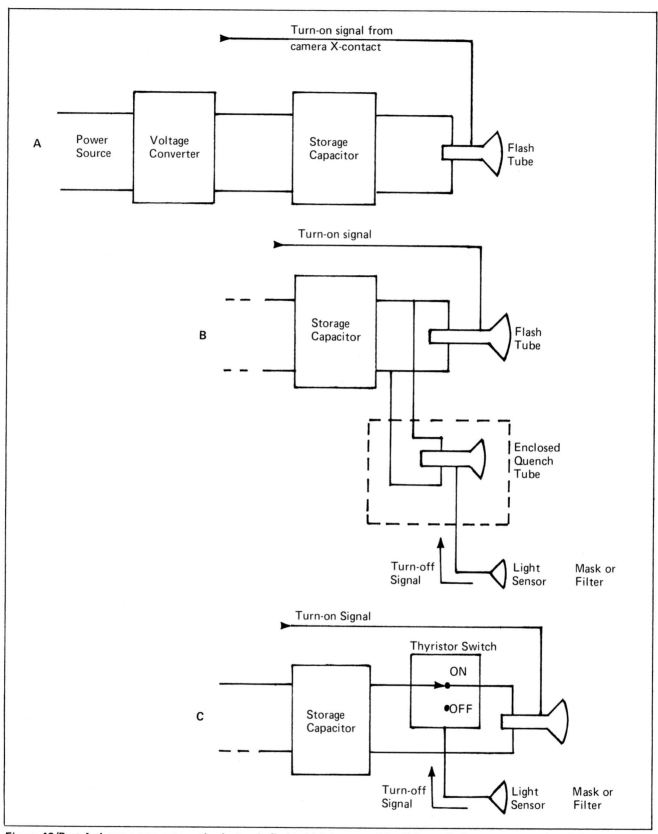

Figure 40/Part A shows a non-automatic electronic flash which keeps making light until the storage capacitor is fully discharged through the flash tube.

Part B shows the "second generation" auto flash units which turn off when desired exposure is reached. Light sensor turns main tube off by turning parallel quench tube on. Quench tube "steals" the current from main tube.

Part C "third generation" thyristor type. Thyristor switch is controlled by light sensor and disconnects capacitor when desired exposure is reached. This saves remaining energy in capacitor for use next time.

the capacitor fully discharges through the buried flash tube, thus wasting electrical energy because no useful light results. It's a modern-day flash in the pan.

Part B of figure 40 shows this system. The camera turns the flash on, the light sensor turns it off by generating a trigger pulse to fire the quench tube. The quench tube is electrically in parallel with the main flash tube and when fired it draws away the current that would otherwise flow through the main unit. The main flash tube extinguishes.

Because the amount of light output from this type of flash is controllable, the maximum and minimum values become important. The maximum light output results when the light sensor never turns the system off. The system makes light until the capacitor is discharged and then stops, just the same as the earlier non-automatic units. Most auto units have a control to turn off the sensor so they can be used as non-auto flashers with a guide number.

The minimum amount of light an automatic flash can produce is governed by the operating time of the sensor and switch. If the flash is turned on and then turned off again as quickly as possible, that's the minimum light output.

This automatic flash unit by Vivitar measures the light reflected back from the subject through the small window below the type number—292. When enough light has been reflected back to create the desired exposure, the flash unit automatically turns itself off.

NOTE: The text and Figure 40 indicate that the sensitivity control on automatic flash units is a changeable aperture or filter in front of the light sensor, which is the most common way to do it. Sensitivity can also be adjusted electrically by a "volume control" in the sensor circuit. Some manufacturers use the electrical method of sensitivity control. To the user, it doesn't make much difference.

Notice please that while the light sensor of the auto flash is measuring light reflected from the scene, it is really measuring it on behalf of the camera. That is, when the flash unit sensor says there is enough exposure, there should actually be enough exposure *inside* the camera on the film. Therefore the light sensor should receive the same amount of light from the scene as does the camera lens. Usually this means the sensor is on or near the camera and pointed in the same direction.

Remember that the sensor will shut off the flash when it has accumulated enough total exposure to reach the threshold. The threshold value must be some amount of light that is useful for normal films and subject distances. More powerful flashes can work at longer distances naturally.

Because the sensor threshold is fixed, what automatic flash units really do is create a standard amount of exposure *as seen by the sensor of the flash unit,* every time they flash without regard to distance or reflectance of the subject. When the sensor says, "That's it!" the thing shuts off.

Now, how can we live with a flash that automatically makes the *standard exposure* every shot, rather than the old type which made a standard amount of light each time.

That standard exposure will "reach farther" with films of higher speed rating, so the flash unit has a computer dial. The computer doesn't have anything to do with the innards of the flash unit, it just gives you information. You set in the film speed and the computer tells you the maximum and minimum distances that the flash will work, which correspond to letting the capacitor discharge all the way or shutting it off as quickly as possible.

To say it another way, with a highly reflective subject very close to the camera the sensor threshold will be reached quickly and the sensor will turn off the flash. With a dark subject at a distance,

Honeywell offers a wide range of automatic flash units. This handle-mounted unit is equipped with a remote light sensor, shown mounted on a Honeywell Pentax camera. Flash unit can be removed from the camera and pointed in any direction for bounce flash while sensor on camera looks and measures in the same direction the camera is pointing.

the flash will have to run full cycle. Those are the max/min limits.

It should have occurred to you by now that the *f*-stop setting on the lens also enters into the problem. With bigger aperture, the same exposure will "reach farther" also. The computer on the flash unit tells you what *f*-number to use, after you tell it the film speed you are using.

Typically the computer offers you a choice of two or three *f*-stops, so you have some control over depth of field. Suppose you have everything set up to shoot and then decide you want to use a smaller aperture than you have set on the lens. Let's say you change it from *f*-5.6 to *f*-11. That reduces the amount of light reaching the film. To balance, you need to reduce the amount of light reaching the sensor of the flash unit by exactly the same amount.

If you do that, the sensor will take a longer time to accumulate enough light to reach its threshold and that will allow exactly enough additional light into the camera for proper exposure with the smaller aperture.

That's the purpose of the mask or filter shown in front of the light sensor in Figure 40B.

If it is a mask with holes in it, the holes will be different sizes to correspond with each of the allowable *f*-stops you can use at the camera. If it is a mask, there will be one position without any hole at all. In this position, the sensor doesn't get any light and the flash unit is non-automatic.

Some flash units use a movable filter with different densities instead of a mask with holes in it. One part of the filter will be completely opaque and that's what puts the flash on non-auto.

Most auto-flash computers display film speed, subject distance range, and *f*-numbers. You can take two points of view about the latter two items. If you choose *f*-stop, your subject should be in the indicated distance range. If distance is your main concern, then you use the appropriate *f*-stop.

The mask or filter placed in front of the light sensor is a new type of control to photography and people don't seem to know exactly what to call it or how to mark it. Obviously it's a sensitivity control for the sensor. Functionally it's tied in with distance ranges to the subject and *f*-stops. On some flash units, the control is color-coded such as red, green, and blue. If you have it set on green, then the green distance scale on the computer is the one. Others use letters as identification of control setting and range.

Now if you will please locate Figure 40 again and look at part C, we can take the next giant stride. A new type of electronic switch, called a *thyristor*, came into use in auto flash units. It does have the capability of interrupting the current flow from capacitor to flash tube, so that's the way it is used. There is no buried flash tube inside. The main advantage of this circuit trick is that the storage capacitor does not dump its charge uselessly into a dummy flash tube. This is called energy-saving in the ads and it helps you to get more flashes per set of batteries in a battery-powered unit. Also the recharging time is less when the capacitor is not fully discharged so the time between flashes can be less—provided only part of the capacitor charge was used in the last flash.

I think there is a worthwhile advantage in a flash system that allows you to disregard guide numbers, subject distances (within reason) and mental arithmetic. You can get this advantage from the automatic light-measuring flash units or from the Canon CAT system or the Nikon GN lens

or similar developments of other brands.

A small advantage of the systems that close aperture when focusing nearby subjects and allow the flash to operate for a longer time is this: They tend to keep abnormally bright light off the film which might otherwise drive the emulsion into reciprocity failure. RF causes underexposure of black-and-white film and can cause color changes in color films as you will see later in the book.

A compensating advantage of the light-measuring auto flash units is that they can be used with practically any lens without any other special attachments or built-in mechanical gadgets. So you pays your money and all that.

Some auto-flash units offer greater user convenience. Most have beam angles suitable for normal lenses (about 50°) or moderately wide-angle lenses (about 70°). Some flash units have a normal beam angle and come with an adaptor which broadens the beam for wide lenses.

Some auto flash units have provision to insert filters in front of the flash tube. Gray-colored filters don't change the color of the light but do change the amount of light. These are called neutral-density filters and they can be used to work up close to a subject without putting too much light on it. Which, by the way, is one auto-flash answer to the reciprocity failure problem.

Electronic flash units simulate daylight and will expose daylight color film so the colors look natural. Some units have provision to insert filters to change the color of the light output to resemble tungsten illumination so you can shoot flash with indoor film.

Some auto flash units have a swiveling light-head so you can bounce the flash off the ceiling to get more diffused illumination. The main body of the flash, with the sensor, continues to point toward the subject so it measures reflected light directly.

More versatility is obtained through remote sensors which mount on your camera and connect to the flash with a cable. With these, you can point the flash in any direction and the sensor still looks where the camera does.

MULTIPLE LIGHT SOURCES

A single source of illumination on the subject, particularly if the source is physically small, tends to cast harsh shadows with sharp edges and

While you are buying your camera equipment be sure to get a good sturdy tripod such as this Vivitar model marketed by Ponder and Best. It will sharpen up your pictures, allow you to do multiple-exposure tricks, and build strong muscles while carrying it around. If it doesn't do that last part, it isn't sturdy enough.

virtually no illumination in the shadowed area. An unsatisfactory photograph frequently results.

One way to improve the situation is to use more than one light source. If you imagine a light off to the side, so it illuminates one side of your subject's nose, the other side is in shadow. Now, put a similar light on the opposite side and it fills in the shadow. As far as each side of the nose is concerned, it receives light from only one of the two sources. The tip of the nose, the forehead, and any surface that is illuminated by both lights, gets more total light. If the two sources are the same distance from the subject and have the same light output, then any surfaces illuminated by both lights get twice as much illumination. To keep that skin tone at the same location on the film curve, exposure should be reduced by one step.

Doing that is not likely to drive the shadows into the toe of the curve though, because the shadows are getting more light, so the exposure range on the film is less with fill lighting than without.

In making portraits it is desirable to arrange lighting so more is coming from one direction than from the other because this improves the sensation of depth in the picture and gives *modeling* to the features.

This is described by a lighting ratio such as 4 to 1, which means that the main-light illuminance on the subject is four times as much as the fill light. When light sources are identical, illuminance is varied by putting the sources at different distances from the subject and the lighting ratio is calculated on the assumption that the Inverse Square Law applies. For example, to get a 4 to 1 ratio, one source should be *twice* as far from the subject as the other.

This won't be exact, but nothing simple will be exact because it depends on the light pattern of the sources.

A technical distinction must be made between *lighting ratio* and *brightness ratio* of a scene. If the light from one side is three times as much as from the other, the *lighting* ratio is 3 to 1. Wherever the scene receives light from the most remote source, or the one with least luminance, the surface receives one unit of light. Where the other source is the illuminant, there are three units of light. But where both are effective, there are four units of light. So the scene *brightness* ratio is 4 to 1 when the lighting ratio is only 3 to 1.

With all that out of the way, the main question is, how do you expose for a scene with multiple light sources? It depends on the ratio of illuminances and also on how much light from one source spills over into the area illuminated by the other source.

If there is no overlap you can expose for the brighter of the two areas. If the two areas are equally bright, expose for either.

If there is overlap, and you are worried about too much exposure in the overlap area, decrease exposure appropriately.

BOUNCE FLASH

Flash from the camera position often results in unflattering illumination of the subject and sometimes even enters the eye pupils of your sub-

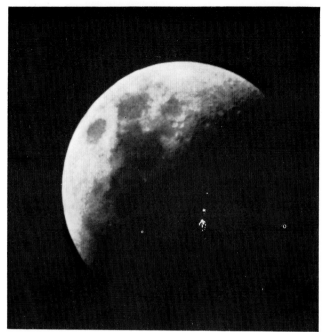

Subject is receiving only side lighting. A little fill lighting on the other side would help the portrait but science has not yet solved this problem. Shot with a 400mm lens, 35mm SLR on a tripod, mirror locked up to reduce vibration.

ject and reflects back to the camera as two spots of red light due to coloration of the blood vessels in the eye. Flash held away from the camera even a short distance usually stops the "red eye" problem and may give more flattering illumination.

A better solution, indoors, is to bounce the flash off ceiling or wall to give a different angle to the light and also diffuse it to provide less contrasty illumination.

If you are using flash bulbs or a simple electronic flash, use the guide number along with the ray-path distance the light must travel from flash to subject—the distance to the point where the light bounces plus the distance from the bounce point to the subject. Because the bounce-surface will not have 100% reflectance some light will be lost, so you should open up the lens a half-stop or so beyond what the guide number and ray-path distance calculation suggested. Naturally if the bounce-surface is colored, it will make colored light. Green paint reflects green light, makes green people.

Automatic flash units are very handy for bounce flash if they can point in one direction while the light sensor looks at the scene.

Color vision

You remember that sunlight contains all colors of the visible spectrum and each color of light has a different wavelength than other colors. The visual sensation of blue results from a band of wavelengths centered approximately around 450 nanometers, green is a band centered around 550 nanometers, and red is produced by long waves in a band around 650 nanometers. You can look back at Figure 10 again if you want to.

The mechanism by which these wavelengths cause the sensation of color involves both the eye and the brain and is not completely understood. Some observations about human vision lead to a theory about how it works. Because this theory explains most of the observations it is useful and

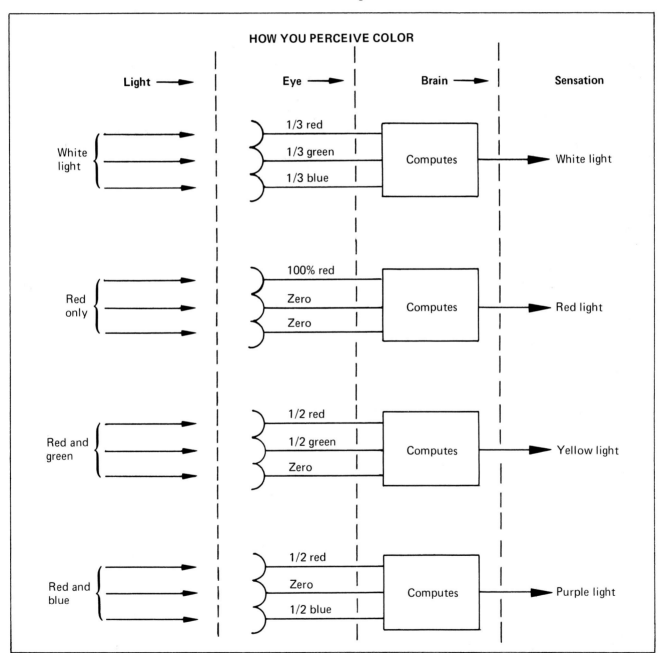

HOW YOU PERCEIVE COLOR

Light → Eye → Brain → Sensation

White light — 1/3 red, 1/3 green, 1/3 blue — Computes → White light

Red only — 100% red, Zero, Zero — Computes → Red light

Red and green — 1/2 red, 1/2 green, Zero — Computes → Yellow light

Red and blue — 1/2 red, Zero, 1/2 blue — Computes → Purple light

Apparently the brain decides what color we are looking at by noting the proportions of red, green and blue as reported by the sensors in our eyes.

generally accepted. Color photography is based on the trichromatic or three-color theory of color vision.

The idea is that we appear to have receptors in our eyes which respond to the three primary colors: blue, green and red. Each group of color-receptors responds to a band of wavelengths. However it is not necessary for *all* the wavelengths in the band to be present to stimulate the receptor. *Any* wavelength in the blue band causes the blue sensation. That's important.

SPECTRAL COLORS

In passing through a denser medium, light rays are bent or refracted. Different wavelengths are refracted different amounts—the mechanism a prism uses to separate sunlight into the colors of the spectrum. Sometimes a drinking glass does the same thing and raindrops in the air do it on a grand scale to produce a rainbow.

These "white" light constituents are called *spectral colors.* If we look at a spectral color in the absence of any other light, we are seeing the purest form of that particular color. If the color happens to be green, then our green-receptors get the strongest signal and the other receptors get little or no signal. This kind of color purity is called *color saturation.* Spectral colors are fully saturated. If some other wavelengths get mixed in, or if white light gets mixed in with a spectral color, the spectral color is diluted and is less saturated.

COLORS OF THINGS

Most things we look at just reflect light that falls on them. If an object is in white light and reflects all components of that light, then the object appears to be white. If it absorbs all colors except red and reflects only red wavelengths, then the object appears to be red.

But most things we look at are not a *spectral* color. We see pink and purple, raspberry and lime, and a tremendous variety of different colors. We can see all these different colors under white light, and we know that the objects appear to have color only because they *do not* uniformly reflect all spectral colors. Selective reflection causes these things to have color.

Every color we can see can be made by *removing* some wavelengths from white light. If you remove all the wavelengths the result is black.

The idea of removing some wavelengths from white light to create color is not the customary way to talk about it. If you take all the spectral colors, discard some and combine the remainder, some particular color results. It is common to say the color resulted from combining the wavelengths actually present, rather than by omitting the wavelengths that aren't there. So we can now state it conventionally:

Non-spectral colors are made by combining spectral colors. If you combine them all, the result is white. Every color you can see is some combination of spectral colors.

HOW DO YOU SEE NON-SPECTRAL COLORS

If it's true that you have three sets of color-receptors, sensitive to spectral blue, green and red, then how do you see some non-spectral color? Such as purple—a combination of blue and red.

The explanation is that your mind is a computer which decides what the color sensation *should be* from the data it receives. The data comes from the three primary-color sensors in your eyes. Suppose the report says: No green at all; 30% red and 70% blue. Computer decides: Color is purple . . . on the blue side. If the report changes to 70% red and only 30% blue, then the sensation is purple . . . on the red side. We get bluish-purple or reddish-purple depending on the relative percentages of the two colors combined to produce the purple sensation.

Many colors are some combination of all three primary colors.

There is a word for what the computer in your mind is doing. The word is *synthesis*, meaning to take the parts and put them together to make the whole.

Your mind synthesizes color by noting the amounts of the three primary color stimuli and producing the color sensation appropriate to that combination of colors. Because of this process, you can see a color that isn't there.

In the spectrum, yellow is between green and red. If you look at the yellow in a rainbow, that wavelength stimulates both green and red receptors in your eyes because they are broad-band receptors and the sensitivity of each overlaps yellow in the spectrum. The report to your computer is, "Some green and some red." The color you recognize is yellow.

You can see yellow another way. If spectral green and spectral red are combined, and no other wavelength is present, the report to your computer is, "Some green and some red." The color you sense is yellow even though no real yellow light exists in your view.

Here's a summary of things which are important because they are the basis of color photography.

All colors can be made from some combination of the three primary colors: red, green and blue.

The color receptors in your eyes "see" only those three colors.

The sensation of color is synthesized in your mind.

NIGHT VISION

You have probably noticed that you cannot distinguish color at night. The reason is that the eye has two groups of light-sensitive cells, one for daytime use and another for low illumination. The daytime sensors—called *cones* due to their shape—are the ones with color discrimination. The low-light sensors are called *rods.* They allow us to see by moonlight and even by starlight but they don't offer us the luxury of perceiving color. Cones are more populous near the center of the retina. Rods are more prevalent near the edge of vision. This explains why you can see objects better at night if you don't look straight at them—as any Indian scout knows.

EFFECT OF ATMOSPHERE ON SUNLIGHT

The sun produces light containing all the colors of the spectrum balanced so it appears white.

Sunlight entering the atmosphere is scattered by air molecules. The long red wavelengths are scattered much less than the short blue wavelengths.

Scattering means just what it says. Blue light waves bounce around among air particles like balls on a pool table whereas the red light waves continue straight-arrow from the sun to you on a direct path.

Blue light waves are scattered in all directions. Some leave the direct route from sun to your house and head off toward the horizon. Along the way they continue to bounce around and change course constantly. From all points in the sky some

Atmospheric scattering "extracts" blue light waves from sunlight and scatters them all over the sky. Without the blue component, sunlight looks more red-colored. At sunrise and sunset, sunlight travels through more atmosphere, more blue light is scattered, so sunlight is reddish.

of them are deflected downward and head straight at you. That's the reason the sky looks blue. Blue light from the sun got scattered all over the sky. Without atmospheric scattering the sky would be black and no light would come from it. In space the astronauts see a black sky for that reason.

An object shaded from the sun but illuminated by light from the sky receives mainly blue light and this has an influence on color photography. We say this light is *cold-looking.* Direct sunlight has more red light in it and is *warm-looking.*

The amount of blue light extracted from the sun's rays by atmospheric scattering depends on how much atmosphere the sunlight passes through. At high noon there is only about 50,000 feet of tangible atmosphere between you and the sun. At morning or evening the sunlight travels at an angle through a longer path in the atmosphere and therefore loses more of its blue component due to scattering. That's why sunrises and sunsets are red-colored and why the instructions with your color film say don't shoot within two hours of sunrise or sunset. If you subject is in sunlight it will be "too red." If your subject is in skylight, it will be much more blue because all those short wavelengths extracted from the sun's direct rays are scattering about in the sky.

Personally, I will allow and even encourage you to expose film at sunrise, sunset, during solar eclipses and earth tremors on any day of the week.

COLOR OF LUMINOUS OBJECTS

An object can make light by several processes, one of which is the effect of heat. Something hot enough to glow emits a continuous spectrum of light similar to the spectrum produced by the sun. Low-temperature objects generate light with a lot of long wavelengths but few of the shorter wavelengths to produce blue and green. Candlelight and firelight look red or yellow.

In color photography the color of light illuminating the scene is very important. Because vision adapts readily to different kinds of light we tend to think an incandescent lamp is white and we also accept light from the sky as white even though the color of these two sources is considerably different.

When we take a color shot the viewer of the print or slide is not so considerate and our photos look *off-color*. The difference between daylight and incandescent light is so pronounced that color films are made and identified for each type of light and the photos won't look "right" unless you expose them in the light for which the film was designed.

Because not all daylight is the same and not all incandescent light is the same, some standard is needed. The standard is derived from the observation that the temperature of a glowing body determines the spectrum it radiates.

The issue is complicated slightly by the possibility that a surface might both emit light and reflect light. In which case the incident-light spectrum blends with the radiated-light spectrum and fuzzes up the whole deal. A surface which does not reflect any light is black. Therefore scientists speak of a black-body radiator, meaning one which does not reflect incident light. On the premise that the object is black, the radiation spectrum is described just by stating its temperature.

Here are some approximate color temperatures:

Burning candle	1,800°
Household incandescent lamps	2,500 to 3,000°
Professional photo lamps	3,200 and 3,400°
Clear flash bulbs	4,000°
Direct sunlight at mid-day	4,500°
Commercial theater motion picture projector lamps	5,000°
Average daylight (sun, sky, and random clouds)	5,500 to 6,000°
Electronic flash	6,000°
Sun and blue sky	6,500 to 7,000°
Blue sky only (no direct sunlight)	8,000 to 20,000 or more

The temperature scale used in the foregoing is absolute temperature in degrees Kelvin (K).

Some light sources are not heated to produce illumination: Neon and fluorescent lamps, lightning bugs and lasers. The light-producing mechanism is complicated and we don't need to worry about it. The essential difference in light produced by these sources is that it is not a smooth and continuous spectrum, as is the case with incandescent sources.

The light typically occurs in narrow bands called *lines*. In between the lines there is no radiation. By tailoring the source so lines are produced at several locations in the spectrum, the light can trigger the trichromatic sensors of the human eye to give the effect of white light. However, color film doesn't "see" light the way our eyes do and a photograph taken under fluorescent lighting may

When an object emits light due to elevated temperature, the amount of light at each wavelength can be plotted on a curve like this. The curve will be continuous and relatively smooth so we say it is a continuous spectrum. The temperature of the object can be used to specify the radiant spectrum.

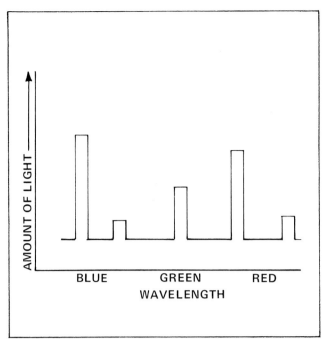

Objects that emit light by other mechanisms such as fluorescence do not produce a continuous spectrum. The idea of color temperature does not apply to these light sources.

not produce natural-looking colors.

Electronic flash is made to simulate daylight in its effect on color film and can be used as such. Blue flash bulbs and photofloods also simulate daylight.

The amount of change in color temperature which makes a visible difference in the color-quality of light varies with the color temperature of the source. Many professional photographers use special meters to measure the color temperature of the light they are using. At lower temperatures, smaller changes are visible. In the range of 3,000°, a shift of 100° is visible to an observer. In the vicinity of 6,000° a shift of about 300° is required before a color change is visible.

RECIPROCAL DEGREES

By converting to reciprocals and using the resulting numbers to represent color temperature, the visible *differences* become more nearly uniform across the spectrum, which is handy. The reciprocal of 5,000° is 0.0002—an unhandy number because it requires locating the decimal point and writing all those zeros. So we play another trick. Instead of dividing degrees into the number 1 to obtain the reciprocal, we agree to divide degrees into 1,000,000, which amounts to a multipli-

cation of the reciprocal by a million. The number 0.0002 then becomes 200, which is handy.

The short name given to this reciprocal number used to *represent* color temperature is MIRED which is an acronym formed from the long name MIcro REciprocal Degrees. The word "micro" is the tip-off that we threw a factor of one million into the arithmetic for our own convenience.

The following table shows four color temperatures, the equivalent mired numbers, and some differences to illustrate the point.

Color Temperature	Difference in Degrees	Mired Number	Difference in Mired
3,200°		313	
	100°		10
3,300°		303	
5,000°		200	
	300°		11.3
5,300°		188.7	

It does appear that through the magic of reciprocals the 100-degree change in color temperature at the low end resulted in a *mired* difference of 10 units. Also, a 300-degree change in color temperature at the high end produced a change of approximately 10 units. Because this is the *visible* change in both cases, the advantage of using mired units is to give us this handy rule: Any time the mired number changes by 10 units the light has changed color enough to worry about.

Do you believe those restless pioneers of photographic mathematics could leave that alone and not fiddle with it anymore? No indeed. Somebody decided it would burden the brain to have to remember the number *ten* whereas practically anybody can remember the number *one*. Possibly by counting himself occasionally.

Accordingly, with fanfare and foofoorah, a shiny new model was announced. The DECA-MIRED! The mathematical prefix "deca" means ten times as large. A decamired contains ten plain ordinary mired units. Now look again at the table with decamired units in mind and you will see a change of only *one* decamired unit causes a visible color shift.

To calculate decamired units divide the color temperature into a million and then divide the result again by ten. Or divide temperature into 100,000 to begin with. Luckily there are color temperature meters such as the Gossen Sixticolor which both measure the color and give you the needed filter correction in decamired units.

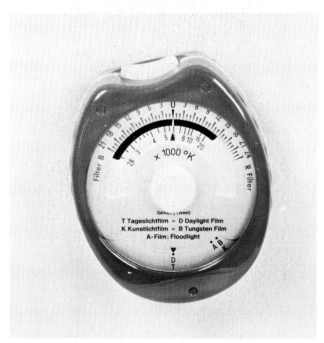

Instruments like this Gossen Sixticolor color temperature meter reduce theory to practice. The meter measures the color temperature of the light you are using to take pictures. Dial in the type of color film you are now using and the instrument also tells you what filter you need to correct the light so it fits the film. Pop that filter over your camera lens and your photo should have natural colors. If you also get the exposure right.

You will read about mired and decamired in photography publications and the authors often don't bother to explain all that. Possibly out of embarrassment.

We will encounter the subject again in the discussion of filters so please keep it in mind.

One more thing. You have probably already fixed in your mind the idea that low color-temperature numbers mean reddish or yellow-colored light. As color temperature goes up, light gradually changes toward white, therefore higher color temperatures imply the addition of green and blue wavelengths in the radiation. When color temperatures are converted to mired or decamired units you have to reverse your thinking about what the low and high numbers mean. As you can see from that handy table, the lowest color temperature produces the highest mired number. Therefore changing the light so it has a *higher* mired makes it more red. This is called a positive shift. A negative shift in mired makes the light more blue.

Another thing. You may not have appreciated all the hidden info in the list of color temperatures given earlier because you didn't know then that a change of 100° to 300° in color temperature means something. A model photographed in average daylight bravely exposes herself to a color temperature of about 5,500°. Average daylight means some rays from the sun, some rays from the blue sky and possibly a random cloud or two hovering around.

Put your model in the shade so no direct sunlight reaches her and the color temperature of the light can go up to 12,000° and sometimes more. That's blue light but you won't notice it because of your visual adaptation. The film will respond and the viewer of your picture will respond by noting that your model turned blue. You can correct for the blue color of open shade by popping a filter over the lens of your camera and we're going to talk about filters pretty soon.

COLOR SPECIFICATION

Color temperature as a way of stating color applies properly to the total spectrum produced by bodies which are radiant due to elevated temperature and emit a continuous spectrum of light waves. If we wish to describe some color that is only part of a spectrum, or some color obtained by combining two or more spectral colors, we have to do it some other way.

The scientific system of describing individual colors was established by an International Commission on Illumination in 1931. It is called the CIE system because CIE is the initials of those words in French.

The first consideration is the human eye response. This varies among people—some are even color-blind—however a standard "observer" has been defined whose color vision is depicted in Figure 41. This graph shows the sensitivities of the three sets of color receptors, plotted against visible spectrum wavelengths. Notice that the green sensors have some response over nearly the entire spectrum, with peak sensitivity at about 550 nm (nanometers). Red sensors peak near 600 nm but have a second smaller peak in the blue region.

If the eye receives pure spectral light of only a single wavelength, each group of color receptors responds according to the wavelength and the sensitivity curve of that group. Notice *every* wavelength stimulates at least two color-receptor

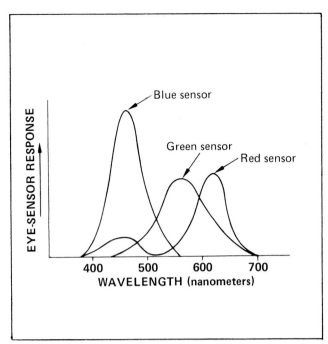

Figure 41/This sketch shows how the three color sensors in your eyes respond to different wavelengths in the visible spectrum. Notice that every wavelength stimulates at least two of the three color sensors.

groups. For example: At 600 nm, both green and red sensors respond. At about 475 nm all three groups respond.

This allows rediscovery of the trichromatic model of color vision—through the back door. If single-color light stimulates two or three groups of sensors, then two or three different colors each exciting one sensor group to that same degree should produce the identical color sensation in the mind of the viewer. Experiments show that this does happen.

An instrument known as a *colorimeter* is used to match two colors visually. There are two illuminated panels side by side in the observer's view. One panel is illuminated with the color to be matched. We can think of this as the specimen panel.

The other panel is illuminated with some combination of the three primary colors—red, green, and blue. The amount of each primary color is adjustable by the observer.

With this instrument we can experiment to find *proportions* of the three primary colors which together produce a color to match the specimen. Suppose the specimen is a pure spectral color at the wavelength where the green and red response

curves cross each other on Figure 41. This is a wavelength of approximately 575 nm, and that color is yellow.

Where these two curves intersect they have the same value, meaning a spectral color at 575 nm stimulates the red and green sensors equally and produces little or no blue-sensor response.

We can conclude that spectral 575 nm can be *matched* by green and red light in equal proportions, and no blue light at all or a very small amount. Colorimetric measurements verify this conclusion.

Similarly, every spectral wavelength can be matched with some combination of three primary colors and a table of data assembled to show the proportions of each primary needed to match a particular spectral color.

Figure 42 shows a few wavelengths you can find on the curves—and the equivalent set of primary colors visually matching the spectral color.

Inspection of Figure 41 shows general agreement with the numbers in the table.

This scheme works with any set of three primary colors selected so the three color receptors are each stimulated by one of the three primaries. For example, in the blue region the primary wavelength could be 425 or 460 or 472 nm, all slightly different hues of spectral blue. Naturally the proportions of primary colors matching a spectral color are influenced by the exact wavelengths chosen for the three primaries. In the CIE system the three wavelengths used as standard primary colors are:

Red 700.0 nm
Green 546.1 nm
Blue 435.8 nm

Figure 42/The sensation of color is caused by stimulation of three color-receptors in our eyes. This table shows the proportion of each color-stimulus necessary to give the sensation of certain spectral colors such as 450 nanometers.

Wavelength of spectral color (nm)	Proportion of primary colors		
	Red	Green	Blue
450	0.1566	0.0177	0.8257
500	0.0082	0.5384	0.4534
575	0.4788	0.5202	0.0010
650	0.7260	0.2740	0.0000

You can see green and blue are very near the peak of the visual response curves for those colors, which seems reasonable. Red is 'way off base at 700 nm. The reason is complicated but basically the red primary wavelength is chosen so the system is able to match all spectral colors even though in the real world it doesn't stimulate red vision very well. Any book on colorimetry will give you more information if you are curious about it.

The end result of all this labor is going to be a map with a location for every color. The three color proportions in the table are officially known as *trichromatic coefficients* and the mapping scheme, when we get to it, uses these numbers to locate colors on the map.

Every map has a boundary and our mental exercise, so far, has defined the boundary of a map of all colors. The reasoning is straightforward. We have trichromatic coefficients for every spectral wavelength. Light at some single wavelength is a particular color and is as pure as you can get, for that color. A single-wavelength color is said to be *fully saturated* or 100% pure. If white light is mixed in, then that color becomes less intense and is said to be *desaturated.* The point is, when you get to 100% purity or full saturation, that's as far as you can go. Therefore the coefficients for the spectral colors define the outer edges of a color map. No color can be outside this boundary because no color can be more than 100% pure.

I tend to think that smartness exists mainly in our own time and am always mildly astonished when I discover that the old-timers were pretty smart themselves. Back in 1931 they were able to figure out a handy way to make this color map, using the *three numbers* for each color as a form of address on the map.

This is really the most complicated part of the whole deal and it has nothing at all to do with color. It has to do with arithmetic and the construction of curves on a piece of paper. Paper is flat and has two dimensions. Therefore a graph or curve can be drawn on two axes, horizontal and vertical, and each point on the graph is identified by two numbers, one for each axis. We now have the problem of three-number addresses.

The solution is clever. Remember that the trichromatic coefficients are *proportions* of each primary color. Assume the proportions are 1/4,

1/4, and 1/2. Notice the total of all three fractions is one. Look again at the table of coefficients in Figure 42 and you will see the sum of the three coefficients for a particular wavelength is always one.

If I tell you two of the values you can immediately calculate the third. So, to get sets of three numbers onto a two-dimensional graph we need only display two numbers of each set. Which automatically implies the third number.

We choose two of the three primary colors for the axes of the graph and allow the third to be expressed by that secret code. Normally red is shown on the horizontal axis and green on the vertical as in Figure 43.

Coefficients for all visible wavelengths are plotted on this chart and the result is an odd-shaped horseshoe. Spectral 650 nm is located at 0.726 on the red axis and about 0.274 on the green axis. Because these two numbers add up to 1.0 there isn't any blue at all. This agrees with the trichromatic coefficients in the table and also with the standard observer back in Figure 41.

The curve stops at 700 nm on one end and 400 nm on the other because these are considered to be the limits of human vision. These two points on the curve are connected by a dotted straight line closing the figure into a rough triangle.

Now let's find white on the map, properly called a chromaticity diagram. If we agree white should be produced by the three primaries in approximately equal amounts, we just find the point about 0.33 on the red axis and also about 0.33 on the green axis, leaving about 0.33 for blue. This location is shown as a circle near the center of the map.

That white was arbitrarily chosen. Suppose we want a near-white with some red in it. The "reddish-white" point would be farther out on the red axis and therefore lower down on the green axis and probably also with less blue. The point could be 0.4, 0.3, and 0.3 for the three primaries in red-green-blue order. You can also find points for bluish-white and greenish-white if you want to do it.

The wavelength 550 nm is a spectral green. If a line is drawn between the white point near center and 550 nm on the boundary curve, every point on that line is the same hue or color of

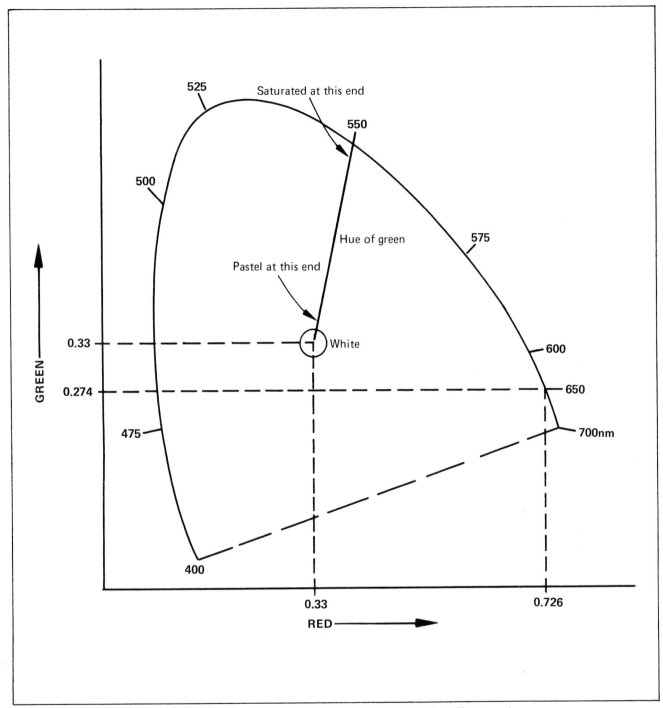

Figure 43/Sketch of a map with a location for each color, just to show the basic idea. Not to scale.

green. However, saturation changes from 100% at the boundary to zero at the white point. This is equivalent to combining spectral green with white light and simultaneously reducing the amount of green while increasing the amount of white.

All colors lie somewhere on this map. Gray and black lie exactly on top of white because black has no color and gray is the combination of white and black.

Imagine some non-spectral color, perhaps a brown shoe or a pickle, and imagine that we are using some kind of a colorimeter to find the three primary coefficients to match the specimen color. To see the color of the specimen we have to illuminate it with light and the apparent color of the specimen is influenced by the color-quality of the light by which it is viewed.

Those smart guys back in 1931 thought of that problem too and specified three standard illuminating sources each with a different spectrum or color temperature.

Source A is an incandescent lamp at color temperature 2,848° K, approximately the same as indoor electric lights or ordinary photofloods.

Source B is intended to represent noon direct sunlight at a color temperature of 4,800° K.

Source C represents average daylight, a combination of sunlight and skylight with a color temperature of 6,500° K.

When any color is specified by its trichromatic coefficients, it is also necessary to state which illuminant source is used or intended because colors look very much different under lights of different color temperatures.

Figure 44 is the same as the previous color map. We will use this new map to show two additional ideas. The cross-hatched area in the middle contains white and a large number of colors, but none of the colors contained in this area reach full color saturation. This represents the color *reproduction* problem in printing books and magazines and also in photography—both slides and color prints. Color reproductions are made with dyes, pigments, and printing inks. In general, none of these colors are ever as pure as spectral colors and therefore never reach 100% saturation. The better the reproduction process, the larger the area of available colors and saturations as shown on a chromaticity diagram. Among conventional reproduction methods, color slides are one of the best in terms of high color saturation.

The boundary of the chromaticity diagram is closed at the bottom by a straight line connecting 400 nm to 700 nm; blue to red. All combinations of blue and red lie on this line. Equal amounts of the two colors are on the line, halfway between the extremes. A higher proportion of blue lies nearer the blue end, and so forth.

Combinations of blue and red create purple and magenta colors. They are real and visible in the sense that you can see them, even though they are not on the spectrum of white light.

A special kind of wavelength, called *complementary*, is assigned to each color along that straight line by the following method. From a purple or magenta color, draw a straight line through the illuminant point, or white point, on the diagram and extend it on to intersect with the spectral boundary curve. The spectral wavelength at the far end of this line is assigned to the purple or magenta color with the subscript c to identify it as a *complementary* wavelength and not a real spectral wavelength. On Figure 44, the purple color 550_c is complementary to the spectral color at 550 nm, which is a hue of green. Magenta at 500_c is the complement of spectral 500 nm. The sense of this will be clear when we discuss additive and subtractive color synthesis.

THANKS

I asked an assortment of nice people with varied backgrounds to read the manuscript of this book to find errors large and small, and make suggestions. Naturally the feedback was bewildering. Some said put more math in, some said take it all out. Some said it's a mighty fine book—some politely didn't. All found errors and oversights which have been considered or corrected. So I am grateful to:

Dr. Philip Slater, Associate Director, Optical Sciences Center, University of Arizona.

Orval Northam, Chairman, Industrial Education Department, Rincon High School, Tucson, AZ.

Lou Jacobs Jr., Photojournalist, book author and columnist.

Robert A. Moore, Media Specialist, Sierra Vista Arizona Public Schools.

Robert Routh, Associate Professor, California State University, Long Beach, CA.

Bruce and Barry Loux, college and high school students respectively, friends and neighbors.

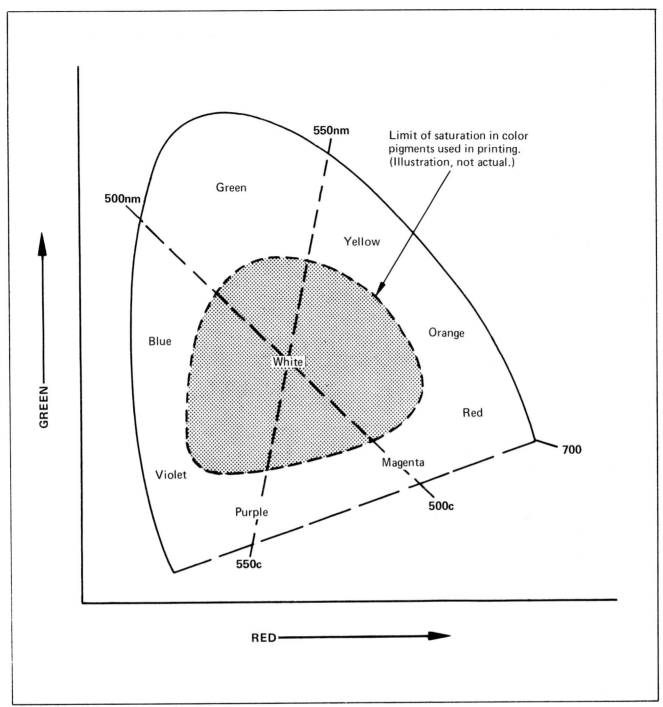

Figure 44/Another sketch of the same *chromaticity diagram* to illustrate a couple more basic ideas, possibly explained in text.

Filters

There are a lot of practical reasons to change the color of light. This section discusses the general idea of color filters. Optical filters are made of colored glass, gelatin or plastic. Sometimes a gelatin filter is sandwiched between two layers of glass to protect the relatively fragile gelatin.

Because a filter has color when you look "through" it at white light, it is obvious that the filter is changing the color of white light as it passes through. If the transmitted light is green, then the other colors are blocked or absorbed by the filter.

Filters are only effective in changing the appearance of broad-band colors, or colors with a combination of different wavelengths.

Assume monochromatic light of only one wavelength, such as blue at 500 nm. As this light passes through a filter the only wavelength which can be affected is 500 nm because that is the only wavelength present. Depending on the filter's transmission characteristic that monochromatic blue light will be absorbed some amount—a little bit or a lot. No matter what happens, any light getting through the filter will still be single-wavelength spectral blue and therefore the color of the light was not changed by the filter—only the amount. This is true no matter what color the filter is.

If light is composed of more than one wavelength, and the filter absorbs some of the wavelengths more than others, then light transmitted through the filter will have an altered spectrum and a different color quality.

You can measure the optical performance of a filter and express the result either in terms of the amounts and wavelengths of light absorbed and not transmitted—or the transmitted spectrum. The information is the same in either case but the point-of-view is reversed.

Fortunately, the analytical tools are the same as those described earlier in connection with white light and black-and-white negative film: transmit-

tance, opacity, and density. I am conducting a brief review course in these matters which you may attend by turning back to page 18.

Because transmittance of a color filter is not uniform across the visible spectrum it can not be stated with a single number. A data table is required to show transmittance at closely-spaced points along the spectrum, such as every 10 nm.

The data can also be presented in the form of a curve and it is customary to display both in a filter catalog. A filter curve representing optical performance is handy to visualize filter color and what it does to the light. The numerical data are useful for precise calculations.

STACKING FILTERS

Sometimes two filters, one behind the other, are necessary to achieve some particular result. Each may have an effect on some wavelength and the question is, "What is the combined effect of

All filter curves in this book are reproduced by permission from the TIFFEN PHOTAR filter catalog No. T371. This curve shows the characteristics of a green filter. The curve shows that it transmits the green wavelengths with a peak transmittance of about 60%. The data table gives transmittance percentages all across the visible spectrum. Blue and red wavelengths are suppressed.
Wavelengths shown on these filter curves are in millimicrons which is another name for nanometers. This book uses nanometers in the text.

TIFFEN Color 11 (Green 1)

WAVE-LENGTH	PERCENT TRANS.
400	--
20	--
40	.8
50	1.4
60	3.1
80	13.0
500	40.0
20	59.1
40	60.1
50	54.5
60	46.5
80	30.0
600	15.0
20	9.5
40	9.9
50	9.9
60	7.5
80	2.0
700	17.0

Most lenses for 35mm SLR cameras accept filters which screw into a threaded section on the front of the lens tube. The front side of the filter repeats the thread pattern so you can "stack" filters by screwing one to another.

the two filters on that wavelength?" Suppose the first filter attenuates or reduces orange light at about 590 nm, allowing 90% to pass through. The second filter has a transmittance of 60% at 590 nm.

If we assume 100 units of light to begin with, the first filter transmits 90% or 90 units. The next filter transmits 60% of the remaining 90 units; 0.6 x 90 = 54 units. The transmittance of filters in series is the product of all the individual transmittances. If there are three filters with transmittances, T_1, T_2, and T_3, then the total transmittance of the three in combination will be their product: T_1 x T_2 x T_3. This is called Bouguer's law and he figured that out in about year 1730 give or take a few.

NEUTRAL-DENSITY FILTERS

A special type of filter, called *neutral density*, is gray which attenuates light uniformly all across the spectrum. Its purpose is to adjust the amount of light *without* changing color balance. It solves the garbage can problem.

If you have high-speed film in your camera and Aunt Minnie wants you to take a picture of her dog in the rose garden, and it is a very bright sunny day, you have the problem. With fast film and lots of light you must close down the aperture of your lens to *f*-16 or *f*-22. This gives great depth of field so, in perfect focus, you can see Minnie's garbage can right there behind her dog.

Naturally the artistic composition of the dog

Tiffen designation ND 0.6 means a neutral density of 0.6, which is two exposure steps. The first step cuts the light in half, to 50%, the second step cuts it in half again, to 25%. Notice on the curve that all visible light waves are affected about the same—25% transmittance approximately. When the transmittance is essentially uniform across the band, a data table is unnecessary.

and rose bush is just perfect when the garbage can is in full view and of course it is undignified for a talented photographer to move trash receptacles.

With less light, you could open up the lens to reduce depth of field and throw the offending can out of focus so it would be just a vague blur in the picture. That's the purpose of a neutral density filter, which you fit over your camera lens.

Its middle name is density which describes its virtue. Accordingly, such filters are often labeled with their optical density. ND-2 for example is a neutral density filter with a density of 2.0.

If you are keen on mathematics, you remember that two numbers can be multiplied by taking the logarithm of each number and then simply *adding* the logs together. Because density is the log of opacity, etc., adding densities together is exactly equivalent to doing Bouguer's thing with transmittances. When stacking ND filters you predict the result by adding the densities. Filter ND-1 stacked with ND-0.3 results in a total density of 1.3.

How much density do you need to solve the garbage-can problem? Suppose the normal exposure turns out to be *f*-16. If you have an SLR camera, you can stop down the lens and look through

it to see depth of focus and watch the garbage can disappear as you increase aperture. Assume this happens at *f*-4. You need to open up by four stops.

A density of 0.3 cuts light in half, so you need a total density of 0.3 + 0.3 + 0.3 + 0.3 = 1.2. Two filters stacked, ND-1 and ND-0.2 will do that, and you can shoot at *f*-4 instead of *f*-16.

This table leads to a mnemonic system so you can remember about ND filters if you want to:

Neutral Density Change	Exposure Step Change
0.1	1/3
0.2	2/3
0.3	1
0.4	1 1/3
0.5	1 2/3
0.6	2
0.9	3

Each additional 0.3 of density represents one full exposure step and each 0.1 of density represents 1/3 exposure step, approximately.

FILTER FACTORS

All ordinary filters which do something to light do it by blocking passage of some wavelengths. Therefore there is less total light on the output side of the filter. Or less light on the film if the filter is in front of your lens.

Before the days of through-the-lens metering, everybody who measured light to set camera exposure did so with a separate hand-held light meter. These meters assume there is no filter on the camera and suggest exposures based on that assumption. If a filter is used, exposure must be increased over the separate hand-held light-meter recomendation by an amount which compensates for the light lost in the filter.

Filter catalogs and photography technique books often have a table of different filter colors and types, along with a filter factor for each. This factor is the amount of exposure increase required when using that particular filter, such as 2X or 3X.

A modern SLR camera with TTL metering measures light through the lens and through any filters you have put in front of the lens so the exposure recommendation made by the built-in meter and computer already includes the filter factor as well as the light sensor in the camera can judge it. Usually this judgment is satisfactory for exposure and therefore TTL is a great convenience.

Light from the sky is both blue and polarized whereas light from clouds is neither. Sky can be darkened in b&w by a red filter, or a polarizing filter, or both as was done here. In color, a polarizing filter is the only way to darken blue sky without changing the colors of the picture.

Polarizing filters

Polarization phenomena have no simple everyday explanation, so I suggest you just take them on faith. Which should not be difficult if you still accept the adage, seeing is believing.

Sunlight has "vibrations" in all directions perpendicular to the direction of travel of the light. It is called either unpolarized or randomly polarized light.

In its travels, sunlight can become polarized in several ways. Whenever that happens, vibrations in one direction are suppressed or completely eliminated so the resulting light consists of vibrations mainly in a single direction such as up-down, left-right, or some angle in between.

Three ways of causing light to become polarized are important to photography. One is reflection from smooth non-metallic surfaces such as glass or the surface of a lake. When the angle between the reflected ray and the surface is about 35 degrees, the polarizing effect is maximum. In the case of a horizontal surface, such as water, vertical vibrations are suppressed but horizontal vibrations are reflected from the surface. The resulting light is called horizontally polarized because more of its vibrations are horizontal.

Light from the sky is polarized, depending on where in the sky it comes from. If the sun is at right angles to the direction you are pointing your camera, light entering the lens from the sky is polarized.

There are special filters which polarize light by transmitting vibrations in one direction but blocking the other direction. If they are passing horizontally polarized light they are blocking vertically polarized light. Such filters can be put over a light source to produce polarized light, or over a camera lens to allow transmission of light with a certain angle of polarization, or both.

The polarizing filter mount allows rotation of the filter so you can turn it until you find the best angle for whatever you are trying to accomplish.

If you are photographing a landscape, a polarizing filter over the lens can be used to darken the sky by blocking that portion of skylight which is polarized which makes the sky appear less bright. While looking through the viewfinder, rotate the filter and judge the effect visually.

You are about to see why I'm a fan of polarizing filters. Black & white in the photo pairs that follow, color in a few more pages. Polarizing filters screw into the lens, but the filter glass is held in a ring so you can rotate the filter element after it is installed on your camera.

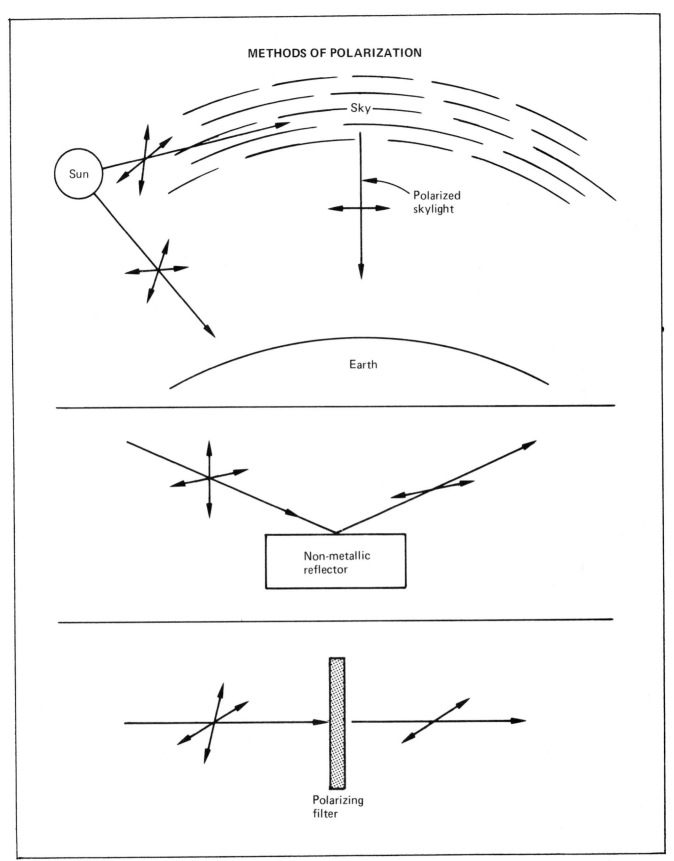

METHODS OF POLARIZATION

Light from the sky is polarized and has maximum polarization when viewed at right angles to the sun. Reflections from non-metallic surfaces are polarized. Light transmitted through a polarizing filter or "screen" is polarized. All of these effects can be used in photography. Smooth unpainted metal surfaces do reflect light with a small amount of polarization-effect but it is not strong enough to be noticed in ordinary photography.

171

Because surface-reflected light is usually polarized it can be blocked by a polarizing filter. This effectively "strips away" surface sheen and makes images better.

You'll think this is about as good as your camera can do—until you start fooling with a polarizing filter.

Polarizer "sees" right through glare and brings out the grain pattern in wood furniture.

Reflections from store windows and the surfaces of paintings can be reduced by a polarizing filter. They can be reduced even more by polarizing both the light source and the camera filter.

Because reflections from smooth surfaces in a scene are usually specular rather than diffuse, these bright rays enter the lens and bounce around to reduce image contrast on the film. Such rays are also polarized by reflection so they can be suppressed before they get into the lens by use of a polarizing filter. Contrast can sometimes be greatly improved that way. When shooting color, diffused light over the image will not only reduce contrast but also desaturate the colors. The improvement in color landscapes by using a polarizing filter is dramatic.

If a filter blocks all the light which has one direction of polarization, but passes all light with the other, then it transmits only about half of the total light. The filter factor in that case would be 2, and you should open up one stop to allow for that. However the actual attenuation depends on the actual polarization of light from the scene. The material of the filter itself absorbs some light, so the filter factor is more often considered to be 3.

Two polarizing filters in combination can be used as a neutral density filter of variable density. If one is rotated so its angle of polarization is the same as the other, both will attempt to block the same light and pass the same light, so the second filter in agreement with the first will not have a major effect. If the second filter is turned 90 degrees, then it will block the polarization which is being passed by the first and the total light attenuation will be high. Any effective density between those extremes is available by rotation of one of the two filters.

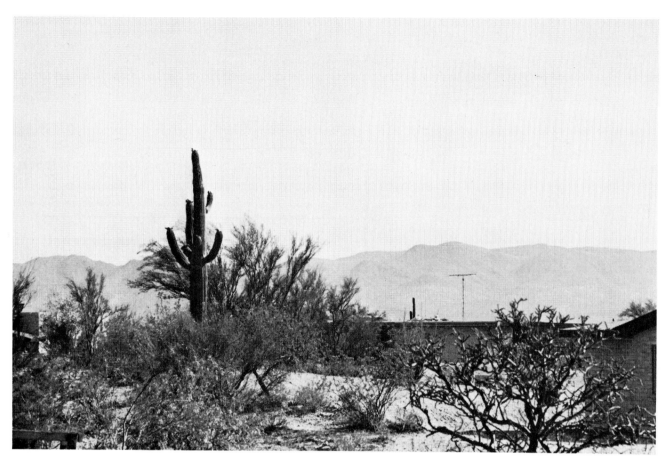

Polarizing filter also cuts glare from surface reflections of landscapes. Notice the improvement of the distant hills.

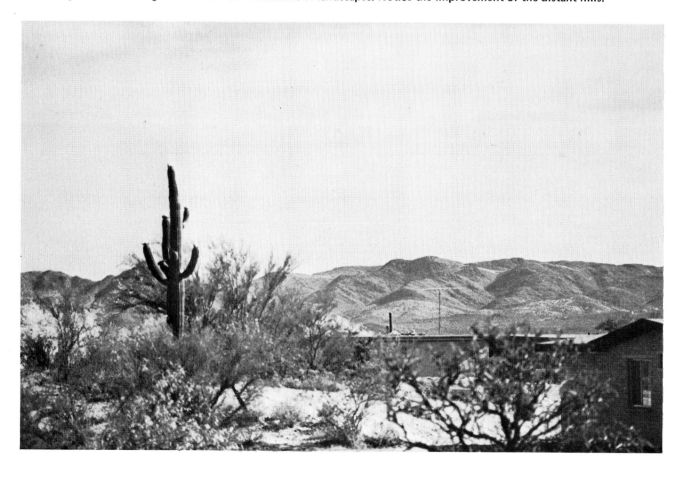

Unpolarized light from my desk lamp falls on film can, magnifier lens and pipe tool.

Polarizing filter on camera lens removes glare from glass surface but not metal surfaces. "Clean" reflection from magnifier lens now shows lamp and bulb. I darkened the room to exclude daylight, shot with large aperture, got poor depth of field, and lavished it all on pipe tool. You can do better.

THANKS

Good people from the firms listed below helped make this a better book by furnishing information, photos, and drawings about their products. They answered all the questions I asked, but I may not have thought of everything I should have inquired about. So, what this book says is my responsibility and I don't blame any of it on these kind people.

Dorothy Hogan of the American National Standards Institute.

M. L. Green and Fred Walker of Berkey Marketing Companies, Inc.

Louis Surdin of Canon U.S.A., Inc.

P. Corey of Ehrenreich Photo-Optical Industries, Inc.

Dave Carlson, Don Cohee and Ernst Wehausen of Honeywell Photographic Products Division.

Kenneth Lassiter and Hubert Scheffy of Eastman Kodak Company.

Minolta Corporation.

Barry Goldberg of Ponder & Best, Inc.

Rollei of America, Inc.

Stan Ernenwein of Tiffen Optical Co.

John Lewitsky of Yashica, Inc.

Omission of other manufacturers and products does not imply criticism, preference, or favoritism. Maybe absentmindedness.

ABOUT THE ILLUSTRATIONS

I didn't try to dazzle you with footwork when I did the illustrations for this book. Some of the equipment photos were furnished by the manufacturers which saved me the bother of making them myself. Except where noted, I shot the rest of the pictures using simple camera equipment and materials that are easy to find such as a yardstick. Except where I reproduced drawings from other publications, the sketches were made by Erv Acuntius from my hand drawings. They are mainly intended to show concepts rather than exact numbers for any particular film or equipment. Any inaccuracies or crudities in the drawings are mine but I hope they serve the purpose.

Additive and subtractive color

It may be that I confuse easily. I seem to spend a lot of time puzzling over some set of facts, trying to get them sorted out in my mind. When I finally do resolve the puzzlement to my own satisfaction, I rejoice, exclaim about it, and give lectures to my wife and any other nearby victims who usually have not the slightest interest in the topic.

I got confused about making color by the additive and subtractive processes that are described in books and remained so until I achieved the simple-minded idea that all color is additive in its effect on human vision. When an assortment of different wavelengths is presented to the eye it responds to all of them in combination—in an additive way. The eye can't subtract any visible wavelengths or ignore them.

The business about additive and subtractive color then is merely some over-elaborate arm waving about how wavelengths can be selected for people to look at.

If you wish to make a color with red and blue light, you can take some of each color and combine them to get the desired shade of purple. That is considered to be an *additive* process because you started with two primaries and combined them.

The same visual result can be demonstrated by starting with white light and removing the green primary color to leave only red and blue. The result is purple again, but this time it was created by *subtracting* green from a color which originally had all three primaries.

Thus the *concepts* of additive and subtractive color are trivial. However, they cannot be dismissed as trivial in the practical world of gadgets and hardware in which colors are made by light and filters. The mechanizations of the two ways of achieving color are different and those *mechanical* differences are very important.

To add colors together implies separate light sources—one for each primary color. Maxwell's famous demonstration of trichromatic stimulation used *three* projectors, each equipped with a filter for a single primary color. The visually red filter produced red-colored light by stopping blue and green. Similarly a filter transmitting any one primary color *must* exclude the other two.

To create color by subtracting wavelengths from white light implies only one light source. This is so much more convenient and manageable that virtually all color processes today use a subtractive process. The logic of it requires subtracting only one primary color at a time, so *subtractive* color filters *transmit two* of the primaries and stop only one. That's important.

These ideas lead to two groups of colors or filters, three in each group. One group is said to be complementary to the other.

Primary Filters	Transmit	Stop
Red	Red	Blue and Green
Green	Green	Red and Blue
Blue	Blue	Red and Green
Complementary Filters	Transmit	Stop
Cyan	Blue and Green	Red
Yellow	Red and Green	Blue
Magenta	Red and Blue	Green

The names given to the filters indicate the visual color of light transmitted through the filter. Cyan is visually a combination of blue and green. Yellow, when used to designate a complementary filter, does not mean a filter which creates spectral yellow by passing only that narrow band of wavelengths in the spectrum which incite the sensation of yellow.

A yellow complementary filter passes both red and green and as you know, these two colors in combination cause the visual sensation of yellow. By passing both red and green, this filter *also* passes the spectral-yellow wavelengths but this is only a happenstance as far as the subtractive color process is concerned. Magenta is a shade of purple, the visual result of combining red and blue.

ADDITIVE AND SUBTRACTIVE COLOR

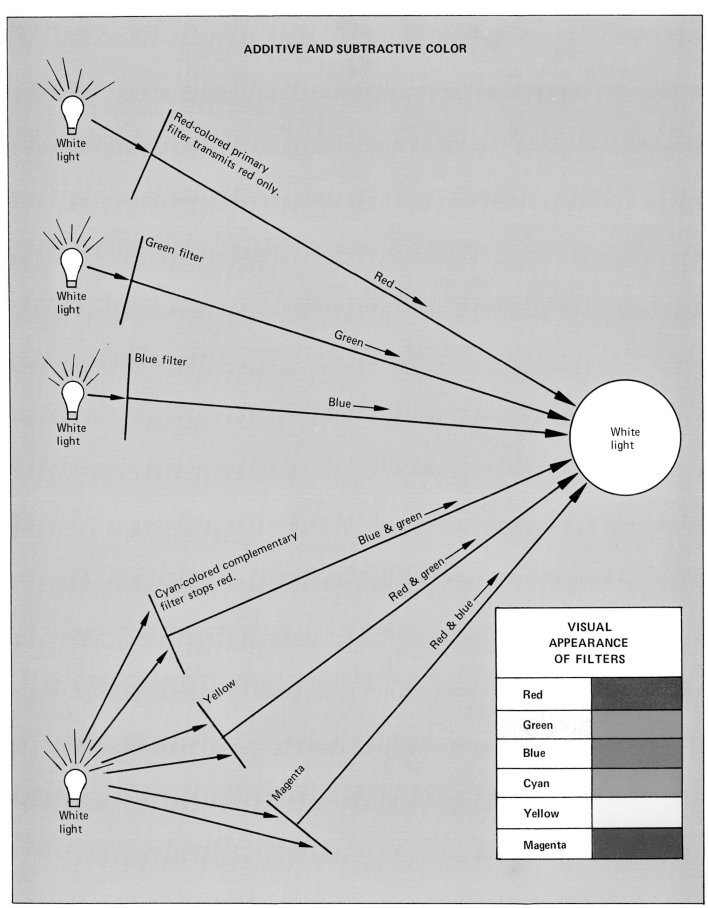

Equal amounts of the three primary colors cause the visual sensation of white. You can do that by adding wavelengths or subtracting, the end result is the same.

The word *complement* is a variant of the word *complete* and describes some ingredient which, when added to the rest of the stew, makes it complete. A wife complements her husband in marriage, whether he is complimentary about it or not.

Among the three primary colors which combine to make white, any one is the complement of the other two.

REVERSAL PROCESSING

When a black-and-white negative is exposed and developed, image tone-values are reversed. The neg will be most opaque where it was struck by the most light. Using that negative between a uniform light source and another piece of film allows exposure of the second piece of film and produces another reversal. We call the result a *positive.*

If the backing of the second film is transparent, it is a positive transparency. If the backing is white paper, it's a print. A positive image resembles the original scene.

An important procedure in photography is based on the fact that the original exposure of a negative actually produces two potential images on the film—one is *negative* and the other is *positive.* The silver halide particles altered by exposure to light represent the various brightnesses of the scene in a negative way and when these particles are developed a negative image results.

However, the silver halide particles in the emulsion *not* altered by light during the original exposure also form a record of the image. For example, where the scene did not reflect much light onto the film most of the silver halide will not be sensitized and these particles will not be developable to metallic silver. Where a lot of light struck the film, most of the particles will be sensitized and very few will remain in the unaltered state. The *unsensitized* particles represent a *positive* image of the scene.

The positive and negative potential images exist at the same time and in the same location, one being an overlay on the other.

Because a positive image can be produced directly on the originally exposed film, rather than on a second piece of film, the procedure is sometimes referred to as *direct positive.*

The film is exposed and first developed for a

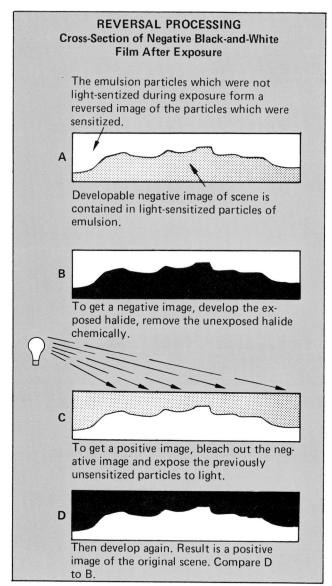

REVERSAL PROCESSING
Cross-Section of Negative Black-and-White Film After Exposure

The emulsion particles which were not light-sentized during exposure form a reversed image of the particles which were sensitized.

A

Developable negative image of scene is contained in light-sensitized particles of emulsion.

B

To get a negative image, develop the exposed halide, remove the unexposed halide chemically.

C

To get a positive image, bleach out the negative image and expose the previously unsensitized particles to light.

D

Then develop again. Result is a positive image of the original scene. Compare D to B.

Reversal processing yields a positive image of the original scene on the same piece of film used to shoot that scene. The transition from negative image to positive image is shown in this diagram. Reversal processing is fundamental to the production of color slides.

negative image, formed by metallic silver in the emulsion. That negative image is removed by "bleaching." Then the film is exposed to uniform light—a non-image *second* exposure—to sensitize the silver halides not sensitized during the *initial* exposure. Silver halide sensitized during the second non-image exposure is developed to produce metallic silver. The second image is a *positive.*

This can be done with varying success using any piece of black-and-white film. Some films specially designed to produce a direct-positive

This slide tells a lot about color. It's a triple exposure of white clouds drifting in a blue sky. Exposures were made with no filter, green filter, and red filter. The clouds moved while I was changing filters.

Because of cloud movement, you can see patches of white, green and red clouds where the reflected light from the clouds did not overlap with different filters in place. Where red and green overlap, there are shades of yellow. The combination of blue sky, red filter and green filter creates gray, which is a shade of white.

See how polarizing filter brightens colors by eliminating surface reflections. Nobody would take a picture at this angle, except to demonstrate that.

179

image are called *reversal films* and the processing is known as *reversal processing.*

Color slides are the same piece of film you originally exposed in your camera. They receive reversal processing similar to that described above, with the added luxury of color. How the color gets there will be discussed later.

COLOR PHOTOGRAPHY

Color photography is difficult to comprehend only because it seems like a lot of different things are happening all at once. It helps to observe that all the things which are happening are basically the same. A lot of the same thing is happening all at once. Three of them.

Imagine a spot on a color photo with some particular color such as an elephant hide. Imagine that you are establishing the color of that spot by controlling the amount of the three primary colors present—just as with a colorimeter.

You need three individual controls, one for each primary, which we can think of as light valves. If you want more blue light, open the blue valve more.

Color film has these three light valves arranged in three layers on the film, one for each primary color. If you start with white light which passes through the three light-valves in sequence, then one layer must control each primary color. The layer controlling blue should do only that and the other two layers should not affect the amount of blue light. Each should control only its assigned color.

These colored layers act exactly like filters of varying color-density.

Now we get to the part which is sometimes confusing. What visual color should a layer have if it is going to control the amount of *transmitted* green light? Control means to act as a valve—to shut off or stop green light in varying degrees.

The complementary color does that. Purple is the combination of red and blue. The shade of purple about half red and half blue is called magenta. Magenta is the complement of green.

A strong shade of magenta got that way by stopping *most* of the green light and allowing both blue and red to pass through the layer.

Colors are desaturated by adding white light, or by adding missing wavelengths so the result is nearer white. A pastel shade of purple is closer to

white and has some green wavelengths present. Therefore varying the density of magenta actually varies the amount of green light passing through that layer.

Three complementary-colored layers on the film control the three primary colors by a subtractive process.

THE IDEA OF COLOR FILM

The way it is done is clever. Film which records a color image has three layers of regular black-and-white emulsion made with silver halides. By some trickery, each layer is exposed to only one of the three primary colors from the scene being photographed. This exposure creates a developable negative image of black metallic silver just like any black-and-white negative film.

Because of the trickery, that layer of film even though still a black-and-white image is actually a record of the amount of light of a primary color which exposed the layer. If the layer was exposed only to the red part of the light from the scene, it is a record of the amount of red at the various locations in the scene. The next trick is to convert that record of the red values into a filter which will reproduce the red values.

The color-development procedure first develops the halide image in each layer. Then it removes the resulting metallic silver and replaces it with a dye image in one of the three complementary colors. If a layer is intended to control or modulate red light, it will be dyed the complement of red, white minus red, that is, blue and green, called *cyan.*

The red-sensitive layer of the negative winds up with a cyan-colored image. The blue control valve is a yellow-colored layer and the green valve is a magenta-colored layer.

There are a couple of important ideas here and we may as well go over them carefully because after this, it's easy.

The red valve allows some amount of red light to pass through. After that, neither of the other two valves have any effect on the red color. Each is busy controlling its assigned color and each ignores the other two layers. Magenta transmits both red and blue while busily controlling green. Yellow passes both red and green while controlling blue. After red light gets through the cyan layer, it goes the rest of the way without further

THE IDEA OF COLOR FILM

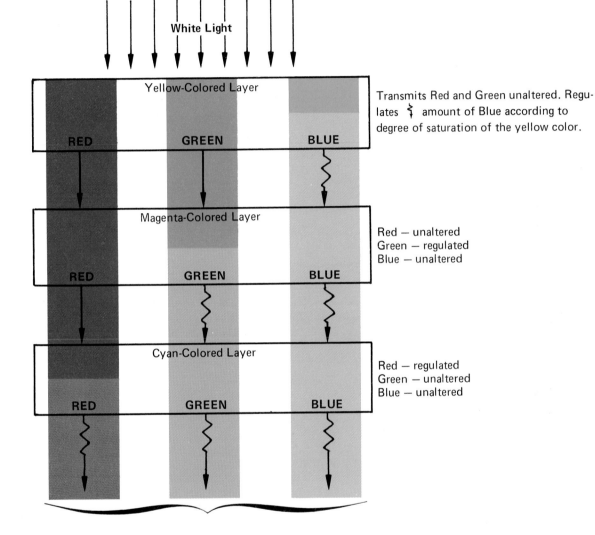

White Light

| Yellow-Colored Layer | Transmits Red and Green unaltered. Regulates ↕ amount of Blue according to degree of saturation of the yellow color. |

RED GREEN BLUE

| Magenta-Colored Layer | Red — unaltered Green — regulated Blue — unaltered |

RED GREEN BLUE

| Cyan-Colored Layer | Red — regulated Green — unaltered Blue — unaltered |

RED GREEN BLUE

Amount of each primary color has been regulated by the film layers to produce the desired color.

Processed color film has three layers, each a complementary color which has some density to one of the three primary colors but is transparent to the other two. Each layer acts as a "valve" to control the transmission of only one primary color. When that layer has regulated the amount of the color it controls (shown by the wiggly arrow symbol) no other layer should affect that particular color.

When it's all done, each of the three primaries has been regulated by *some* layer of the film and none has been affected by more than one layer. For example, from top to bottom, green is not affected by the yellow-colored layer. It is regulated by the magenta layer. Whatever amount of green is transmitted by its controlling magenta layer is then passed through the cyan layer without further change.

This is a subtractive color process because each layer *subtracts* some or all of the color it controls.

Scenics are often dramatically improved by a polarizing filter. This is the essence of color scenic views, foliage and blue sky. Notice how filter darkens sky and removes glare from leaves. Try it; you'll like it!

attenuation.

If the red valve is wide open, but the other two are closed, the light that gets through will be red. If all three valves are wide open, the result is white light. If all are closed, the result is black.

If all three valves are open an equal amount, but not wide open, the result is some shade of gray. Any time the three layers transmit equal amounts of light, the result is some shade of gray between white and black. Any time the three layers do not transmit equal amounts of light, the result is some color which you could locate on a chromaticity diagram if you knew how much light each was transmitting.

The color negative has to create all the colors with varying amounts of saturation and also all shades of gray.

If you have a color negative of some scene, and transmit white light through it, you will get a negative image. The colors will be all topsy-turvy and black will be where white should occur. The image will be dark where it should be bright, and vice versa.

To get a positive image, another piece of three-layer color film is exposed by light through the negative. The second piece of film does the same thing all over again. It makes a negative image of the negative image, resulting in a positive. All the colors are correct now, and the black-and-white tones are also correct.

The layer that controls red in the negative is cyan-colored. The layer that controls red in the positive is also cyan-colored. The difference is, the density pattern is reversed so one is a negative image and the other a positive image. Both are cyan-colored and both represent the red component of light from the scene.

SPECTRAL SENSITIVITY OF SILVER HALIDE

I skipped over the basic trick of color film: exposing each of the three layers to only a single primary color. It rests on the nature of silver halides.

Silver halide is "naturally" sensitive to blue, violet and ultraviolet light. By a technique known as dye-sensitizing, the natural sensitivity range can be extended to the red and IR end of the spectrum.

The color sensitivity of silver halide is important even in black-and-white photography because it can alter the apparent brightness of parts of the scene due to their colors.

For example, early films had very little red sensitivity and in those days ladies wore red lipstick. Because the emulsion did not respond to red-colored light, red had the same effect as black.

Ladies' lips looked black or very dark in photographs.

The first improvement in the color sensitivity range of silver halides was called Orthochromatic which means something like "correct color." This film was responsive down into the greens but still deficient in red sensitivity, so the name was mildly fraudulent.

Then came Panchromatic film, represented to respond to all the colors of the visible spectrum, and it does so satisfactorily.

COLOR FILM STRUCTURE

Because of the necessity to expose the three silver-halide layers of color film so each records only one color, the sensitivities of different emulsions are important.

These sensitivities are used according to the diagram in Figure 45. The top layer is old-fashioned silver halide, sensitive broadly to blue and not much else.

The inner two layers are also likely to preserve their characteristic blue sensitivity, so a layer of yellow filtering material lies beneath the top layer. The filter excludes blue light from the bottom two layers, so it doesn't matter if they are blue-sensitive or not. Red and green come through the yellow filter. In subsequent processing, the yellow filter is dissolved out so it does not interfere with projecting or viewing the picture.

The middle layer is orthochromatic, sensitive to both blue and green, but blue has been excluded by the yellow filter, so this layer responds to the green component of the image.

The innermost layer next to the base is specially made to be red-responsive with reduced green sensitivity, so we consider it the red-sensitive layer.

This order of layering is used on both negative films and color slide films to achieve the desired color sensitivities of the layers in the simplest way. Color printing papers have much slower speed ratings than negative materials and the photographic chemists can play more tricks. These emulsions are manufactured to have high sensitivities to one of the three primary colors, no yellow filter is required, and no particular order of layers is required.

MASKING

In photographic uses, a *mask* is an image placed over a similar image. Normally the masking image is derived from the original and the mask can be either a negative or a positive, as can the original.

The basic purpose of masking is to alter the density range of the image which usually has the effect of changing the visual contrast. Let's consider masking first in respect to black-and-white photography.

Figure 45/Color film starts out with three layers of b&w emulsion. On account of their different sensitivities to different wavelengths, plus the yellow filter present temporarily in the emulsion, each layer records a different primary color. More info about that in the text. In subsequent processing, each of the b&w layers is converted to a colored dye-image and then it is color film.

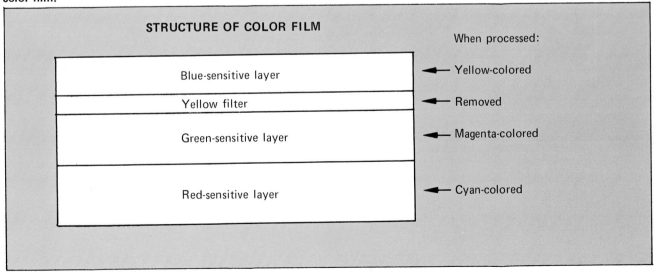

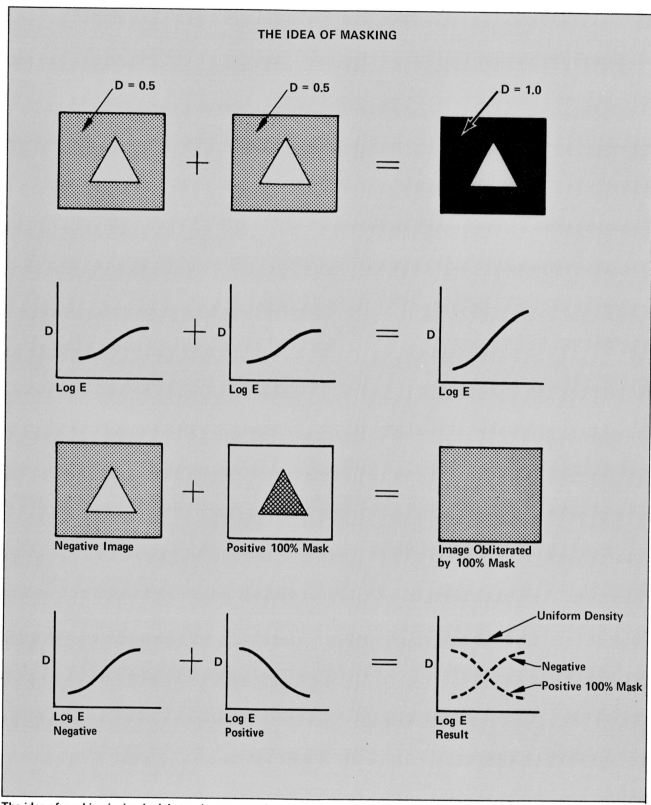

The idea of masking is simple. It's two images superimposed. If they are both negatives they reinforce each other—dark tones get darker. If one is negative and the other positive, they tend to cancel density variations so the result is a uniform density across the frame. It's equally simple when applied to color negatives but it doesn't seem so.

Assume there are two *identical* negatives with the same image and the same density range, such as 0.3 to 1.5. If one is placed over the other, in register so the images coincide exactly, then the one on top can be considered a mask. The density of the combination will range from 0.6 to 3.0, because densities add directly. The density range of the unmasked negative was 1.2; the density range of the masked negative became 2.4.

We can derive a rule from this: When a mask is the same as the original image—that is, both are negatives or both are positives—contrast is increased.

When a negative mask is overlaid on a positive image, or vice versa, contrast is reduced. For example, a positive mask over a negative image adds opacity where the negative would otherwise be clear with the result that the range of density values is reduced.

A mask which completely cancels out the image is called a 100% mask.

MASKING FOR COLOR CORRECTION

Some things, such as a black eye or a bandaged thumb, are so obvious they require comment even though the conversation can't possibly help any.

Anybody who has seen color-negative film after development has to notice that it has an overall orange color. So we have to discuss it. It is an integral color-mask to correct for deficiencies in the dyes used in the three layers.

If these dyes were perfect, each would transmit two-thirds of the visible spectrum with no absorption while acting as a light valve for the primary color the dye is supposed to control. That is, cyan *should* transmit both blue and green perfectly while absorbing red as required, and so forth.

Even though the dyes used are triumphs of ingenuity and chemistry, they don't have the perfect characteristics indicated by the solid lines in Figure 46 (page 186), and behave more like the dotted lines instead. The yellow dye does its job reasonably well and correction is usually not required. The magenta and cyan dyes are not close enough to ideal and correction of the negative is required so color prints will have reasonable color fidelity. Cyan controls red as it should but absorbs too much blue and green which it should transmit without attenuation. Magenta absorbs too much blue and red.

Color negative at top has overall orange cast due to color masking. Resulting color print has that uniform orange color removed by filtering during printing process.

Notice strong red patch on positive, labeled primary red. Same spot on negative is cyan colored with orange overlay. Let's think about that.

On positive, that patch has lots of red which means the blue-green cyan layer that controls red is letting red come through. The layer has a low density to red. On the negative the densities are inverted, so the red-controlling layer should have a high density to red. If that layer blocks most of the red it will let blue-green through. In other words it will be a strong cyan color. The patch on the negative labeled primary red is cyan because it has a high density to red light.

Notice also the gray scale on the print. Theory says if you take a color picture of neutral gray it should look like neutral gray or something is wrong with the color process. Nearly true. With some films and processes, if you print for best skin tones a gray patch will get a bit of color in it. This is a fault of the dyes and color processes, not the theory.

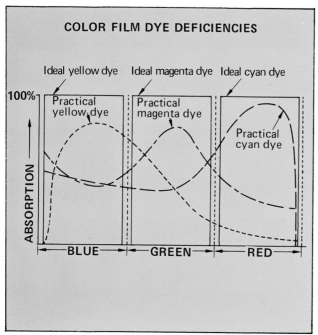

COLOR FILM DYE DEFICIENCIES

Ideal yellow dye Ideal magenta dye Ideal cyan dye

100%

Practical yellow dye Practical magenta dye Practical cyan dye

ABSORPTION

BLUE — GREEN — RED

Figure 46/If dyes in color film were perfect, each would lop off a chunk of the spectrum as shown by the solid lines. Real world dyes do what the dotted lines show, approximately, which is the basic reason for color masking.

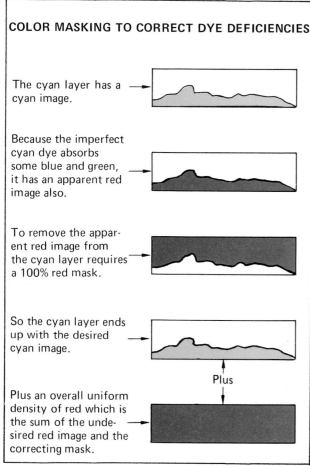

COLOR MASKING TO CORRECT DYE DEFICIENCIES

The cyan layer has a cyan image.

Because the imperfect cyan dye absorbs some blue and green, it has an apparent red image also.

To remove the apparent red image from the cyan layer requires a 100% red mask.

So the cyan layer ends up with the desired cyan image.

Plus

Plus an overall uniform density of red which is the sum of the undesired red image and the correcting mask.

Color masking to cancel out an undesired spurious color image in one of the layers.

This is a basic deficiency in the film process itself and will result in reduced color saturation and a general deterioration of colors. It isn't a major deficiency if it happens only one time between taking the picture and viewing the result.

In the negative-positive process, dyes are used two times because the positive is effectively a photograph of a photograph. Color degradation repeated two or more times due to dye deficiencies is noticeable and therefore color negative films use a form of built-in masking to correct the problem . . . at least partially.

Let's consider correcting the cyan layer which is absorbing too much blue and green. A dye which would normally absorb both blue and green is primary red, because it transmits red only. The cyan layer is behaving as though it had *two* dye-images. One of cyan color which controls the transmission of red, and another undesired image of red color absorbing blue and green according to the same image pattern. You can't see or find the spurious red image in the cyan layer but, if it acts like it is there, then for all practical purposes it is there.

The problem is to eliminate the effect of an undesired apparent red-image in the cyan layer. This is done by 100% masking. To mask a red image, real or apparent, requires a red-colored mask. When that 100% mask is properly made and registered with the undesired image the result will be a uniform red density everywhere in the image space on the film. This will give the entire picture a uniform reddish hue which can be removed later by a filter. Remember, we are dealing with a nega-tive. Filtering out a uniform shade of any color is not a major problem in color enlarging and printing.

The way such an integral color mask is formed is clever and we should admire it respectfully.

FORMING INTEGRAL COLOR MASKS

In the curious way chemists have of saying things, the chemical process by which silver halide is changed to metallic silver is called "reducing." This doesn't mean make it smaller and it is not achieved by putting the film on a diet. Chemical reducing is a process which produces or liberates oxygen as a result of the chemical reaction. If a compound contains some oxygen molecules and a reducing agent is brought into contact with it, the oxygen is released and some different compound

1/When I was painting this masterpiece my wife lost control and asked, "Whatcha doing?"
"I am demonstrating," said I, "That adding white to any color produces a pastel or less saturated version of that color."
"Sniff," said she, departing, "I'd think anybody would know that!"
Maybe so.

2/Anyway, if I put a big sheet of neutral density filter over it the filter would reduce the light at all wavelengths, which is equivalent to taking the white back out. The colors should get greener.
I did the same thing just by closing down the lens by one exposure step because that takes less light from every point without color discrimination. If you want to, you can think of it as adding gray everywhere, which is the same thing.

or element results. In this case the result is metallic silver.

A lot of things happen all at the same time while the film is in the soup. A negative silver image is formed—a replica of the light pattern which exposed the emulsion layer. A positive image is contained in the unexposed silver halide and this positive image can be brought out through reversal processing if desired.

Oxygen appears in the emulsion during negative development and the most oxygen appears at the locations where the most chemical activity is going on. Therefore a temporary negative image also exists in the oxygen pattern in the emulsion.

If nothing else happens to it, this oxygen will be absorbed by the wash water or combine with some residual product of development or maybe just leak away into the air. Whatever, it's harmless and not noticeable. If the silver image is later reversed to get a direct positive, then there is also a transient positive image formed by a second release of oxygen in the emulsion.

The liberated oxygen is used to form the dyes in the three layers of color film, by combining with other chemicals. In some color processes, the other chemicals are part of the processing solutions and in a very complex procedure the three

3/Here it is two steps down. Several things are happening. The overall brightness is less, so your eyes may be playing tricks. The darkest patch of green is being shoved down onto the toe of the film curve. And the color is getting more saturated. People say that less exposure gives more saturated colors on slides. Sniff.

dyes are formed at the right places, in proper amounts.

In other color processes, the chemicals which combine with liberated oxygen to form the dyes are already in the film and don't have to be soaked in during processing. These chemicals are called color-couplers and they are placed in the layers of the film during manufacture. The developing technique is called *coupler-development.* It's simpler than the other process and is the one you are allowed to do at home.

To make a color negative, the dyes are formed on the first release of oxygen from the negative silver image, with a different dye color produced in each layer.

In a color-masked negative, the mask is made chemically at the same time the dyes are produced. The color-coupler will already be the desired color for the mask. Red in the example above. The density of the coupler to red light will be the same as the apparent red density of the "phantom" image in the cyan layer because you have to be able to match maximum densities if you are going to make a 100% mask.

When the red-colored color-coupler combines with the liberated oxygen to make the cyan dye, it does so in proportion to the amount of oxygen present. A little or a lot of the coupler may be converted into dye. That which is converted becomes cyan; that which is not converted remains red. Therefore the cyan image and the remaining red image in the coupler have a negative-positive relationship between them. The remaining red image is a 100% mask for the "phantom" red image in the cyan dye.

Therefore it works. And, it's amazing.

It is usual, also, to correct the undesirable blue absorption of the magenta layer. This is done by a complementary-colored yellow mask. The logic of it is identical.

The two masks, one red and one yellow, give color-negative film an orange color. As you already know, the orange cast is taken out by filters during the printing process.

COLOR-NEGATIVE-FILM DENSITOMETRY

A film-characteristic curve for color-negative film is similar to that of a b&w negative except there are three layers to consider and three wavelengths of light to worry about.

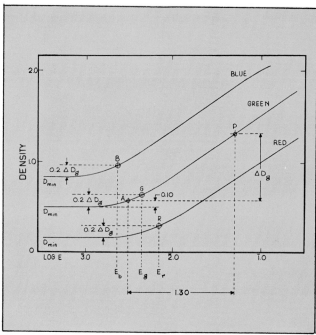

Figure 47/ASA film speed measurement of color negative film is similar to b&w negative film except that three layers are involved. Basically, the speed point is found for each layer and the three exposure values are averaged to give an exposure labeled E_m. For more information consult the applicable standards document referenced below. This material is reproduced with permission from American National Standard Method for Determining the Speed of Color Negative Films for Still Photography, PH2.27-1965 (Reaffirmed 1971) copyright 1966 by the American National Standards Institute, copies of which may be purchased from The American National Standards Institute at 1430 Broadway, New York, New York 10018.

The magenta layer is intended to have a density to green light which changes to stop more or less green light. The significant measurement of that layer then is its density to green light, symbol D_g. Similarly there are two other densities to be measured in the other two layers, D_b and D_r. The idea of it is shown in Figure 47, where the three curves are labeled for the color they each control rather than the colors they actually are.

The measurement of film speed is more complicated than for b&w film but basically it amounts to finding the speed of each layer and averaging the results.

The three curves should have the same shape and be parallel to each other. It doesn't matter in negative film if the curves are displaced vertically from each other. Among the three, the one highest on the graph simply has a higher average density than the others. This higher density can be con-

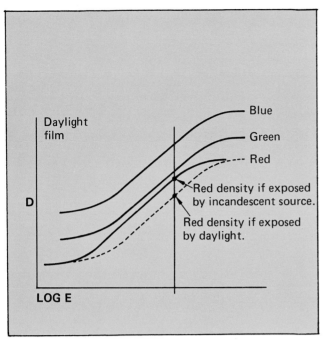

Figure 48/The characteristic curves of the three layers are tailored to suit light of a certain color temperature. If you use a different color temperature, more light than expected will fall on some of the layers. The layers will appear to have shifted left or right which affects color balance. At shoulder and toe, this cannot be compensated by filtering during printing.

trolled by filters in the printing procedure in the same way that color masking is compensated.

COLOR BALANCE

If one of the three curves is displaced to the left or right, then the color balance of the film will be upset. Color balance means that the film is designed to create proper colors when the scene is illuminated with some specified source such as daylight or incandescent light.

If the film is balanced for daylight, a white area of the scene would reflect unaltered daylight onto the film at some location along the Log E axis. This amount of daylight exposure should produce some definite density in each of the three layers such that the end result after printing is again white.

If daylight film is exposed indoors with tung-sten illumination and no correcting filter over the camera lens, white areas of the scene will reflect incandescent illumination onto the film. This light has a lower color temperature and a higher proportion of red. More red-layer exposure will result from every value of Log E and higher red-layer densities will result.

The film behaves as shown in Figure 48; the curve for the red layer appears to have shifted to the left. It would appear that if this shift causes some definite amount of increased red density, that could also be compensated in printing by filtering the printing light to make up for the loss in red. In the middle of the curves, where they are straight, this can be done. But look what happened at both extremes, where toe overlaps straight segment and shoulder overlaps straight segments. In these areas, the amount of correction needed changes because the slopes are changing; therefore no fixed amount of printing-light filtering can correct the entire range of the film. The effect is more pronounced in highlights and shadows.

The result is that minor changes in color temperature of the light on the scene can be corrected in printing, but large changes cannot. When the film is exposed so one of the curves is effectively shifted to the side a large amount, the case is hopeless.

The practical fix is never let light get on your film which is much different than the light the film was balanced for when manufactured. The film maker tells you the kind of light to use.

If you intend to expose daylight film with tungsten light, or vice versa, put a filter over the camera lens to change the spectrum of light reaching the film and maintain the built-in color balance of the film.

COLOR-NEGATIVE EXPOSURE RANGE

The three principal color characteristics we use to distinguish one from another are *hue*, *saturation* and *brightness*. Hue relates to the basic color, such as red or green. Saturation is an indication of the amount of white added to the basic hue—added white changes a strong hue to a pastel of the same hue. Brightness of a color is what would be noticed by a color-blind light meter, basically the amount of light reflected regardless of hue or saturation. Therefore, in general, colors

1/Let's watch this film struggle with recording both gray-scale and color information. Here the card is reasonably well exposed except where the film can casts its shadow on the red stripe. In that area, the three film layers are too full of black to allow much room for red information.

2/A 3-step exposure increase causes all three layers on the film to reduce density uniformly, effectively adding white. Now there is not enough room on the curves to allow the density differences required to reproduce the red. Except in the shadow of the film can. It's doing fine there. Pink overall cast indicates that this overexposure also affected color balance.

are of some hue, to which both white and black are added, which means some shade of gray is mixed in.

Color film has the job of reproducing gray-scale values either when some shade of gray is actually in the scene, or when some shade of gray is part of a visible color. In addition, the film has to reproduce color by recording different densities in response to the three primary colors.

To reproduce any shade of gray, the three color-densities must be balanced so equal amounts of the three primary colors are visible in the positive. For differing shades of gray the three densities must go up or down in value *together* and in equal amounts. To reproduce black, densities of all three colors must be very high and equal. To reproduce white, the densities should be minimum and equal.

But, the only way the film can also produce colors is to have the three densities *unequal.*

The result is a technical conflict in which density range of the color film is needed to reproduce gray scale, or brightness, and also needed to convey color information.

To allow a lot of color information and colors of high saturation, you should deliberately reduce the brightness range. When you can control scene illumination, avoid large brightness variations. This produces acceptable pictures because parts of the scene are differentiated from one another by color differences and if the viewer has that, he doesn't yearn much for brightness variations as well.

When you can't avoid contrasty scenes, you will notice that color is lost in the shadows and highlights because too much of the range of the film is used up in handling the gray-scale information.

This is usually acceptable to the viewer because it is comparable to what we see in nature. An interesting experiment is to look at a piece of brightly colored cloth, folded or rumpled so some of it is in shadow. You know that whatever amount of light is reflected from the cloth down in the folds is in fact the same color as that reflected from the well-lighted portions of the cloth. The reason you can't see color there is because the light level is below your threshold of day vision and you are using your night receptors to look into the shadows. They are color-blind.

1/This series shows both gray-scale and color problems due to increasing exposure. This photo of an ordinary everyday scene looks pretty good. Gray scale isn't bad and colors are realistic. Watch gray scale and primary red patch.

2/One step more exposure. Gray scale is starting to block highlights, colors are starting to change.

3/Two steps up and changes are pronounced.

4/Three steps up. Highlights are blocked from the mid-point of the gray scale. Look what happened to primary red. This slide film was driven into the toe so far that the three curves are no longer parallel.

Strong highlights in scenes are often specular reflections and are colorless anyway, so we tend to accept loss of color in the highlights of a color photo and think it is probably the way the scene actually looked.

Because of the dual requirement placed on the color-negative film, gray-scale information and color information, the brightness range should be more limited than b&w film.

Speed ratings are based on the same philosophy as b&w, and of course exposure calculators do the same thing without regard to the type of film in the camera. For the assumed average outdoor scene the shadow detail is placed near the toe of the curve and the highlights do not reach the shoulder. Therefore there is some latitude—one or two steps typically. If shadow detail is important, you can give more exposure, as with black and white. This applies to color-*negative* film only!

Because color fidelity requires that the three color-curves have the same shape and remain parallel, it is usually not a good idea to try to use the toe and shoulder regions of the curves. Manufacturers of color film manage to get the straight-line portions of the curves parallel but the problem is more difficult at toe and shoulder where the slopes are changing. It is common for the curves not to have the same shape at toe and shoulder and therefore color balance is degraded. Very dark shadows or bright highlights may end up with a color cast due to color imbalance between the characteristic curves in these regions . . . another reason to reduce brightness range of the scene.

Color slides

When you project a color slide, the film is the same as you originally exposed in your camera. It has undergone reversal processing. The negative silver image was developed, then reversed to a positive silver image. Then color development took place to dye each layer of the positive. The end result is a positive image very similar to a color print, except that the slide is on a transparent base.

In the original exposure you effectively exposed both the negative and the print, introducing some exposure considerations we need to discuss. Also, color masking is not practical because you can't filter out the effect of the mask when making the positive image. As noted earlier, the dye deficiencies are tolerable when the dyes are used only once and in making a color slide the dyes do not appear until the positive is being formed.

If you make a color-slide duplicate of a color slide then you have used the dyes twice and their deficiencies begin to appear as color changes. Amateurs generally ignore such changes or say they don't exist. Professionals make a negative as an *intermediate* stage between a color positive and another color positive—called an internegative—just so there will be some color masking in the process.

Because internegative film is specially designed for the purpose, it can be designed for maximum response to the dye-wavelengths of the positive being reproduced and can be color-balanced to compensate for deficiencies in that positive as well as the succeeding positive copy. Also, positive-to-positive copying usually results in increased contrast. Internegative film reduces the contrast at that stage of copying so the final positive is less contrasty.

This is just a reminder of something so obvious you don't need reminding about it. When you use a color filter with color film, the filter changes the resulting colors on the picture. For better or for worse. More info on use of color filters is down the path a ways. This sunrise sky got red-colored because I put a red filter on the lens.

Film characteristic for reversal film

On reversal film the original exposure determines the final positive density. When positive density is plotted against Log Exposure to show the film characteristic it appears "backwards" in respect to a negative H & D curve. Greatest exposure causes least positive density, as shown in Figure 49.

Because color correction with filters is not practical in the reversal process, the curves of the three layers should overlay each other exactly. This is a more stringent requirement than for color-negative film where vertical displacement of the curves is tolerable.

As in all color films, the design goal is easier to accomplish over the straight part of the film curves, and in fact must be accomplished to achieve color balance. The curves are likely to have dissimilar shapes at toe and shoulder and degraded color balance at toe and shoulder.

EXPOSURE DOCTRINE FOR SLIDES

The generally accepted exposure rule for negative films, both color and monochrome, is "expose for the shadows and let the highlights fall where they may," another way of saying that the shadows should be placed at or near the toe on the negative film curve.

With color-reversal film, standard doctrine is to expose for the highlights and let the shadows suffer if necessary. Bear in mind, please, that the highlights are at the *toe* of the curve for reversal film.

As with all great rules of the universe, the rule is true and correct as long as it is true and correct.

Fundamentally, the idea is that highlights and flesh-tones are more important to the viewer of a projected slide than the shadows. If the entire color image is correct except the highlights are too dark, the slide will appear too dark when projected and nobody will like it. You could make such a slide acceptable to your viewer if you could put more light through it, but projectors aren't built that way.

Based on that standard, people say the highlight exposure of a color slide has to be exactly right—within a half step either way. The reason is not really a characteristic of the film, it lies in the doctrine. A full step of exposure is noticeable to the viewer, particularly in the brighter areas of the picture, so we have to control exposure to keep the highlight density within a full step. Say, a half step either way.

Figure 49/Because there is no opportunity to make corrections when printing, the curves of the three layers of reversal color film should lie on top of each other. To determine speed of color slide film, points are located near toe and shoulder as shown. The exposure values for these two points, H_s and H_t are averaged geometrically yielding a mid-point exposure, H_m. Speed is 10 times the reciprocal of H_m or $10/H_m$. For more information see the standards document referenced below.

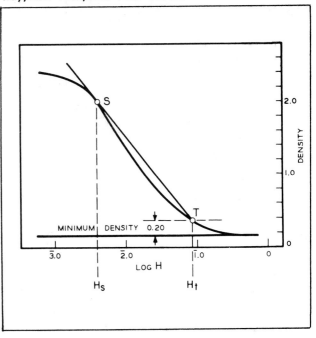

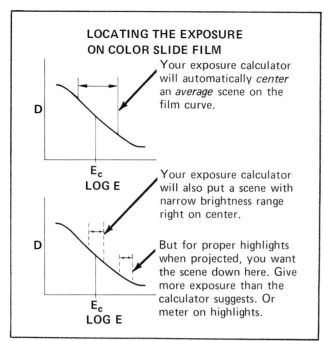

LOCATING THE EXPOSURE ON COLOR SLIDE FILM

Your exposure calculator will automatically *center* an *average* scene on the film curve.

Your exposure calculator will also put a scene with narrow brightness range right on center.

But for proper highlights when projected, you want the scene down here. Give more exposure than the calculator suggests. Or meter on highlights.

With an averaging exposure meter, highlights will move up and down the curve on color slide film according to the brightness range of the scene. To keep highlights such as skin tones uniform from slide to slide, it's better to meter on them.

To do that from scene to scene you have to meter on some highlight in each scene. Such as skin, sky, a white shirt, or even an artificial highlight that you put into the scene to meter on and then remove to take the picture. Most people don't do that.

Exposure calculators don't do that either. You know what they do. The bumbling amateur is **saved again** by the legendary average scene and the film-speed rating method for slide film which will peg the highlights on the curve satisfactorily when shooting that legendary scene.

This tells us also that the tight exposure control you read about for color slides doesn't really mean there is no exposure latitude. If the viewer is willing to accept changes in highlight brightness from slide to slide there is some exposure latitude—a step or a step-and-a-half in each direction with an average scene before the photographer gets in trouble with the film.

The trouble that results is interesting and unique to the reversal process. If the slide is underexposed, less of the silver halide will be sensitized, developed in the standard first developer, and then removed. More of the halide remains to be exposed and developed in the second developer. When the

layers are dyed, the dyes replace the *positive* silver image in proportion to how much silver is there. If there is too much, there is too much dye. The slide turns out dark and murky.

That's from *too much* underexposure. A little bit of underexposure, say one-half step or one step, causes the same general effect, more dye in the positive and therefore more *apparent* color saturation of the image. Mild underexposure is the standard recipe to get vivid slides.

If a slide is overexposed, too much of the halides are used up in the first development and there is not enough left to give good dye images in the positive. The colors are weak and washed out.

The rule for *negative* film is, underexposure is worse than overexposure.

The rule for *reversal* film is, both are bad. If you have to have some, take a little at both ends of the curve. That reasoning leads to a different way of measuring speed.

SPEED OF REVERSAL FILM

Figure 49 shows the way. Maximum and minimum densities, **S** and **T**, short of toe and shoulder in each case, are chosen. Then they are averaged geometrically to find a mid-point which is the speed point.

An exposure calculator centers the exposure on the speed point, *if you allow it to*, and if it is an average scene the exposure range will extend equally in both directions from there. An 18-percent gray card should land exactly on the speed point.

If you are shooting a non-average scene and you allow an exposure calculator to do your thinking, you will get a bad picture, same as with any other film.

Substitute metering is very handy with slide film. The substitute metering surface that you are never going to leave at home or in the car is in the palm of your hand. Put it in the same light as the scene, meter on it, open up one stop and shoot. That automatically puts flesh-tones on the film curve in the proper location no matter whether the scene is average or not. This is a form of substitute metering for highlights.

RINKY DINK

You can skip this section if you want to. It's about the arithmetic of color-slide speed ratings. The problem is, the speed point of slide film is up

in the middle but the speed point of negative film is down near the toe. The exposure calculator always takes the reciprocal of the speed number you dial into it and then multiplies the result by 8 to get the average exposure for the scene.

Something has to be done to compensate for the higher speed-measuring point of slide film so the resulting speed number doesn't confuse the calculator.

To review, speed of color-neg film after averaging the speeds of the three layers is $1/E$, where E is the exposure at the speed point on the curve. For b&w, it is $0.8/E$ and we say this causes a 20-percent safety factor.

For slide film, speed used to be $8/E_c$ according to the American National Standard published in 1961. The E_c symbol denotes the exposure at the speed point for color-slide film only. The reasoning is that E_c is about 8 times larger than it would be if measured down near the toe as is done with negative films. Therefore $8/E_c$ has the same equivalent value as $1/E$, if E_c is 8 times larger than E. The exposure calculator can go right on doing its regular thing if you feed it a speed number derived by $8/E_c$ and it will try to position the exposure on the curve correctly.

In 1972, the United States standard was changed and speed became $10/E_c$ with the method of finding E_c not changed. What does this mean? The standards document says the change was made to increase rated speeds by approximately one-third of an exposure step because practical experience indicated that the result would be better pictures with a little less exposure.

There's nothing wrong with a bit of fine-tuning like that and I recite the circumstances mainly to point out that film-speed numbers do not descend upon us from the sky.

Developing monochrome and color.

Monochrome is fancy for black-and-white. It really means "single color" but unless you are playing tricks monochrome is b&w.

Most of us average folk manage to learn the names of camels and elephants and apply the correct name to each. We transmit that information to our children and all parties in the episode are satisfied with the result. The animals don't even care.

Without a background in chemistry, most of the solutions and procedures used in processing film are just names that we learn. We rely on recipes and advice from professionals in the film industry. One of the great successes of my youth was to avoid learning very much about chemistry all the way through a guessing game which was then called Analytical Chemistry. My guesses were mainly wrong.

Even without penetrating very far into the chemistry of it, lab procedures for making negatives and positives are detailed and require manipulative skills and perception of such things as which side the emulsion is on. Because you can see that you are very near the back end of this book, you can rightly suspect that what I am sneaking around to tell you is that you won't find those procedural and manipulative matters here. They are another book full of information, part of this H. P. Books series on photography. *Do It in the Dark* by Tom Burk. There are of course a few things which need discussing here.

If a point on a silver-halide negative is fully exposed, which means enough exposure to reach maximum density with full development, then it *can* reach that density through development. If the amount of exposure is less, a smaller percentage of the halide crystals were sensitized and a smaller percentage will be developed even under *full* development. If the amount of development is less, the resulting density can be less, for every value of exposure.

Even though the developer mainly operates on sensitized grains of halide, it will also reduce unexposed halides and convert them to metallic silver. During normal development this happens a small amount, adding density all over the negative. This added density is most noticeable in the clear areas and is called *fog*.

If the negative film is left overlong in the

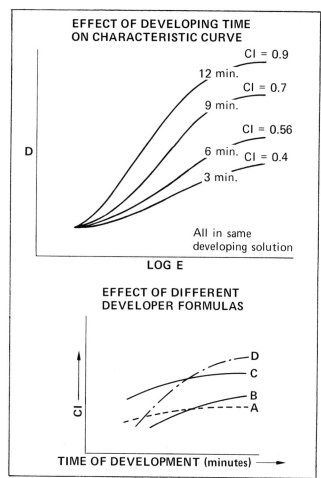

EFFECT OF DEVELOPING TIME ON CHARACTERISTIC CURVE

CI = 0.9
12 min.
CI = 0.7
9 min.
CI = 0.56
6 min. CI = 0.4
3 min.

D

All in same developing solution

LOG E

EFFECT OF DIFFERENT DEVELOPER FORMULAS

CI

D
C
B
A

TIME OF DEVELOPMENT (minutes) →

Figure 50/Longer time in a developer solution raises Contrast Index. Also, different developer solutions yield different CI values. If you do your own processing, these are important tools to work with. See also Figure 9.

index, depending on how it is measured.

The important observation is that the curves produced by different amounts of development have different slopes. The starting point doesn't change very much because developments which raise the fog level too much are not usually recommended and are not shown on the chart. The maximum-density point does change considerably, and the slope changes. It appears as though the curves pivot at the fog level and get steeper as they reach higher densities.

Varying the amount of development alters the film curve in two ways: its slope and its maximum density. In practical terms, this results in some limit to exposure range and a corresponding limit to density range for that curve.

Usually the important thing is to get the scene brightness onto the film, therefore the scene brightness range as it appears to the negative is the dominant consideration and determines the selection of one of the film curves—by controlling the amount of development.

Often scene brightnesses are not what you expect just from looking at them. This scene was metered from the camera location with a Minolta 1° spot meter. Readings based on ASA 400 film speed were: Sky, *f*-8; Left face of mountain in direct sunlight, *f*-8; Big shadowed area on mountain, *f*-5.6; Wall under porch, *f*-2.8; Garage opening, *f*-1.4. It's not necessary to expose for detail inside the garage, so the exposure range in this shot runs from *f*-2.8 to *f*-8, a range of only 3 steps.

developer, fogging continues but it can't create more density than the maximum. It will gradually increase the densities of the lighter parts of the negative, reducing the density range and the contrast.

Accordingly, there is some desired development which reaches some density for the brightest parts of the scene, produces some shade of gray for each different brightness of the scene, and does not fog up too much in the clear areas.

The amount of development is an important photographic control for b&w film as illustrated in Figure 50. Longer development produces higher maximum density and slightly higher minimum density due to fog. Less development produces lower densities everywhere, and a lower slope—which we have learned to call *gamma* or *contrast*

This is a Cholla cactus shot with large aperture to put the background out of focus, and backlighting to create the halo effect and show the skeletal structure.

Same cactus, front lighted, has less visual impact.

It turns out that the reduced exposure range available when you choose a high contrast index is not a major problem because you would only choose that curve when the scene-brightness range is low.

Therefore, if you are controlling development, you should do so by notes or recollections of the exposure. This is very practical and is standard procedure for photographers who use sheet film so there is only one exposure on each piece of film, and who do their own processing or have it done by somebody who will follow instructions. It is also practical for roll films, if the entire roll is shot under similar conditions. You can process the whole roll for a low or high gamma.

If you do not control development, then you have to try to control exposure so you get acceptable results with standard development, which produces a CI of about 0.6.

For b&w films, the allowable exposure range is stretched by using part of the toe of the curve so an average scene will extend from the toe region up into the straight-line portion but not come very close to the shoulder. You can use two or three steps too much exposure and still not get into the shoulder region, as long as you are shoot-ing that legendary average scene. There is a lot of latitude. In the last section of this book, I will get more specific about what an average scene really is and try to relate it to what you do with your camera.

The main point here is the control of development for a desired contrast index. You do it by following the recipes. Manufacturer's data will show you curves and give you information so you know what developer formula, length of time, and temperature will give the desired result for a particular film type.

DEVELOPER SOLUTIONS

There are a bunch of recipes. Some are more "active" than others and do the job faster as you can see from data-sheet curves. For whatever solution you use, CI will be determined by the length of time the film is in the solution and by the temperature of the solution. There are curves and charts which show the trade-offs between time and temperature. In general, higher temperatures require shorter times for the same CI, which is not surprising.

Agitation is vital—so much that the time and uniformity of development is influenced by how well and how much you agitate. When the devel-

Sometimes you just can't get the shot without doing something about the light. Photo of toy Volvo needs more light on the side of the car.

A reflector helps—in this case just a piece of paper held to throw some light into the shadow.

oper is in contact with exposed silver halide a chemical action takes place. As the action proceeds, the developer is "used up" chemically and reaches a point where it can't reduce any more halide. If that spent layer of developer is allowed to remain stagnant in contact with the halide, development stops. By agitating the solution or moving the film around in the tank or tray, fresh developer is continually being brought into contact with the film so development is both continuous and uniform.

The gelatin in which the halides are dispersed is more than just a mechanical support for the silver. It is permeable to the photographic solutions so they can soak in and get at all of the silver particles.

STOPPING DEVELOPMENT

When the specified time in the developer is ended, some developer is still down inside the gelatin, working away. It is important to get the development stopped as promptly as possible. Sometimes just rinsing in water is adequate because the water permeates the gelatin and washes out the developer chemicals. A more rapid cessation is produced by solutions called *stop baths*.

Developer action takes place in an alkaline environment and if it is changed to an acid envi-

ronment development stops or becomes very sluggish. Mild acetic-acid solution is a commonly-used stop bath.

FIXING THE IMAGE

When the light-struck halides have been converted to metallic silver, the remaining unexposed halides have to be removed because otherwise they would turn dark over a long period of time. A chemical is used to dissolve the halide but not metallic silver. Sodium thiosulfate and ammonium thiosulfate, along with secret ingredients, are used. These *fixers* are commonly called *Hypo*.

Halides in the emulsion give it a cloudy or pearly appearance. When they are removed, the clear gelatin is left. Therefore the visible effect of fixing is clearing of the image during a measurable time called "time to clear." To be sure, film is normally left in the fixer longer than that.

WASHING

The last major step before drying is to wash out the remaining chemicals from the various solutions because these will otherwise affect the image over a long period of time. Effects can be lightening, darkening, or staining, depending on circumstances.

Film labs and processing instructions pay an astonishing amount of attention to final washing,

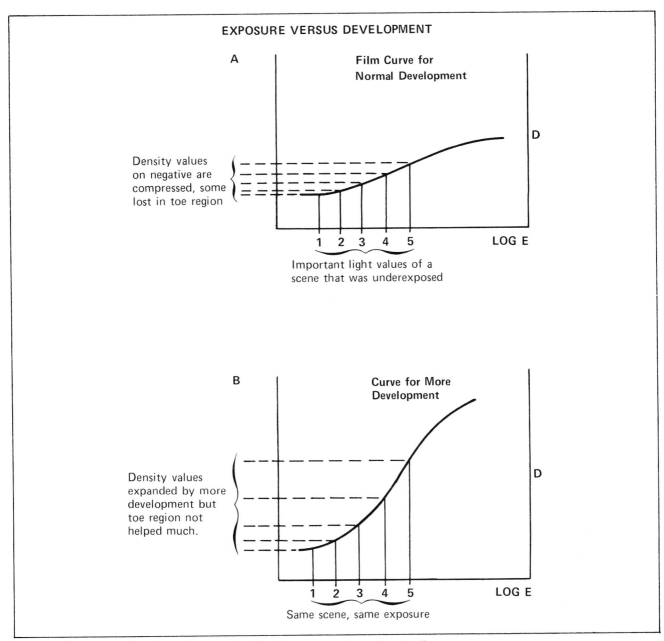

Figure 51/Push-processing is another name for "underexpose and over develop."

for a reason that is obvious after you think about it. Naturally, agitation or circulation of the wash water is vital.

A good analogy is to imagine that you are approaching a wall in a series of steps but each step can only be half of the remaining distance to the wall. Theoretically, you will never get there. Washing processes are similar. If half of the chemical residue is removed in the first minute, half of the remainder in the second minute, and so forth, the question is not "When is it all gone?" The question becomes "When is most of it gone?" So you wash a long time or use some of the special

chemicals available to reduce wash time.

PUSH-PROCESSING MONOCHROME

Push-processing has an undeserved glamor about it—like breaking the speed limit with your car and getting away with it. Basically it relates to underexposure followed by overdevelopment.

In Figure 51 let's suppose curve A is the normal characteristic from some standard processing. Also, for some reason such as not enough light, the scene was underexposed compared to normal. If the scene has average brightness range and was underexposed, some of the shadow-tones were jammed down past the toe of the film. If the film

is developed normally, along curve A, all densities will be lower than with normal exposure and some shadow tones will be compressed so much they are indistinguishable from each other.

What can be done about that? Develop for curve B to get a higher gamma. This gives more density to the higher exposures, some increase in density to the middle exposures, and no help to the values lost below the toe.

Some people argue that this changed the speed of the film. Plainly it did not. The speed of film is measured by use of a characteristic curve with a *specified* slope. If you operate on a different curve, the stated speed is not relevant.

Some people say push-processing changes the *effective* speed of the film which I think is more reasonable even though I don't know what it means. The root of the idea of film speed has to be an assumption that if you tell your exposure calculator the speed, if you then follow its advice, and if you shoot an average scene, you will get a picture with all the gray-tones visible. That didn't happen here because some of the tones were still lost down in the toe. So, what is this strange effective-speed business?

If the scene has less brightness range than average, then you can underexpose without losing tone-values in the toe. By developing to a higher CI, you will separate the tones more and get more contrast between adjacent parts of the scene. You also did this with less than recommended exposure. Did the film speed change? I don't think so.

Developing color negative

The major steps in development of color-negative film are: Color development—developing the silver image and simultaneously forming a matching dye-image by chemical reaction with the oxygen. Stopping silver development. Fixing to remove undeveloped silver halide. Bleaching to remove the metallic silver. Washing and miscellaneous processes.

Color development happens in all three layers and the process in each layer is a little different than in the others because a different dye color results.

Because there are three layers, the one on the inside which is red-sensitive is the last to begin

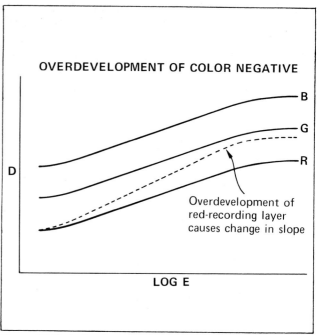

OVERDEVELOPMENT OF COLOR NEGATIVE

D

LOG E

Overdevelopment of red-recording layer causes change in slope

Figure 52/Any development different than recommended for color negative film may alter color balance by changing the slope of one or more of the curves, so they are no longer parallel.

development of the silver image because the developing solution has to penetrate the outer two layers first.

It's like a race with handicaps. The slowest racer starts first, the middle-speed racer starts next, and then the fastest racer takes off after both of them. If the handicapping is correct it will be a photo finish.

Because of the delayed starts the green layer develops faster than the blue and the red layer is quicker than the green. At the end of *correct* development, the three curves are parallel and approximately the same shape . . . essential for color balance to the intended color temperature.

If color-negative film is overdeveloped, the red layer is no longer parallel. The green layer changes by a smaller amount. Let's stick with red. As shown in Figure 52, the red layer is now steeper than it should be in relation to the other curves. The color balance of the three layers changes according to the amount of exposure, and no filter can fix that. If underdeveloped, the opposite trend occurs.

Therefore it appears there is only one amount of development that should be used for color negative film and for best color that's true.

These two pictures are from same location with same exposure. One used large aperture and short time, the other small aperture and long time.

Unless you depart from standard conditions, you are stuck with the gamma the film gives you, averaged among the three characteristic curves.

COLOR-NEGATIVE RECIPROCITY FAILURE

If you could separate the three silver layers of color-negative film and use them individually as b&w films, they would have three different speeds.

Reciprocity failure causes b&w density to be less than expected when the illuminance on the film is out of bounds. For black-and-white films, you change exposure time and sometimes development time to compensate for RF.

In color film, if any layer ends up with less density than it should, color balance is affected. RF will normally not affect all three layers the same because they have three different b&w film speeds to begin with and are *not* the same silver-halide emulsions. If RF strikes more in one layer than the other two, color correction as well as exposure correction may be required. This is done by reading the instructions that come with the film and using the appropriate filter over the lens.

PUSH-PROCESSING COLOR NEGATIVES

There is still only one degree of development that will produce best color balance in color film, however some amount of degradation may be acceptable to solve an otherwise impossible problem, such as not enough light.

Some color films can be underexposed, compared to what your exposure calculator suggests, and adjustments made in the developing process. The adjustment is longer development of the negative silver image.

As far as each silver layer is concerned, this does exactly the same thing as push-processing b&w. The main problem is keeping the curves parallel and judgement of that is a subjective matter.

DEVELOPING COLOR-REVERSAL FILM

Two kinds of slide films are available. One has built-in color couplers and can be developed relatively simply by an amateur. The other requires a much more complicated process: The three color couplers are introduced during processing by commercial labs—including those of the

film manufacturer.

The general process involves reversal of the silver image to make a direct positive followed by substituting dye images for the three silver images. The silver is then bleached out.

As with color-negative film only one degree of development gives the best color balance.

PUSH-PROCESSING SLIDE FILM

Kodak will "push" Ektachrome which has been underexposed by 1-1/3 steps. They also furnish instructions for do-it-yourselfers to process for underexposures up to 2 steps. The instructions also cover overexposures up to 2 steps, or push-processing in reverse, so I suppose we should call it pull-processing. Either way, color quality is not as good as with normal exposure and development. Independent labs and do-it-yourselfers will work with even greater under or overexposures.

Long focal-length lenses are sometimes essential to isolate images from a nondescript background. If you need a photo of crossbars on electric poles, you can get it with a 200mm lens.

Printing papers for black-and-white

Halogen is a "family name" for a group of elements, fluorine, chlorine, bromine, and iodine which combine with other elements to form halides. The latter three, when combined with silver, are photo-sensitive and useful in making emulsions. Iodine is the fastest, photographically, and is used in negative films more than printing papers.

Printing papers made with bromides are faster than chloride papers. Chlorobromide papers are in between, using some of each.

Except for speed, printing emulsions are similar to negative emulsions, with slope, density, exposure range, density range, and all those old friends.

Usually positive emulsions are coated on a paper base so they are effectively a thin layer of clear gelatin in intimate contact with the paper surface. Metallic silver is scattered around here and there to make an image. The density property of the emulsion, when so arranged, is called *reflection density* because light must enter the emulsion and reflect off the paper surface, passing back through the emulsion to become visible. Because light makes two trips through the emulsion it seems that reflection densities should be higher than transmission densities. This is true at low values but as silver density in the emulsion increases, the reflection density reaches a maximum value of about 2.0 and does not increase beyond that even if more metallic silver is added to the emulsion.

The reasoning for this strange behavior is that surface reflection from the front surface of the print sets a limit. If emulsion density is low, some light is reflected from the surface and some goes through the emulsion to be reflected back out toward the observer. Visible light from that point on the print is the sum of the two. As emulsion density increases, less light makes the round trip through the emulsion but the amount of light reflected from the front surface remains the same. Even if the silver is so dense that no light makes

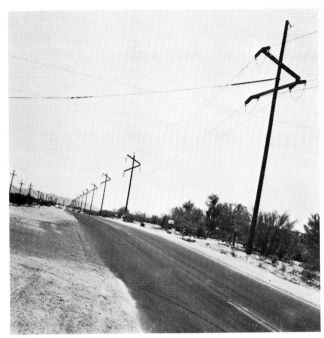

With a normal 50mm lens at the same location you get half the county.

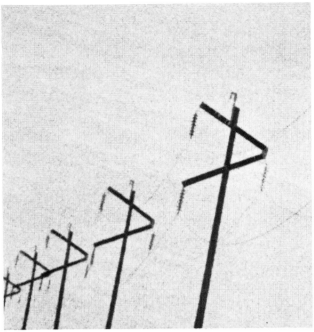

You can always enlarge a portion of the neg to get the same effect as a long lens, but you may also get a lot of grain. This photo is an enlarged section of the view at left.

the round trip, the surface reflection is still there. So surface reflection establishes a maximum value of density of a print on an opaque backing.

Front-surface reflection depends greatly on the smoothness of that surface. The emulsion layer is thin, so the front surface has the same general characteristic as the paper surface under the emulsion. For maximum surface smoothness, prints are ferrotyped—placed against a very smooth metal surface to dry out after processing—to "iron out" surface irregularities.

For a complex reason, glossy prints have the highest maximum density and matte surface or textured surfaces have lower values. Typical values of maximum density range from about 2.0 for glossy surfaces down to about 1.4 for matte surfaces. Fine detail is more apparent in the smoother surfaced papers.

Because of this maximum-density limitation, increases of silver in the emulsion have no benefit beyond a certain point and therefore print emulsions typically have less silver halide than negative emulsions. However, to get a good black image in the areas of maximum exposure, all of the silver must be developed. Therefore printing papers are normally given full development to maximum density.

This rules out the technique of varying development to get different slopes of the positive emulsion characteristic. For a particular emulsion, development is carried to maximum density and the highest gamma that emulsion can have—sometimes called *gamma infinity*—meaning no matter how long you develop you won't get more slope.

Figure 53 (page 204) shows three curves for the same emulsion. Curve A is the shortest time of development which will reach maximum density. Curve B is the same emulsion developed for a longer time. It has about the same shape but is shifted to the left along the Log E axis, toward lower exposures. Curve C has still longer development and is shifted farther to the left.

This shows a complementary relationship between exposure and development. The same image results from several pairs of values of exposure and development, with less exposure requiring longer development. The practical limit to longer development times is increased fog which darkens or mottles the whites in the print. The limit to shorter development times is that increased exposure is required which can complicate matters by driving the emulsion into reciprocity failure.

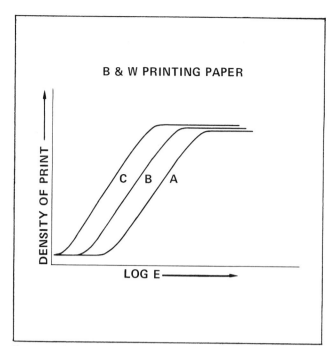

Figure 53/With b&w printing paper there are several combinations of exposure and developing time that give essentially the same characteristic curve. Curve A has more exposure, shorter development. Curve C got less exposure, longer development. The slope of the curve and the density range of the print is the same in all three curves so you can use whichever you choose.

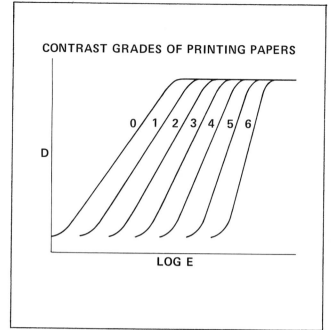

Figure 54/Slope of printing paper should be chosen to complement slope of negative film characteristic. Printing paper comes in several different contrast grades with different emulsions and therefore different characteristic curves, numbered from 0 to 6. Grade 0 is sometimes called "soft" and grade 6 "hard" for reasons I don't understand. Grade 6 obviously produces the most contrast of the image but can accept only a narrow exposure range.

Because each emulsion used for printing paper has only one useful slope, a range of gamma values is obtained by a range of printing papers with different emulsions. These are called *contrast grades* and for many general-purpose papers there are six grades, numbered from 0 to 5. As shown in Figure 54, grade 0 has the lowest slope and therefore the greatest exposure range. Grade 5 has a steep slope and a very short exposure range. Agfa makes a grade 6, which is even steeper.

Remembering that a print is exposed by light from a uniform source passing through a negative, the exposure *range* given the print is the same as the density *range* of the negative. The center of the exposure range can be changed on the print by enlarger adjustments, f and time, just as the center of negative exposure is established by camera controls. But, wherever you center it, exposure range on the print is still determined by the range of densities on the negative.

Unless you deliberately choose to distort the gray scale on your print so as to compress highlights or shadows, you will want to choose a contrast grade of printing paper to place the exposure extremes between the toe and the shoulder. This exposure range is a fixed value for each type of paper and each contrast grade of that type. So the simplest way to select contrast grade is to relate it to the density range on the negative as follows:

Contrast Grade of Printing Paper	Typical Density Range of Negative
0	1.6
1	1.4
2	1.2
3	1.0
4	0.8
5	0.6
6	0.4

The table is representative but does not apply to any particular brand or type. You can get information about particular brands from the manufacturer or shop where you buy it.

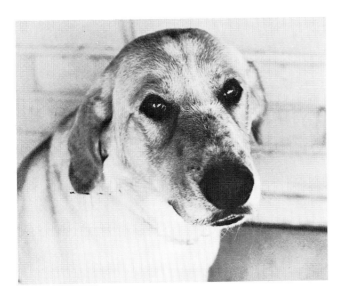

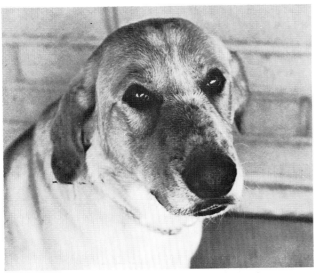

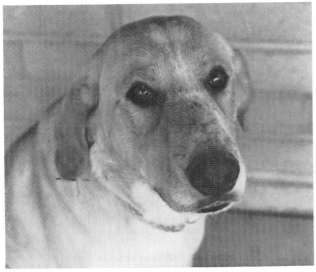

Faithful Goodo. Same negative printed on grades 6, 2, and 0 paper (top to bottom). Grade 2 is usually considered normal. Notice increased tone separation of "harder" papers. Check nose, eyes, and wall in background.

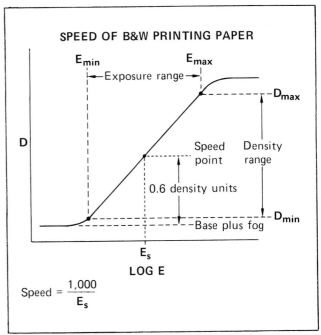

Figure 55/ Speed of b&w printing paper is calculated from a point on the curve which is 0.6 density units above base density plus fog, when paper has received specified development. Speed is **1,000** times the reciprocal of exposure at the speed point.

B&W PRINTING PAPER SPEED

Because different amounts of development result in essentially the same image from different amounts of exposure, as long as they are used in complementary pairs as discussed earlier, speed has a different significance in respect to printing papers.

Figure 55 shows how speed is calculated for black-and-white printing papers. A standard development is specified.

If you have made a print and decide to try another one with a different contrast grade paper and the speed of the new paper is different, there is a handy way to figure the exposure you will need for the second try.

$$\text{New exposure} = \text{Old exposure} \times \frac{\text{Old Speed}}{\text{New Speed}}$$

Or, if it is easier to remember: **New** exposure times **New** speed equals **Old** exposure times **Old** speed.

VARIABLE-CONTRAST PAPER

A clever idea is to make printing paper with a combination of two emulsions of different contrast and color-sensitize them differently. Then contrast can be controlled by using color filters in the enlarger head. If the filters produce a printing light nearer the sensitivity of the emulsion with higher contrast, the printing paper acts like it has a high contrast-grade number. And vice versa. The printing filters are numbered according to contrast steps, however the available range is less than that afforded by separate papers in various grades. The range of the single variable-contrast paper spans about four normal contrast grades and will suffice for most negatives. The big advantage is that you don't have to stock a bunch of different grades.

PRINTING PAPER COLOR RESPONSE

Most printing papers are not modified for broad-spectrum response because they are intended for exposure through a b&w negative. They are blue-sensitive and suit the purpose.

Exceptions are the variable-contrast type mentioned above, and papers to make a b&w print from a color negative. The benefit is the same as that from using panchromatic film in your camera.

Making color prints

The structure of color-printing paper is similar to color-negative film, except that the emulsion is slower. Each layer is response-tailored to its own color, and no inter-layer filters are required. Therefore the layers can be in any order.

Color prints have the same reflection-density problem as b&w and usually about the same maximum density. The exposure-range limitation due to the requirement to convey both gray-scale and color information afflicts color paper as well as color film.

As a result, color papers have the lowest exposure range in terms of subject brightnesses.

Color papers are developed a specified amount to preserve the color balance between layers and therefore have no gamma flexibility. Normally they are not offered at different gammas, except for special purposes. Because both negative gamma and positive gamma are fixed by development and normally unchangeable, the paper should

When you get it all together for color printing, you'll have something like this deluxe setup. Super Chromega C Dichroic Color Enlarger has built-in color filters in the head. Select desired amount of cyan, magenta or yellow just by moving pointers along the scales on the color head. Chromegacolor analyzer, at left, with sensing probe reads color balance of the projected image and helps you set filtering. Electronic timer and line-voltage stabilizer are at right of easel.

complement the negative so their gamma product is one or higher.

Printing is based on the assumption that the negative was well-exposed both in the amount and color of the light. Therefore only minor adjustments for color correction should have to be made during printing to compensate for minor color variations of the light at exposure, variations in emulsions and processing. If the color negative has internal masking, the color filtering required in printing will seem like a lot, but most of it is to cancel out the effect of the masking and therefore it does not really have anything to do with the variable color corrections.

Color printing is done in two ways. Some commercial printers make three exposures separately—one for each primary color—and vary the

The big problem in automatic high-volume color printing is correcting for variations in exposure and color balance of shots fired at random by the public. Also coping with non-average scenes which in the trade are euphemistically called "subject failures." Automatic printers have had a good batting average in the past by following the rules of thumb that scenes should have 18% reflectance and the colors should integrate to gray. The machines were allowed to make corrections in those directions when needed and the resulting prints made a lot of people happy.

But not everybody. The Kodak 2610 Color Printer and companion Kodak 2610 Computer and Control Assembly is a very sophisticated step toward making everybody happy with automatic prints. It has a good chance. Under computer control it electronically scans each negative to check background value, color saturation, color density, fog level, and 105 other things. Then it makes the necessary adjustments and exposes the print. If something goes wrong, the machine stops itself, rings a bell, and prints out a message to tell you where it hurts.

That's a long jump from eyeballing your prints and stirring the soup with a stick.

amount of each exposure to adjust color balance. Others make a single exposure, starting with white light, and use subtractive filters to adjust the spectrum of the printing light. Most amateurs do subtractive color printing, with a single exposure.

The simple way is to make test prints over a range of exposures and select the one that seems to have the best exposure. Then examine the test print for color balance and adjust filtering of the projection light to suit.

Filters for color corrections are identified by visual color and density to the complementary color, such as 10Y, meaning a density of 0.10 to blue light. Because blue wavelengths are stopped partially, the filter has a yellow color.

This nomenclature is handy and actually fits the problem. If you have made a print and it is too yellow-looking overall, you should adjust light filtering and try again. Because the print is yellow, the color balance is wrong. What color is missing? Blue, because red and green in the absence of blue make yellow.

The layer in the print that controls blue has too much density to blue. For the next exposure you want to reduce the blue-density of that layer by reducing the blue light during exposure.

If you add a yellow-colored filter into the printing light beam, that reduces the amount of blue in the exposure and reduces the density of the blue-controlling layer of the print. Now look at the print under a suitable white light and it will look better because more blue light is present.

In practice all you have to remember is a simple rule: To reduce an unwanted color in the print, add filtering with the same visual color. Print too yellow; use *more* yellow filter.

When you read specific instructions for color printing it all seems very complicated for a couple of other reasons. One is that adding or subtracting filters in the printing light also changes the *amount* of light and therefore the exposure. Tables help you make exposure adjustments for different filter combinations.

Another complication results from the fact that a stack of filters using all three primary colors, or all three complementary colors, or even the two types mixed, has more of everything than necessary. If you have a set of complementary filters in the light beam, made up of 50M plus

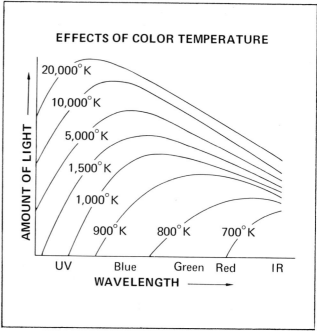

EFFECTS OF COLOR TEMPERATURE

A reminder. This is a sketch of what happens to an incandescent light source when its temperature goes up.

30Y plus 10C, there are 10 units of unnecessary neutral density in the filter pack. The 10C along with 10 units each of M and Y balance each other out in color effect and result only in an effective gray density of 0.10. The color effect of that filter pack would be exactly the same with 10 units removed from each of the three filters, leaving 40M plus 20Y and no C at all. The rule is: When all three primary or all three complementary colors are combined, subtract the value of the filter with lowest density from all three. This causes one to disappear. If you are mixing primaries and complementaries for some reason, the idea is the same but the execution is more complex.

It seems odd that a very good check on the color reproduction quality of a print or transparency is a neutral gray patch in the original scene. The color balance throughout the system should preserve the neutral-gray patch and not give it a color.

This is a test of the color-layers because the gray in the original scene should cause equal densities in each of the three color layers of the negative. When it's all done, the final image presented to the viewer should still have equal densities in the three color layers and the patch should still look neutral gray. If it has a red color cast, the color process didn't work right.

Instead of a single gray patch, you can expose a gray scale of varying densities which gives exposure points ranging from toe to shoulder on all three curves. This will show you what the three layers are doing at different exposure levels.

Another test strip used with color film has high-saturation patches of color. These can also be examined visually or with a color densitometer.

The best way to examine either a gray scale or a color set is with a color densitometer. It works like a b&w densitometer except it uses blue light to measure blue density, and so forth.

Making test strips or prints and using them as a guide to correcting filtration is slow and wasteful of paper and chemicals. There are several levels of automation. One is to use a light meter at the surface of the print to measure the total amount of light without regard to color. This is a guide to exposure. If the meter is equipped with filters to measure the three colors, then it can also serve as a guide to color balance and indicate the values of color filters to be used.

These meters, sometimes called *photometers,* are used in two ways. The best way is to measure a small area or "spot" of the projected image from the enlarger at a point on the scene which requires some definite color balance.

Face tones can be measured and corrected to a standard color balance. Some advertisers use standard colors, such as the corporate symbol or the color of a product. When processing film against this requirement, the color balance of the standard color should be measured and brought to a specified value.

"Spot" measuring is custom work and not suitable for high volume. The oldest idea for high-volume production of color prints, called "integration to gray," is based on the fact that average scenes have some average color if the light from the scene is thoroughly mixed and sampled as a whole. It turns out that the average color is gray, which I think is just a happenstance, applicable to outdoor scenes in general. If you are photographing a white poodle against a purple wall, that scene is not average and any processing which expects it to integrate to gray will not succeed.

For most color photos taken by the public and processed at the drug store, it works. Even when it doesn't work well, the public loves the pictures anyway because they show Aunt Minnie and they have emotional value.

Another solution to the high-volume problem is called "video scanning" and amounts to placing the color negative in front of a TV camera. A TV screen visible to an operator shows the positive image in color that will result with standard exposure. If there is a color cast, the operator turns some knobs to adjust the filtration that negative will receive. The video scanner shows him how it will look with the correction. When he gets it just right, in his opinion, he punches a button and the negative is printed that way.

Using color filters

The utility of a book like this, other than as a door stop or to flatten prints, is based on the assumption that it helps to understand what the gadgets and processes are all about. You should depend less on rules and recipes and more on your own analysis and decisions.

The more you know about making pictures, and the more you do of it, the more importance you will assign to getting the right image on the negative. There are controls and alterations avail-able in subsequent processing, but it's much better to make a proper negative and then send it off on its journey.

Among all the things you think about when exposing film, some are obvious and visible if you remember to look at them. Such as composition of the scene, point-of-view, perspective, focus and depth of field. What you can see is less helpful in judging the amount and color-quality of light, the brightness ratio of scenes, and where you are lo-

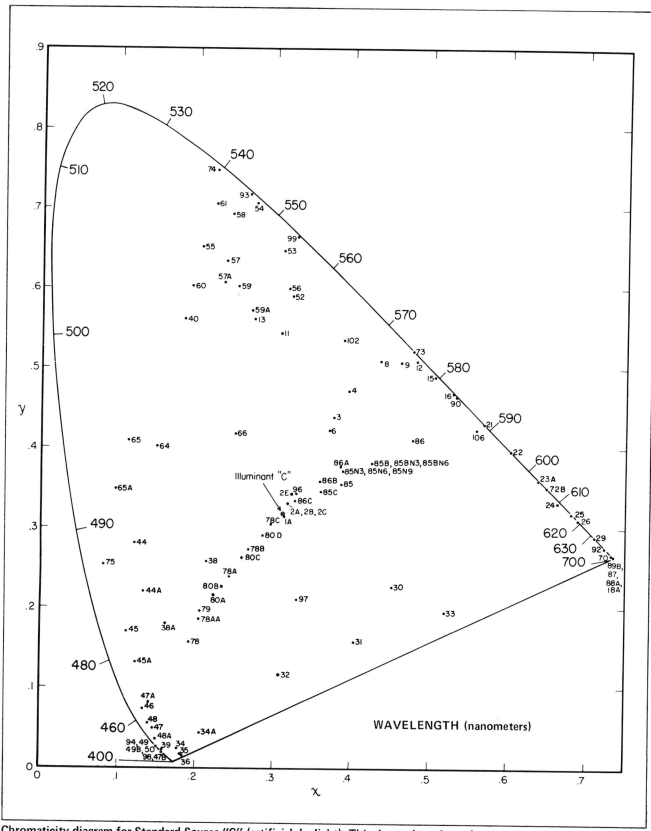

Chromaticity diagram for Standard Source "C" (artificial daylight). This shows the colors of various Kodak filters when they are illuminated by the Standard Source "C" which is approximately equivalent to average daylight. Reproduced with permission from a copyrighted Eastman Kodak publication.

Horizontal axis is red, vertical axis is green—same as my sketches shown earlier. This drawing is accurately dimensioned.

cating the exposure on the film curve. Which boils down basically to color-quality and exposure. This—and the next section—offer some ideas about these topics.

Color filters are usually categorized with names to indicate the problem they solve, which is something like selecting a bandage and then looking for a wound to fit.

I think it's more helpful to diagnose the problem and then search for the remedy.

A problem with b&w film is that even panchromatic film does not have the same color-sensitivity as your eye. It is more responsive to blue wavelengths than to green and red. Therefore a blue object in a scene lit by daylight will appear brighter to the film than to your eye. Even though recorded as a shade of gray, the shade will be lighter than your own subjective assessment of brightness. If you want a more normal tone rendition of a scene in daylight, put a filter over the lens to slightly attenuate blue wavelengths—a light yellow filter.

If you expose b&w panchromatic film indoors under tungsten illumination, the film still wants to be overly sensitive to blue light, but there isn't much blue in incandescent light. It is mainly green, yellow and red. Blue subjects will appear less bright in monochrome and red items will have about the same brightness, but more *relative* brightness. A filter that suppresses the red end of the spectrum will restore normal tone-values. Such a filter transmits blues better than reds, and therefore *looks* bluish, or blue-green, or cyan.

Landscape photographers like clouds. I was at Elephant Butte lake in New Mexico one sunny day, feeding peanuts to the squirrels and loafing. A camera-laden tourist rushed up and took in the vista with one sweeping glance. Dragging his wife back to the car, he said, "You'd think they would have some decent clouds around here!" I felt a pang of sympathy but I was engaged in more important business.

If there had been a nice puffy white cloud, he would undoubtedly have stayed on another 20 or 30 seconds to take a picture. He would have made the cloud stand out dramatically against the sky by taking advantage of the fact that light from the sky is strongly blue. A filter that suppresses blue blocks a lot of light from the sky but only a little bit from the white cloud. A yellow filter. If

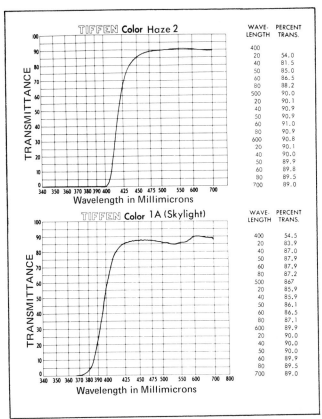

TIFFEN Color Haze 2	
WAVE-LENGTH	PERCENT TRANS.
400	
20	54.0
40	81.5
50	85.0
60	86.5
80	88.2
500	90.0
20	90.1
40	90.9
50	90.9
60	91.0
80	90.9
600	90.8
20	90.1
40	90.0
50	89.9
60	89.8
80	89.5
700	89.0

TIFFEN Color 1A (Skylight)	
WAVE-LENGTH	PERCENT TRANS.
400	54.5
20	83.9
40	87.0
50	87.9
60	87.9
80	87.2
500	867
20	85.9
40	85.9
50	86.1
60	86.5
80	87.1
600	89.9
20	90.0
40	90.0
50	90.0
60	89.9
80	89.5
700	89.0

A haze filter cuts the UV wavelengths below 400 nm which will expose film even though you can't see them and are scattered the most by the atmosphere so they do the most damage to image sharpness and contrast. This filter does cut a bit into the visible wavelengths. It would be OK to cut haze in b&w. It would also cut haze in color but the loss of blue might be noticeable.

A skylight filter is intended for use with daylight color film when you are shooting in the shade. It removes some of the blue cast and makes skin tones look more natural. Obviously it will also cut some haze on distant scenes. A lot of people put on a skylight filter and leave it there—to protect the lens while warming skin tones.

he wanted a stronger effect, he would have used a darker shade of yellow, or orange, or red, in that order.

If your camera has metering behind the lens, you can see and judge the effect of a filter very easily. Expose on the sky, without the filter and without the cloud in view. Set the camera to take that picture but don't. Notice where you set the controls. Now put the filter on and do it all again. Compare the control settings, and you can see the amount of darkening you are doing to the sky. If the first setting was f-16 and the second f-11, you darkened the sky one step, which is perceptible. You also darkened the cloud. You can check that

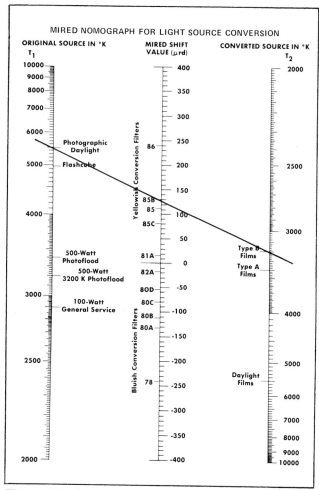

MIRED NOMOGRAPH FOR LIGHT SOURCE CONVERSION

| ORIGINAL SOURCE IN °K T_1 | MIRED SHIFT VALUE (μrd) | CONVERTED SOURCE IN °K T_2 |

This is a Mired nomograph, reproduced with permission from a copyrighted Eastman Kodak publication. It helps you select filters for light source conversion to match the film you are using. A straight line drawn across the three scales gives you three related numbers.

In the example, you are using Type B color film designed for lighting with a color temperature of 3,200 K as shown on the right hand scale. But you are shooting in daylight at a color temperature of 5,500 K as shown on the left scale. What filter do you put over the lens? Center scale says use a Kodak 85B which will give a Mired shift of about +130 units. Plus means toward red as you probably remember. The Kodak filters listed on this chart can also be found on the chromaticity diagram shown earlier.

To use this nomograph, you have to know the color temperature of the light you are using. You can measure it with a color temperature meter or consult charts such as the one on page 158 to get approximate values for various light sources.

A good book to read is Kodak publication B-3 "Kodak Filters for Scientific and Technical Uses" which has a table of color temperature values for various sources and a bunch of information about filters and how to use them.

the same way and see that it is a lot less. The difference in darkening causes the visual effect on the print.

As you know, distant scenes lose contrast due to scattering of light in the atmosphere, called *haze*. Shorter wavelengths are scattered most. Ultraviolet is scattered more than blue. You can't see UV, but the film can, so what you get on film is always *worse* than what you what you see in the real world.

It's pretty sad to learn things the hard way. Before I became serious about pictorial photography, I walked up Mt. Whitney one weekend with a camera in my pack. Standing there on top of the highest point in the 48 states, I spoke to my feet.

I said, "Congratulations," and set about taking pictures to prove they had been there. Lacking any better ideas and also lacking a UV filter, I took four shots, one in each direction.

The atmosphere is itself a filter for UV and shorter wavelengths, but the higher you get the less air there is above you to do that. I was literally immersed in strong UV up there and the shots proved it. I had North haze, East haze, etc. Feet said, "Too bad, Shipman, want to go up there again?" If I had really tried to beat the haze I could have used a red filter with panchromatic film or even a filter which transmits only infrared and special IR film in the camera.

With b&w film, you can be pretty wild with the colors you put in front of the lens because the image will still be gray. You can use filters to make a brightness difference between subjects of different colors but about the same brightness. If you don't do that, they will be hard to distinguish from each other on the print. The rule, for b&w exposures, is: A filter lightens its own color.

If you want to improve visibility of a green frog in the mud, use a frog-colored filter.

With color film, you have to worry about the effect of the filter on the *colors* of the final image. Color film is also sensitive to UV but the filter to remove it should not work down in the visible wavelengths. To your eye, a UV filter will be practically clear glass. Some photographers who shoot color film outdoors put on a UV filter and just leave it there.

Sunlight has a color temperature of 5,000 or 6,000 degrees whereas skylight is maybe 12,000 degrees. Daylight film is balanced for sunlight. If

A rule for color filters in b&w photography is, "A filter lightens its own color." It also darkens the image of colors not passed by the filter. The Vivitar deep red filter out of that box was on the camera lens when I took this picture of the color patches you saw earlier in color. Notice what the filter did to the primary red patch and nearby wavelengths such as magenta and yellow. Notice also what happened to the blues and greens which can't get through a red filter.

1/A practical application of color filters in b&w photography is to alter the relative gray-scale brightness of colored subjects. This rose, photographed without a filter, is about the same tone as the leaves.

2/A red filter lightens the red rose and darkens the leaves, for more visual contrast.

3/A green filter lightens the leaves and darkens the rose.

your subject is under a tree, in the shade, the illumination is from the sky and it is blue. Your eye won't notice it much until you see your print or slide. Then you will wish you had used a *skylight* filter which attenuates blue and higher wavelengths. Therefore it also cuts UV. It will also cut haze from distant scenes. This filter is performing a mired shift of the color temperature of the light.

If you use daylight color film indoors with an electronic flash or blue flash bulbs, it thinks it is seeing daylight. If you use it with tungsten lights the color balance is wrong. Which color balance is wrong, the light or the film? Naturally it is the light, so that is what you fix with a mired shift.

Use a filter to reduce the amount of red and yellow in the tungsten illumination. To use tungsten-balanced film outdoors, use a filter that does the opposite. All filter makers offer filters to do these tricks, but they give them different ID numbers. The literature from any manufacturer will clarify which is which.

You can sometimes use a filter on your camera with color film to make a scene look warmer or colder. It's a curiosity that light of lower color temperature makes things look warmer and light of higher color temperature makes things look colder. Basically you are altering the colors of the scene as presented to the camera. A red-colored filter will make all parts of the scene appear to be more red.

That rule appears to be in conflict with the rule for color *print corrections* where a red filter removes red from the print. We can ignore that apparent conflict, or wrestle with it.

The reason is, a print is really a negative of a negative. A red-colored filter between camera and scene actually makes the red layer more dense on the negative but then less dense on the print. So a filter over the camera lens does darken its own color on the color print. The effect goes through two stages and is reversed in the second stage, the printing process.

When you use a filter only at the second stage, there is no subsequent reversal of densities. A red filter when printing will lighten the red tones of the print.

SIXTICOLOR	KODAK	SIXTICOLOR	KODAK
B 3	82 B	R 3	81 B
6	82 + 82 C	6	81 EF + 81
9	82 C + 82 C	9	85 C
12	80 B	12	85
15	80 B + 82 A	15	85 B
18	80 B + 82 C	18	85 B + 81 B
21	80 B + 82 B + 82 C	21	85 B + 81 EF
		24	85 B + 81 EF + 81 D

The Gossen Sixticolor Color Temperature Meter shown earlier reads out filter corrections in Decamired units. A set of filters available with the meter is marked in the same units with B indicating a shift toward Blue, R meaning toward Red. This table relates these filter designations to Kodak numbers. R 15 shifts 15 Decamired units, or 150 Mired units toward red, which is pretty close to an 85B.

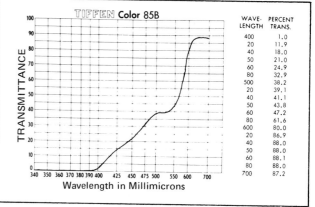

The Tiffen 85B filter with a plus 131 Mired shift looks like this. As you can see, it cuts a lot of blue and green to make daylight look like 3,200° K.

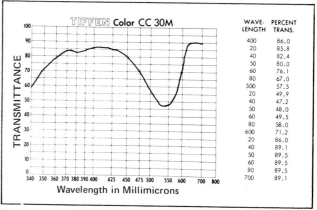

For color printing a family of Color Compensating filters is available to change the color-quality of the printing light. You can get them in red, green, blue and cyan, magenta, yellow. Nomenclature is CC30M, for example, where CC means color compensating, 30 indicates a density of 0.30. M is magenta, the visual color of the filter, so it passes blue and red. The density then is to green light. A density of 0.30 is one exposure step, so the filter should transmit about half of the light at green wavelengths. The curve shows that.

Exposure

Besides color-balance for color films, exposure has two problems: Locating the exposure properly on the curve, and the relationship between the image-brightness range on the film and the emulsion exposure range.

Quick review: The brightness range of scenes is reduced by atmospheric scattering because light gets where shadows are supposed to be in the light beam. For nearby scenes, the effect is negligible because there isn't much air between subject and lens.

The brightness range is then reduced still more by reflections and scattering inside the lens and camera. The net effect is: The brightness range of the light image on the emulsion is less than the actual brightness range of the scene by some amount.

Whatever the brightness range of the image is, it will fall somehow on the film-characteristic curve. It can be shorter than the exposure range of the emulsion and therefore there is some exposure latitude. It can be longer and hang over each end, or hang over only one end if you choose that.

The exposure range on the negative causes some density range after processing. The density range is equal to the exposure range multiplied by the gamma or CI of the film, approximately.

The density range of the negative, whatever it is, is translated into the exposure range of the print and should fit between the toe and shoulder of the print emulsion for reproduction fidelity.

The exposure range on the printing material is again multiplied by the gamma of the printing emulsion and the result is the print density range. Unless the emulsion is driven past the toe or shoulder. If so you will get density equal to what the material can produce, no matter how wide the exposure range was.

Based on happenings between negative exposure and print, a film gamma-product of one is desirable. Based on happenings between scene and print, including contrast reduction in the atmosphere and lens, an overall gamma of more than one is desired. If negative gamma is 0.6 and print gamma is 2.0, overall gamma is their product, 0.6 x 2.0 = 1.2.

The object of this exercise is to get a better feel for that chain of events, starting with scene brightness.

An average scene as you remember has 18-percent reflectance. Some authorities say 20-percent. It doesn't matter much.

Early in the book, I said the average scene had a maximum reflectance of about 90% and a minimum reflectance of some dark part of about 3.5%. The main merit of those numbers is they do have a geometrical average of about 18%. It can be a little higher or lower on each end and I won't get upset.

When film makers define an average scene they also specify nearly uniform illumination of the scene—without really admitting it. With that assumption, let's figure how many exposure steps are occupied by the average scene out there.

One exposure step is twice as much light, so it's easy. Start at the bottom and double up as you go. 3.5, 7, 14, 28, 56, 118. These are reflectances, but with uniform illumination light is proportional to reflectance.

The first exposure step is from 3.5 to 7. Up to 56 there are a total of four steps. There is no reflectance higher than 100% and we think the average world stops at about 90%, so we can say that from 56 to 90 is about a half step. The brightness range of an average scene under *uniform* illumination must be about 4.5 steps. Maybe 5. By the time it gets into the camera and onto the film it will be less than that.

If we rule out far-distant scenes—because typically they are only background to what we really want on the film—we can figure that the loss in air and lens is about half a step, so the exposure range *on the film* is between 4 and 4.5 steps.

As soon as you set foot on my film, you are in the curious world of logarithms where a step is not identified as double the amount of light, but a log increase of 0.3 because 0.3 is the log of 2. If we inquire how many log-exposure units result from doubling the light four times, it is 0.3 + 0.3 + 0.3 + 0.3 = 1.2 which is the same information concealed another way.

Most authorities agree that an average scene

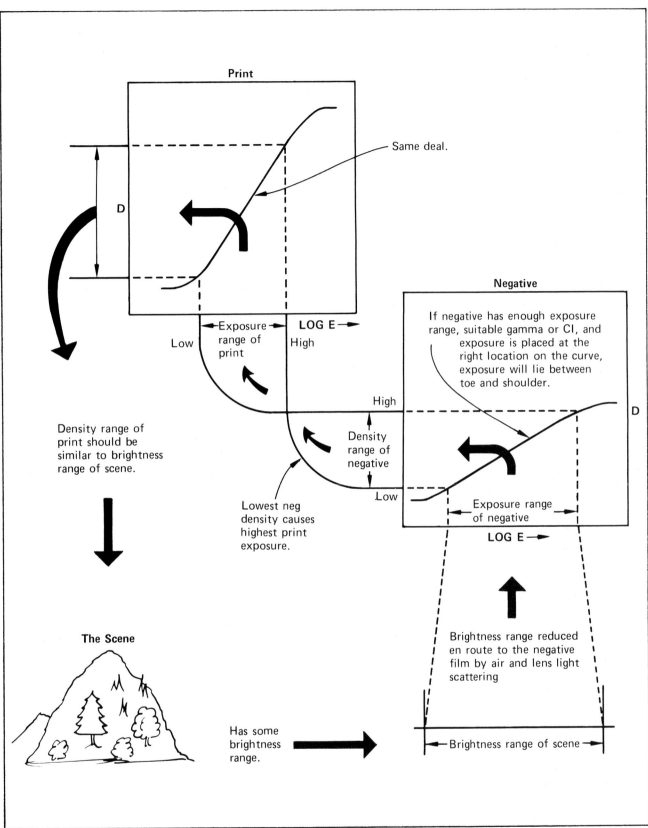

Print

Same deal.

D

LOG E

Low ← Exposure range of print → High

Density range of print should be similar to brightness range of scene.

Lowest neg density causes highest print exposure.

Density range of negative

High

Low

Negative

If negative has enough exposure range, suitable gamma or CI, and exposure is placed at the right location on the curve, exposure will lie between toe and shoulder.

D

Exposure range of negative

LOG E →

The Scene

Has some brightness range.

Brightness range reduced en route to the negative film by air and lens light scattering

Brightness range of scene

Perhaps I should have showed you this in the first place.

puts a Log E range of about 1.2 or 1.3 on the negative. They agree with us.

Now we come to the fine print that takes it away. Most scenes do not have uniform illumination. If the sunlight falls on your face, your nose makes a shadow and the illumination in the shadowed area is not as much as elsewhere on your handsome visage.

To get at the problem more dramatically, imagine a bed of gravel made of two kinds of rocks. One kind is white with 90-percent reflectance. The other is dark with 3.5-percent reflectance. They are thoroughly mixed so each is in all parts of the scene. Sunlight falls on half of the scene, a tree shades the other half. The brightness range of that scene ranges from 90-percent reflectance *of full sunlight* down to 3.5 reflectance *of shadow*.

The bottom fell out, if you will allow that. In full sunlight, the lowest scene luminance was 3.5-percent reflectance of sunlight. Now the least luminance is 3.5-percent reflectance of shadow. We can find out how much less that is if we can find out how much less light there is in shadow than in bright sun. You can just go out and measure that with your exposure meter.

You need a piece of sidewalk or wall, some direct sun and some shadow. If you do it, you will probably find three or four steps difference, depending on how dark the shadow is.

You can estimate a shadow's darkness by considering how much sky you would see if you were there. Because the sky sends light to a scene from all directions, the light is proportional to the area of sky in view. Cut the visible sky area in half and you lose another step. So your shadow could be 5 or 6 steps darker than sunlight. Let's call it 4 anyway.

The overall-brightness range of an average scene partly in shadow is the reflectance range of about 4 steps plus the illuminance range of about 4 steps, a total of 8 steps, maybe more.

Notice I am making a very special definition of an average scene here. It must have an overall reflectance of 18% which agrees with everybody's definition. In addition, I am requiring the average scene to have some white area of about 90% and some very dark area of about 3.5% reflectance. Among all possible average scenes, I am choosing the one with the most brightness range—the worst case.

Then I am putting that scene in the worst possible natural illumination, half sunlight and half shade. The result is an exposure range on the film of 8 steps or so and you can't get that on a lot of films.

If you have a scene with a smaller brightness range, say only 2 steps, and you have a lighting variation across the scene of only 2 steps, then the total exposure range needed is only 4 steps which you can get on nearly any film.

For most scenes, you can measure the brightness range by metering on the lightest part and the darkest part that you want to reproduce with visible detail. Or you can estimate it.

I think it is handy to have an idea of the exposure range films can tolerate without too much compression of tones. The simplest way to get at it is to take the density range of the positive and work backwards through the two gammas to find an approximate exposure range for the negative.

When I do that, I get these results:

With black-and-white film, you can choose the slope of the negative by varying the development and the slope of the printing paper by selecting contrast grade. With normal development to a CI of about 0.6 and the normal contrast grade of paper, 2, the log-exposure range is about 2, nearly seven exposure steps of 0.3 each.

At one extreme, with a negative gamma of 0.5 and a printing paper of contrast grade zero, the negative exposure range is about 9 steps. Naturally the contrast between adjacent brightnesses on the print will be low

At the other extreme, with negative gamma of 0.8 and contrast grade 5, the negative exposure range is about 0.75 step. The resulting contrast on the print would be very high and that would be a good way to shoot the marshmallow on the white tablecloth.

If you use commercial processing, assume the exposure range is about 7 steps for b&w.

For color negatives and prints, we can't fiddle with the gammas. The density range of color paper is used up with a negative exposure range of about 5 steps, assuming there are some strong colors in the scene. This says that color negative-positive does a good job on average scenes with fairly uniform illumination, which is true.

The speed of color slide films is *based* on a log-exposure range of 1.8 and normal exposure

calculators will center the exposure in the middle of that range. So the film must have an exposure range of 6 steps because 6 x 0.3 = 1.8. I think it is a little more than that for some types. The reason slide film does not have the limitation of color-negative film is due to the limited reflection density of the color print. The transmission density of color slides goes up to 3 or more.

If you know the image-brightness range you are putting on the film because you are measuring it inside the camera—and if you know the approximate exposure range the film will accept—then you can worry about positioning the exposure on the curve.

Exposure calculators figure required exposure by doing the arithmetic backwards to discover the recommended minimum exposure near the toe, and then multiply that by 8, which means add three steps. That allows some safety factor between minimum actual exposure on the film and the minimum useful exposure.

If an average scene in uniform light covers four steps of log exposure, and the middle of it is placed three steps above the minimum useful point on the curve, then the safety factor is one full step. If the average scene is 4.5 steps, the safety factor becomes 0.75 step. Obviously the factor depends on how you define an average scene, but 4.5 steps is in the ballpark.

If you have a scene only 3 steps wide in exposure and you want to make a thin b&w negative, then your exposure meter will do it wrong. You can use about 1/2 step less.

If you have a scene that is 9 steps wide and you want to fit it all onto a b&w print, you have to develop for minimum gamma and print on low contrast paper. Even if you do that correctly, you won't get a good image if you let the exposure calculator manage the problem. It will position the center of that 9 steps above the minimum by only three steps, so you will lose 1.5 steps of shadow detail after all that work to get it.

If you want to center the exposure of a scene that is some number of steps wider than average, you should increase exposure by half that number. If it is two steps too wide, increase exposure by one step, compared to the integrated or averaged light reading of the scene.

If you meter the highlight and shadow, and then take the middle exposure step, you have done

that automatically.

Because there are lots of film types and manufacturers, there is no agreement in the literature about exposure ranges of film, average scenes, and the things I have discussed here. You can find different values in different publications. The exact values are not as important as the ideas. When you use these ideas, plus ideas of your own so you get better results with your equipment, the purpose is served.

GOODBYE, MANIPULATORS

I own a book titled *Human Behavior* which is a collection of scientific findings about why we do the things we do. It covers most of the human frailties and irregularities, so I enjoy looking in it occasionally to read about myself.

A point in this book that impressed me was a statement that humans and lower animals seem all to have a definite manipulative urge. We will fool with things just to be doing it, with no promise or expectation of reward. We tie knots in a piece of string, arrange rocks in a pattern and then rearrange them, and do more complex things too. We like to solve puzzles and sometimes complicated problems, mainly for the satisfaction of having solved them.

I am convinced that many of the hobbies we enjoy are expressions of this manipulative urge. I have a friend who alters motorcycles. When he has changed everything possible about the original design, he sells it and starts over again with a standard model. Plainly the fun is in the doing, not in the end result.

I think a lot of photographers, who are really into it as a hobby or profession, find as much reward in the things that lead to a photograph as in the end result. This is manipulation, puzzle solving, and complex problem solving. I hope this ramble has helped you get better results, but even more I hope it gives you fun along the way.

"Goodbye, Manipulators."

"Goodbye, Shipman."

Index